GLOBAL
SOUTH
ASIA

Padma Kaimal
K. Sivaramakrishnan
Anand A. Yang

SERIES EDITORS

Displaying Time

THE MANY TEMPORALITIES OF THE FESTIVAL OF INDIA

Rebecca M. Brown

Publication of this book has been aided by a grant from the Millard Meiss Publication Fund of the College Art Association.

Additional support was provided by the Department of the History of Art and the Krieger School of Arts and Sciences at Johns Hopkins University.

University of Washington Press
www.washington.edu/uwpress

Library of Congress Cataloging-in-Publication Data

Names: Brown, Rebecca M., author.
Title: Displaying time : the many temporalities of the Festival of India / Rebecca M. Brown.
Description: Seattle : University of Washington Press, 2017. | Series: Global South Asia | Includes bibliographical references and index.
Identifiers: LCCN 2016023732 | ISBN 9780295999944 (hardcover : alk. paper)
Subjects: LCSH: Festival of India in the United States (1985-1986) | Time and art. | Art—Exhibition techniques.
Classification: LCC NX430.I4 B76 2017 | DDC 700.954/07473—dc23
LC record available at https://lccn.loc.gov/2016023732

The paper used in this publication is acid-free and meets the minimum requirements of American National Standard for Information Sciences—Permanence of Paper for Printed Library Materials, ANSI Z39.48–1984. ∞

Portions of "Flickering Light, Fluttering Textiles" were published in "Moments of Resistance: Small Interventions and the Festival of India," in Kim Youngna, ed., *Exhibiting Asian Art: Issues and Perspectives* (Seoul: National Museum of Korea, 2011), 193–226; this text was translated into Korean by Heeryoon Shin and published in expanded form in *Misuljaryo* 82 (2012): 14–44.

"Material Transformations" is an expanded and revised version of a chapter included in Deborah S. Hutton and Rebecca M. Brown, eds., *Rethinking Place in South Asian and Islamic Art, 1500–Present* (New York: Routledge, 2016).

An earlier version of "The Contemporary, at a Distance" was published as "A Distant Contemporary: Indian Twentieth-Century Art in the US Festival of India (1985–86)" by the College Art Association in the September 2014 issue of the *Art Bulletin*.

To Sam

Contents

Plates appear after page 160.

Plates and Figures

Acknowledgments

I HAVE been overwhelmed and honored by the generosity of those who have answered my questions, reminisced about their experience in the distant 1980s, explained the workings of bureaucracies then and now, and shared tea, biscuits, and their homes over the course of this research. I began this project in earnest as I transitioned from the U.K. to the U.S.; the communities in both places have supported my scholarly inquiry and have shaped it in ways I often only realize in retrospect. This work also took place during a time in my career when I did not have a permanent post at an institution, such that I had to snatch moments of research between semesters, take the commuter rail from Baltimore to D.C. to work at the Smithsonian Archives for the day, grab a weekday or two to spend in museum archives in New York, meet with colleagues over holiday periods in India and the U.K., and chat with my many interlocutors, when necessary, over Skype or the phone. Without the luxury of the traditional academic sabbatical, this book has managed to take shape in fits and starts. In some ways that has been a blessing, as the thinking for this book matured over the course of many years without the pressures of administrative work or the demands of university promotion systems. On the other hand, now that I enjoy the stability and privilege of a tenured position (and look forward someday to that elusive sabbatical), I am mindful of the ways in which all research is shaped by limited access to particular modes of knowledge. This book is about time—short, minute durations that we understand in the flutter of tent fabric or the slow decay of a terracotta sculpture. And indeed, the attention I pay here to these small moments perhaps emerged unconsciously from the instability and the moment-to-moment sensibility I had to cultivate during the years I spent in academic limbo. I want to recognize the growing number of colleagues who operate in that unstable temporality, and to acknowledge the overwhelming privilege and responsibility that a tenured position demands in this age of the adjunctification of the university. Knowledge can be produced in the interstices, certainly, but we must be mindful of the damage to the intellectual community that our new era of academic life engenders.

Museums in the 1980s were just beginning to realize that they might keep archival records of their own practices and exhibitions. As a result, I have depended heavily on the

memories and personal archives of many of the curators and others involved in these exhibitions. Without them I would not have been able to pursue this project, and so I thank Amy Poster, Thomas Sokolowski, Edith Tonelli, Eliza Rathbone, Zette Emmons, Dorothy Globus, Brian Durrans, Richard Kurin, Jyotindra Jain, Mark Kenoyer, Stephen Huyler, Rochelle Kessler, Haku Shah, and Rajeev Sethi. These exhibitions would not have happened were it not for the activities of a number of diplomats and employees of various governmental organizations in both India and the U.S. Maureen Liebl and S. K. Misra were invaluable interlocutors for me and were able to introduce me to a wide range of people involved in the Festival of India, often over whiskey at their home. I could not have done it without them. Asharani Mathur, Niranjan Desai, Didar Singh, Patricia Uberoi, and Kapila Vatsyayan all took time out of their busy schedules to speak with me about their memories of the 1980s and the key issues at stake during the Festival planning stages and the busy months during its run. Sushma Bahl, Puran Bhaat, Jatin Bhatt, S. M. Kulkarni, and Jyoti Rath shared with me their experiences of helping to organize, make objects, install galleries, and perform at the Festival, and offered keen insights as to the place of that mid-1980s moment in their own histories as well as the political and art historical flows of the twentieth and twenty-first centuries.

At each museum archive I was struck by the generosity of the staff and the excitement over my project. Some repositories had little to offer me but were able to send what they had; others opened their voluminous archives and worked with me to sift through the material. Kristi Ehrig-Burgess at the Mingei International Museum has helped transform the remaining tiny contact prints of the installation into usable photographs. Elizabeth Broman at the Cooper Hewitt, Smithsonian Design Museum in New York shared the *Golden Eye* archives with me and enthusiastically worked with me to help identify some of the images and individuals involved. Stephanie Smith and Jeff Place at the Rinzler Folklife Archives set me up with hours of raw film footage of the *Mela!* events on the Mall, which I watched and listened to as music spilled out of the offices around me (a real treat for an art historian used to relatively silent photographs and objects). Tad Benicoff, Ellen Alers, and Mary Markey at the Smithsonian Institution Archives helped me identify where the materials might be in the various branches and categories of that vast organization. Karen Schneider at the Phillips Collection Archives shared not only the institutional records but also her own memories of the Festival of India in D.C. Barbara File, Navina Haidar, and Jean Tibbetts at the Met helped me navigate the various departments where Costume Institute and Islamic Department records were stored. Veronica Szalus, then Director of Exhibits at the National Children's Museum, scanned and sent their thin file on the Nek Chand exhibition and then invited me to visit his works in storage, a privilege and joy that will stay with me for a long time. Charlotte Brown at the UCLA archives brought me all kinds of sources and raised wonderful interconnections across campus in the 1980s that I would not have found otherwise. David Ziegler in the History of Art department at UCLA helped me professionally scan the slides from the archive with patience and care.

Many of these individuals assisted me again later on in the project as I sought permission to publish the images in the book, as did many others. Susan Bean, Shivaji K. Panikkar, Gulammohammed Sheikh, Atreyee Gupta, Karin Zitzewitz, Sonal Khullar, Beth Citron, and others over the years have helped me reach out to modernist Indian artists and their estates to seek permission to use their work in my publications. Often gallerists and artists' collectives from around the world have been of great assistance in reaching out to artists and their families, and I thank Prajit Dutta and Amy Distler of the Aicon Gallery in New York, Reginald Baptiste and Pratiti Basu Sarkar of the CIMA Gallery in Kolkata, and P. Gopinath of Cholamandal Artists' Village outside of Chennai. And I sincerely thank all of the artists themselves for granting me permission to include their work in the book. I would like here to especially thank Vasundhara Tewari Broota for her hospitality in Delhi and her enthusiasm for the project as a whole.

Many colleagues read portions of the manuscript over the years during which I developed this project, and what emerges here has benefited greatly from their insights, proddings, and encouragements. I'm incredibly lucky to have had an extensive community of readers who have given generously of their time and intellectual energy to help make this work better: Ruth Feingold, Deborah Hutton, Hilary Snow, Sanchita Balachandran, Elizabeth Rodini, Rebecca Hall, Atreyee Gupta, Susan Bean, and Samuel Chambers all read portions of the book and provided insightful and probing feedback. I'm also grateful to my Hopkins colleagues Chris Lakey, Molly Warnock, Mitch Merback, and Jane Bennett, whose comments helped to hone portions of my arguments here. Amy Miranda, Elizabeth Bevis, Rebecca Teresi, and Nicole Berlin provided crucial support as research assistants as the project came to fruition. I likewise thank the anonymous reviewers of the book manuscript and of portions of the book that have appeared elsewhere, whose attention and care demonstrated the utmost collegiality and generosity. Natasha Eaton, Karin Zitzewitz, and several anonymous readers read the entire manuscript with enthusiasm and offered comments that take my breath away in their generosity and intellectual engagement—my deepest thanks. Portions of the book benefited from the incredible copyediting of Lori Frankel, whose attention to words, sentences, and argument demonstrates that good editing truly is an art. It has been a pleasure working with Regan Huff, who ushered the book through the process from beginning to end, and the production team at the University of Washington Press; my sincere and deep thanks to the Press and to the series editors for shepherding and supporting my work. Hawon Ku, Julie Romain, Parul Dave Mukherji, Stephanie and David Hershinow, and Julian Brown and Jane Elliott extended much-appreciated hospitality and support to me in cities all around the world during the course of this research. Audiences at the 2011 American Council for Southern Asian Art symposium in Minneapolis, Seoul National University, the National Museum of Korea, the University of Virginia, the Walters Art Museum, Johns Hopkins University, the University of Maryland Baltimore County, Yale University, Washington and Lee University, Syracuse University, the Musée du Quai Branly, Columbia University, the University of Minnesota, Mankato, and the University of Chicago helped hone the arguments presented

here, and I thank my many hosts at these institutions for generously including my research in their intellectual conversations.

I also owe a great deal to the students who have worked with me in various courses and seminars while I was working on this book. The topics only occasionally overlapped with the material here, but as always with these things, our conversations have spurred new insights for me and are one aspect of the academic life that truly inspires me each day. A special thanks to Elizabeth Rodini, my collaborator on a seminar devoted to materiality, and to the students in my Active Body and Epistemology of Photography graduate seminars, who assisted me in the project of weaving together anthropological readings with art historical material to see what new conversations might emerge.

The publication of this book has been funded by a grant from the Millard Meiss Publication Fund of the College Art Association, supplemented with grants from the Department of the History of Art and the Krieger School of Arts and Sciences at Johns Hopkins University. I thank both institutions for their support.

My family has provided multiple metaphorical and literal shelters during the course of the writing of this book. I've experienced new relations to time by entering triathlons thanks to and with my sister Katharine, and I've stolen moments of my sister Elizabeth's time in the interstices of her frequent trips to D.C. Over the course of writing the book, I've treasured the short and long periods of time I've been able to share with both of my parents and with the rest of my family in both Denver and Portland.

I write this in a snatched moment, sitting in Brighton (actually just over the city line in Hove), listening to the seagulls pierce the morning's quiet. This project has been a wonderfully multifaceted, exciting journey, and I look forward to seeing where it might go in the future; what new embroideries and tent formations it might inspire. I thank everyone who has participated in helping me set up, strike down, unpack, and unfurl this particular tent, and most particularly Sam, whose exceptional ability to negotiate temporalities in tension and the limbo of academic life has enabled us to find shelter: a small, quiet tent where this book has slowly and quickly, in fits and starts, taken form.

DISPLAYING TIME

Flickering Light, Fluttering Textiles

It is heartbreaking to hear that we are not going to have a tent! We must have a tent, or a section of a tent, a bit of a tent, or something, that can be built into a corner or a side or within one of our smaller rooms.

—DIANA VREELAND

As part of the Festival of India—a multi-sited set of exhibitions, public talks, poetry readings, and music and dance performances held across the United States from June 1985 through to the end of 1986—the Metropolitan Museum of Art in New York staged two major exhibitions. Stuart Cary Welch curated *India! Art and Culture, 1300–1800* for the Islamic department, and Diana Vreeland curated *The Costumes of Royal India* for the Costume Institute. Despite Vreeland's worries, both exhibitions included a tent. The *India!* tent came from Mughal emperor Shah Jahan's seventeenth-century court, on loan to the Met from the princely collection of Jodhpur in Rajasthan (figure 1.1, plate 1); the tent in the *Costumes* show was a canopy of draped modern fabric decorated on its interior with a silk brocade throne cover, itself held in place by ivory rug weights, topped with bolsters that were draped with a silk scarf, or dupatta, and punctuated by a stunning white peacock (figure 1.2, plate 2). The tent in these two shows serves as a malleable, spectacular pivot around which the other objects and set pieces revolve. The exhibition becomes encampment, environment, all-encompassing lived experience.

I would like to think with and through the tent here in my introduction, as a metaphor for both the Festival of India and my own project to unpack, shake out, stake down, erect, decorate, and explore the moveable, multiple experiences of the Festival. (You can see already how much fun this metaphor will be.) Tents are objects, like many of the things art historians study and put on display in museums. They have a physicality to them, made of cotton or wool or occasionally silk and embellished, in the case of the Mughal

[3]

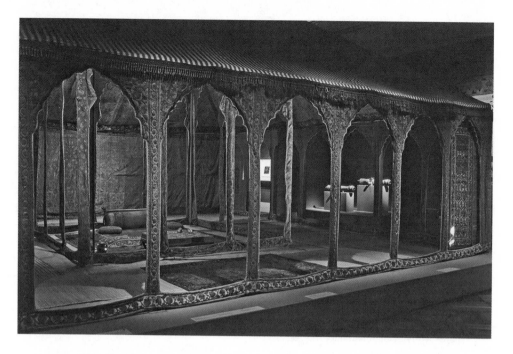

FIGURE 1.1 (Plate 1). *India! Art and Culture, 1300–1900* installation view with Mughal tent, mid-seventeenth century, silk velvet, embroidered, with metal-wrapped yarns and cotton, 152 × 297 × 294 in. (380 × 742.5 × 735 cm). Object in the collection of Mehrangarh Museum Trust, Fort, Jodhpur, on loan from Maharaja Sri Gaj Singhji II of Jodhpur (L21/1981). Photo by Al Mozell. The Metropolitan Museum of Art, September 14 1985–January 5, 1986, Special Exhibition Galleries. Image © The Metropolitan Museum of Art. Image source: Art Resource, New York.

tent at the Met, in elaborate embroidery. As such, one might analyze them as static entities, but to do so would overlook one of the most crucial elements of tents: *they move.* And they move not only from one site to another—set up and broken down as the ruler moves across the imperial landscape—but also in the breeze, as the flap opens and closes to let people in, as the temperature changes and the moisture of the dawn dampens the outside of the fabric. The fabric of the tent responds to warming fires, the heat of bodies, and the blazing sun. Its embroidery seems to move in the light of lamps and candles, the gold thread shimmering as the flame passes by. Air and sound filter through its fabric, leaving dust, mold, and fragrance behind and reminding us of the permeability of the temporary walls, walls that provide only partial isolation, partial privacy. These minute movements of textile and light, heat and moisture, perfume and mold, join the larger movements of pitching and securing, packing and unpacking. A tent's movements, minute and major, occur in time. The tent metaphor therefore stakes out the central thematic of this book: temporality.

By temporality I don't mean large grandiose cycles of time, such as ancient Indian conceptions of *yuga*s, the forty-thousand-year cycles that begin and end in the destruction

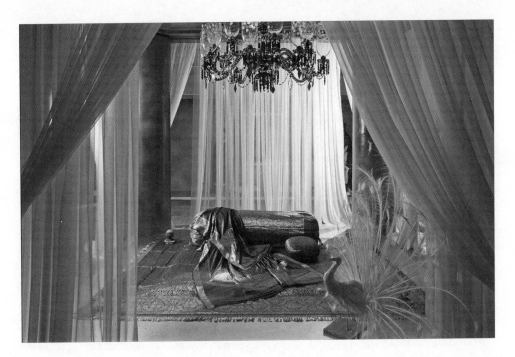

FIGURE 1.2 (Plate 2). *Costumes of Royal India* installation view with tent. The Metropolitan Museum of Art, December 20, 1985–August 31, 1986, The Costume Institute Galleries. Image © The Metropolitan Museum of Art. Image source: Art Resource, New York.

and re-creation of the universe. I also don't intend to discuss similarly expansive modern conceptions of time that attempt to articulate the relation of, for example, labor to clock time or that presume a linear, forward-moving, accelerating progress shared universally across cultures and periods.[1] My project differs from these in scale. I would like to refocus our temporal lenses on the minute, small durations of making—for example, harvesting the silkworm's cocoon, spinning it into thread—that, in slower and faster aggregations, comprise the tent in the *India!* exhibition. Making and remaking continues in the processes of setting up the tent—curators sending telexes to the Maharaja's staff, flying five experts to New York from Jodhpur, the days of preparation involved, the evocation of the past that the smells of the tent bring forth in the unpacking—and the life of the tent in the gallery—moving ever so slightly in the air-conditioning, expanding and contracting in the carefully staged lighting, interacting with the smells of the visitors and the humidity controls of the museum.[2]

These durations, with their differing flows—interminably slow, continual, instantaneous—enliven and illuminate exhibitions such that we can see past what sometimes reads as a set showcase of static, interrelated objects, joined together through the intellectual narrative of the curator, a narrative communicated via placards and audio tours. Instead, exhibitions are about time: presenting the past, perhaps, yes. But they also embody a range of small temporalities, minute durations—these varying viscosities of time accumulate in

planned and unplanned ways, coming together in exhibitionary moments and dispersing again. Flickering and fluttering, gathered, pitched, and broken down.

The Festival emerges from conversations between Ronald Reagan and Indira Gandhi in 1982: highly rarified diplomatic exchanges that provided the impetus for setting in motion over 215 India-related events in the United States.[3] The U.S. sought to push India to continue its slow opening to global markets (and to move away from the Soviets), while India wished to redefine itself as a tourist and trade destination (and to work against continuing postcolonial misconceptions about its culture, heritage, poverty, and so-called backwardness).[4] These grand political maneuvers occurred against a backdrop of economic deregulation and the rise of neoliberalism, evident in the growing language of individual entrepreneurism (a 1980s neologism), the over-the-top drama of Reagan's two inaugurals, the rise of grandiose architectural pastiche in the postmodern, and the cultural embrace of the massive and rapacious profit making of Wall Street, as evidenced (and critiqued) in the 1987 film of the same name.[5]

Thus, the exhibitionary temporalities I unpack here, as I set up my particular tent, remain anchored in a ground saturated with the particular flows of a mid-1980s globe as punctuated by Cold War politics, postmodern culture, and neoliberal economics. In reading the durations of making, displaying, performing, and viewing, I understand these motions and processes as engaging with a larger social formation—these particular temporalities, in this particular relation to one another, emerge from and help to produce the relations of power at work in the 1980s. Indeed, one could also include in this historical moment many of the theories and theorists I think with here—the salience of Derridean ways of thinking for the North American academy, the publication and translation of Roland Barthes's *Camera Lucida*, Foucaultian understandings of power and history, Edward Said's *Orientalism*, Paul Virilio's and Marc Augé's rethinking of postmodernity and time—these theoretical conversations are bubbling in the academy even as the Festival is happening. While the insights of these theorists sometimes took decades to become dominant, they nonetheless embroider the fabric of both my thinking and the historical period I am working with.[6]

Likewise, the rise of postmodernism in architecture, design, and visual culture permeates this period and informs my approach to these small durations and fragmentary temporalities (see Adamson et al. 2011). An emphasis on pastiche and jarring juxtapositions permeated the visual culture of the long 1980s. In India, a greater access to global media, whether through film, television, or magazines, and a parallel increase in the import of goods from around the world brought a wide range of source material into the visual landscape. The impression of stability in 1950s America and India flows through 1980s visual culture as a sense of nostalgia for an ostensible postwar utopia, in India inflected with a post-1947 Nehruvian optimism. The turn to colonial histories with Raj nostalgia films and television series also participates in the overarching search for (and valorization of) a moment of stability in the past. With the uncertainty of the Cold War and nuclear annihilation hovering over the entire world, the destabilizing wars in Afghanistan and Latin America, and the infusion of new forms of cultural bricolage in architecture,

film, and popular media, it is not surprising that an underlying temporality of fragmented, small moments emerges as a mode within which these exhibitions operate.

Thus these large-scale narratives of the Cold War and the postmodern rest on an unstable ground of minute moments, and it is the latter I focus on here. Rather than narrating grand, high-level politics or trying to reconstruct curatorial motivations, I instead turn to the small-scale temporalities of the exhibition—the minutiae—to enable us to run our fingers across the nuanced texture of tent, sensing the embroidered stitch that produces the multifaceted, often fragmented exhibition. In doing so, I engage with histories of these exhibitions that privilege the small over the grand, and I offer continual reminders that these sometimes intimate and quiet and sometimes bold and brassy moments— the movements of the tent in the breeze—take place because of and help to shape what seem like larger flows of money, information, political dialogue, fashion, and commerce.[7] I unpack this multilayered tent, set it up, inhabit it for a time, and then take it down so that a remnant of that mid-1980s rhythm might ring out again, this time through the iteration of metaphor and history writing.

Hints of my own prior encampments appear in these pages. I have long been interested in the ways in which visual culture participates actively in the production of knowledge. My book on the genealogy of the image of the spinning wheel and the act of spinning engaged with questions of making, craft, and duration in ways that resonate with the discussion of the Festival of India here (Brown 2010). That book only touched on the range of sensorial processes at work in spinning, but the discussions of the stages of cloth production, the fits and starts and interruptions of developing spinning as political rhetoric in Gandhi's anticolonial movement, the syncopated rhythms of the arm and the meditative concentration demanded by the process all relate to understandings of temporality I explore in this project. Likewise, my earlier book, *Art for a Modern India, 1947–1980*, engaged with the ways in which art, architecture, and a range of visual culture shaped what modernism and modernity might be in the first decades of independent India (Brown 2009). That project left off in 1980 for a number of reasons, including the very real sense that an economic and political shift was under way in India during that long decade. This book therefore serves as an opportunity for me to delve more deeply into the rise of neoliberal capitalism and the exigencies of the late Cold War during the long 1980s while maintaining a concern with the sensorial minutiae of making, the object, and doing that serve as crucial threads throughout my thinking and writing.[8]

Tents house activities and people as well as objects; the metaphorical tent of the Festival of India gathered together a wide range of exhibitionary practices, from performance to demonstration to spotlit objects and embroideries moving slightly in the breeze. The Festival cannot be housed in a single tent, as this was a multi-sited, internationally funded series of events resembling a series of tent cities rather than a single tent. The U.S. Festival followed the U.K. Festival, a similarly multi-sited event on a slightly smaller scale that took place in 1982.[9] The United States sought, in superpower fashion, to outdo its northern Atlantic neighbor, and with hundreds of activities it succeeded in terms of sheer numbers.

Thirty-two U.S. states and the District of Columbia hosted exhibitions, talks, and performances; New York state and D.C. had fifty-four and twenty-five events, respectively.[10] In the official calendar, seventy-seven art exhibitions took place across the country. These shows ranged widely, focusing on medium (terracotta, sculpture, textile), period, or occasionally theme (folk art). Many of them remain landmark events that reoriented the direction of the study of Indian art history in the decades that followed.[11] India set up diplomatic officers in D.C. and New York to handle the Festival; scholars, curators, performers, and artists were recruited from across India to participate. Museums and galleries in the U.S. responded to the availability of funding and the potential for access to India's art collections by expanding existing plans for India-focused exhibitions or by proposing new shows; ideas came from both India and the U.S., and most shows involved a great deal of international collaboration.

From 1982 through to the end of the Festival in 1986 and for several years afterward, institutions in both countries worked to mount shows, carrying samples and plans in suitcases, waking up at two a.m. to receive important phone calls, meeting in boardrooms in Delhi and workshops in Kashmir, and generating pithy responses for the chattering telex machine. Most scholars of India in the U.S. at that time participated in some way; for some, the Festival solidified an interest in India that led to graduate study and an academic or museum career. Many Indian scholars, too, used the opportunity to build ties with the United States, and many of them secured positions in North America and Europe after visiting in the mid-1980s. For other participants, the Festival was one of a series of performance venues as they toured the world demonstrating their craft or playing their music for European, American (North and South), Antipodean, Asian, and African audiences. And for many, the Festival became an opportunity they were unable to take advantage of, due to active and passive forces of economic and political exclusion. The Festival also served as a touchstone for criticism from those who read its project as neo-Orientalist, from those who decried the missed opportunities and erased representations, and from those who saw it as a boondoggle pursued by spectacle-happy politicians.

Indeed, Vreeland's exclamation, demanding a tent, supports these kinds of neo-Orientalist readings of the Festival. What could be more Orientalist than the evocation of an Indian ruler reclining in a tent, the desert landscape outside and the excesses of the court inside? (Perhaps adding a white peacock to the tableau? Done.) The tent, then evokes not only textile in the breeze, the flickering of light against gold embroidery, the setting up and taking down, dust and mold, but also a long history of Orientalist imagery, something the Festival of India participates in, works against, and falls prey to. India is thus "All the Raj," according to the fashion news headlines; the mid-1980s saw a revival of Nehru collars, fabrics evoking saris, and bejeweled sandals (Harden 1985). And advertising for the Smithsonian's exhibition *Aditi* proclaimed that "to miss it would be like turning down a trip to India on a flying carpet" above an image of two courtiers on a fully caparisoned elephant (figure 1.3). But tents are, of course, not just fantastical and imagined—a wide range of cultures across South Asia used tents, and the courtly wealth they evoke certainly

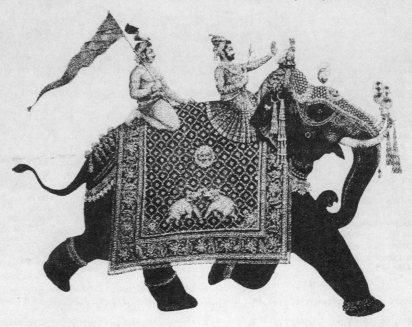

> *"To miss it would be like turning down a trip to India on a flying carpet"*
>
> The-Sunday Telegraph, London

Aditi
A Celebration of Life

The first American showing of a unique living exhibition of the arts of India, both ancient and modern, which was a resounding success in London three years ago.

A magnificent display of 1,500 artifacts . . . Demonstrations by master potters, painters, toymakers and other craftspeople . . . Continuous performances of Indian dancers, singers, musicians, puppeteers, jugglers and acrobats . . . All brought to Washington from India to celebrate the cyclical nature of life from the perspective of the child.

The works of art, the artistry of craftspeople and performers, all recall the ancient yet contemporary meaning of the Sanskrit word ADITI, the creative power that sustains the universe.

Visit Aditi, Tuesday, June 4 through July 28, 11 a.m. to 5 p.m., daily except Wednesdays (open Wednesday, June 5). Admission free.

NATIONAL MUSEUM OF NATURAL HISTORY/MUSEUM OF MAN
Constitution Avenue at Tenth Street, Northwest

Aditi—A Celebration of Life is part of the Festival of India 1985-86. Aditi was organized through the collaboration of the Smithsonian Institution and the Government of India. Important additional support has been given by Air-India, the Armand Hammer Foundation, the Chicago Pneumatic Tool Company and the Indo-U.S. Subcommission on Education and Culture.

FIGURE 1.3. Newspaper advertisement for *Aditi: A Celebration of Life*. Smithsonian Institution Archives. Accession 97-012, National Museum of Natural History, Office of Exhibits, Special Exhibition Records, box 5.

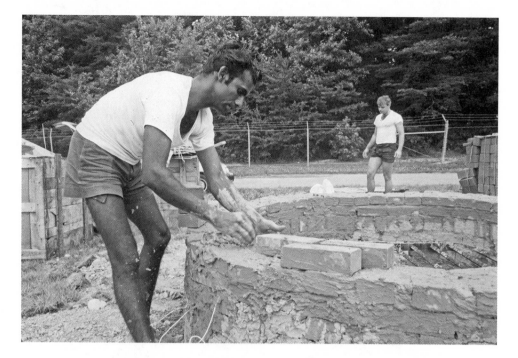

FIGURE 1.4. M. Palaniappan (L) and Mark Kenoyer (R) building a kiln, Suitland, Maryland. Photograph by Tracy Eller, courtesy of the Ralph Rinzler Folklife Archives and Collections, Smithsonian Institution. Also published in Kurin 1991b, 18.

has roots in history. One has no need for ivory carpet weights unless the court primarily inhabits tents. Their courtly context, their circulation within Orientalist discourse, their rearticulation in a range of museum spaces—tents put all of these elements in play, and the Festival, too, had to juggle and navigate these competing pressures.

It should be clear that a single book cannot shelter all of this under one tent, and I will not attempt such a feat of imaginary textile engineering. Instead, I offer a few smaller shelters, within which I gather some of the elements of the U.S. Festival together, not to encapsulate the Festival but instead to trace its irruption in the mid-1980s in order to read the nuances of the temporalities at play in this jumbled and chaotic exhibitionary context. I start with a chapter focused on materiality and making, following the mean stuff of art into its form and then into display. The in-gallery activities of demonstration, performance, and entertainment follow in the "Time, Interrupted" chapter, butting up against and feeding the flows of objects, people, and ideas within the gallery, from workshop to studio, and from gallery to department store. These opening chapters examine at close range the minute durations and layering of temporality. The following two chapters extend the fabric of those engagements, exploring first an exhibition—*Golden Eye*—that engages in ideas of design, trade, and craft, embodying an entrepreneurial futurity, finding potential and economic hope in the minute workings of exhibition planning, and in the tactile encounters in design studios and art workshops. I turn then to the question of

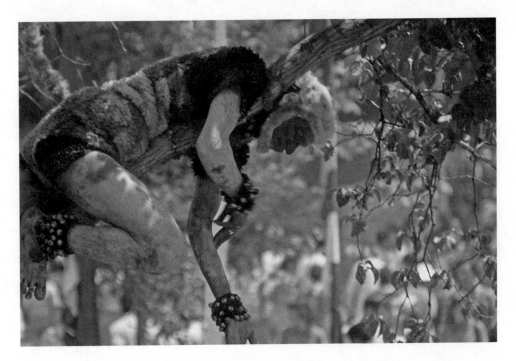

FIGURE 1.5. Krishna as *bahrūpiyā* (impersonator), at the 1985 Festival of American Folklife program *Mela! An Indian Fair*, Washington, D.C. Photograph by Daphne Shuttleworth, courtesy of the Ralph Rinzler Folklife Archives and Collections, Smithsonian Institution.

the contemporary at the Festival, thinking through the disruptive potential of modernist art as it found its way onto gallery walls. These shifting temporalities necessarily exclude and erase, and that flickering light of potential, so often hidden and snuffed out, opens a way toward ascertaining how this tent stands on its ground and in the wind, pointing toward its eventual dismantling (and re-erecting).

The magic of transformation—cloth into tent—imbues the Festival; let me introduce two individuals who helped to create this transformative magic. In and around Washington, D.C., a horse and a monkey emerged from the hands, bodies, and minds of two Indian artists who had traveled to the U.S. capital for the Festival. M. Palaniappan, a ceramic sculptor from Tamil Nadu, built a kiln to fire his six-foot-tall terracotta horse sculpture in a grassy hollow in Suitland, Maryland, on the grounds of the Smithsonian's storage facilities (figure 1.4).

He transformed clay, straw, and other materials gathered in India and in the U.S. into a mount for the deity Aiyaṉār, one that would have stood at the edge of a town in southern India, protecting the crops and fields. Meanwhile, Krishna, a street performer from one of Delhi's poorest areas, transformed his body with makeup, fur, and a long sinewy tail, ready to climb the trees of the Mall and steal visitors' sunglasses in mischievous monkey fashion, as befits his profession as an impersonator, or *bahrūpiyā*, here of a monkey (figure 1.5). Transforming mundane materials—makeup, textile, clay, fire—into dramatic

animal forms, these two artists participated in an interlinked set of exhibitions on the National Mall.

On the lower level of the National Museum of Natural History, the Smithsonian mounted over two thousand historical and newly made objects in a show called *Aditi: A Celebration of Life*, which included designated spaces for craft demonstration and performance by forty artists and performers (Thomas M. Evans Gallery 1985). Palaniappan sat in the gallery on a dais labeled with his name, making smaller objects while visitors looked on and occasionally asked questions via the volunteer translators provided by the museum (see figure 2.3, plate 3). And on the Mall itself, the annual Folklife Festival paired the art, music, and food of India with the cultures of Louisiana; Krishna's monkey thus vied for attention with Mardi Gras floats and the wafting rhythms of the parading second line (Kurin 1991a, 1991b, 1997). Called *Mela!* (Festival), the outdoor extravaganza included tents demonstrating crafts, a village photographer, an active temple, a tent with text panels providing information about India's regional cultures, religions, and political history, and a food area with huge tandoor pots producing hundreds of pieces of naan per hour. Not to be outdone by the New Orleans re-creation of Mardi Gras, the culmination of *Mela!* for the India section involved erecting colossal effigies of Ravana and his companions followed by their fiery destruction in a reenactment of the Dusshera festival in the heart of the U.S. capital (figure 1.6).

Palaniappan and Krishna, then, take different material—physical stuff—and transform it into sculpture or use it to transform themselves. The two artists then animate their materials, changing their daily bodily practices to perform the role of monkey or master artist. Both interrupt the rhythm of festival-going or museum-going visitors, demanding an engagement with an active "object"—their creations and themselves.

The manipulation of material centers "Material Transformations," a chapter that springs from a consideration of clay, whether historical terracottas or demonstrations of pottery making in the gallery, and lands on an exploration of reuse and recycling of detritus in the work of Chandigarh-based artist Nek Chand. Focusing on material opens up questions related to the time it takes to make an object, the duration of waiting and the uncertainties of process, the time of the demonstration and the recording of the performance, the decay of materials over time, and the gallery presentation of historical time.[12] To navigate these questions, I draw on Barthes's use of temporality in his writing on photography alongside a Derridean understanding of recursive, creative time (Barthes 1981; Derrida 1988 [1972]).

In the following chapter, "Time, Interrupted," I turn from material to performance and demonstration, focusing here on the *Aditi* exhibition at the National Museum of Natural History. Palaniappan's dais with his Aiyanār horses represents but one of the many locations for demonstration and performance housed in the galleries. These kinds of artist demonstrations often provoke scholarly dismissals that read the display of people alongside objects as objectifying and dehumanizing, or as continuing the spirit of nineteenth-century colonial and international expositions that put people on display in "native

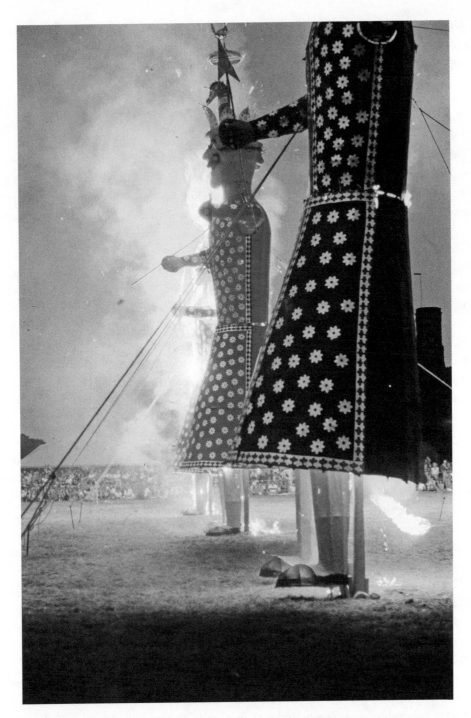

FIGURE 1.6. Burning effigies of Ravana and his companions on the National Mall, as part of the program *Mela! An Indian Fair* at the 1985 Festival of American Folklife, Washington, D.C., July 1985. Photograph courtesy of the Ralph Rinzler Folklife Archives and Collections, Smithsonian Institution.

village" environments alongside life-size dioramas and displays of products from colonial empires.[13] While exploitation and objectification do remain in play, recent scholarship has shown that the nineteenth-century cases are far from straightforwardly objectifying.[14] No matter the century, the difficulty of controlling people once they are "on display" in museum, exhibition, and festival contexts enables those same people to push at the boundaries provided for them by those institutions.[15] Rather than static objects set out for observation by a dispassionate, distant audience, artists and performers—of the nineteenth century and the 1980s—remade these relationships in small and large ways. While the participation of people in the Festival of India exhibitions only distantly echoes the nineteenth-century colonial ethnographic exhibition, the resistance found in the late twentieth century suggests that similar moments of exceeding the bounds and changing the rules occurred in the nineteenth century as well.

In "Time, Interrupted," rather than focus on the static—the spaces and the objects—I examine the ways in which the participants in *Aditi* engage in a flow of temporalities, from the daily rhythm of performing and engaging with visitors to the drawn-out duration of being "on the road," representing India to the American audience as but one in a series of similar international performances. Slowing down, arriving late, changing activities, combatting boredom, performing *pūjā* (worship), telling stories—these activities with their own rhythms and durations enable resistance and participation alike. These temporalities circulate, sometimes facilitating commercial circulations but more often gumming up those flows, flows further interrupted by the exigencies of international trade agreements, customs rules, and work permits. This chapter also attends to the ways in which these active people in the galleries interrupt the experiences of museum visitors, who expect a certain level of control over their pace through the gallery, a normalized rhythm that meets constant interruption in the face of the smells, sounds, and activities in *Aditi*.

Both *Aditi* and *Mela!* brought certain forms of art making and performance into wider circulation, creating new fashions in clothing, supporting and growing small groups of Indian American dancers, and introducing the Bengali story scroll into American living rooms. One of the stated goals of the Festival was to encourage both tourism and trade, in part by making links between handicraft producers and potential buyers in the U.S. and Europe. Indeed, some of the exhibitions articulated their purpose in precisely those terms. *Golden Eye*, an exhibition at the Smithsonian's Cooper Hewitt in New York, recruited a dozen European and American designers to work with select craftspeople in India on new design projects. The products included textiles and clothing, shoes, jewelry, furniture, glass, toys, and decorative objects. The designers traveled to India to meet and work with their counterparts there, and then developed the designs in part with an eye to future collaboration and ongoing relationships with the manufacturers in India. The exhibition included these objects along with banners silk-screened with quotes from interviews with the Indian artists who worked with their more famous counterparts

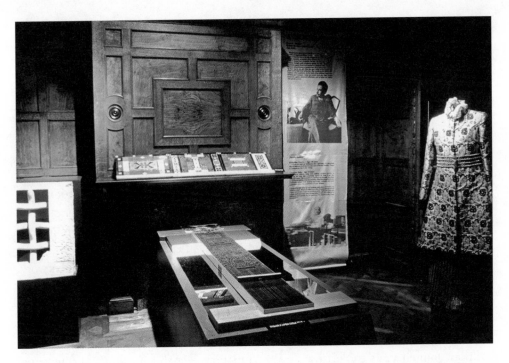

FIGURE 1.7. *Golden Eye* exhibition, installation view with text panel providing translations of the craftspeople's own words. Cooper Hewitt, Smithsonian Design Museum.

(figure 1.7). A few craftspeople came to New York to demonstrate their techniques in the gallery, although not on the same scale as in the *Aditi* exhibition. Some of the European and American designers already had longstanding relationships with manufacturers on the subcontinent, while others entered into the Indian production market for the first time. This kind of exhibition made manifest one of the underlying goals of the Festival: to strengthen commercial as well as cultural ties with India.

Golden Eye anchors the "Entrepreneurial Exhibits" chapter, in which I explore the circulation of ideas, bodies, and objects—in loose concert with one another and in the ostensible service of a future market. This chapter shifts the trajectory of the book slightly in that one of its guiding temporal principles is the idea of potential or futurity through entrepreneurism. Where the previous two chapters delve into minutiae of small durations and layered temporalities, this chapter takes that fabric, folds it up, and sets out to make something big—to transform the future through these more intimate moments. This innovative exhibition brought business to bear on cultural diplomacy and challenged the ostensible independence of art and museum from both economics and politics. Other exhibitions in the Festival were similarly implicated, but only *Golden Eye* openly embraced a commitment to future economic exchange and collaborative commercial entrepreneurship.[16] As such, the show clearly demonstrates the imbrication of the entire Festival

in the spectacular mid-1980s, from the political and art world celebrities who attended its opening to the often stuttering flow of information and ideas in a moment of emergent neoliberal relations of power. The complex temporalities of this exhibition, from the simultaneity of telex messages to the simultaneity of idealized, distant village time and ostensibly speedy, New York fashion time set their stakes in the shifting sands of the postmodern, neoliberal, late–Cold War 1980s.

The subsequent chapter turns to some of the many exclusions and erasures, seeking out the Festival's three significant exhibitions of contemporary Indian art and reading them for their articulation of a distance within the contemporary. These three shows present India's recent art as coeval with that of the northern Atlantic urban centers, but these exhibitions simultaneously insist on temporal dissonance—that the work arrives too late, represents a movement behind the times, or connects with abstracted temporalities beyond history and thereby somehow Indian, authentic, and universal. Drawing from recent theorizations of the contemporary in art history, most notably Terry Smith's work, I leverage Johannes Fabian's problematization of the tension between contemporaneous subjects and a simultaneous denial of coeval existence—a constitutive distancing (Smith 2009, 2010; Fabian 1983). Chapter 5, "The Contemporary, at a Distance," then, marks some of the temporal operations in play at the Festival that efface rather than reinscribe.

These four chapters comprise a kind of temporary, ever-shifting group of conceptual tents that bring together, between the covers of this book and for the time of its reading, issues and concerns related to the Festival of India in the U.S., its mid-1980s context, and the ghostly strands of exhibitions long dispersed, with only their traces extant in catalogs, archives, and memories. Other formations of these particular tents remain imminently possible; I have found the thematic of time—the flickering durations of movement, light, and air—to provide a productive path through the complexities of such a massive undertaking as the Festival of India.

Textiles, as Arthur Danto reminds us, live and breathe; tapestries hung on a wall move subtly as we walk past them, enabling the flickering light of an oil lamp or candle to catch on the reflective gold threads, animating the wall and responding to our presence (2002, 85). To close this introduction, I want to magnify a small flutter of a story I found in the archives of the *Neo-Tantra* exhibition, one involving the voice and work of an artist trying to circulate her art despite the pressure of international politics, a hesitation to acknowledge contemporary India, and the rising demand for neoliberal flows of capital and labor. The story also illuminates, with a dimly flickering light, the fragility and ephemerality of the archive—this whisper, this flicker, somehow survived in the face of the endless series of erasures constitutive of any archive, any exhibition, and any historical trace.

The three exhibitions I examine in the final chapter include two held at the Grey Art Gallery at NYU in New York and the Phillips Collection in Washington, D.C., both of which drew their works entirely from the private collection of Chester and Davida Herwitz. The other exhibition, *Neo-Tantra*, at UCLA, excerpted its artists from a larger show that the National Gallery of Modern Art in New Delhi had organized in 1982 for a museum

in Stuttgart, Germany (Sokolowski 1985; Phillips Collection 1985; Tonelli 1985; Sihare 1982). While these shows were in the planning stages, Vasundhara Tewari (now Broota) won a scholarship awarded by India's Ministry of Culture, and this enabled her to travel to the U.S. between 1982 and 1984 to try to expand her own art practice and share her work with a wider audience. In the archives at UCLA, handwritten correspondence from Tewari to the curatorial staff traces her struggle to find recognition for her work as she sought inclusion in what must have felt like a tidal wave of Indian art exhibitions related to the Festival.[17] She had a solo show at the University of Illinois, Chicago, in 1984, but her efforts to participate in the Festival the following year fell almost entirely on deaf ears.

Because curator Edith Tonelli and her collaborators at UCLA had decided to focus on a particular movement—Neo-Tantra—they could not include Tewari's work in their exhibition (Tonelli 1985). They therefore had an easy excuse for the exclusion of this young artist. Tewari was unsuccessful in pleading her case. However, in recognition of the narrow focus of the exhibition, Tonelli organized a slideshow of Indian contemporary art to be projected from the huge opening cube that dominated the entry gallery, continually rotating through images of other types of India's contemporary art while the *Neo-Tantra* exhibition hung in the adjacent rooms. These works included a list of top names in Indian twentieth-century art, a list much more inclusive and more broadly defined than the two other contemporary shows on the East Coast. The selection of images for this slideshow emerged from conversations with the NGMA staff in New Delhi and the Herwitzes themselves—images from both collections appear in the show. And, in addition to objects from these collections, Tewari's work is represented, too. Two flickering images of her figural drawings rotated through the carousel in that slide show, briefly exposing American audiences to her work, however removed from the objects themselves and however briefly they might flash on the wall (figure 1.8).

Tewari's narrative adds another layer to the movement and display of people within these exhibitions and within our galleries. Her fight for recognition and inclusion marks a struggle that all of these exhibitions could tell, had we the archival remnants to read these stories. That her quest fell somewhat short does not undercut the resistance to the norm her efforts represent. Like the monkey impersonator, the voice of the Indian artist and craftsman, or the clay horses of Palaniappan, Tewari's handwritten notes in the archive lead us to another interruption of the institutional frameworks on which these exhibitions rely. Those few seconds when her work graced the wall of the gallery complicate and inject a note of dissent into the neat presentation of India for American audiences. The flickering light and heat of her figural abstractions briefly, and for a set, repeated duration, challenged the boundaries of *Neo-Tantra*. Her presence in the show might have gone unremarked were it not for a note catching my eye in the stacks of papers and files I went through in the archives, causing me to pause and consider, to look again at lists of artists and slide labels for further traces of Tewari's interruption. And, the remnant of her handwritten note in the archives at UCLA prompts further questions: What people remain in the galleries, haunting and interrupting the production of narratives about Indian art?

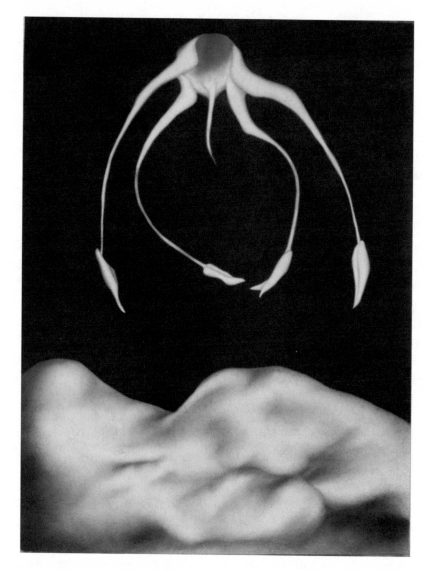

FIGURE 1.8. Vasundhara Tewari Broota, *The Approach*, 1984, pencil and printing ink on craft paper, 40 × 30 in. (101.6 × 76.2 cm). Work © Vasundhara Tewari Broota, reproduced with the permission of the artist.

Which permutation of the exhibitionary tent structure went unbuilt? Which panel of the tent, which gesture of performance retained the dust from its last engagement, halfway around the world, and shared that experience with those entering the tent for the first time?

The ephemerality of the archives and of the exhibitions, and the emergence of small flickers of light and whispers of exclusion, provide yet another temporal flow to follow: the brief duration of the exhibitionary project alongside its legacies. All of these exhibitions are ghostly and difficult to grasp through photographs, reconstructions, archival

records, and remembrances of curators and artists. Yet they haunt the present, some of them through catalogs that have become memoirs we reread in survey classes, plumbing their plates for key works and elevating entire collections to canonical status. Others haunt in different ways, resisting incorporation into neat narratives, charming and disturbing us at the same time. A *bahrūpiyā* on the Washington Mall, Palaniappan constructing a kiln in suburban Maryland, Tewari injecting herself into the flickering light, an Indian artist speaking from the walls of a museum. These moments, from the processes of making to the duration of viewing and the repeated temporality of performance and then on to the flicker of potential not fulfilled—these moments comprise the exhibitionary fabric, the textile with which multiple hands build the tent, again and again.

While this metaphor enables the ever-moving, ephemeral approach to the exhibitions I pursue here, I insist throughout the book that these temporalities do not operate outside of historical, political, economic, and cultural flows. The temptation to present an abstracted, universal theory of the exhibition, one which somehow "reveals" or "explains" all things for all time, must be met with a continual reminder of the particularities of each complex of social and political relations. The Festival, as many of my interlocutors reminded me again and again, could not happen today. It could not have happened in an earlier decade of the twentieth century, either. The funding, the political will, the obsession with big spectacle, the popular culture interest in colonialism and in India, the planet-wide rivalries for economic primacy and political might—these factors all contributed to the particular temporalities at play in the basement of the Natural History Museum in D.C. or the offices of the university gallery at UCLA. I listen, watch, and feel for the ghostly traces of these particular shows and in relaying them in this book—in reconstructing these tents this time around—I offer a sense, a narrative, a construction of the complicated social formation that produced and was produced by the Festival of India in the mid-1980s.

Derridean Temporality at the Festival

How to engage with duration, with small moments, with the minute changes that make up the underlying fabric of this book's many tents? I interrupt so as to lay out what is at stake for me in pursuing a particular approach to temporality, one very much distinct in scale and kind from those historians often engage with. I insert this as an interruption to signal that these understandings of time, drawn from Jacques Derrida's reading of Edmund Husserl's phenomenology, are already in play in chapter 1 and continue to shape my thinking throughout the book. This material is constitutive of the book itself, embedded in its fabric. Rather than let its implicit presence go unremarked, I offer here, for those interested in the thoroughly interwoven theoretical threads of my thinking, and for those who might wish to think further about minute, small, layered temporalities, an unpacking of this particular tent (perhaps an unpicking of the embroidery as well), one whose design and fabric shape and form the thinking in the preceding and the following pages.

Jhithru Ram came to the U.S. during the Festival to participate in *Aditi*, where he, along with thirty-nine other craftspeople and performers, demonstrated his craft—pottery—for the visitors to the basement galleries of the National Museum of Natural History. He has a space marked for him on the blueprints for the exhibition, where the low platform he occupies is marked "Tribal Potter" (see figure 3.5). He wears a yellow name tag pinned to his shirt; a placard on the platform gives his name, place of residence, and craft specialization. Publicity photographs of the exhibition often include him working on his platform, squatting next to the wheel or seated with a clay toy in his hand, modeling snout, ears, or legs.

If galleries are primarily spaces within which one arrays objects in order to teach visitors something about a culture or historical period, then Ram, within that framework, becomes another object, akin to the clay toys and ceramics arrayed about him. In an installation photograph of Ram at *Aditi* (figure 3.7, plate 8), the four children (and one adult, partially cut off at the right edge) operate in the photograph as the active observers

of an object of study, absorbing new information regarding ceramic production in India and generalizing from this example to the entire subcontinent. Indeed, the exhibition encourages such metonymic thinking, as it follows the life of a Indian village child from conception to marriage, collapsing regional distinctions and obscuring elements of Indian life and of craft production that depend on the postindustrial and the modern. Indian craft simultaneously occupies the present and takes the role of an unchanging tradition, matching tourist slogans that to travel to India is to travel back in time.

This photograph of Ram also recapitulates a long genealogy of paintings, prints, and photographs of potters dating to at least the eighteenth century (see, e.g., Dewan 2004). The hand-driven wheel, the squatting potter, the vessel taking form in the center—these elements make up hundreds of depictions of the craftsman, not just potters from India but those from all over the world. In the nineteenth and twentieth centuries, these images were collected with other depictions of craftspeople (weavers, wood carvers) and village life (water carriers, butchers, barbers) in sets of small paintings, in groups of postcards, in small painted clay models, in full-scale dioramas, or on the pages of the *Illustrated London News*.[1]

This installation photograph, then, reinforces a number of readings of *Aditi* that were in circulation at the time and have been voiced since. With its reddish, earthy, rough stucco platforms, the labeling and separating of "Tribal Potter" from the visitors, and the generalized narrative of an Indian child's village life, *Aditi* certainly invited charges of ahistoricization, oversimplification, objectification of the people in the exhibition, and a series of erasures that enable a firmly Orientalist understanding of the show.

But let's look a little closer at this photograph. The visitors, themselves primarily children, don't stand separated from the potter's space—on the contrary they drape themselves across the boundary between the gallery's wooden floor and the pseudo-dirt ground of the stucco platform. In doing so, they mark the boundary between viewer and object, but they also obscure it, a mechanism further amplified by the taking of the photograph itself. The photographer adds an additional viewer to the mix, an extra layer of observation, something recapitulated by the viewing of the slide in the archive, and the reproduction of this photograph in this book. The three girls in the foreground add another complication to the narrative of objectification in that they drape themselves over and almost completely block the museum label for Jhithru Ram. Ram's own physical position means his name tag, too, is not visible and cannot provide a further reinforcement of objectification. The photograph refuses to capitulate fully to an Orientalist reading: Ram uses modern plywood to set his finished pieces out to dry, and in the background one can see the plastic sheets he uses to slow the drying of the wet clay overnight. The children's presence in the photograph carries just as much weight as the potter's; they transform the photograph into a picture from the installation-in-progress. The potter *inhabits* this scene and therefore cannot be timeless, as the children's tennis shoes and polyester shorts situate the moment in the fashion of the 1980s, and the sundresses and sandals point to the heat and specificity of D.C. in June.

And these observations do not touch on one of the most striking elements of the photograph: its depiction of *motion* in the blurring of the girl at the left, the boy at the right, and the wheel. This detail—Ram, one notes, keeps still despite the motion around him—reminds us of the duration manifest in this and any photograph. Duration is brought out through composition and light: the three girls point us, in gaze, pose, and coloration, toward the potter and the wheel. The slight overexposure of the image enhances the white of his garment and the white T-shirt worn by the girl in the center of the photograph, on the same vertical axis as Ram. The boy and adult at right are in a slight shadow, along with the wide-mouthed, upward-looking animal toys behind them. And, almost as if bringing the subtle emphasis on the process of pottery making to its culmination, three sets of vessels sit on plywood at the center. The two at right are slightly darker in tone than that at left; their reflection of the light is less shiny, more matte. They are drier, older, earlier than the group of five vessels at the left. In looking closely, one might even identify three stages of drying across these three sets, from the most matte to the most shiny.

The photograph, the moment, the situation, the installation—*all* are complicated. The hierarchies of observer/observed, visitor/demonstrator, photographer/subject, local/foreign, white/brown all permeate the photograph's formal qualities as well as its subject matter. And these elements in the exhibition, in the photograph, in the moment it presents us with, in the mid-1980s, in scholarship then and since, remain essential components of *Aditi* and of any reading that engages with the Festival of India.

In perhaps the most crucial passage in *Orientalism*, Edward Said reminds us that the construction of the Orient cannot be swept away to reveal its underlying truth: "One ought never to assume that the structure of Orientalism is nothing more than a structure of lies or of myths which, were the truth about them to be told, would simply blow away" (1978, 6). Here, Said refuses the separation between representation and reality in order to acknowledge the very real force that Orientalist understandings have in people's material existence. But too often scholars and others lose sight of this important maneuver in Said's thinking, working instead to mark the ways that representation differs from reality or highlighting the falsity of Orientalism, a move that, perhaps ironically, capitulates to Orientalism's own logic of difference and othering.

This difficulty—the trap embedded within Orientalism—has deep roots in European and Mediterranean philosophies, philosophies that sought to identify and define the difference between thought on the one hand and the *expression* of that thought on the other, reality and representation, pure experience and the digestion of that experience into knowledge. Most often these debates happened in relation to language, seeing thought as "prelinguistic" and its expression as linguistic but therefore also contaminated, impure, and distant from the original thought. Speech, for the ancient Greeks and many who followed, was seen as closer to pure thought than writing, and as a result the spoken or voiced text was privileged over the written one.

With the rise of phenomenology, philosophers sought to map experiences that were not obviously linguistic into the conversation regarding representation. These thinkers

often saw a problem with the distinction between thought and language and sought to reconfigure and complicate that binary by bringing what they saw as nonlinguistic experience to bear. Husserl, in his *Ideas I*, lays out a theoretical framework that sees experience as pure until it is expressed or indicated, and as a result he proposes a silent, meditative, inward-looking mode of experience (called "solitary mental life") that is prior to its contamination by both speaking and writing, or in other words by representation to another person, to the outside world, or even to oneself. But in seeking to define a moment outside of language and to valorize experience as a way of accessing pure thought, Husserl inadvertently recapitulates the underlying difference between the pure and the contaminated, thought and language. One might read his articulation of experience and his argument's reliance on a temporal binary of before-language and after-language as akin to the struggle to negotiate Orientalism. In seeking to transcend the othering and distanciation embedded in Orientalist understandings of the world, one is tempted to seek out a time or an experience prior to or outside of Orientalism, just as Husserl attempted to find an experiential moment of purity prior to speech or writing. But the logic of Orientalism relies on a presumption that a "before" exists, and so in seeking one out, the ostensible critic of Orientalism winds up recapitulating Orientalist modes of thinking.

Through his in-depth rereading of Husserl's phenomenology in *Speech and Phenomena* (1973 [1967]), Derrida refuses the prelinguistic/linguistic, pure/contaminated distinction, instead showing us that these things are mutually constitutive, and that there is no pure prelinguistic moment. To do so, Derrida probes and questions the *temporality* of Husserl's claims, showing that the prelinguistic, experiential "solitary mental life" Husserl sets up is not pure but is *already* contaminated and constituted by language, and has *always* been so.

Husserl wants to move beyond language (spoken or written) to include acts, gestures, and sensations in a theory of how we make sense, of how we think. In so doing, Husserl intends his phenomenological project to exceed traditional philosophical approaches to meaning. But even as Husserl adds these sensorial and experiential elements, he retains the underlying structure that presumes a purity of an idea or experience prior to its indication (in voice or text or act or gesture). By reading Husserl against himself, Derrida shows that phenomenology, despite its hopeful incorporation of new ways of grasping experience, does not free itself of a linear progression that necessarily moves from pure expression or experience to sign or indication. Instead, Derrida demonstrates that experience does not exist prior to its outward indication. The experience and the interpretation of it are constitutive of one another and impossible to peel apart. Husserl seeks an experience that is instantaneous—a flash of a moment that is pure; Derrida's argument enables us to see that every instant, every blink of an eye is constituted by both the opening and the closing of the eye. "There is a duration to the blink, and it closes the eye. This alterity is in fact the condition for presence, presentation, and thus for *Vorstellung* in general" (Derrida 1973 [1967], 65).

This understanding of "presence" enables us to move beyond the "now" as a single moment to a recognition of the implication of the not-now in the now, such that we can

see temporal moments as taking part in a larger web of relations. Acts and experiences, moments and durations thus work in relation to one another, such that instead of seeing a static gallery setting we can begin to witness the dynamic interrelations of multiple, repeated, overlapping presences. Jhithru Ram starts the wheel spinning, a young girl leans against the rough surface of the stucco platform, a set of vessels transforms slowly from wet to dry, the pile of plastic sheets shifts slightly in relation to the flow of the air-conditioning, the boy's leg moves just as the photographer pushes the shutter: none of these moments are pure. All of them have happened before; all of them engage with one another in mutually contingent and mutually constitutive relations. Derrida's acknowledgment that experience is constituted in and through language (rather than separating them into a two-step process) enables a reading of these gallery moments and durations as themselves productive acts—not pure experiences but productive and historically constituted presences.

The historical element of this Derridean understanding of presence is crucial for the project of this book, as, like Derrida, I refuse the notion that any experience can be thought outside of time and language, which in turn means that all actions and experience are historical. Or in other words, for Derrida, there's no pure moment of expression prior to indication, and therefore he sees language as constitutive of experience—it's impossible to separate one from the other—such that without language, itself embedded in history, experience and presence don't exist.

> Husserl no doubt did want to maintain, as we shall see, an originally silent, "pre-expressive" stratum of experience. But since the possibility of constituting ideal objects belongs to the essence of consciousness, and *since these ideal objects are historical products*, only appearing thanks to acts of creation or intending, the element of consciousness and the element of language will be more and more difficult to discern. (Derrida 1973 [1967], 15, my emphasis)

Derrida articulates not only the denial of a separation between consciousness (pre-expression) and language, but also the necessity for consciousness to be historically contingent. This element, for Derrida, comes out of the denial of any pure, prelinguistic state. This notion helps me to articulate the ways in which these small moments in the gallery cannot be separated from the immediate context of the museum setting (whether at *Aditi*, with its deep maroon stucco and the sound of drums playing in the next room, or the National Gallery in D.C., with its white-walled, pedestal-filled gallery punctuated by hushed reverent whispers) or the historical flows of the mid-1980s, the Cold War, Raj nostalgia on the television, and the rise of neoliberal approaches to both politics and economics in India and the U.S. This historical sense also comes through in the moment of representation, as with the genealogical link between the photograph of Ram in the gallery and hundreds of earlier images of potters in preceding centuries, whether from India or elsewhere.

If we follow Derrida's move here, away from linear causal—first A then B—modes of thinking to one that sees the ways in which A cannot be thought without B and vice versa, then it makes sense that any action must operate and be produced within a larger flow of similarly produced actions. Repetition is therefore a central element in thinking through Derrida's deconstruction of Husserl's phenomenology. For Derrida, any origin or "new" idea isn't actually an origin or anything new but instead a repetition, or more subtly, a reiteration. In *Speech and Phenomena*, this takes the shape of a critique of Husserl's understanding that ideas come from nothing. For Husserl, ideas are the pure origins that are then contaminated by our attempts to put them into words or actions. Since Derrida has already broken down the idea that there is a pure "before," he also unpacks this presumption in Husserl by denying the idea of the origin-as-pure. For every object, every act, is a repetition, a reiteration. In performance (and Derrida uses the language of the stage here), one repeats actions, words, movements, and directions in relation to an audience and a distribution of things in space. Each iteration of a performance is slightly different; it falls short of a wholeness and is constituted in relation to other actions, other performances, other audiences. But one must always remember that for Derrida, all the world is indeed a stage; all language is citational, reperforming already spoken, written, and acted elements in new contexts. The performance is therefore not an exception from the everyday but a constitutive element of it. And the process of producing clay vessels offers an easy example of this. In the photograph, Ram has produced three sets of vessels, each set nearly an exact copy of the other, each type of vessel nearly the replica of its neighbor. They share a sameness, but none of them are identical. And this is true as well of the movements and actions Ram takes when he makes each vessel, and of the gestures and sensorial encounters one might have when picking up the vessel.

For my project, the reiteration is central, as objects in a gallery always operate in relation to other gallery settings and in relation to earlier situations they found themselves in (e.g., a clay sculpture cemented to the side of a temple, or a tent unpacked and set up on the plains of the seventeenth-century Deccan); visitors to a gallery likewise repeat actions and behaviors (whispered comments, do-not-touch), and works are produced by repeated actions (the shaping of clay, the dipping of the brush into paint). None of these moments, durations, or actions has a pure origin, and each is slightly different than the one before. Each "presence" is, again following Derrida, partial and constituted by what it lacks; all presence is also absence. The object no longer occupies its temple context; the gallery visitor dearly wishes to touch things and sometimes does; the works produced always stand in relation to other works and are never whole in themselves.

Derrida extends his deconstruction by also refusing the singularity of the photograph-as-record or the photograph-as-archive of these moments. The acts themselves—moving aside the plastic sheeting, crouching next to the wheel, setting it in motion, holding hands with one's mother in the gallery, collapsing onto the platform of the potter, registering the familiarity of the smell of the clay—are archives themselves. In the repetition of these acts and moments they are recorded and rerecorded, performed and reperformed, such that the

taking of the photograph operates as another performance and reperformance rather than a mere representation of something that happened at one moment in time. Thus for Derrida there is always recording and repetition, in a never-ending recursivity.[2]

My engagement with the temporalities that run throughout the Festival of India is thoroughly imbued with Derridean understandings of a partial, repeated presence that denies an origin or a pure before and instead engages with the productive reiterations of act, object, writing, making, and doing. Central to Derrida's deconstruction of Husserl is the insistence on the relation to history; since there is no pure moment of experience, that experience must always be participating in and productive of the historical. It's fitting that Derrida himself uses a gallery-related quote from Husserl as both an epigraph at the beginning of the book and as the quote he turns to at its end:

> A name on being mentioned reminds us of the Dresden gallery and of our last visit there: we wander through the rooms and stop in front of a painting by Teniers which represents a gallery of paintings. Let us further suppose that the paintings of this gallery would represent in their turn paintings, which on their part, exhibited readable inscriptions and so forth.[3]

While Husserl tries to comprehend this experience by separating the experience from the interpretation of it,[4] Derrida sees this example as demonstrating the argument he has made throughout the book: "The gallery is the labyrinth which includes in itself its own exits" (Derrida 1973 [1967], 104). Thus, Husserl would read the photograph of Jhithru Ram and the children in the gallery as a document, a recording of something already past. Derrida would see the unfolding and refolding of the repetitions at play, from the subject photographed to the very fabric of the photograph itself. Always repeating, always historically contingent, always partial, and always imbricated in the duration of looking, seeing, reminding.

Derrida provides a supportive, interwoven, and nimble framework that resonates with the exhibitions I engage with in the book. I turn to several other thinkers as well who lend a hand in the unfolding of the tent. Roland Barthes's engagements with photography enable me to bring the temporality of the photograph, often included in the exhibition, to bear on the durations I engage with in the gallery. Barthes is particularly salient for discussion of the different tenses, pasts, or temporal moments embodied in a photograph, particularly a photograph of a historical site. I turn to his work in conjunction with the above Derridean maneuvers in order to unpack the subtle temporalities of materials, from the processes of making to their monumental or everyday use to their display, movement, and decay in the gallery, to their reuse in new objects. The thought of Jacques Rancière also informs my understanding of presence, historical contingency, and reiteration. Rancière's understanding of the interruptive potential of sensory experience—alongside the fleeting quality of that disruption—helps me to think about the ways in which these exhibitions challenge the political norms and reshape relations among objects, people, spaces, and times. Those three thinkers permeate my writing throughout the book; read-

ers will also see hints of a few others, such as Johannes Fabian's theorization of coevalness or Timothy Mitchell's understanding of the exhibitionary order and the spectacle. But I am primarily guided by a Derridean understanding of nonteleological temporalities enlivened by interjections from both Barthes and Rancière.[5]

The book mobilizes these concepts in an engagement with a node of exhibitions from a specific historical moment. These exhibitions both shaped and were shaped by a particular set of bureaucratic, diplomatic, and cultural orders. I stake down my tent in the minutiae of the flows of performance and repetition, the lives of those who create durations and instants, slow things down and speed things up, and the not-at-all static objects they produce, work with, and animate. The Festival of India offers an opportunity for studying a range of these intersecting temporalities and enables me to give some form to this approach to reading museum exhibitions; indeed, a Derridean approach means that it is impossible to discuss these things in the abstract. Ram's pottery platform at *Aditi* serves as just one incredibly rich example among those that I unpack in the book. For while I see all exhibitions embodying a range of temporalities, I also see these durations as contingent—participating in and produced by the historical, political, economic, and cultural flows that constitute the larger social formation.[6]

Material Transformations

CLAY, TERRACOTTA, TRASH

O F the over seventy art exhibitions staged during the Festival of India, a small but significant group took a particular material as a starting point, focusing on clay or terracotta, or, in one case, detritus and trash. Because they were grounded in foundational "stuff"—clay, cast-offs—these shows explicitly and implicitly highlighted processes of transformation: from clay to figurine, from cast-off to built environment. Material becomes medium in these processes, with clay molded, dried, and fired into ceramic and discarded metal or concrete forming new sculpted gardens. As these objects go on display, the material remains central to each object: the idea of transformation embodies within it a constant reminder of the stuff that came before, the material-that-was ever-present in the thing-that-is.[1]

And that folding over of transformation—the then in the now—guides my reading of these shows, a reading that draws out ever-shifting currents of temporality operating in these exhibitionary orders.[2] In chapter 1 I unfolded the metaphor of the tent as a way of articulating the multiplicity of temporalities in this book, and that too involved transformation—from thread to fabric to tent panel, the multiple steps of making and setting up the tent, the reminder of earlier encampments in the dust, mold, and wear on the tent's material, and the constant movement of the tent in the breeze, on a plane, and in the gallery. Transformation involves time—from the time it takes to fire a clay pot to the recognition of many hands touching and remaking fabric, to the nonteleological recycling of material into new forms. To transform each of these materials involves a range of durations, returns, and reworkings, all operating at different viscosities, from the worried waiting for the kiln to fire to the patience required to let cast-off objects come to you.

I think of these temporalities as lowercase, small times, not the oft-capitalized Historical Time or Cyclical Time of grand overarching narratives (or their deconstruction).[3] As I discuss at greater length in chapter 1, I find myself resistant to single, large-scale explicative temporalities, especially as they so often get attached to particular cultural, ethnic, or national identities in unproductive ways. Instead the small moments I'm working with here might better be thought of as intimate and malleable durations that shape relations among things in the world. They might be short or long, recursive, unending, thick or thin, slow or fast, but they animate—make alive—the often static elements of exhibitionary orders, from objects to visitors to cases to photographs. Grand historical narratives often have purchase in these shows, but I focus instead on the layering of localized, small-scale durations in a range of viscosities and rhythms in order to read these exhibitions anew.

A further point about these temporalities: they do not float free, to be tapped or experienced without limit. In unpacking the many temporalities of these Festival exhibitions, I am not seeking to demonstrate a universal, phenomenological truth. Yes, visitors to these shows, in varying degrees, experience the temporality of clay transforming into sculpture, or cloth moving slightly in the air circulation system, or metal armatures rusting in the humidity. But these same visitors bring their historical and political milieu with them as they move through the gallery. The Festival exhibitions took place in the mid-1980s, when South Asia's art and craft traditions interfaced with the late Cold War's diplomatic, economic, and political demands, both in the U.S. and in India. Ethnographic and art museums challenged long-standing curatorial approaches, sometimes borrowing from one another and from performance-driven art forms. Popular culture images of India, from Indiana Jones to Nehru collars and block-printed textiles, inflected audience expectations of these exhibitions. In the wider art world, artists such as Joseph Beuys, particularly in his use of felt and fat, turned to materiality in their work, shifting away from the conceptual and minimalist directions of the 1960s and 1970s. The 1980s also saw a return to craft in contemporary art circles, emphasizing both process and material, and coming at a time when new museums of craft were opening across the world, including North America and India (Hickey 2015, 110; Jain et al. 1989). The aggregate textures of these shows' temporalities shore up, challenge, and are shaped by socially necessary relations of power. To unpack these temporalities is to explore the workings of the exhibitionary social formation of the Festival in its mid-1980s context.[4]

None of the temporal transformations detailed here happen without the social, in a combination of diplomatic political relations, museum missions, donors, and funding, old and newly crafted stereotypes, dissatisfaction with the industrial and postindustrial landscape, expectations of bodily and spatial relations among museum goers, performers, and things, racial and class difference, and presumptions of both distance and connectivity. As this chapter unpacks the transformations and temporalities of these exhibitions, it also unpacks that larger social formation which these exhibitions helped shape and within which these exhibitions took place.

The three exhibitions I focus on here share a commitment to particular engagements with material, and each operates in dialogue with other Festival exhibitions. Two focus on clay: *From Indian Earth: 4,000 Years of Terra-cotta Art*, at the Brooklyn Museum, and *Forms of Mother Earth: Contemporary Terracottas from India*, at the Mingei International Museum in San Diego. The Brooklyn exhibition's focus on clay works from the past contrasts here with the contemporary, vernacular focus of the Mingei show. Thus Brooklyn resonates with other historical exhibitions mounted at the Festival, most prominently the National Gallery of Art's *The Sculpture of India, 3000 B.C.–1300 A.D.*[5] And the Mingei show finds an echo in the Smithsonian's *Aditi: A Celebration of Life*, staged at the National Museum of Natural History in Washington, D.C.[6] Both of these cognate exhibitions will be brought into the discussion here to situate the ways in which transformation and process are highlighted in Brooklyn and San Diego. The final exhibition in the chapter uses trash to create both sculpture and a new built environment: Nek Chand's *Fantasy Garden* at the Capital Children's Museum in Washington, D.C. Chand's transformation of the museum's entryway directly involved visitors in collaborative creation. As such, it echoes some of the activities elsewhere in D.C., at both *Aditi* and *Mela!* (part of the Festival of American Folklife on the Mall).

Terracotta and trash relate to everyday human life in ways that monumental stone sculpture or architecture, elite manuscript and album painting, and metal sculptures do not—we eat from clay-based objects and generate our own worn out detritus in a never-ending recursive flow.[7] I see this connection as one perhaps unconscious reason curators at the time of the Festival chose these materials as vehicles for showcasing India's culture.

TRAVELING TERRACOTTAS: CLAY HORSES ACROSS AMERICA

In 1985–86, M. Palaniappan was everywhere. Seated on a dais at the National Museum of Natural History near the Mall in Washington, D.C., or working with local brickmakers on the West Coast to produce massive terracotta horses for an exhibition at the Mingei International Museum—Palaniappan and his work permeated the Festival. His work also anchored the entryway to the Brooklyn Museum's *From Indian Earth*, leading visitors into the gallery spaces beyond. Palaniappan made these works in the U.S., often demonstrating his techniques in person in the gallery and collaborating with local ceramicists to find or construct kilns suitable for both the scale and the type of object he produced (see figure 1.4). Indeed, a large part of his ubiquity had to do with the dramatic scale of his sculptures—his horses often rose above his head and in groups they drew the eye and anchored the room.[8]

During the Festival, Palaniappan's horses found themselves displayed next to contemporary Assamese hand-built pots, Gupta-era plaques made from molds, and Mithila and Warli wall paintings. Clay asserts its malleability as it moves across time, dialogues with other contemporary art forms, and operates on scales large and small. Clay also slips across temporalities, operating as the most immediate, made-on-site contemporary

FIGURE 2.1. Installation view, entry. *From Indian Earth: 4,000 Years of Terracotta Art.* January 16–
April 14, 1986. Brooklyn Museum Archives. Records of the Department of Photography.

object, as a marker of a timeless craft, and as a link to historical uses of mud and brick.
The chemical and physical transformations of clay during its production, whether working
it into form, waiting for it to dry, or determining the length of firing, continue in the changes
these pieces underwent in a multitude of diverse gallery settings as they moved across the
world and from exhibit to exhibit. The repetition of forms, from the multiple modular
cylinders used to build the legs and body of the horse to the variously scaled sculptures,
reminds viewers of the continual return of any potter to the same form, a recursive ele-
ment often associated with the medium of clay. The temporal duration of the process of
making—from sourcing the material to firing and positioning in the gallery—reaffirms
time as a central problematic undergirding the display of clay works as representative of
India's historical past and living present.

 At the Brooklyn Museum's *From Indian Earth*, Aiyaṇār's large-scale mounts stand out-
side and to the left of the opening entryway, guiding visitors into the exhibition beyond
the dramatically labeled arch (figure 2.1). The terracotta horse sculptures include a clay
image of Aiyaṇār himself in the center, while two small potted trees draw together the
objects, wall text, and the title of the show. This combination of contemporary sculpture

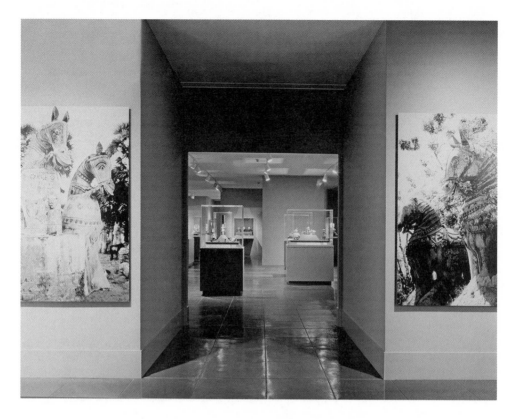

FIGURE 2.2. Installation view, through entry to first gallery. *From Indian Earth: 4,000 Years of Terracotta Art.* January 16–April 14, 1986. Brooklyn Museum Archives. Records of the Department of Photography.

alongside living foliage—a gesture to the horses' home in southern Indian forests—creates a physical and metaphorical passage from the museum space to a space elsewhere. Moving underneath the exhibition title, visitors encounter a second doorway flanked by photographs of the Aiyaṉār horse sculptures in situ (figure 2.2).[9] The contemporary sculptures appear new and shiny in contrast to the faded paint on those in the photograph—we move from the freshness of clay to decay—decay built into the rhythms of worship of Aiyaṉār in Tamil Nadu.[10] This subtle reminder of living tradition—the fresh clay, the tree—transitions to a patina of attractive antique decay as seen in the photographs, which in turn lead the visitor into the galleries of variously preserved historical examples of terracotta, from the Harappan cultures of c. 2000 BCE to plaques depicting Europeans from the nineteenth century CE. Visitors are thus guided from the contemporary to the historical via a patinated vision of picturesque village tradition, a melding of the immediacy and ubiquity of earth and clay with the distance in time and space of India's terracotta art.[11]

And the objects are truly contemporary. In both D.C. and San Diego, artists' activities animated the gallery, creating vessels, small animals, and in the case of the potters from

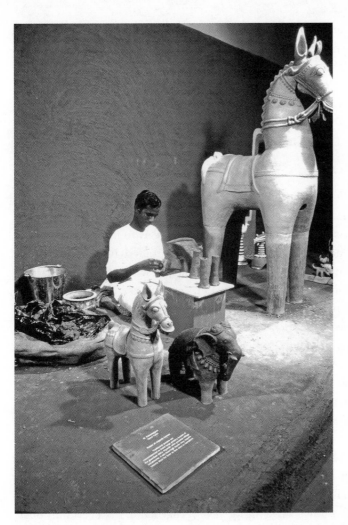

FIGURE 2.3 (Plate 3).
M. Palaniappan in *Aditi: A Celebration of Life.* National Museum of Natural History, Smithsonian Institution. June 4–July 28, 1985. Smithsonian Institution Archives. Accession 97-012, box 5, folder: Aditi–A Celebration of Life Clippings and Slides, folder 2.

Tamil Nadu, large-scale horses. In D.C., Palaniappan worked with Mark Kenoyer, then serving as the program assistant for the Office of Folklife Programs at the Smithsonian, and Renée Altman, a potter based in D.C., to plan the kiln construction and firing of a large-scale horse sculpture at the Smithsonian Museum Support Center in Suitland, Maryland (Beaudry et al. 1987). In San Diego, Palaniappan worked with local brick maker Hazard Products, which served as one of two firing sites for the exhibition.[12] Firing an object on this scale involves a great deal of risk—poor clay or an air pocket could cause the object to explode in the kiln. Those in the U.S. helped the potters at these exhibitions find suitable clay, often matching texture and color with samples sent from India and seeking out various supplements to the clay that would provide the proper weight and texture for the sculptures and pots (Beaudry et al. 1987). Photographs from the Festival show Palaniappan both sculpting in the gallery and building kilns in the Maryland summer heat (figure 2.3, plate 3; also figure 1.4). Thus, Palaniappan's process, its links to and

divergence from practices pursued in southern India, his repetition of these processes across the U.S. for multiple exhibitions, the work to replicate the texture of the clay, the heat of the kiln, the forms that make up the sculpture—all of these moments come together multiple times over, echoed in photographs in the gallery and situated next to historical examples of clay. Palaniappan was everywhere: repeating and reworking moments and durations, and effecting and watching transformations.

DURATION IN THE GALLERY

At San Diego's Mingei International Museum, the installation itself underscored an attention to making and the phases of production by including in the exhibition several sets of objects showing the stages of creation, from lump of clay to finished object (figure 2.4). Making and its concomitant duration served as an underlying constant in the gallery, whether through watching someone craft an object, viewing a film in the gallery, or seeing the object frozen in particular moments of its production. The catalog underscored the temporality of process by including extensive diagrams, photographs of materials and tools, and two-page spreads with photographs and text showing artists producing their objects.[13] As a result, the emphasis lay in breaking down the process into smaller portions. While these stages were presented through static photography and diagrams in the catalog and on the walls of the museum, when placed in dialogue with the live artists and a film that played in the space, a sense of the duration for each stage, and the additive duration of processes, becomes explicit in the multilayered presentation in the gallery.[14]

Unlike the show in Brooklyn, this exhibition did not emphasize a historical narrative, as its focus lay entirely on work produced by craftspeople at that time, and so the smaller, processual temporalities took center stage. One might therefore presume that the show presented an ahistorical, universalist narrative of vernacular craft. It certainly operated within a discourse surrounding clay that universalized its experience and use in ritual and domestic environments, exemplified by Pupul Jayakar's 1980 publication *The Earthen Drum.* This text offers an extensive overview of the subcontinent's vernacular crafts, including clay-based objects, from the Indus Valley to the present, and acknowledges the changes in form and practice across this long temporal span. But Jayakar's focus lies in celebrating the unity of craft across time and space for South Asian ritual practices, and as such the work dehistoricizes and universalizes the textual and material content it presents. In many ways this exhibition takes up Jayakar's celebration of clay but resituates the focus in the contemporary processes and techniques used by the artists, delving into regional and material differences across the subcontinent. Stephen Huyler, one of the members of the team responsible for installing and conceiving of the show in its form at the Mingei, notes that the show sought to do away with the distinction between ritual objects and everyday objects, demonstrating a continuity of both making and use in a wide range of cases.[15] This desire to transcend certain kinds of typologies, combined with

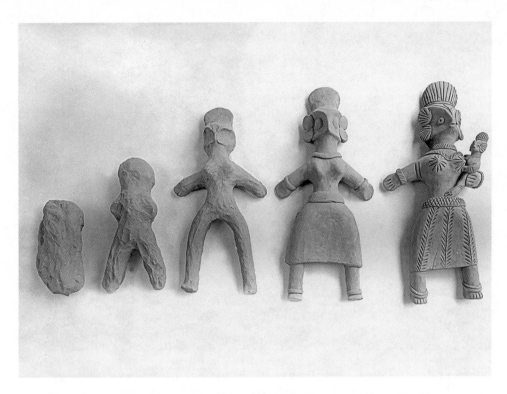

FIGURE 2.4. Sarojadevi (from Goalpara, Assam), Stages of Making "Mother and Child," from Haku Shah, *Form and Many Forms of Mother Clay: Contemporary Indian Pottery and Terracotta,* New Delhi: National Crafts Museum, 1985, 124, catalog no. 132. Photograph courtesy Haku Shah.

the present-ness of the exhibition's focus, produces a heightened attention to the smaller temporalities and durations of the transformation of clay into made object.

The Mingei filmed its own short documentary, showing two pairs of artisans, one making a pot with painted designs and the other creating a toy animal with an armature of straw (Mingei International 1986). The camera shows the working processes of husband-and-wife potters Ismail Siddique Buzarg and Aisan Bai Ismail as he throws the pot on the wheel, finishes its shape, and she paints the designs on its surface. The film then turns to Sona Bai and Daroga Ram, who use straw, clay, and paint to create a small tiger sculpture. As it shows each step along the way, the film focuses on the hands and faces of the artists, emphasizing their concentration and their dexterity as they make small adjustments as the objects take shape.[16] As a film, it presents process but also duration: not only the various small pieces of action that take place in the making, but also the various temporal senses of durations, repetitions, "re-doings" along the way.

The Mingei film operated in tandem with live artists in the gallery.[17] The museum hosted eight artists over the course of the exhibition: four each for a single six-week period, including Palaniappan, the artists in the film, and several additional potters.[18] The demonstrations took place in the gallery, with the artists integrated into the display space

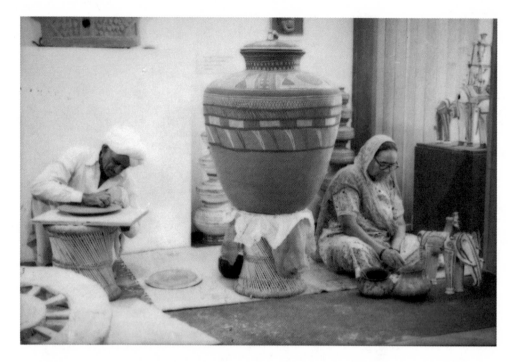

FIGURE 2.5. Ismail Siddique (L) and Aisan Bai Ismail (R) at work in the gallery at the Mingei International Museum, 1985. Mingei International Museum of Folk Art Archives, India–Forms of Mother Earth folder. Photo by Allyson Kneib, © Allyson Kneib Estate, photo courtesy of Mingei International Museum.

but not separated by partition walls, elevated on a dais, or labeled (as artists sometimes were in other Festival exhibitions).[19] Aisan Bai Ismail and her husband, Ismail Siddique, both featured in the film, sat with their requisite equipment—his wheel and her painting tools—surrounded by examples of their work (figure 2.5).

The Mingei deployed a combination of photographs (photomurals as well as sequences showing the production process), platforms, cases, demonstration areas, and strategically positioned plants to create a varied vision of clay in India, from the process of making to the arrangement and use of finished products. For example, several sculptures, including the deity Aiyaṇār, and a sheaf of dried grass were arranged in front of a large photograph of a person standing next to a monumental horse sculpture in Tamil Nadu. Photographs were used to reinforce the making of the object, such that a group of pots on a platform melded with their counterparts in the wall photograph behind, and the people in the photograph seemed to transcend the photographic space, coming into the gallery with the pots themselves. Occasionally photographs peek through partition walls, melding with the environment created inside the gallery. The conversation among photograph, living plant, living artisan, objects, and visitor gave the gallery space a dynamism, moving between locations in India and the museum in San Diego, and moving from objects made

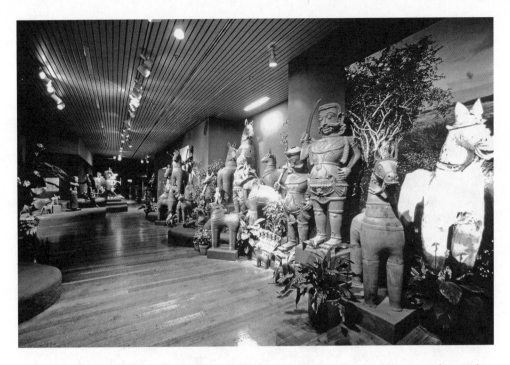

FIGURE 2.6 (Plate 4). Installation view of *Aditi: A Celebration of Life*. National Museum of Natural History, Smithsonian Institution. June 4–July 28, 1985. Smithsonian Institution Archives. Accession 97-012, box 5, folder: Aditi–A Celebration of Life Clippings and Slides, folder 2.

in the recent past to those made right in front of visitors on-site, using photographs and stage-by-stage objects as temporal bridges.

The *Aditi* exhibition in D.C. shared several elements with the smaller Mingei installation in San Diego. At *Aditi*, the Aiyaṇār horses stood on a platform with their sculptor while they also punctuated a passageway of clay sculpture interspersed with plants and backed by photomurals (figure 2.6, plate 4). Rather than a frontal array of Aiyaṇār and his soldiers, as presented at the Mingei, Aiyaṇār here stands surrounded by several large horses, a five-faced snake offering (*nakapampu*), three seemingly broken horse heads arranged artistically at his feet, an elephant, a bull, and small pieces of broken terracotta. The aesthetic of the tableau overtakes any attempt to re-create what an Aiyaṇār shrine might look like; the broken horse heads and pottery shards evoke a picturesque ruin, telescoping a range of pasts and presents in the same space. The platforms along the passageway jut out into the space, creating triangular nooks and crannies to frame leafy plants. The gallery space thus moves the viewer through a variegated range of objects, producing an overall effect of immersion without attempting to replicate any particular village or worship setting. The objects operate both as art and as pieces in the decoration of a larger environment—the aestheticization highlights the overall experience rather than the individual work. Temporalities here mix in a jumble—one moves back and forth from

FIGURE 2.7. Installation view, cases. *From Indian Earth: 4,000 Years of Terracotta Art.* January 16–
April 14, 1986. Brooklyn Museum Archives. Records of the Department of Photography.

the present-ness of the living plants to the ruined quality of the broken horse heads and
pottery shards to the black-and-white evocation of a past "now" in the photomural.

At the Mingei, rather than a jumble of temporalities one instead sees connections
across time. The photomural of women using water vessels at the bank of a river serves as
both backdrop and setting for the same vessels displayed on a platform. The arrangements
of objects here are certainly aesthetically pleasing, but instead of focusing solely on the
visual, their presentation instead emphasizes the steps and durations of making and trans-
formation, a clarity lost in the seductive juxtapositions of the *Aditi* show.

Both shows stand in contrast to the Brooklyn Museum's installation, where the walls
remain a light neutral color, the objects sit neatly in plexiglass cases on individual plat-
forms with clear labeling, and aside from the initial small gesture of a plant in the entry-
way, no living material enters the space devoted to the aesthetic appreciation of the
terracotta objects (figure 2.7). Here too, the main galleries include photographs to provide
visitors context for the architectural terracotta objects. These images do not provide a
mural-like background but instead help to place objects in context, adding information
to the works nearby but not interacting with them directly.

Where the Mingei focused on the dynamic, durational temporalities of crafting pro-
cesses, the Brooklyn show transported visitors from the opening passage with Aiyaṉār
horses to a series of historical objects, contextualized in periods and with accompanying
materials indicating the objects' earlier contexts. The show thus emphatically asserted its
identity as an art history exhibition, arranging the objects in chronological order, moving
from the Indus Valley Civilization (objects 1–7) and some transitional objects (8–12),
through the Maurya, Shunga, and Kushan periods (objects 13–68), followed by a large
group of works from the Gupta period (69–112), before closing with some later works from
the Pala period (eighth–tenth centuries) in the eastern subcontinent (objects 113–21) and
then jumping to a group of more recent works from the last three centuries (123–33).

The installation echoes Pramod Chandra's *The Sculpture of India, 3000 B.C.–1300 A.D.*,
which sought to legitimize India's stone, ivory, and metal sculpture at Washington's
National Gallery by presenting the works almost exclusively as aesthetic art objects.
Chandra organized the show not by dynasty or period but through simple date ranges;
the installation and publicity highlighted the formal qualities of the sculpture, with some
attention to iconography. At the Brooklyn Museum, curator Amy Poster took an approach
that in some sense was similar to Chandra's, highlighting the objects as examples of India's
art history rather than evoking an experience of India, as both the Mingei and *Aditi* shows
sought to do. Brooklyn's installation of terracottas and stucco sculptures spanning four
millennia thus focused in part on celebrating the objects' formal qualities. But here, in
contrast to the National Gallery show, the aesthetic celebration is grounded in a sense of
historical period combined with an evocation of the ways in which these objects might
have been used—as architectural decoration or as ritual objects of worship. In an exten-
sion of this scholarly project, the catalog for the Brooklyn exhibition enabled visitors to
explore the objects' excavation contexts, along with the problems associated with identi-
fying and dating examples of terracotta, injecting a sense of the biography of the object
into the temporal conversation already begun in the gallery (Poster 1986). Thus the Brook-
lyn show presents clay in a number of transformations, from the new entry sculptures by
Palaniappan through a range of historical examples and via details of the journeys these
objects took to come to the museum. As such, the exhibition moved beyond simple art
historical show—its focus on clay injected a number of minute, intimate temporalities
suppressed in other historical exhibitions.

In her analysis of the National Gallery's *Sculpture of India* exhibition, Tapati
Guha-Thakurta draws out the impetus to present a selection of "masterworks" of Indian
sculpture, and indeed the catalog for the show traces its roots to the earlier landmark
exhibition of India's historical art held at the Royal Academy of Arts in London in 1947–
48, which then traveled to Government House, New Delhi in 1948.[20] Guha-Thakurta notes
that the National Gallery show stood out from other Festival exhibitions in its emphasis
on artistic form and its suppression of questions of religion, spirituality, and practices of
worship in relation to these objects.[21] She details the negotiations, arguments, and con-
troversies that dogged the National Gallery exhibition, as it drew most of its objects from

Indian museums, collections, and religious institutions. Resistance by curators and temple administrators in India to loan religious objects that would be exhibited as art led to last-minute substitutions and objects left out of the show (but included in the catalog). Guha-Thakurta points out that not only in debates centered on loans but also in the audio tour and other materials, the religious seeped back into the discussion of these objects through iconographic discussion, guidance to visitors on how they would have been worshiped in their Indian contexts, and the opening, which included an inaugural *pūjā* and performances by Indian dancers (Guha-Thakurta 2007, 643–45). I would add to Guha-Thakurta's analysis that the large-scale photographic wall murals found in several rooms of the exhibition punctuated the space with major religious structures (the Great Stupa at Sanchi, for example), and gestured to "in situ" contexts and practices in an installation otherwise focused on the objects as art.

The National Gallery show included no terracotta objects, and thus despite some similarities in approach and aesthetics to the Brooklyn exhibition, the latter remains distinct, with a clear focus on medium balanced with thorough art historical and archaeological scholarship. As such, Brooklyn draws together the historical focus of the *Sculpture of India* with the medium-based focus of the Mingei's *Forms of Mother Earth*. Terracotta enjoyed a slightly different staging in each case, with elements of artistic isolation and elevation, evocation of the work's in situ creation and use, and relation to history and time. Aiyaṇār's mount features at the Mingei, Brooklyn, and at *Aditi*: Palaniappan was everywhere. The horse sculpture operated as a stunning large-scale object drawing viewers into the gallery; as a work-in-progress as demonstrated by Palaniappan and laid out in pieces in the gallery; as a photograph connecting the objects in the gallery to a distant place and its worship practices; as a brand-new object echoed by broken and older examples that referenced the passing of time and decay caused by weather and age.

For Brooklyn, the show's last section included an example of a nineteenth-century Aiyaṇār sculpture clearly pieced together from a formerly broken state, highlighting at once a sense of fragility and age for the contemporary practice of making these objects, perhaps inadvertently playing on a sense that these craft traditions are fading (figure 2.8). Stephen Huyler, in his essay for the Brooklyn catalog, makes this sentiment explicit:

> The very existence of a museum exhibition of this kind, which attempts to show for the first time the development and continuity of terracotta traditions in India over the last four thousand years, demonstrates a basic change in attitudes toward terracottas in both India and the West. . . . With this newfound interest in the art of simpler, indigenous cultures, it is possible that the decline in production of terracottas over the past two centuries will be halted and that future generations will still be able to share in the customs and rituals of giving low-fired clay sculptures to the gods. (Huyler 1986, 66)

At Brooklyn, *Aditi*, and Mingei, then, a narrative of living arts, and occasionally the call to save these practices, entered into the conversation, drawing from earlier nineteenth-

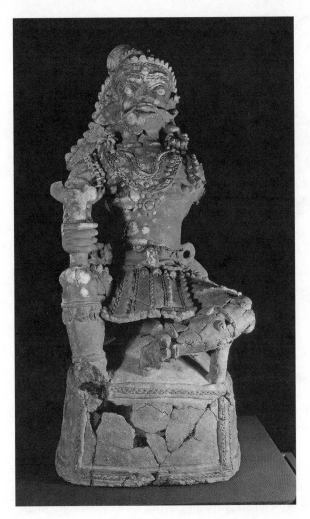

FIGURE 2.8. *Aiyaṉār*, Sittanasvasal region (Tamil Nadu), nineteenth century CE, red hand-modeled terracotta with applied ornaments, 33 in. (83.8 cm), private collection. Image: American Council for Southern Asian Art (ACSAA) Collection (University of Michigan, History of Art Department, Visual Resources Collections).

and twentieth-century understandings of the role of these exhibitions in "salvage ethnography."

But more pressing, I find, in these three shows is their focus on duration and time—the process-driven making of objects, the use of the objects and their aging in that use, the renewal of the object each year with new iterations, and the exhibition of each stage of production in the case of the Mingei show. In each instance, the shows highlight the quick and slow durations required for transformation. Clay becomes terracotta in a series of processes over time, and similarly clay sculptures become art, clay pots transform from utilitarian object to one representative of a community, clay horses repeat again and again to suggest both timelessness and the passage of time. At the Mingei and *Aditi*, the activities of doing and making center the temporalities on display; at Brooklyn, the temporalities bridge the ancient past with the present and highlight the imprint of the hand on the clay while probing the processes of loss and decay. Where Chandra's *Sculpture of India* uses

FIGURE 2.9. Entrance to the Capital Children's Museum. Sculptural installation by Nek Chand (1924–2015), 1985, various materials. Photograph by Veronica Szalus in 2001, courtesy National Children's Museum Archives.

time as a leveling device—a tool of erasure, simply marking out dates in linear periods—these other shows use time as evocative of fragility and decay, processual repetitions, making, and doing.

TENDING TIME: GARDEN OF DISCARDED TREASURE

But clay does not stop transforming once fired—Nek Chand's work demonstrates the further malleability of clay, whether in his figural forms wrapped in broken plates or his constructed environments shimmering with broken ceramic (figures 2.9–11). At the Capital Children's Museum in Washington, D.C., a massive, five-month process involving hundreds of volunteers and tons of materials produced a new sculptured entrance environment for the building. Using cast-off industrial materials, trash, and donations of used goods, the Nek Chand "fantasy garden" at the Capital Children's Museum embraces several elements of transformation and time that push the central focus on clay beyond its final firing into its reuse.

Chand's work came to the attention of the Capital Children's Museum through

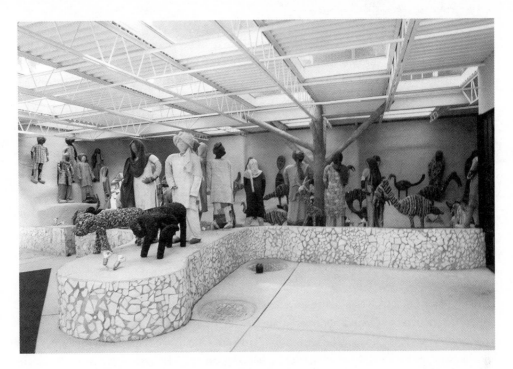

FIGURE 2.10. Partially covered entryway to the Capital Children's Museum, 1985. Sculptural instal-lation by Nek Chand (1924–2015), 1985, various materials. Photograph by Seymour Rosen, 1985. © SPACES–Saving and Preserving Arts and Cultural Environments.

various offices at the Smithsonian working to bring a wide range of India's culture to the capital. The *Smithsonian Magazine* had already developed a story on Chand in the sum-mer of 1983; Bennett Schiff at the magazine sent a note to Ralph Rinzler at the Smithso-nian alerting him to the forthcoming piece and suggesting that the Hirshhorn might be interested in hosting Chand and displaying his work.[22] When the Hirshhorn rejected the idea, Rinzler turned to Ann Lewin at the Capital Children's Museum, who enthusiasti-cally took up the idea on a grand scale, seeing in Chand's work its potential to unlock a child's creative imagination.[23] Lewin managed to raise funds and donations of materials and labor such that the project shifted from a small section of the museum's H-Street exterior to a full-scale transformation of the entryway to the museum, bringing what she termed the "whimsical" creative imagination of the work out into the parking lot (fig-ure 2.9). The installation included a covered area where Chand's more fragile cloth sculp-tures served as a transition into the interior (figure 2.10).[24]

With Chand's work, materials tossed aside serve as armatures and decoration while handmade concrete and the byproducts of industrial production create the underlying forms. As such, the materiality of his work echoes the liminality of its setting—in Chan-digarh, where he created a hidden garden in the forest on the edge of the planned Corbu-sian city, and in D.C., where the work straddled interior and exterior at a museum located

in a transitional neighborhood between the acropolis of the Mall and the poverty of the city's Northeast quadrant. Chand and his work hover in between categories, a quality that the curators and scholars working to bring him to D.C. often acknowledged.[25] Wilcomb E. Washburn, then director of the Department of American Studies at the Smithsonian, argued that Chand's work was and was not folk art: "While an individual creative artist like Chand is not doing 'folk art' in the sense of continuing a long popular historical tradition, he is, I believe, a genuine folk artist in the sense that he sees with simple but original eyes and utilizes folk materials and folk themes in his work."[26] But liminality and Chand's "outsider" status suggest a fundamental distancing of his work, one that obscures the connections to the other art discussed in this chapter. Through my inclusion here of Chand and his use of cast-aside materials, I want to take seriously two claims he makes for his own work. First, that the substance of the material drives his work: "I don't do drawings. I directly work on everything. . . . Without material there is no idea" (Howe 1985, B11). And second, that he understands his calling as an ongoing, ever-extending process: "'Simply,' says Chand, 'I am doing'" (Howe 1985, B11).

Chand's work involves staging an encounter with an environment—he incorporates walls and small passageways not to emulate a child's scale but to shape the visitor's bodily engagement with the space (see Irish 2004, 110–12). One must bend down and enter the passageway, not knowing what might be waiting on the other side. He draws visitors through the space with hints of what comes next. Chand's raw materials, from concrete and bicycle rims to cotton and ceramic, include the "medium" of display—he operates as both creator and curator. His work includes a major collaborative and participatory element as well (see Kester 2011; Bishop 2012). To gather material for Chand's installation, the Capital Children's Museum set up a large collection bin for cast-off objects so that D.C. residents might contribute part of their own lives; in Chandigarh, he did the same with the cast-off elements of the newly emerging city—one can read the names of the city's hotels in the broken ceramic and see the slag emitted by its furnaces.[27] In D.C., construction companies donated materials and labor to create the undulating platforms and hills for Chand's environments. Local schools participated in the installation, designing, with Chand's guidance, one of the ceramic murals at the entrance. Chand had made the three-dimensional sculptures in India; they, along with additional materials, were brought by ship to D.C., where Chand repaired them and, again with the help of volunteers, installed them (Lewin 1985).

Chand's "doing" for the children's museum thus included making and remaking the environments, spaces, and figural sculptures; collaborating with contractors, museum staff, the architect of the museum, and over five hundred volunteers;[28] traveling around D.C. to try to find a rock with a soul;[29] giving interviews to numerous media organizations; and guiding children in his methods as they worked to complete his vision. Doing involves duration: Chand's five-month stay in D.C. over the course of the project; the slow journey of a glass bangle from manufacture to a shop to someone's wrist to its breaking to the hands of Chand and its use as part of a garment;[30] the slow decay of the installation due to water damage, rodents and birds eating holes in the textiles, and simple neglect; the sub-

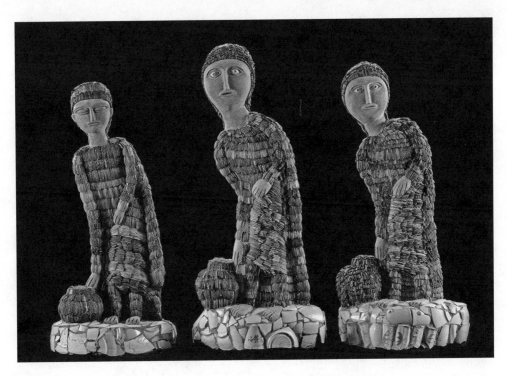

FIGURE 2.11 (Plate 5). Nek Chand (1924–2015), *Three Ladies Fetching Water*, Chandigarh, India, c. 1984. Glass bracelet fragments, porcelain tableware fragments, and cement, on mortar and iron armature. From left: 27 × 10 × 4 in. (68.6 × 25.4 × 10.2 cm); 32 × 11 × 4 in. (81.3 × 27.9 × 10.2 cm); 31 × 11 × 4 in. (78.7 × 27.9 × 10.2 cm). Collection American Folk Art Museum, New York, Gift of the National Children's Museum, Washington, D.C., from the Capital Children's Museum Nek Chand Fantasy Garden, in honor of Gerard C. Wertkin, American Folk Art Museum director (1991–2004), 2004.25.2, 11, 10. Photograph by Gavin Ashworth.

sequent dismantling and restoration of some of the sculptures, now in a different context at the American Folk Art Museum in New York (figure 2.11, plate 5).[31] It also, as Chand notes, involves a relation to celestial bodies and their temporality: "'When the rays of the sun come up,' says Chand, pointing to the mosaics, 'they light up, and when the rays of the moon shine, then they shine like candlelight. I consider these as jewels of the rock garden'" (Howe 1985, B11).

The Capital Children's Museum did not foreground art in its displays, as it saw its mission as firmly rooted in broad educational goals. Lewin had a reputation for innovation in this area, bringing technology into the museum along with a range of hands-on exhibits that encouraged creative, educational play. Chand's work may appeal to children, but he does not see it as children's art (Maini 1986, 4). Its position at the children's museum thus engaged with the pedagogical and process-oriented aspects of the museum's mission.

Chand remains difficult to pin down; even so, critics and museums label him an outsider artist, self-taught, folk, or naive.[32] Iain Jackson offers a counterpoint to these prob-

lematic labels, drawing from Edward Said's rereading of the term "amateur," in which Said returns to the French root of the term: "amateurism, literally, an activity that is fueled by care and affection rather than by profit and selfish, narrow, specialization" (Said 1996, 82). Jackson thus reads Chand as a "knowing and subverting amateur" who reworks the presumptions of modernity found in Chandigarh's Corbusian urban planning and architecture (Jackson 2003, 139–43). This amateurism gets at the heart of the "self-taught" aspect of so-called outsider art; Chand remarks that anyone can learn how to do what he does, reemphasizing doing as learning: "'It's easy . . . This takes no partaking of degrees. You learn in a day,' he says, leaning over the face of one of his statues, his finger inscribing the familiar straight eyelids, lips and nose of a Buddha. 'First you do like this, then this, then this'" (Howe 1985, E11).[33] For museum director Lewin, Chand demonstrated that anyone can make art out of any material (Groer 1985, E7). And the installation, unlike other Festival shows, did not emphasize the particularity of India. The brochure, written by a group of local high school students, includes one gesture to the subcontinent: "The figures reveal the colorful atmosphere and the vibrant mystery of traditional India and its many landscapes."[34] In general, though, the Indic elements of the work do not receive much attention. The commentaries and justifications for the exhibition all focus on the process and the many different durations associated with the works, whether the making of the environment, the experience of visiting this "fantasy garden," or the subsequent development of creative ideas in children and their caregivers.

Chand's work involves, at its core, transformation—of trash into potentially inspiring environments and engaging objects, of rocks into soul-filled monuments. As Gay Hawkins and Stephen Muecke (2002, xiv) note, "Waste is a product of time, since it is literally an end product and the end of all living things. But it is a temporizing effect, since the inevitability of waste is a repetitive and qualifying event." Waste is the end but not the end, with time central to its production. Chand's commitment to starting from this temporally imbricated material, joined with an understanding that his process involves not creating art but doing, brings together a number of temporalities shared by the other examples in this chapter.

THE TEXTURES OF TIME

Transforming clay into Palianappan's terracotta sculptures takes time—the time of seeking materials, the time of building the forms, the time of constructing the kiln, the time of waiting and wondering. Nek Chand's sculptures participate in these temporalities as well, and recycled and repurposed materials also embody recursive time, as for example in the unknown stories of broken dishes and shattered bangles. These materials take a circuitous path from making to breaking to remaking that continues in their display, decay, restoration, and redisplay in the museum. Visitors move through the galleries at a particular pace, imaginatively traveling to distant times and spaces, drawn on by glimpses of the next room and the next treasure. Photography, too, punctuates each of these

museum experiences, and it adds a further temporal layering to the conversations already in play in the materiality of the clay.

At the Brooklyn, Mingei, *Aditi*, and National Gallery exhibitions, large-scale photographs and wall-covering photomurals participated in the shaping of the visitor's temporal experience, providing a sense of what Barthes calls "perverse confusion":

> For the photograph's immobility is somehow the result of a perverse confusion between two concepts: the Real and the Live: by attesting that the object has been real, the photograph surreptitiously induces belief that it is alive, because of that delusion which makes us attribute to Reality an absolute superior, somehow eternal value; but by shifting this reality to the past ("this-has-been"), the photograph suggests that it is already dead. (Barthes 1981, 79)

The objects, sites, or craftspeople pictured existed at the time of the photograph, but that moment automatically slips into the past, perhaps suggesting those objects, sites, and people inhabit only the past. This temporality reinforces the oft-repeated refrain of loss, whether the lost cultures and knowledges of the ancient world, now unpacked and on display for our retrieval, or the contemporary remnants of "traditional" practices, soon to disappear through neglect and the pressures of "modern" progressive time.

The photography of sites is often meant to show context, but these images provide, for Barthes, a different kind of confusion:

> In 1850, August Salzmann photographed, near Jerusalem, the road to Beith-Lehem (as it was spelled at the time): nothing but stony ground, olive trees; but three tenses dizzy my consciousness: my present, the time of Jesus, and that of the photographer, all this under the instance of "reality"—and no longer through the elaborations of the text, whether fictional or poetic, which itself is never credible *down to the root*. (Barthes 1981, 97)

The dizzying effect of Barthes's three tenses resonates as well in these photomurals of archaeological sites—the viewer's present, the time of the monument's construction, and moment of the photograph—but here one finds an additional, fourth tense: the long, continuing duration of the ruin and the observable, changing process of decay. The viewer's process of triangulated looking adds a further twist, as one looks from the object to the label to the photograph and back, in a recursive, highly active duration.[35] Barthes interprets these multiple temporalities as disorienting, using terms such as "confusion" and "vertigo," describing feelings of dizziness and shock as he examines photographs (particularly of people). But in the late twentieth-century gallery, these dramatic emotions and disorientations fade; photography has become ubiquitous and the use of it in historical museum shows—particularly in relation to architecture—and in ethnographic galleries has normalized, even if the use of photomurals and photography also draws criticism (see Guha-Thakurta 2007, 632). Rather than vertigo, then, a layering of multiple temporalities coexists in these museum displays, providing a texture of different tenses,

durations, pasts, and presents. Photography thereby participates in and deepens the clay-based and process-driven transformations already at play in the objects, films, diagrams, and experiences visitors move through in the gallery.

The Capital Children's Museum installation did not include photography, but often in shows of Chand's work, photomurals of his work in Chandigarh serve as a backdrop for the decontextualized objects in the gallery (Shuster 2006). At the children's museum, the temporal takes on a new twist related to Barthes's focus on tenses. If photography provokes thoughts of the past and the death or decay of those people and objects depicted, trash seems the deadest of all materials—worn out, discarded, and broken—until it finds its way into its next life. Discarded objects also share with photography and clay a connection to the person who owned and used those objects—one that is written and rewritten each time the object or piece is seen, used, displayed, or remembered. The broken bangles and discarded tiles carry memories of use and care with them, even for those who have no direct connection to these objects.

Chand's use of waste has different resonances, carrying associations not with the personal but with twentieth-century modernist "progress."[36] His reworking of industrial detritus, including slag, a byproduct of metal casting,[37] and clinkers, a rocky, lava-like substance produced in large-volume furnaces, reconnects the personal cast-offs, themselves made through mass-production, with the massive waste involved in producing the objects and structures of twentieth-century life.[38] As Jackson argues, Chand's work transforms both personal and industrial detritus into groups of differentiated figural sculptures: "He takes the debris of mass production—its molecularised fragments—and turns it into the mass; they are almost always presented as a mass—not faceless, standardised and universal, however—but individuals who form a collective through shared anthropological and sociological characteristics" (Jackson 2003, 132). In this unending folding over of transformations, raw materials become glass bangles through industrial processes from which slag and clinkers emerge, coming together in Chand's hands to create communities of anthropomorphic form in environments built of reclaimed earth and concrete.

Temporality here takes on different forms than in the other exhibitions in this chapter; from the long burn of an industrial furnace to the slow wear of household objects, the materials themselves already embody the passage of time and the imprint of use. Their travel into Chand's orbit—or his attentiveness and patience for their emergence—adds another temporal layer. The recollections and memories carried in these materials and in the durations of their transformation into something new through modeling, decorating, repairing, and installing—these temporal elements Chand's exhibition shares with many others.

But the metaphor of the garden adds another temporality: this installation is, as Lewin and the Festival of India organizers trumpeted, "permanent," one of the few exhibitions to last beyond the Festival's eighteen-month duration.[39] But its decay points to the underlying temporality of all Chand's creations. These gardens require constant tending, an

a-teleological mode of action and time.[40] Many media articles on Chand note the amount of acreage he has completed and how much he has left before he "finishes" his garden, as if the project has an end and the work could be "complete." Until his death, Chand himself continued to find objects and build and expand with no end in sight; his successors continue his work. The unending process of creation, re-creation, decay, repair, and addition means that Chand's gardens escape a teleological temporal mode, challenging on yet another register the modernist tenets of Chandigarh and its Nehruvian industrializing, forward-moving vision. At the Capital Children's Museum, one might read a certain kind of teleology in the decay and de-installation (and de-accessioning) of Chand's works, but they live a new, perhaps more circumscribed life in the hands of the conservators and curators of the American Folk Art Museum.

In unpacking these many temporal layers as they build on one another, this chapter presents a further transformation, reading and writing again these durations and processes. Barthes led us to the intimate and dizzying layering of tenses at work in these exhibitions, and underneath the surface throughout my own writing lies a Derridean resistance to a singular, original moment of creation, such that each encounter with these materials, whether one in the gallery as an artist makes something from clay or in a magazine spread celebrating Nek Chand's vision—or in my text—the works are rewritten again and again.[41] I'd like now to situate these exhibitions and their small durations within a larger temporal fabric—in other words to historicize the Festival exhibitions that I've detailed here in order to show how a reading through their intimate temporalities might guide a further reading of their situatedness within the larger social formation of the mid-1980s.

Material and temporality: these two terms were imbricated in mid-1980s culture and politics—of the U.S. but also beyond the northern Atlantic—in several ways. For the art world, a postminimalist approach to material emerged from 1960s and 1970s experimentations at the border of installation art and sculpture. Beuys's experiments with materiality, shifting the emphasis from medium to the "stuff" itself, as well as with living, growing things such as trees, helped to change the discourse of the relation among art, time, and material. And, the consolidation of conceptual art in its immateriality reinforced the continued movement within sculpture/installation to question material and medium as grounds for art making.[42] The decades prior to the Festival also saw the unpacking of relations to the past and the "now" in postmodern architecture and film, questioning any presumption of a chronological relation to the past and building on earlier filmic tropes of the jump-cut and the montage to bring these deconstructive temporal modes into popular culture.[43] As academics began to analyze the legacy of colonial relations of power following Said's 1978 intervention, popular culture presented films and television nostalgic for the colonial era at a time when identity politics threatened the status quo (Rushdie 1984a, 1984b). And the rise of neoliberal economic approaches around the world, with their leveling of difference and monetizing of culture, reinforced already-extant anxieties about the loss of pre-industrial and pre-globalized ways of life. In this milieu, museums

on both U.S. coasts presented the seemingly staid and conservative exhibitions of India's so-called folk crafts in clay, the subcontinent's four-millennia old history of terracotta, and a fantasy garden at a museum for children.

Aside, then, from the rather empty gesture of labeling these shows "cultural diplomacy," they seem on the surface not to engage with the wider discourse of the 1980s. But I would like to argue that in examining their temporal layering, one can articulate their imbrication in and production of these social formations. These connections come to the fore most strongly in Nek Chand's installation, where a critical engagement with modern understandings of linear time intersects with an attention to and rereading of the material detritus of that very modernity under critical scrutiny. But in the material focus of Brooklyn's terracotta show I also see an engagement with temporalities that slip out of the grasp of historical or linear time, such that the show's opening via newly made clay objects, living plants, and the frisson of time in photographic mural panels undoes the security with which art history so often frames the contextualization of ancient objects. That this slipperiness undergirds the very study of historic terracottas—difficult to date through their material and often dislocated from the authority of a "scientific" archaeological dig—only reinforces the destabilizing discourse the exhibition participates in. The closing gesture of a fragmented Aiyaṉār figure allegorizes the fragmentary, slippery, and fragile relations to material and time embodied also in Chand's pieced-together mosaics. And the multilayered, articulated flow of durations in the Mingei show evoke nineteenth-century pasts that valorized and packaged the figure of the craftsman, but they reclaim and deconstruct those pasts through the dynamic flows of intimate temporalities at work in the galleries. These shows engage with the discourse of postminimalism, postmodernity, and globalization, and offer intimate interventions into relations of power at work inside the gallery, across the U.S., and with an ever-shifting world.

Time, Interrupted

PEOPLE IN THE GALLERY

PERFORMING, demonstrating, or making—people have long had an active role in exhibitionary spaces. Nineteenth-century exhibitions included people from around the colonized world, demonstrating their crafts, performing their daily lives in constructed villages, or putting on elaborate shows for audiences large and small.[1] The later twentieth century brought forth a wealth of performance art, with the bodies of artists, their collaborators, and visitors to their shows or passersby wittingly and unwittingly incorporated into the work of art—a work increasingly porous, often ephemeral, and focused on the experiential, or as some theorists might term it, the theatrical (Fried 1967). Performance art's emergence in the twentieth-century postwar era partially inured gallery visitors to the shock of confronting a living human in a space otherwise circumscribed by the expectations of museum viewership of ostensibly static objects. And yet this frisson remains persistent and particularly heightened in contexts outside of contemporary, metropolitan, "high" art, such as the museum focused on historical material or the natural history museum. In these contexts, the inclusion of living, active people in the gallery calls into question not only the separation between viewer and viewed, and not only the spatial relationship of living, moving viewer and static object, but also the temporality of the gallery and its displays.

This chapter turns to the inclusion of people in the galleries in several of the exhibitions staged during the eighteen-month-long Festival of India in the U.S. from June 1985 to the end of 1986. The most prominent of these, *Aditi: A Celebration of Life* at the Smithsonian's National Museum of Natural History, included forty painters, sculptors, ceramicists, toy makers, henna artists, textile dyers, musicians, dancers, puppeteers, magicians, impersonators, and acrobats (figure 3.1, plate 6).

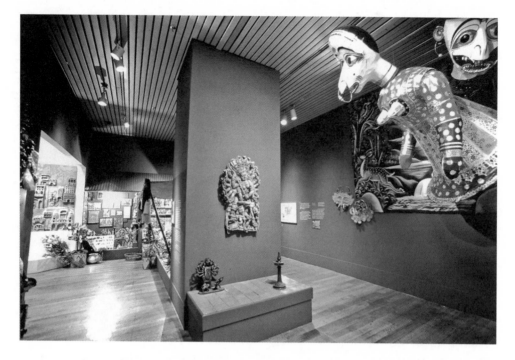

FIGURE 3.1 (Plate 6). Overview of first gallery, *Aditi: A Celebration of Life*. Smithsonian Institution Archives. Accession 97-012, National Museum of Natural History, Office of Exhibits, Special Exhibition Records, box 5.

During the almost three weeks of overlap between *Aditi* and the Smithsonian Folklife Festival's *Mela!* in the summer of 1985, the Washington, D.C., Mall hosted forty *Aditi* participants and sixty *Mela!* performers and artists (figure 3.2). In addition to the activities in D.C., many other Festival of India exhibitions included people in the galleries, often as short-term features during the grand opening or for a week or two during the longer run of the show.

In highlighting the living, active people in the museum, my project in this chapter moves away from the predominant mode of thinking exhibitions through space—objects (and objectified human displays) arranged in a series of galleries—to refocus attention on the temporal element of the exhibitionary complex. One of the most impressive readings of nineteenth-century exhibitionary space, Timothy Mitchell's exploration of Egyptian visitors to Paris's Exposition Universelle of 1889 engages with the ways in which spaces operate: the mosque façade opening to a tea house, the boldness of the department store window drawing the viewer's eye, or the labyrinthine trap of the interior of the store itself with its unending stagings of objects, such that the entirety of Paris seemed to the visitors as one inescapable exhibition (1992). I find Mitchell's work incredibly helpful in understanding the epistemological shifts taking place at the turn of the twentieth century in relation to spectacle, commerce, display, and the space of the city as it melded with the space of the shop and the exhibition.[2] Here, in turning to a reading of the 1980s Festival

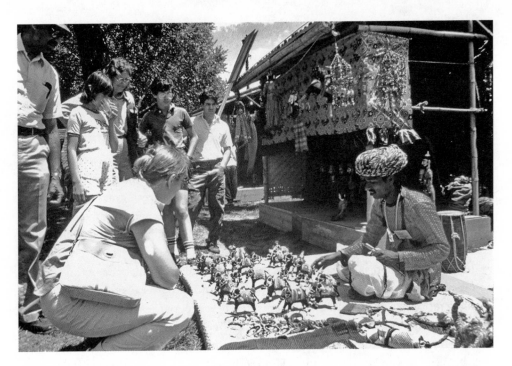

FIGURE 3.2. One of the toy sellers at *Mela!* on the National Mall. Photograph courtesy of the Ralph Rinzler Folklife Archives and Collections, Smithsonian Institution.

of India through temporality, one finds a different kind of shifting historical context, one in which experience, performance, interruption, and daily fragmented moments of time coalesce into a differently inflected understanding of the world. While spectacle certainly remains a touchstone in the Reagan America of the 1980s, I see it in these exhibitions as poked and prodded by the dispersal and layering of small moments of encounter or activity. Thus, when unpacking the *Aditi* exhibition or the *Mela!* programs on the Mall—with performing, demonstrating, living people; viewing, participating, and conversing visitors; and active, negotiating mediators—an attentiveness to modes of time opens up new avenues for understanding what the exhibition did and how the bodies in the galleries challenged much more than the object/active boundary. I see a shift here—not a complete break, but a genealogical shift—from Mitchell's nineteenth-century spatial labyrinth to a temporal layering of interruptions and fragments that comprise the exhibitionary mode of the mid-1980s.

With this approach, instead of seeing a visitor take offense at observing craftspeople "objectified" in gallery settings, thinking this moment through temporality acknowledges the discomfort and shock of the interruption to the visitor's expectation of static museum relations. The duration of the craftsperson's activity and the back and forth of conversation (sometimes through a third party) change the entirety of the temporality of the visitor's movement through the gallery (Leahy 2012). No longer does the visitor control

the pace and the engagement with the exhibition. Seeing this as an interruption of expected museum temporality opens up myriad possibilities for rethinking the gallery experience.

Likewise, thinking exhibitions through temporality allows for multiple, overlapping, interconnected rhythms of performance, presentation, eating, conversation, labor, worship, and entertainment through which the artists and performers in *Aditi* experienced their own exhibition. Workers often articulate their relation to labor through temporalities and manipulate their positionality in relation to hegemonic structures by slowing down, speeding up, or mobilizing other modes of time to help them navigate an often difficult workplace (Apostolidis 2016). Museums, coffeeshops, restaurants, and libraries manipulate time in conjunction with space, sound, light, surfaces, and other factors, encouraging, for example, quick turnover of tables by providing uncomfortable chairs, loud echoing rooms, and cramped quarters.

In the gallery context, these everyday relations to and manipulations of time take on an exceptional quality: festivals interrupt and reconfigure everyday temporal modes, enabling resistance and creating new intensities, new experiences of duration. Boredom, quick flashes of conflict, waiting, memories of kindness, longing for the past and seeking a better future—these durations and relations to time operate in the Festival of India as well, but here they are on display and take an active role in the production of exhibitionary experiences for all involved. Participants, organizers, and many visitors are also aware of the long history of displaying humans in museum and festival settings; the precedents of the nineteenth century haunt these twentieth-century examples, inflecting the exhibition with histories of human violence and the ghosts of exhibitions past.

The mid-1980s exhibitions, then, engage with a genealogy of prior displays of human beings in galleries and international expositions. But these shows emerge at a particular historical and political moment, one that shapes and is shaped by the moments and temporalities at play in these galleries. As such, *Aditi* and *Mela!* participate in the larger flows of the mid-1980s, including the rise of neoliberalism, the promise of "Third" and "First" world parity, Reagan's spectacle-driven economy, the nostalgia for the Raj, the touristic time of the visit, the duration involved in handmade objects, and the nostalgic longing for authenticity.

The first half of the chapter unpacks the interconnections and genealogies of the longstanding practice of people in the gallery. Rather than suggest that the 1985–86 Festival represents something utterly distinct or new, instead the precedents I trace here from the nineteenth and early twentieth centuries demonstrate the complexities of all of these exhibitionary histories. I then turn to contemporaneous examples of people "on display" in performance art, historical "living" museums, and gallery demonstrations that help to situate the Festival examples as part of a larger web of contemporary exhibition practices. With these two genealogies in mind, the second half of the chapter turns to the moments and durations at work in the *Aditi* and *Mela!* shows, from boredom and waiting to making and performing.

PRECEDENTS: PEOPLE ACROSS TIME

The practice of presenting humans as exemplars, on display as craftspeople or as representatives of an exotic race, culture, or societal role, has a long history, as long as the history of the museum itself. Nineteenth-century exhibitions included people from around the world, sometimes in the service of "representing" the nation, but more often to demonstrate the extent of colonial control over geography and human culture. Thus various African individuals, from "Hottentots" to "Pygmies," traveled around the world to these shows at the behest of their colonizing empires or wealth-seeking showmen, as did representatives of Native American tribes, Pacific Islanders, Southeast Asian tribal groups, and South Asians. Some groups demonstrated rituals or performed music; others produced handicrafts or were asked to live in reconstructed villages on midways. These popular living exhibits, so similar to zoological display, reinforced and demonstrated the increasingly racialized hierarchies of nineteenth-century global anthropometrics and provided exotic titillation to the visitors moving through these multisensory displays.

A common approach to reading these histories of human display sees these exhibitions as objectification or zoomorphization. On the one hand these descriptors capture some of the relation between viewer and viewed, exhibitor and exhibited. But on the other hand, they trap all of the actors into binary roles that fail to account for the richness of the relations of power—from the different modes of exploitation across a spectrum to the different modes of resistance—evinced at these shows. How does one become a person "on display"? Or, following ancient philosophical debates over the line between a being with *logos* (human) and one with only *phone* (animal): how do we know a being has *logos*? For Jacques Rancière, participation and the potentiality to participate enables the distinction, and while the display contexts of these nineteenth-century colonial exhibitions serve to shut down any sort of radical equality, they offer the *potential* for moments of recognition and the assertion of a shared *logos* (see Rancière 1999).

Examples of active resistance and recognition, even from the earlier nineteenth-century exhibitions, abound. In the case of South Asians on display, Saloni Mathur's work on the Colonial and Indian Exhibition of 1886 in London has given us the traces of a homeless Punjabi man, Tulsi Ram, and a group of inmates from Agra jail, as they navigated and challenged the institutional power relations that put them "on display" as craftspeople from the subcontinent (2000, 2007). Ram's insistence on seeking arbitration from his sovereign, Queen Victoria, in the matter of the ownership of his land, meant that British colonial administrators' attempts to track him as he moved around London found their way into the archive; his story, while not a whole or complete one, therefore appears with enough presence to recognize his interruption of the dominant mode of being "on display." Ram took his shared humanity and his shared subjecthood in relation to the Queen as given, thereby asserting his shared *logos* in the face of its active and repeated erasure.

Ram's problem-causing movement around London also involves a temporal element, I would argue. How did he have, find, or claim the time to move about, depart from his

handlers, traverse London, and seek an audience with the Queen? Rancière's archival study of nineteenth-century workers in France hinges on just this question: how do people whose participation is in question find the time to participate? In Rancière's insightful reading of democratic theory going back to Plato's *Republic*, lower classes for Plato are allowed to enter the community, but only insofar as they take on their roles as carpenter, shoemaker, or weaver, serving the community in that one, single way as their sole duty (Rancière 2012 [1981]). And yet somehow, these same workers, craftspeople, and artists manage to find time to study, to read, to talk with one another, to grasp the philosophical underpinnings of subjecthood within an empire, and, in Ram's case, to navigate the complex streets of London, to slip away from the grand exhibition and operate effectively in the heart of the metropole.[3] In that production of knowledge and engagement Rancière tracks the emergence of what he calls "the part which has no part"—the momentary and fleeting democratic interruption of the larger institutional police order. That these workers have (or make) the time is a paradox for the logic of the social order: craftspeople can have no time other than for their occupation, and yet Ram dashes off, slips away, takes or steals or grabs the time to petition the Queen.

Later cases enjoy slightly more documentation than the South Asians at the 1886 exhibition. The 1904 St. Louis World's Fair has attracted a great deal of scholarly attention for its many instances of humans on display. The exhibition occurred in the wake of the Philippine–American War, and as a result, the inclusion of a wide range of regional Filipino groups anchored the ethnological displays, organized under the auspices of the Smithsonian's chief anthropologist, William J. McGee. Touted as the ultimate educational context, where one could see the entirety of human development through both archaeological artifacts and the living "primitives" of both the Philippines and Native America, the 1904 fair inherited many of the traits of European colonial exhibitions, reworked through the imperial and colonial relations of the U.S.

Native American participants like the Cocopa Indians took some convincing to come to Missouri, and once they arrived, they experienced many of the negative implications of world's fairs for those on display: poor sanitation, limited mobility outside of the fair, struggles to get paid for their work and their image, conflict within the group, and various levels of mismanagement by those in charge. Alongside these many challenges, the Cocopa group negotiated their own representation: refusing to wear "traditional" costume in favor of their everyday frontier-style clothes and adjudicating conflict in their own manner when necessary (Parezo and Troutman 2001).

The several delegations from the Philippines likewise engaged with the fair through established languages of marketable, commercial culture, operating as part of larger "cultural companies" that contracted with different fairs around the world to present living exhibitions of Bontoc, Suyoc, and other regional communities to Americans and Europeans (Quizon and Afable 2004). Many of these groups were led by former American soldiers and officers who had fought in the Philippine–American War, thereby directly linking these efforts to the new American colonial and imperial relation with the region.

With a history of mission schools and education in the highlands of the Philippines, these communities included young multilingual mediators whose positionality shaped and was shaped by the particular men, women, and children who chose to travel abroad with these companies (Afable 2004). The practice of including live exhibits of Filipinos dressed in loincloths and performing a "dog feast" several times each week drew criticism from the elites of the country, who, rather than shutting down the ethnographic displays, wanted to turn their rhetoric toward a message of national advancement (Afable 2004).

Visitors to the Festival of India in the mid-1980s would bring with them familiarity with these precedents, whether a generalized sense of a sad and violent history of people on display, a resonance with the tales of nineteenth-century individuals, or a knowledge of historical and contemporary "freak shows." While scholars have complicated the history of humans in the gallery or on the midway, popular imagination has largely remained one of horrified objectification, shaping the reactions of some of the visitors to *Aditi* I spoke with. Others recognized the relation to other kinds of self-performance—a creation of cultural and individual identity through the aegis of techniques also found in theater and dance.[4]

Visitors might also bring with them the history of Indian art exhibitions that took place consistently across the long twentieth century. In addition to major shows of historical art, craft often centered exhibitions focused on India and South Asia. One major precedent, for example, was Stella Kramrisch's exhibition *Unknown India*, held at the Philadelphia Museum of Art and traveling to San Francisco and St. Louis in 1968. This exhibition valorized the handcrafted objects of the subcontinent as art, presenting them as both aesthetically and ritually important works, situating them in their regional contexts and assiduously avoiding labeling the works as craft or folk. It operated as a counterpoint to the Museum of Modern Art's 1955 *Textiles and Ornamental Arts of India* exhibition, which brought the aesthetics of India's handmade vernacular art into the modernist narrative as potential source material rather than as art in its own right.[5] These exhibitions did not feature demonstrations or performances in the gallery, but they indicate an ongoing conversation regarding the presentation of India's visual culture across the twentieth century.

The complexity of different types of performance, living display, and material culture, combined with a multiplicity of negotiating techniques on the part of the participants, mediators, and organizers, means that no single critical engagement or overarching explanatory frame can encompass these histories.[6] A similar layering occurs for the Festival of India exhibitions, and the narratives from the Festival echo some of the earlier examples in slightly altered form. The discourse of the Festival included heated politics surrounding which performers and craftspeople represent India, how to mediate their engagement with exhibition visitors, and how to navigate the traveling group's internal dynamics—all taking place alongside new negotiations with global capital, ongoing and shifting asymmetries of power, vocal and active mediators and organizers.

International festivals persist today, often framed by national identity or by performance medium—a Swedish festival or a choral or dance festival. In addition, people continue to

be employed to demonstrate craft practices and rituals, and to perform music, dance, and storytelling. These twentieth-century modes of demonstration, performance, and ritual in the gallery move human display from the grand, temporary fair and international exhibition into the museum and heritage site. Where a festival temporarily interrupts the everyday rhythms and spaces of a city for weeks or months, people performing or working in the galleries interrupt the smaller environment and localized temporal rhythms of the museum institution, operating therefore in a more intimate scope. The case of the Festival of India combines both festival and museum interruptions in a multi-sited interpenetration of the two.

CONTEMPORARY HUMAN DISPLAY: HISTORY MUSEUMS, SAND MANDALAS, CRAFTS MUSEUMS, AND PARTICIPATORY ART

Several contemporaneous cognates further situate and circumscribe the Festival of India's use of people in the galleries: the living history museum and the (usually non-Western) religious or cultural ritual. Finding its roots in sixteenth-century reenactments of historical scenes for the court, the living history museum emerges out of a nineteenth-century drive to salvage practices that collectors and historians saw as disappearing with urbanization and industrialization. Artur Hazelius's living history open-air museum at Skansen in Sweden opened to the public in 1881 and brought together Hazelius's vision of Sweden's many rural farming spaces, practices, and rituals. Scholars who work on living history often cite Skansen as an exemplar for later North American institutions such as Plimoth Plantation, Colonial Williamsburg, or Greenfield Village.[7]

While all of these institutions seek to make history "come alive," they do so from differing founding contexts and through a range of techniques, including employing guides, mediators, and actors working in both first and third person. At Skansen, for example, women demonstrating cooking answer questions and narrate what they are doing in third person, acknowledging that they are not pretending to be nineteenth-century farmers but instead are contemporary women trained to guide visitors through a multisensory historical experience. At Plimoth Plantation, first-person narration has dominated such that a similar figure would answer questions "in character." Scott Magelssen has argued that the first person, while enabling visitors to suspend disbelief and imagine themselves as time travelers, also precludes critical analysis of the historical moment (2004a). At Williamsburg, while the predominant mode is first person, mediators who lead tours focused on the role of slavery in colonial America do so in the third person, largely because the critical distance allows for visitors and tour guides to discuss explicit and difficult questions. At times, leaders of these third-person tours encourage visitors to pose questions of the first-person actors, raising issues related to slavery, miscegenation, and race, simultaneously challenging the underlying premise of the "time machine" and the constructed, sanitized vision of history found at Williamsburg.[8]

The nineteenth-century living history museum and its twentieth- and twenty-first-century counterparts employ actors to illustrate the crafts and daily activities on display: even the first-person narration operates at a distance, as both visitor and actor tacitly acknowledge the gap between the performance and a person from the eighteenth- or nineteenth-century doing and making in the course of their day. The gap shrinks but does not disappear in the case of rituals performed by religious clerics and community members in gallery settings. The Tibetan example of religion in the museum—whether one finds monks creating a sand mandala or sees them inaugurating a constructed shrine—stands out in its relative ubiquity.

Since 1988, Tibetan monks have performed the ritual of creating (and then ritually destroying) sand mandalas in museums and galleries across Europe, North America, and elsewhere around the world. The spiritual, political, and cultural pointedly intersect in the sand mandala. A ceremony brought out of its original context into the museum and drawn out from a six-day process to several weeks in order to engage the widest audience, sand mandalas nonetheless retain a significant and central spiritual element (Bryant 1992, 33). A single monk or group of monks use metal funnels to distribute colored sand onto a platform in the gallery while being observed by visitors to the exhibition. Museum visitors often arrive first thing in the morning to observe the opening chants performed by the monks at the beginning of each day, and large crowds attend the final immersion of the sands into nearby bodies of water. The monks interact with the visitors, answering questions related to the spiritual content of the mandala and adapting complex religious doctrine and practice into accessible language (Bryant 1992). All of this takes place within the larger context of the international political movement to "save Tibet" in terms of both culture and governance. The presentation of Tibet as a spiritual land with a culture primarily centered on Buddhism has grown since the Dalai Lama and others established a government in exile in 1959. Tibetan religion, in the nineteenth and early twentieth centuries seen as a degraded form of Buddhism, is now held up not only as the purest form of Buddhist practice but also as a religio-cultural complex that has the potential to save the world (see Harris 2012). The sand mandala participates in the production and maintenance of a politically inflected Tibetanness for museum audiences, the Tibetan diaspora, the government in exile, and the activist political movement engaged in preserving Tibet as a political and cultural entity (see McLagan 1997; Hess 2009).

Buried within this complex political, spiritual, and cultural web, the presence of people in the gallery shares a great deal with both historical and contemporary examples. Monks, not always from overseas, are presented as authentic exemplars of an ancient and pure culture (despite the extremely visible plastic tupperware containers in which they store the colored sand). The hushed, reverent atmosphere that often surrounds these mandala performances underscores their spirituality and constructed authenticity, but does so only for a North American and European audience used to the disciplined quiet of both museum and congregational religious spaces. Buddhist ceremonies in the Himalayan

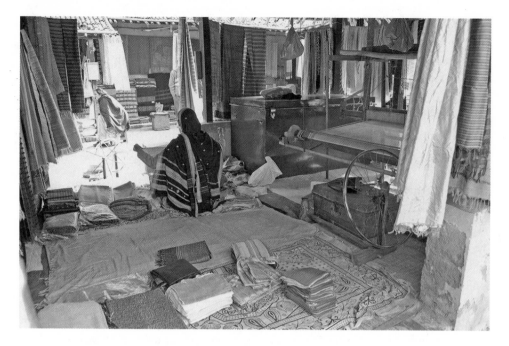

FIGURE 3.3. Artisan area, National Handicrafts and Handlooms Museum, New Delhi, January 2009, photograph by the author.

region, Southeast Asia, and elsewhere are often loud, bustling affairs with cell phones ringing and people chatting. Museums usually place both the mandala and the monks behind velvet ropes or even low walls, elevating the mandala itself on a platform that the monks' bodies also share, reinforcing the spatial element of being "on display." A sense of striving for authenticity thus stems from the setting and the expectations of the museum-goers as much as from the monks themselves.

The contemporary display of craftspeople in the gallery uses similar techniques to assert the authenticity and sacrality of the demonstrated practice. Inviting craftspeople to create their work in the gallery, whether in a staged demonstration or a longer term residency, has become part of the educational and curatorial norm for museums focused on craft. In the South Asian context, the most well known example of this phenomenon began in the late 1980s at New Delhi's National Handicrafts and Handlooms Museum, where artists from across India practice their crafts in the courtyard of the museum over the course of months-long residencies (Jain et al. 1989; Greenhough 1995; figure 3.3). Multiple craftspeople thus live at the museum, receive a small stipend, and create objects in the courtyard for sale to the public. Separated from the historical collection of craft objects at the museum, the artists are encouraged to use these as exemplars and are discouraged from cross-regional and cross-media collaborations—the authenticity and purity of regional craft traditions occupy the forefront of this incorporation of craftspeople into the museum environment.

In both the Tibetan case and the case of craftspeople-in-residence, an extended dura-tion and repetition of their activities in the museum space marks their gallery presence.[9] The slowness and slowdown of the making of the Tibetan sand mandala, the rhythm of the day of the craftsperson, often opening with a ritual invocation, the minute accretions of craft labor that gradually build a pattern or a form (in the case of the sand mandala often filmed from above for further "live" display on-line and subsequent sped-up filmic reenactments)—these negotiated and constructed temporal flows occur in these longer-term engagements of artist/monk/practitioner in the gallery. And interruptions occur, often directly thwarting attempts to produce an "authentic" atmosphere, whether in violent ways—a gallery visitor destroying the sand mandala in progress—or in more sub-tle ways—the ceramicist incorporating metalwork techniques from a neighboring col-league (Bryant 1992; Greenhough 1995). As living history, at nineteenth-century world's fairs or "freak shows," as religious ceremony, or in contemporary demonstration, the audience-performer-museum relationship breaks down, in both predictable and unpre-dictable ways. Against this fragility, all participants involved perform a continual and vigilant rebuilding of the constructed relation among museum, visitor, created object, organizer, and practitioner.

Performance artists and curators of contemporary art are well aware of the need for the persistent building and renewing of the relation among audiences, performances, artists, and interlocutors. What's more, performance art often brings with it a commit-ment to provocation and interruption, as Amelia Jones has argued: "Performance has been thought of not as confirming presence but as provoking, precisely, 'moments of danger' that flash up and (if we are open to it) open the possibility for acknowledging the impossible folds in time that defeat every desire to write history in the old-fashioned, art-historical sense as a final and true choreography of objects progressing over time" (2011, 34). The elements of people in the gallery I discuss here—the frisson of encounter, the interruption of expectation, and the reorientation to a new gallery experience—resonate with Jones's understanding of performance art and the challenges it presents to art his-tory.[10] From the beginning, the ephemerality of the event and its consequent problems of documentation played a central role in performance and participatory art, sometimes as motivating factors for the artists and also as constitutive issues in the construction of a history of performance art.

But performance art itself also explored questions of temporality, often in conjunction with laboring bodies. The artist Mierle Laderman Ukeles, in her maintenance art perfor-mances of 1973–74, cleaned the gallery space as a critical engagement with labor, gender, and art institutions, dispassionately highlighting the small, everyday actions and repeti-tions that enable the museum space and the subsequent encounters and engagements of gallery visitors (Molesworth 2000; Kwon 1997; Jackson 2011, 75–103). The problem of the fleeting and intangible moment of the performance thus emerges as central to art prac-tice, as acknowledged both by those who study humans on display and by scholars of performance and participatory art. These forms share the lack of tangible output, the

centrality of temporality (whether the endurance involved in long spans of time or the fleeting instant of an encounter), the role of repetition, and—particularly in the cases of participatory art and human display—a connection to the improvement of society or uplift of the participants. Jones's articulation of the folds in time evident in attempts to write performance art histories operate centrally here as well, and in focusing on the temporal layering of small and long durations in the experience of artist, visitor, and mediator, I see my project as taking up Jones's call for an art history of performance attentive to time.

Few scholars have thought through the genealogical connections between nineteenth-century humans-on-display and twentieth-century performance practice.[11] Intersections and overlaps abound, from the celebratory festivals staged by students at the School of Fine Arts at M.S. University in Baroda (Vadodara) India, where artists and community members came together to produce an ephemeral combination of visual art, craft, theater, music, singing, food, and dance (Sinha 1997) to the multi-year high-art and local-art collaborative participatory process that improved the spaces around village wells and instigated a wide range of intangible community engagements in the villages of the central Indian Bastar district (Kester 2011, 76–95). Scholars in performance studies have perhaps been better situated to explore these interconnections, examining the practice of historical U.S. Civil War reenactment, for example, in conjunction with performance art, the long history of the tableau vivant, and other popular staged and street actions (see Schneider 2011).

The exhibitions that incorporated people as part of the Festival of India echo many of the elements found in contemporary and historical examples of people on display. Moreover, this collection of historical and contemporary examples belies the common misconception that putting people into museum settings is a thing of the past: a nineteenth-century practice embedded in histories of racism and imperialism. Indeed, with racism and imperialism, the incorporation of humans into the fabric of the museum display is not an aberration in the history of museums but a constant. But the persistent fact of humans in the gallery does not in itself suggest that these practices all carry the same meanings or that they immediately imply the objectification or zoomorphization of these individuals. Indeed, as Qureshi and others have argued, even in nineteenth-century contexts, the link between imperialism and racism on the one hand, and shows focused on human display on the other, cannot be clearly and easily drawn.[12] And evidence continues to emerge regarding the role of the people on display, whose active participation in shaping their relationship with a larger economic and institutional framework of exhibitions, commerce, and cultural construction belies presumptions of objectification and the erasure of agency.

Thus in the mid-1980s, the Festival of India exhibitions, drawing on these contemporaneous and historical examples of human display, include the multivalent presence of human actors in the galleries, a presence that, like all performance, proves difficult to fix and freeze in time or history. These precedents and contemporary examples haunt the

Festival's exhibitions, shaping and prodding the expectations of visitors, the daily practice of performers, and the production of an exhibitionary experience for all involved. In the remainder of the chapter, then, I turn to these exhibitions, carrying with me the fabric of the genealogies discussed above, to explore how the small moments of encounter, performance, duration, and other temporalities participate in a larger context of mid-1980s cultural and social politics.

In what follows, I engage with particular examples of time, from the ostensible production of an authenticity "out of time" that is destined to be interrupted (and then reconstituted), to the ways in which curators, translators, and cultural guides spent months preparing to welcome and facilitate the participants in the exhibition, preparation that proved partial in the face of the need for continual, creative, and engaged mediation with the craftspeople and visitors throughout the run of the show. I turn then to two final sections devoted to the craftspeople, participants, and performers themselves in order to explore the layered temporalities they operated within and resisted during their time in Washington, D.C. I not only explore the day-to-day machinations of their experience in and out of the galleries, but also turn to the temporality of being "on tour" as a way to think about the artists' productive interventions in this exhibitionary context.

"THE LIVING ARTS OF INDIA"

Of over seventy exhibitions across the United States during the Festival of India, seven were held under the aegis of the Smithsonian.[13] The centerpiece of the Smithsonian's Festival of India exhibitions was *Aditi: A Celebration of Life*, a show organized by designer and curator Rajeev Sethi and developed from earlier iterations of the same exhibition in 1978 in Delhi and in 1982 in London. Designed along the theme of a child's life, from conception to birth, through childhood to marriage, the exhibition arranged the ritual and visual culture of India in this temporal, life-cycle sequence, incorporating craft traditions from across the subcontinent and bringing together over two thousand objects with forty craftspeople and performers. Each childhood stage incorporated historical pieces borrowed from museum and private collections in India, contemporary objects made for or during the exhibition, and several performers or craftspeople.

Each morning the participants opened the exhibition with a *pūjā* at its entrance (figure 3.4; some participants performed an additional *pūjā* at a small *tulsī*, or basil, shrine in the primary performance space), and then took their places around the gallery as indicated on the exhibition plans (figure 3.5).[14] Amidst the rich arrangements of objects, colors, and textures, visitors to the galleries reported mixed reactions to finding living exhibits in the galleries. Most remember it positively, but others I spoke to recall a sensation of dissonance and shock at turning a corner and seeing a potter at work in a niche or a woman working with textiles on a corner ledge (figures 3.6–7, plates 7–8). Throughout, the exhibition stressed its presentation of the "living" arts of India. The word signals activity and process, a dynamic replacement for "traditional" or "craft"; it also acknowledges the life

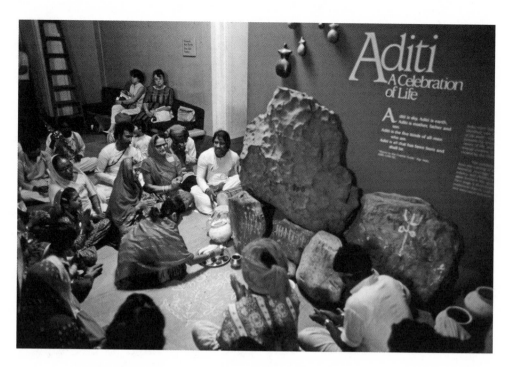

FIGURE 3.4. *Pūjā* at *Aditi* exhibition entrance, National Museum of Natural History. Photograph by Tony Heiderer, courtesy of the Ralph Rinzler Folklife Archives and Collections, Smithsonian Institution.

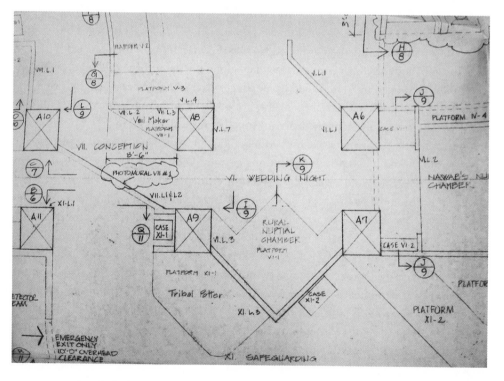

FIGURE 3.5. Detail of *Aditi* exhibition blueprints indicating location of "tribal potter" and "veil maker." Smithsonian Institution Archives. Accession 97-012, National Museum of Natural History, Office of Exhibits, Special Exhibition Records, box 1.

FIGURE 3.6 (Plate 7). Amina Bai Ismail Khatri seated in her "veil maker" niche, *Aditi* exhibition. Smithsonian Institution Archives. Accession 97-012, National Museum of Natural History, Office of Exhibits, Special Exhibition Records, box 5.

cycle represented in *Aditi* and the ways in which the community of participants "lived" within its rubric.

Moving through the exhibition, from the opening *pūjā* space down hallways and around corners, visitors would be drawn forward both by the overwhelming number of objects and by tantalizing sounds coming from rooms ahead: the rhythm of drumming and singing, the calls of the magician, the laughter of visitors, the clatter of the hooves of wooden horse puppets. Urged to interact with magicians and facilitated by local Indian American translators, the visitors' own voices would have added more volume to the bustle of the show. The smells—of henna, straw, clay, incense burning at the *tulsī* altar in the center of the performance space—added to the sensory experience, along with a few tactile interactions: henna paste on the hand, holding a bag for the magician, feeling tie-dyed textiles (figure 3.8).[15]

This multisensory visitor experience relied on the labor and activity of the crafts-people and performers who populated the gallery spaces. Looking solely at the archival photographs of people seated on platforms alongside their sculptures or paintings leads directly to a reading that privileges the transformation of human into object. But acknowledging the cacophony of sounds, smells, and active sights the visitor would have encountered

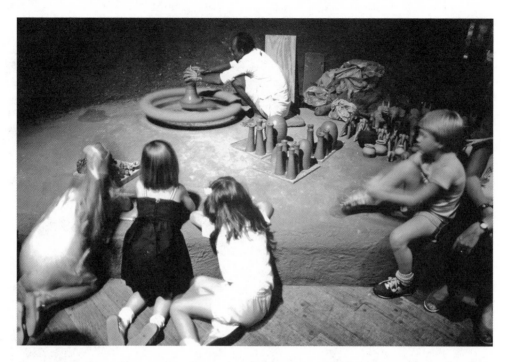

FIGURE 3.7 (Plate 8). Jhithru Ram Kumhar, seated in the "tribal potter" area, demonstrating his Bastar pottery, with children looking on, *Aditi* exhibition. Smithsonian Institution Archives. Accession 97-012, National Museum of Natural History, Office of Exhibits, Special Exhibition Records, box 5.

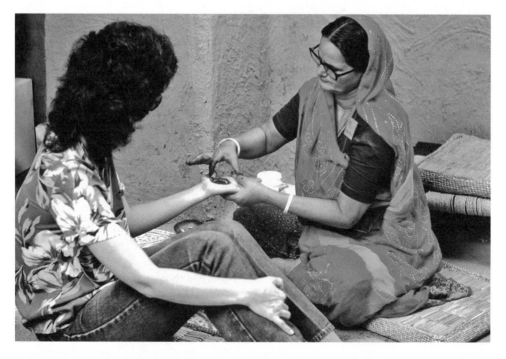

FIGURE 3.8. Rampyari Sharma (at right, with name tag) painting *mehndī* (henna) on a visitor's hand, *Aditi* exhibition. Smithsonian Institution Archives. Accession 97-012, National Museum of Natural History, Office of Exhibits, Special Exhibition Records, box 5.

in the gallery undermines a simple interpretation of the exhibition as presenting person-as-object. Instead, one can turn to the relations of power at work in the gallery, tracing the durations of exchanges among people, spaces, sounds, smells, and things in order to highlight the dynamism and ongoing transformations involved in the "living" exhibition *Aditi* embodied.

AUTHENTICITY, INTERRUPTED

As with living history museums, one of the stated aims for *Aditi* involved creating an immersive atmosphere, one where visitors might get a glimpse of what it would be like to visit an Indian village. The "authenticity" of *Aditi* became one of the exhibition's central selling points for visitors throughout its run. The feeling of immersion it created, however distant from the smells and sounds of agricultural or "village" India, produced an experiential simulacrum that tapped into many visitors' preconceptions of what an Indian village might feel like. Moments of interruption of this narrative were keenly felt, as shown by an exchange in the *Washington Post* regarding the footwear of one of the artists in the exhibition, who sported what were likely newly purchased Nike velcro tennis shoes as he demonstrated his pottery.[16] This provoked a letter to the editor noting the disruption of authenticity this modern intrusion caused in the visitor's experience of *Aditi*, and a response from Walter Hauser, then professor of history at the University of Virginia, who saw no incongruity in the presence of tennis shoes on the feet of a contemporary craftsperson.

This exchange exemplifies the complexity of reactions to *Aditi* that mid-1980s audiences struggled with. Many visitors embraced the wonder and experiential immersion, seeking an India in the galleries that had been sold to them in advertising for the show. The publicity for the Festival of India as a whole, and for particular exhibitions, included newspaper advertisements that played on stereotypical understandings of the subcontinent: one shouldn't miss the opportunity to ride on a magic carpet, to witness burning demons, to travel to India by going to the National Mall (see figures 1.3 and 1.6). These sentiments were often echoed by news media coverage of the Festival in print, radio, and television. Thus media venues, alongside commercial outlets like department stores, sold the Festival of India and, by extension, the subcontinent itself to the American public, playing on their expectations of an exotic land, developed through recent films such as *Gandhi* (1982) and television programs such as the *Far Pavilions* miniseries.[17]

Taking these advertisements and news articles as the central or primary message oversimplifies the exhibitions and experiences visitors engaged with at *Aditi* and other Festival shows. Decorated with elephants and exotic patterns, the advertisements played on particular desires and preconceptions circulating in the mid-1980s regarding India. Americans, in their distance from Britain's colonial history with India, could play with that past in bold puns: India is "All the Raj."[18] But the pun itself, as often happens with humor, belies the underlying acknowledgment of the history and ongoing legacy of colonial relations of power, themselves producing the economic and cultural asymmetries

displayed at the Festival. Advertising and media coverage offers a rich resource to map the stereotypical understandings of India at the time alongside the savvy manipulation of those stereotypes to commodify the subcontinent and draw people to the various spectacles on offer.[19] As with provocative titles for books, films, or even university courses, these advertisement efforts sparked interest and encouraged people to seek out these exhibitions; once through the doors, the curators, performers, and artists faced the challenge of activating visitors' critical engagement within an entertaining frame.[20]

The interruption of authenticity experienced by the Nike shoe letter writer echoes that of several of my interlocutors who were jolted out of their gallery experience by encountering a person quietly doing his or her craft or a translator welcoming them into a gallery space. Others noted the dissonance and a distaste with a connection to the colonial past throughout the exhibition, a distaste often underscored by the labeling of both objects and people. For example, M. Palaniappan, the potter from Sathiyamangalam in southern India whom I discuss in chapter 1 and the "Material Transformations" chapter, sat with his horse offerings to the deity Aiyanār; both he and his objects were provided a label at the edge of the platform (see figure 2.3, plate 3). Every participant also had a name tag, an identifier that stood in partial tension with the object label (figure 3.8). Here each person was individualized, interpolated as having subjectivity through the attempt to bridge the gap between visitor and participant in the personalized name tag. But as the visitors did not also have name tags, this gesture remained asymmetrical, enabling identification only in one direction and thus reinforcing the presumed separation between visitor and participant.[21] In some ways then, the name tag operated as a further interruption for the visitor: rather than move at their own pace through the gallery, taking in the objects in durations shaped by their own preferences and other visitors' presences, they instead had to negotiate their pace in conjunction with living, breathing, labeled people. For some, this was shocking and recalled earlier objectification and other more direct violence done in both the colonial past and the globalizing present. For others this jolted them out of a routine museum visit and underscored the enchantment and immersion the exhibition organizers hoped for. Ghosts of colonial pasts, echoes of current economic and political asymmetries, and the interruption of normal gallery durations—all punctuated the *Aditi*, living craft experience.

One visitor demands a craftsman devoid of modern trappings, while the other claims that the tennis shoes are indeed authentic to the experience of going to the "real" India. Some visitors, perhaps more attuned to the rising tide of multiculturalism and globalization, and more critically engaged with the major economic and cultural shifts happening around the world, acknowledged the penetration of multinationals like Nike into the cultural sphere of not only the U.S. but also India. These visitors recognized the ways in which both countries shared, albeit asymmetrically, in global commercial flows. Just as the hushed silence around Tibetan monks creating a sand mandala occurs only in European and North American gallery contexts, so the reverence for the authentic demanded by

some visitors to *Aditi* fails to acknowledge the complexity of global flows. That the back-and-forth over the tennis shoes occurred in a public forum suggests that while the archive does not retain such traces, a wider range of encounters and engagements with the question of authenticity and experience took place at the Festival's various exhibitions.

CONTINUAL MEDIATION

The multiple experiences and sensory engagements in the gallery required a great deal of maintenance, from the design of the exhibition itself to the labor of a wide range of mediators who worked in India to select and orient those traveling to the U.S., facilitated the day-to-day lives of the artists and performers once they arrived, and served as cultural and linguistic translators in the gallery. In nineteenth- and early twentieth-century exhibitions, these roles were filled by the organizers of the shows, agents from within the ethnic communities who often made human display their livelihood, and ethnographers whose expertise legitimated the shows as an experience of learning (Zimmerman 2001; Magubane 2009; Qureshi 2011). In *Aditi, Mela!* and other Festival of India shows that incorporated live performers and artists, a wide range of people served in these roles, from curators with no experience of South Asia to anthropologists whose research focus and linguistic expertise lay in the subcontinent, to local members of the South Asian American community.[22]

Mediation thus becomes one of the central elements of these exhibitions, an element often considered in terms of the framing that the gallery *space* produces for these individuals and their works, but less well explored when it comes to the human conduits through which ostensible understanding and learning might take place. Mediation occurred over the course of months, sometimes as a continual churn of activity and sometimes in fits and starts as the occasion required. Building connections, working through partial understandings, interrupting patterns and redirecting energies—mediation operates here as a multidurational, varying-speed process requiring both nimble reactions and unending patience. This temporality fundamentally undergirds the entire presentation of *Aditi*, a layer of activity both hidden from the visitors to *Aditi* and occasionally celebrated among the Smithsonian's own inner circles or in the press coverage.

Individuals such as Mark Kenoyer, who had received his PhD in South Asian anthropology just prior to his employment by the Smithsonian, served almost as summer camp directors, helping to negotiate disagreements and misbehavior among *Aditi* participants housed in the Georgetown dorms; at other times Kenoyer found locations and collaborators for the artists, enabling M. Palaniappan, for example, to build a kiln in Maryland and to work with local potter Renée Altman to source appropriate materials (see figure 1.4).[23] The thorough engagement with the international participants often included preparatory planning in India, travel with the group to the U.S., meeting them in New York to facilitate customs clearance for the many materials, objects, instruments, and costumes they

brought, and then living alongside them for the duration of their stay in the U.S. Without this kind of labor, the artists participating in the Festival and the objects they produced and demonstrated would not have appeared in as seamless a manner as they did. Kenoyer and others also worked with Smithsonian filmmakers and photographers to document each of the artists in the exhibition, conducting interviews in multiple languages and helping artists to present their work and experience for future audiences. While some of this footage was edited into films about *Aditi*, the Festival of India, and the Folklife Festival, much of it remains in the archives at the Smithsonian, and in watching it one senses the dual purpose driving the recordings: public relations and preservation.

Let me weave into the discussion of the 1985 *Mela!* a later Folklife Festival—in 1992— when anthropologists Sally and Richard Price served as mediators for the Maroon participants from Suriname and other places across the Caribbean, Central, and South America. The Prices published their field notes and reflections on their experience as facilitators, and their account illuminates the tensions involved for those working as mediators as well as for those performing and participating in these sorts of multilayered extended residencies (Price and Price 1994). A number of layers of mediation greet the visitor to the Folklife Festival, including printed material such as program books and large, introductory text and map panels, evoking a gallery space with labels offering overarching information (geographic and cultural) and placards announcing upcoming performances or identifying particular kinds of crafts, food, or ritual displays (see also Cantwell 1993, 102ff). The space of the Folklife Festival further mediates the performances, navigating a path between generic divisions of space and full-scale reproduction of a local village.

Each year, the Folklife organizers, when designing the spaces for the festival, struggle to produce a balance between these two poles, wanting neither a zoo-like cage atmosphere nor a complete erasure of the display technologies.[24] As the Prices' narrative points out, on a day-to-day level, both types of viewing take place—at one point they cannot get away from the display area for lunch and end up eating behind a makeshift barrier with their Maroon colleagues while visitors unwittingly ogle them in this "authentic" setting. The *Mela!* installation at the 1985 Folklife Festival leaned toward immersion, with its reconstructed village centered on a tree and a temple (figure 3.9). Performances of dance, music, and impersonation took place in the dusty clearing around this center; the village structures sheltered craftspeople who demonstrated making kites, clay sculptures, and decorative objects out of cane and bamboo. Visitors could have their photograph taken and developed so that they appeared in front of famous sites in India (or with Ronald and Nancy Reagan). Music percolated across the constructed village from the surrounding stages and from small troupes of performers who moved through the space. Throughout, English-speaking interlocutors worked with the performers to explain what was happening. In some cases, vendors and performers in the village were themselves living in the U.S.: a local South Asian American dance troupe or a mother and daughter who presented various medicinal and cosmetic herbs and roots.[25] At both

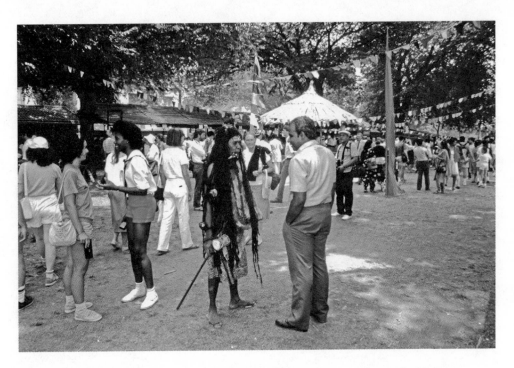

FIGURE 3.9. *Mela!* central area, with *bahrūpiyā* as the deity Shiva, mingling with visitors. Photograph by Jeff Tinsley, courtesy of the Ralph Rinzler Folklife Archives and Collections, Smithsonian Institution.

Aditi and *Mela!* other craftspeople were joined by translators who passed along audience questions, narrated what the performers were doing, or facilitated (commercial and knowledge) exchanges (figure 3.10). Not every stall had a translator; one senses from the film archive that at the *Mela!* site they floated around a bit, and the Prices indicate that they, too, as expert anthropologists and translators, were tasked with a wide range of responsibilities throughout the day. Often craft and food demonstrations went forward without translation, and, as puppeteer Puran Bhaat explained to me about his experience in 1985, this worked just fine: one doesn't need too many words to achieve communication, and the fluidity of exchange proceeded regardless of the presence of official translators (figure 3.11, plate 9).[26]

Facilitators and mediators often took on an active translation role, serving also as a protective barrier for the mundane repetition of questions from visitors throughout the day. At times, visitors would become frustrated that, for example, Sally Price didn't translate their question but instead just answered it herself—saving her Maroon colleagues from answering yet again what dish they were making or what craft they were doing. At other times, mediation enabled the Smithsonian to smooth over international relations or relations with local diaspora populations; in the archival films Kenoyer often doesn't translate fully what the artists say, for example, about the lack of market for their goods

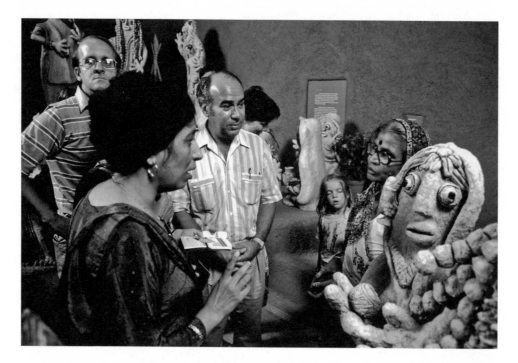

FIGURE 3.10. Volunteer translating for Chandrakala Devi, *Aditi* exhibition. Smithsonian Institution Archives. Accession 97-012, National Museum of Natural History, Office of Exhibits, Special Exhibition Records, box 5.

in India, noting to the filmmaker off-camera that this would be impolitic. The Prices note the erasure of a major political upheaval taking place in Suriname at the very moment of the Folklife Festival; the Festival, like many festivals, as a moment out-of-time, attempted to skirt any intrusion of civil strife, poverty, or war on the presentation of international or domestic folk culture on the Mall (Cantwell 1993, 113).[27]

Cultural and political gaffes also required mediation on the part of anthropologists and other interlocutors; despite all efforts to respect the cultural hierarchies and traditions of the international visitors, Festival organizers sometimes fell short. The mediation also sometimes produced negative reactions among Festival visitors, who, in the case of the Prices' experience, saw the constant translation by white anthropologists as a continuation of colonialist and imperialist histories. Shared ethnic and linguistic background did not necessarily smooth these tensions; organizers of *Aditi* note the need to make sure the South Asian American interlocutors weren't inserting their own reading of the craftspeople's lives or status.[28] Indeed, one of the difficult negotiations made during the *Mela!* Folklife Festival involved acknowledging the caste and class differences between the performers and the South Asian immigrants to the U.S. As Kurin notes, the latter had to be warned that they would be working alongside and eating with people with whom in India they would not normally interact at all (Kurin 1997, 149–51). Most volunteers took this in stride and invited performers into their homes during the course of the Festival.

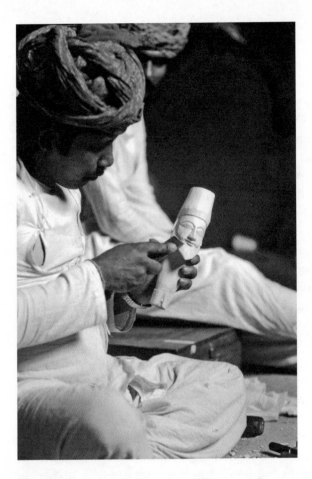

FIGURE 3.11 (Plate 9). Puran Bhaat, puppeteer, carving a new puppet, *Aditi* exhibition. Smithsonian Institution Archives. Accession 97-012, National Museum of Natural History, Office of Exhibits, Special Exhibition Records, box 5.

But tensions did arise along these lines at the *Mela!* and in other years of the Folklife Festival.

Partial and halting, these moments of translation figure centrally in any understanding of the temporality of the museum experience, from the work preparing the exhibition to the interaction between organizer and performer and between performer and visitor, and then on to the way the time of the museum or festival visit returns in memory or narrative for performer, mediator, and visitor alike. Throughout, these durations and long processes of mediation work within the exceptional temporality of the festival, delineated as separate from normal everyday life, staged for visitors and enabling their own shift into another temporal mode. Indeed, the role of mediator itself could be taken up by the visitor or the performer: South Asian interlocutors from the D.C. area also operated as visitors, performers, and mediators; craftspeople often took on their own mediation tasks; visitors joined the performance, connected earlier experiences with the exhibition, and fluidly moved from viewer to performer to mediator. Thus while the boundaries between these roles certainly operated to distinguish one from the other, those lines also proved porous in the day-to-day life of the show.

AGENTIC PROVOCATEURS

Resistance in the exhibition context ranges from the subtle to the overt. The Prices describe participants from Maroon cultures pulling away from the public while on display and insulating themselves from the stares by forming their own circle of sociability. Sometimes that would encourage zoo-like staring from passersby, but it might also create a level of invisibility for the participants, tired of the endless stream of questions, the struggle to cook properly with local ingredients and limited time, or the constant shifting of activity from performing to cooking to storytelling (Price and Price 1994). Tardiness, not showing up at all, drunkenness, and other responses to the intensive exhibition setting cannot simply be explained away as misbehavior but in many cases mark purposive moments of resistance. Often this involves a slowdown, a change in temporality, a resistance to the pacing of the display.[29] The performers and artists working to create the atmosphere of *Aditi* and *Mela!*, and their counterparts in other cultural displays, sought to put on the best performance possible, feeling the burden and honor of representing their country and their particular artistic speciality on the international stage. Moments of resistance to the structure of the exhibition exist alongside this intense desire to present the best of their culture to those visiting the exhibition and the Mall. This overarching goal was shared by organizers, mediators, and participants alike; each, however, had a slightly different understanding of what that might mean. Indeed, often resistance occurs in cases where the frame of the exhibition prevents the performance from fulfilling the vision of one or more of these parties. Several interruptions to these frames occurred at *Aditi* and *Mela!*

Most of the artists and performers had participated in this sort of exhibition before, whether directly in earlier versions of *Aditi* or indirectly in a range of international folk exchanges that took place in the 1970s and 1980s. They were "old hands" at presenting India to a foreign public and understood their role as one of performing the nation for an international audience, even though their own expertise might lie in a specific regional tradition. But because they were old hands they also could subtly manipulate the events to their own advantage, misbehaving when it achieved their aims, trading places with one another when their work became boring, going shopping and playing tourist in their off hours in the capital.

Some "mis"-behavior had an integral place in the exhibition and festival, as the performers included *bahrūpiyā*s, or impersonators, who took the role of monkeys and performed, sometimes with musicians accompanying them, for large crowds on the Mall. With long thin tails, painted faces and bodies, and furry head coverings, the monkeys had several "routines," from climbing trees to picking imaginary lice out of each other's fur to snatching visitors' sunglasses (figure 3.12). These activities often crossed lines: Richard Kurin relates his struggle to enforce the Smithsonian's agreement with the National Park Service to protect the trees on the National Mall while fully understanding that the *bahrūpiyā*s' performance often included swinging from the trees (Kurin 1997). The monkey impersonators also crossed the barrier between audience and performer quite often,

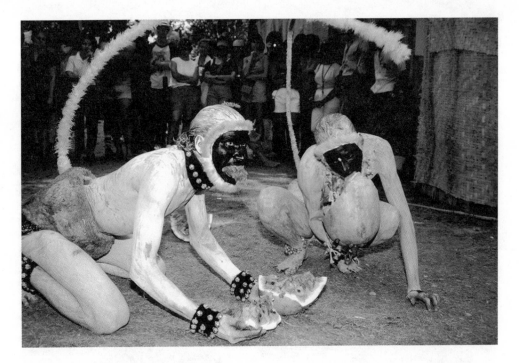

FIGURE 3.12. Two *bahrūpiyā*s (impersonators, here as monkeys) eating watermelon on the Mall as a crowd looks on, *Mela!* Photograph by Dane Penland, courtesy of the Ralph Rinzler Folklife Archives and Collections, Smithsonian Institution.

helpfully picking "lice" from the heads of children, whose parents looked on in amusement while their kids screamed with either delight or fear. This kind of managed transgression of norms took place often at *Aditi* and *Mela!*: the opening *pūjā*, for example, also transgressed museum norms with the lighting of incense and the incorporation of living plants and food offerings within the confines of the exhibition space.

These managed transgressions entered into the norms of the exhibition largely because they fit with the overarching goals of the organizers and mediators to present an immersive village-like experience for visitors, and, in the case of the opening *pūjā*, to acknowledge and respect the negotiations participants made with the context of the museum space. At times the translation to the public fell short; rare complaints about the inappropriate physical interaction with children, for example, appear in the Smithsonian archive. Nonetheless, a level of institutional disciplining of the participants took a variety of forms. Like any group of touring musicians, performers, actors, or artists, the occasional disciplinary issue arose among the *Aditi* and *Mela!* group. Showing up late, sitting mutely and passively, not demonstrating their craft, drinking excessively, arguing with fellow performers—all of these things occurred from time to time.[30] Mediators and organizers occasionally had to step in to discipline performers, but this intervention was rare, and often fraught; Mark Kenoyer, who lived with the participants and had a major role coordinating their day-to-day lives while they were in D.C., recalls reprimanding a participant for showing up late,

FIGURE 3.13. Bundu Khan jams with the Tuxedo Jazz Band from New Orleans. Photograph by Tracy Eller, courtesy of the Ralph Rinzler Folklife Archives and Collections, Smithsonian Institution. Also published in Kurin 1991b, 17.

only to be reprimanded himself by the South Asian translators, who felt he spoke down to the participant.[31] Juggling the expectations and needs of the participants, audiences, mediators, and administrators dogged both the *Aditi* exhibition and the *Mela!* festival.

In the dorms at Georgetown University, as a response to some of the routine disciplinary problems that arose during the run of *Aditi*, the participants formed an informal *panchāyat*-style group adjudication system. In these meetings, roommate concerns, thefts, shirking duties, food complaints, and work issues were aired and resolved within the group, often with the requested help of Kenoyer, who also lived in the dorms with the performers and artists.[32] The Prices report similar internal disciplinary structures during their experience working at the 1992 Festival (Price and Price 1994). The dorms were also a place of continued creation of objects for display, of sharing of expertise and past experience with performing, and of collaboration with performers from other disciplines. Exchanging craft techniques and ideas took place here, even to the extent of occasionally swapping places in the gallery. Exchange of music and performance also took place with the groups from Louisiana who formed the American portion of the Folklife Festival, both during the Festival itself and at the closing "wrap party" at the end of the *Mela!* (figure 3.13).[33]

These transgressions, negotiations, and disciplinary issues comprised important elements of the participants' lives, elements that contributed to the experience of the visitors to the gallery. These activities of course undermine any simple attempt to erase agency from the Indian performers at the Museum of Natural History. Indeed, participants wanted to be there, representing their country and sharing their craft, music, and performance. The subtle manipulations of their museum space, the interactions with visitors and other participants, and the moments of overt resistance enabled many of them to cope with the long, intense hours of working actively in the gallery, and to shape both fleeting and extended experiences shared among participant, visitor, and mediator.

Occasionally Rajeev Sethi, the curator and visionary behind *Aditi*, would visit the participants at their dorms in Georgetown after hours with an inspirational speech, urging them to deliver an authenticity in their craft performances while also enabling and encouraging a level of experimentation.[34] Authenticity on the aggregate level—at the level of the experience of a generic Indian village and a generic Indian life cycle—with a modicum of clever experimentation: this was Sethi's demand, as he saw the potential for both the continuing large-scale festival performances and for the products themselves to support craftsmen in India. To achieve the latter, craftspeople needed to adapt their work to new audiences, a process all of them had already undertaken in a variety of ways. Chandrakala Devi, a papier-mâché sculptor from Bihar, for example, noted that in the village small figural works would be constructed for particular rites of passage, but she had made large human figures for gallery audiences around the world, as they responded to these larger works. The pieces were then in dialogue with the small bowls and other vessels in her display area (figure 3.14).[35]

Wall paintings from Devi's home region of Mithila, in Bihar, had for decades been adapted to circulate on paper such that artists could have an income from these works and the basic aesthetic might be preserved (Davis 2008). As with all adaptations, when a major element such as physical medium changes, the entirety of the work must bend to the new context. But, despite efforts to sell them as such, these are not timeless traditions, and thus adaptations are the norm. The simultaneity of timelessness, adaptation, and a drive to preserve "disappearing" traditions comes together in these display contexts and serves as a productive temporal tension for the artists involved.

The call to authenticity-plus-adaptation took on different forms for different artists. Ganga Devi, perhaps the most famous of the artists traveling with the group, painted Mithila-style compositions during the Festival both on the walls of the gallery and on paper. Several months later, in reflecting on her experiences in D.C., Devi produced her America series—one work focused on a trip to an amusement park the *Aditi* organizers had arranged and the other, anchored by the Washington Monument, illustrated vignettes of American life, such as the practice of passing goods and money through narrow, impersonal windows (Jain 1997; figure 3.15).

Other artists produced small sculptures to gift to visiting dignitaries, making straw images of Nancy Reagan for her visit to the exhibition, for example, or painting the Reagans

FIGURE 3.14. Chandrakala Devi making a small pot in papier-mâché, *Aditi* exhibition. Photograph by Saundra Roger, courtesy of the Ralph Rinzler Folklife Archives and Collections, Smithsonian Institution.

or Rajiv Gandhi in their regional style to gift to them.[36] Still others composed songs and poems of their time in the U.S.; Banku Patua, a painter-singer from Bengal, composed a painted scroll while in the gallery detailing the things he saw in the U.S. His work included panels focused on scenes that struck him as noteworthy: the alien practice of wheeled chairs (for both children and people with disabilities), and the culture of overeating, illustrated by rotund figures near a table of food (figure 3.16, plate 10).[37] While in the gallery, he would work on the painting and also sing the narration of this story as it developed over the course of his stay in Washington. Some inter-artist exchange also took place, with the puppeteer Puran Bhaat migrating out to the National Mall to sit in on the Indian musicians' performances there—the same musicians who themselves sat in on the New Orleans bands' sets occasionally during the Folklife Festival. M. Palaniappan's collaboration with local clay artists informed the work of both parties; photographs in the dorms show different painters working side by side on compositions in their off hours (figure 3.17).

Sethi's call to adapt to the local audience thus serves as a simple exhortation to do what these artists and performers already did in the normal course of their work and lives. The particularity of the international exchange merely changed the terms slightly; even in

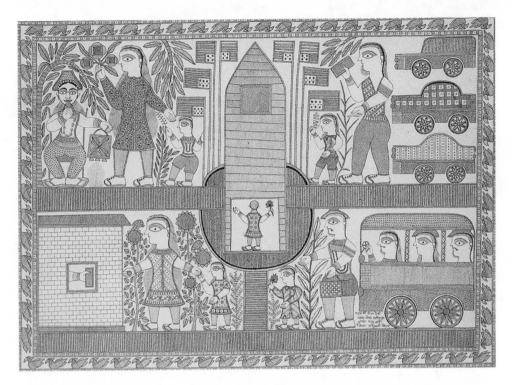

FIGURE 3.15. Ganga Devi, *America Series*, 1985–86, Festival of American Folklife, Washington, D.C. Reproduced with permission from Jyotindra Jain, *Ganga Devi: Tradition and Expression in Mithila Painting*, Middletown, NJ: Mapin, 1997.

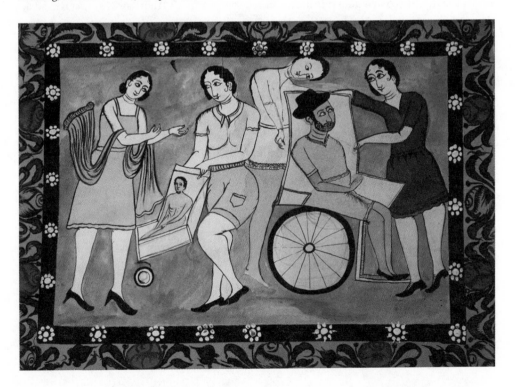

FIGURE 3.16 (Plate 10). Banku Patua, detail of his Washington *pat*, showing panel with a stroller and a wheelchair, *Aditi* exhibition. Photograph courtesy of the Ralph Rinzler Folklife Archives and Collections, Smithsonian Institution.

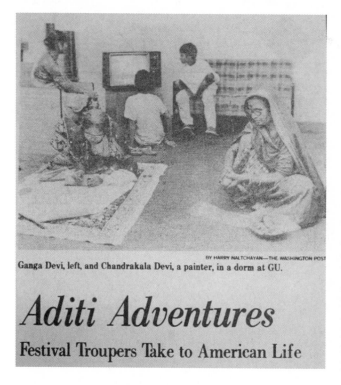

Ganga Devi, left, and Chandrakala Devi, a painter, in a dorm at GU.

BY HARRY NALTCHAYAN—THE WASHINGTON POST

Aditi Adventures
Festival Troupers Take to American Life

FIGURE 3.17. Ganga Devi and Chandrakala Devi in a dorm at Georgetown University. Photograph by Harry Naltchayan, accompanying Michael Kernan, "Aditi Adventures," *Washington Post*, June 25, 1986. Smithsonian Institution Archives. Accession 97-012, National Museum of Natural History, Office of Exhibits, Special Exhibition Records, box 5, press clippings.

India, the practice of producing a special gift, object, or performance for VIP visitors punctuates the rhythms of participants in festivals large and small. That said, against the backdrop of a setting that claimed a certain universalizing authenticity—the generic Indian village moving through a generic Indian child's life cycle—the engagement with the local provided visitors with a pointed reminder of how culturally savvy and globally aware these artists are. Seeing the *patua* singing about contemporary Washington, D.C., undermines any neat presumption that these artists are working in an ancient mode, unchanged for centuries. Instead, visitors must engage with the frisson of a presumed ancient foreignness reinterpreting their contemporary world in real time: watching the *patua* paint, hearing him perform the song, finding delight and perhaps disorientation in the juxtaposition of the two presumably separate temporal and spatial worlds.

This productive tension extended to the educational activities developed for children at the museum, in which Banku Patua demonstrated his painting and singing with the help of a staff translator, working through a more "traditional" *pat* and then showing them his Washington, D.C., *pat*. The children then painted their own *pat*s and sang them to one another and to Banku's amusement; their narrations captured the flexibility of the medium and the storytelling, running the gamut from a fable about a snake to a story of a hot summer day and the relief of the swimming pool. Children and visitors quickly understood the mode of storytelling the *patua* engaged in—this is not to suggest that storytelling is somehow universal, but to point to the efficacy of the techniques of *pat*

painting and singing. The critical analysis subtly embedded in the painter's view of the U.S. was also not lost on those viewing his performance. Where the "traditional" *pat* might be reduced to a marker of timeless storytelling (although it too is adapted for contemporaneous audiences), the clarity with which the Washington *pat* undercuts any claim to ancientness while offering engaged and critical observations of American life (in contrast with life in India) enables the viewer to acknowledge the *patua* as coeval—sharing time with them, using art to work through cross-cultural comparisons with an eye to larger critical questions.

Whether actively resisting the framework of the exhibition by slow-ing down, retreating from the crowds, strategically showing up late, or using the normal adaptations available in their work to address the continually present problem of cross-cultural communication and observation, the artists and performers at *Aditi* and *Mela!* actively pushed at the physical, behavioral, and temporal boundaries constructed by the institutional setting and relationality in which they operated. They adapted the space to their needs, disciplined their own when necessary, shifted their daily routine to accommodate overwhelming demands on their time and bodies, and used their art to work through the tensions manifest in having their bodies, processes, selves, and art put on display. Rather than claim a mythic full agency for those participating in these sorts of exhibitions, these modes of recrafting both space and time, interrupting the presumptive flow of the exhibition, and critically animating engagements with the audience instead all produced a continual animation of moments of resistance, working to reshape the overarching structure rather than seeking its destruction. For in the end, these artists and performers relied on these kinds of festivals for their livelihood; for most, this was not a one-off event but a stepping stone to further projects around the world.

ON TOUR: SUSPENDED TIME

Whether purchasing new sneakers, traveling to local sites, or working with their local counterparts, artists and performers at *Aditi* and *Mela!* had their own experiences of travel, experiences that enabled new visions of both America and their own practices, fitting with Sethi's call for authenticity *and* adaptation. These visitors from India performed and demonstrated their craft around the world from the U.K. and the U.S. to Japan and China, from Brazil and Mexico to Australia and the U.S.S.R. Their visits across the globe might, on one level, be subsumed into tourist travel: while in these cities they often saw the sights, went shopping, tried local food, and certainly they interacted with local people, learning about their customs while sharing their own. But tourism—as a practice of travel in order to establish and observe a difference or distance from the other, a practice grounded in modernist viewing technologies from the flaneur and the sightseer to the bicycle and the camera—tourism does not adequately capture the role and experience of the Indian participants in these exhibitions (see MacCannell 1999 [1976]). Perhaps a better metaphor is the experience of a band "on tour"—the immersive, overwhelming,

exhausting, inspiring, and intensive travel to share your art (whether popular music or artisanal craft) with a wide range of people in different locations around the world.[38]

"On tour" acknowledges the professionalism of these performers and further pushes a reading of the people in the gallery past objectification or zoomorphization toward temporality. With some guidance from the organizers of the exhibition, these artists largely constructed their own performances, a level of control nineteenth-century people on display lacked. While the hours in the gallery could be exhausting, in fulfilling their commitment to the exhibition they still had flexibility to take meals, breaks, and rotate in and out of their positions with fellow artists and performers. "On tour" also embraces the interruption of the normal temporality that bands and theater groups experience while on the road: a suspension of the home-bound routine for a different kind of daily grind, one in which time slips out of its normal rhythm, morphing into long stretches of boredom interwoven with intensive bursts of performance, the days blending into one another in an undifferentiated stream.

This suspension of time echoes that described as central for festivals: a period of interruption for the host community, a series of days or weeks that changes the daily routine and moves participants into a different kind of relation to work, leisure, and one another. Festivals rearrange the space of a town, or in this case the nation's "front lawn," but they also reorder the temporality of a community, enabling people to slow down, speed up, experience a different daily rhythm, or suspend time.[39] Like the upturning of social norms found explicitly in some yearly festivals such as Mardi Gras or Holi, the upturning of the normal temporal rhythm of work and play in the Folklife Festival and, by extension, the Festival of India as a whole has the potential to overcome, momentarily, the distances among people. But it is momentary: it falls short, dissipates quickly, and we return to normal time, only dimly aware of the interruption the festival created. But the interruption remains important, despite a "return" to the norm—often a newly constituted iteration of normal. In these moments of disruption or irruption the potential to move outside of societal and political structures emerges: new modes of thinking political and social relations take shape.

To work through these small, momentary disruptions, I turn to Rancière. For him, politics occurs not in the day-to-day operation of the government or society, but in these moments of disruption (1999). Rancière calls the normal operation of temporal, governmental, and societal relations "the police," not because it involves living in a police state, but to mark as distinct the disciplinary power embodied in everyday politics—whether in a democracy or not. In contrast to the police order, the political interrupts the institutional, structural, and systemic hold of the prevailing disciplinary structure, and does so often in a violent or near anarchic way—festivals, while for the most part remaining within the structural constraints of "the police," often facilitate and produce moments of "the political" when that disciplinary frame is interrupted. The intense, momentary, immersive experience of the festival for both visitor and performer—and especially when that distinction among participants collapses—produces moments of "politics" in the

Rancièrian sense. Moments when, as Rancière says, the "part that has no part" asserts itself, and then fades.[40] But having interrupted the fabric of the norm, that structure cannot reconstitute itself in the same way; the "police" reestablishes itself so that we might reenter everyday temporalities and operate within a regularized set of disciplinary norms, but in subtly different form. The disruption of temporality for both visitors and the Indian artists and performers produces a moment during which which politics might exist, following which a new form of the police might take shape, one that perhaps acknowledges the tension created by the "timeless" artisan on professional tour, showing children how to paint and sing a story about their coeval, contemporary lives.

When asked about his experience in D.C., puppeteer Puran Bhaat mentioned the hospitality of the local people and how welcomed he felt; his recollections focused on his experience carving puppets, demonstrating his craft and performing his musical, rhythmic puppetry for D.C. audiences. When I pressed him on tourist aspects of his visit—the trip the group took to Mount Vernon and the visit to the amusement park—he demurred: no, we were not tourists, there was no touring around. We were there to perform, to show our traditions.[41] Bhaat's response to my query clearly distinguishes his experience from that of tourism: his travel did not come from a desire to see and encapsulate the visited country or culture. Instead he articulated a thorough awareness of an immersive experiential concept of travel, one that extends from the dormitories at Georgetown into the galleries at *Aditi* and out into the suburban living rooms of Washington, D.C. Rather than articulate his experience as a person on display, Bhaat would often come back to the interactions with the visitors: what he did and when he did it depended on the flow of people, the relation to other performances adjacent to his puppeteering area, the rhythm of the day. His life in D.C. flowed around nodes of people, from Mark Kenoyer, to his translator/interlocutor, to the families that invited him to their homes, and to the musicians he played with on the Mall. This movement through these spaces involved an experiential exchange, one in which Bhaat participated fully and actively, facilitated, not confined, by the structure of the exhibition.

But reading Bhaat's experience of travel and performance solely through spatial movement ignores the temporalities involved in the experience of the festival, from the grand interruption of the wider festival to the slow, absorptive whittling of the wooden puppets, and from the sharp rhythm of the puppet horse's hooves on the performance platform to the disjointed attempts of children in the education room to manipulate the strings of the puppets Bhaat handled so fluidly.

Bhaat's response undermines a reading of these exhibitions as objectifying or zoomorphizing the Indian performer or artist, and it moves the people-on-display beyond a viewed spectacle, producing an excess, an overflow of the world-as-exhibition that Timothy Mitchell so insightfully articulates in the rise of department stores and international exhibitions in the nineteenth century (1992). Mitchell focuses on the historical emergence of new technologies of display, commercial spectacle, and exhibition; the mid-1980s Festivals of India occur in a different transitional historical moment. Bhaat's professional performa-

tive travel highlights the familiarity with this mode of viewing, performance, and engagement, an embeddedness in not just local but global flows of people, tradition, information, exchange, one comfortable with the transitory and the temporary, plunging in to experience all of that, not as an outside observer but as a sharer, communicator, and engager of people—an artist and performer "on tour." Instead of imperial and colonial relations of power, one finds here a dissolution of fixed relations, one embedded in the particular political, social, and cultural historical matrix of the 1980s. The hierarchical elements certainly remain—in the economic asymmetries, global geopolitical forces, class differences, and flows of commercial capital—but their diffusion and fragmentary quality dominates.

The particular intersections of societal fragmentation and hierarchization salient in Reagan's America, the distant, mythologized temporalities of the Soviet bloc, the shrinkage of the time and expense of global travel with jumbo jets and long-haul flights between India and the U.S., the shifting spaces and times of entertainment and media with the middle-class ubiquity of VCR technology, recordable music cassettes, and cable and satellite television—all of these elements contribute to the historically contingent time in play at the 1985–86 Festival of India. India's economic liberalization, under way well before "official" legislative action was taken in 1991, produced a growing middle class of consumers whose demand for technologies, connectivity with relatives around the world, and savvy consumption of popular and entertainment media all contributed to a growing globalization and fragmentation of consumer culture. These widespread and subtle shifts in temporality coincide with the particularities of the Festival, with its focus on the immanent disappearance of "authentic" cultures and arts around the world, the Smithsonian's self-appointed role as partial preserver of these traditions through recording technologies, and the constructed and emphasized contrast between the high-speed media world of contemporary America and the presumed slower pace of village life in India. Attempts to produce diplomatic and commercial ties between India and America were bound up with bridging these distinct temporalities, however problematic the presumption of difference might have been. And the temporal pressure arising from Cold War competition with the U.S.S.R.—the overarching sense that the U.S. had to make diplomatic overtures to India before the Soviets—these times intersected on the Mall and in the galleries.

The historically contingent temporal matrix of the 1980s shaped and situated the localized temporalities of the Festival's participants, performers, mediators, visitors, and objects, producing an engagement not only with the immediate atmosphere and experience of those involved on the Mall, but also with the wider social formation of Cold War diplomacy, Reagan-era America, and India's growing economic liberalization. In Bhaat's refusal to describe his role there as touristic, and in the daily negotiations of space and time that the participants in *Aditi* and *Mela!* performed, reading these exhibitions through temporality acknowledges the uncomfortable interruption of the norm that seeing humans-on-display provokes while it enables further readings of resistance, negotiation, and engagement with global temporal flows.

Here the questions of object, display, and authenticity slip out of our grasp as the exhibited not only *refuse to be bothered* by the unending show but also acknowledge the thorough penetration of performativity their role demands. The emphasis on spectacle and vision as found in Mitchell's late nineteenth-century example shifts to a multiply inflected temporal frame of performance and interruption found in the late twentieth. And this performance is not rarified, only for the stage—it imbues everything and exceeds both the moment and the space of the Festival. The larger temporal suspension festivals produce extends here to the exhibitionary spaces and times of the *Aditi* galleries and the *Mela!* village. The experiential immersion of the artists and performers of *Aditi* and *Mela!* undercuts the dualism of spectacle and spectator, or flaneur, instead placing these participants in the larger web of power relations the Festival produced—working within and against the framework of festival, spectacle, and the temporality of Rancière's police order, occasionally creating moments of the political in the frisson of interrupted expectations or the shock of living exhibits of the living arts. And in as with all bands on tour, this iteration continues and repeats, in different historical contexts, linking *Aditi* and *Mela!* to nineteenth-century precedents and twenty-first-century Tibetan monks while demonstrating the particularity of the Festival of India's mid-1980s interruption.

Entrepreneurial Exhibits

This kind of work only started in the 1930s. An American company in Chicago gave an order to an English man who saw in the traditional blankets and floor coverings made by the people for themselves a new export potential.

—TARIQ KATHWARI

The exhibit is an untidy amalgam of futuristic wish-list and respect for past traditions.

—AMEI WALLACH

. . . an exhibit that creates itself in front of people.

—RAJEEV SETHI

I N November 1985, the Cooper Hewitt in New York staged an ambitious exhibition that included a fanciful tent that opened like an umbrella, beaded costumes fit for a Bollywood movie star, and massive stone benches carved by hand (figure 4.1). The show, entitled *Golden Eye: An International Tribute to the Artisans of India*, was the result of a year-long project that brought together eleven famous designers from Europe and the U.S., matched them with workshops and craftspeople in India, and charged them with producing prototypes of top-quality objects using the best hand production the subcontinent had to offer.[1]

Where other Festival of India exhibitions focused on India's historical art or displayed its living craft traditions, *Golden Eye* presented something quite different: the potential for Indian handicraft to contribute to the development of new, economically viable trade, trade that might support and preserve these same crafts.[2] The exhibit thus embodied a futurity that other shows did not: it grasped for something not yet extant. In doing so,

FIGURE 4.1. Overview of *Golden Eye* gallery, with works designed by Charles Moore, Mario Bellini, and Jack Lenor Larsen, 1985. Cooper Hewitt, Smithsonian Design Museum.

Golden Eye engages directly with the economic and cultural flows of the 1980s, fitting well with the growing interest in international trade and globalization, the ethos that working hard and creating new business constituted a moral good, and seeking out the potential that others had missed in order to grow and feed the economies of nations and the bank accounts of those who recognized and seized such opportunities. In short, it was an entrepreneurial exhibition, one that grasped at the potential of combining India's craft with contemporary design in order to bring India into a global economic flow of skill, design, and elite commerce.

The potential that *Golden Eye* identifies and attempts to draw out registers as new, future-oriented, and hopeful in the face of global asymmetries of economic and political power at play in the late Cold War of the 1980s. This potential, however, roots itself in so-called timeless handicraft traditions, passed from parent to child, that are themselves ostensibly dying in the face of plastic goods, industrial production, and globalization. In this narrative, the past, still living in the hands of the authentic (and necessarily "Third World") craftsman, must be saved through the moral good of entrepreneurial collaboration from the outside: one must inject the highest of European and American contemporary design with the timeless quality of India's long-standing craft technique. Certainly this resonates with nineteenth-century salvage ethnography and with similar justifications for the display of India's craft at international exhibitions such as London's Crystal

Palace of 1851.[3] But in *Golden Eye* I see something different from a mere repetition of nineteenth-century Orientalism. In its central maneuver, *Golden Eye* resonated with the postmodernism of the mid-1980s, which sought bold statements and future potential through combinations of historical material, popular culture, and contemporary high art. It also sought to bring India's craft, seen as producing only popular "kitsch" for tourists, into the grand economic flows of the global upper classes. Museum-quality, export-grade craft was pressed to serve the creative vision of international designers. What's more, the argument regarding small overlapping temporal durations I have built in the last two chapters here comes into play in several crucial ways: through the aesthetic postmodernist maneuvers that involved fragmentary elements coming together to create a pastiche; through the multiple actors who, often without direct contact with one another, came together to create bodies of work or even single objects; and through similar postmodernist shifting layers of temporalities that occur across the many sites of creation in this show, from the sketches and conversations with the designers to the manufacturing itself to the labor involved in putting together the display. *Golden Eye* thus participates thoroughly in the neoliberal, postmodernist culture of the mid-1980s and presents a different temporal mode from both nineteenth-century colonial exhibitions and the other shows in the Festival: the time of grasping at potential, an entrepreneurial futurity.

Tariq Kathwari, one of the participants in the exhibition listed rather enigmatically in the short folding program as an "entrepreneur," notes that attempts to tap this potentiality have happened before with his very own Kashmiri embroidery, when an Englishman saw in it "new export potential."[4] He thus acknowledges the constructed quality of the authentic, pure craft and notes its continual appropriation by foreign visionaries. Indeed, he asks why no Indian designers were included in the project—why India couldn't do this themselves. Amei Wallach, in her astute review of the exhibition in 1985, noted its "untidy amalgam" of future and past, both the strength and the weakness of the show, which often drew criticism that it felt like a "chaotic bazaar." The postmodern and the Orientalist join together here, turning up the volume on the potentiality and exuberant enthusiasm embodied in both salvage narratives and entrepreneurial promise. These two voices from the exhibition underscore the complexity of *Golden Eye*, an exhibition of the future that seeks to reimagine the past for elite global markets. In effect, *Golden Eye* brings together several key elements of neoliberal, entrepreneurial economics circulating in the 1980s, and the exhibit proposes that these tenets might "save" India's craft traditions and generate profit for all involved. The "untidiness" of the exhibition marks its instability: its temporal mode of promise and potential could not be sustained for very long, and it dissipated quickly after the show closed.

In this chapter, I follow the voices of *Golden Eye* as they articulate the project, moving from its initial visionaries through the more muted and often ignored mediators and the complicated textual and physical presence of the craftspeople and the "entrepreneurs" to the reviews and responses in the media. In listening to these people talk about the show, I

find a repeated return to the language of potential, of the future, of hope, of opportunity—in short, of entrepreneurial time played out in the processual buildup of the exhibition itself. Indeed Rajeev Sethi, the primary visionary behind the exhibition, wanted to present "an exhibit that creates itself in front of people" (quoted in Wallach 1985). *Golden Eye* presented design-in-progress as it enabled the collaborations it showcased, rather than simply presenting existing exchanges, thereby serving as a conduit for all of the voices and hands involved in the objects and environments of the exhibition. In that spirit, I unfold the exhibition through its interlocutors, re-creating it in an echo of its processual, potential-driven trajectory.

A FESTIVAL OF THE 1980S

The Festival of India was too big to have a singular vision; spread over the entire country and organized by thousands of people from both India and the U.S., its "message" remained diffuse throughout its planning and execution. That said, two prominent goals—not shared by all involved, but driving some decisions—were to build tourist traffic to India and to create longer term trade opportunities.[5] Craft was seen as a key element of this larger, tourist-driven conversation, a focus that some Festival organizers bemoaned, citing India's other industrial and scientific achievements as worthy of emphasis in the presentation of India to the world.[6] At the American Festival, supported by the institutional structure of the Indian government's Handicrafts and Handlooms Export Corporation (HHEC), the focus for Indian organizers was on the potential of India's handicraft traditions to spur new kinds of commercial exchange.[7]

Few Festival exhibitions *actively* sought to develop these relationships. Craft, in the bureaucratic structure of India's government, fell under the rubric of industry, not culture, in that India relied heavily on its handicraft exports to generate revenue and foreign exchange. While the Indian organizers of the Festival saw craft as part of that larger governmental structure, the American organizers allied craft with culture, so that exhibitions like *Aditi* and *Mela!* (both in Washington, D.C., and focused on vernacular art and performance), *Women Painters of Mithila* (a traveling Smithsonian show of a regional vernacular painting tradition),[8] and *Forms of Mother Earth: Contemporary Terracottas of India* (at the Mingei International Museum in San Diego)[9] were seen as visual art expressions, not conduits to trade.[10] In contrast, *Golden Eye* addressed several central themes of interest to Festival organizers: a concern for salvaging traditional craft by infusing contemporary design concerns into the practices of workshops across the subcontinent; the establishment of long-term ties between top-name international designers and local workshops; and the opening up of a new market for the skills of India's craftspeople.[11] This last goal distinguishes *Golden Eye* from other craft exhibitions held under the rubric of the Festival and reveals a tension embodied in the use of handicraft as a vehicle for greater commercial exchange rather than as a representative of India's cultural riches and artistic

heritage. This tension in the Festival—between craft as industry and craft as culture—operated as a constant undertow in the flow of discourse around *Golden Eye*, intensifying the potential embodied in the vision for the exhibition.

Golden Eye also took place at the height of the Reagan 1980s. Planning commenced as the president moved toward his second term, and the exhibition opened in the months between his successful reelection and his inauguration. India had had a difficult year prior to the 1985 Festival: 1984 saw a great deal of political and military upheaval. In June, Prime Minister Indira Gandhi ordered the Indian army to storm the most important Sikh religious site in the world, the Golden Temple in Amritsar, claiming that the temple served as a shelter for anti-Indian Sikh separatists (see Tambiah 1996, 101–62). Gandhi's assassination at the hands of her Sikh bodyguards in October sparked riots across the country targeting Sikh communities; thousands of people were killed over the course of November. In early December, a massive toxic gas leak at the Union Carbide pesticide plant in Bhopal caused the deaths of thousands and became one of the major industrial disasters of the century (see Shrivastava 1992). Alongside these political and social upheavals, the economic picture in India had shifted, with the gradual loosening of India's various trade restrictions in the years before the state officially introduced liberalization in 1991.[12] Other events were on the horizon: while the fall of the Soviet Union and the end of the Cold War remained largely inconceivable, signs of what might come started to appear, with Mikhail Gorbachev's programs of perestroika and glasnost.

Globally, economists, sociologists, and economic historians consider the 1970s and 1980s to be the decades of the full emergence of neoliberalism, as seen in an increasing focus on the individual entrepreneurial economic actor, a push for free markets, and an abandoning of mid-twentieth-century global economic regulation. These economic shifts took place in conjunction with cultural postmodernism, a fuller theorization of the postcolonial, the rise of realist approaches to political policy, the intensification of religious communal tension and politics in India and elsewhere, and the emergence of identity—multiculturalism, feminism, and gay and lesbian activism—as important elements of cultural politics.[13] All of these economic, cultural, and political strands existed well before 1985. The moment of the Festival of India and *Golden Eye*, rather than being a time of beginning or origination, might therefore operate as a key moment of intensification and anticipation, fitting well with its own focus on potential and saving the past for an entrepreneurial future.

VISIONARIES: CONCEIVING AN EXHIBITION-IN-PROGRESS

Everyone mentions his style, and not simply the hand-spun, hand-woven *khadi* shawl Rajeev often wears but also the way in which he carries himself: like a dancer, dramatically swinging the length of undyed cloth over his shoulder. Rajeev Sethi is a designer by trade, but he is much more in the imaginary produced by his own performance, his pursuit of grand visions, and his commitment to utopian ideals. In 1985 he was already a

figure in design circles internationally, attending the annual Aspen Design Conference in the U.S. and working with colleagues in France, the U.K., and around the world.[14] Many people supported *Golden Eye* in its conception, physically and creatively made it happen, and shaped its final form, changing different elements of the whole; all I spoke to agreed that Sethi envisioned it, put it in motion, and stoked the creative fires when they faded in the face of bureaucracy and practicality.

Unlike *Aditi*, the Festival of India exhibition at the National Museum of Natural History in D.C., a project he put together for the celebrations of the Year of the Child in 1978 and then reprised in the U.K.'s Festival of India in 1982, *Golden Eye* was a new idea for Sethi. By the 1980s, Sethi had built up a strong record of design successes, in both the exhibition context and in commissions for public and private spaces, and his work had drawn the attention of Pupul Jayakar. Her role as Chairman of the Indian Advisory Committee for the Festival enabled her to charge charismatic individuals such as Sethi with the production of wide-ranging, complex projects.[15] She and Sethi shared a commitment to supporting India's handicraft and cottage industries, seeing these small-scale manufactures as a way of helping India's rural and urban artisans out of poverty. In the 1960s, Jayakar had been instrumental in a project to assist women of the Mithila region in northern Bihar to transform the wall paintings done in relation to rites of passage such as marriage into portable, thematically varied works-on-paper that might be sold to a wider Indian and international public (Jain 1997; Davis 2008). She subsequently became the voice supporting and valorizing craft in an Indian society focused on technological innovation rather than village industry. The potential of craft to contribute to the uplift of those hit by disaster or stuck in poverty underlay many of Jayakar's intellectual and community projects; these same concerns drove Sethi's vision in *Golden Eye*.

Using his international connections in the design world, Sethi proposed to bring a group of major designers from Europe, America, and Japan to India, connect them with regional handicraft industries, and support the production of design prototypes that might then be used after the exhibition to create a long-standing relationship between "western" designers and India's skills in craft. The language of promoting the craftspeople's *skills* appears often in the discourse surrounding *Golden Eye*—seen as a marriage between the creative juices of Euro-American designers and the skills of India's craft practitioners.[16] This emphasis underscores the logic of neoliberalism at work in the mid-1980s, building on earlier theorization of human capital: individuals possess and can cultivate their own "capital" through skill building, using that capital to become atomized entrepreneurial mini-businesses.[17] What India offers lies in the way its handicraft workers can leverage and adapt their ability to manipulate leather, papier-mâché, clay, wood, enamel, cloth, straw, and other media into forms imagined elsewhere. This narrative parallels other salvage stories: the skills of the "native" artisan have been lost in the turn to the machine-made in Europe, the U.S., and Japan, and these high-end designers seek to maintain and revive these techniques in the service of new, cutting-edge design meant for the living rooms, walls, and closets of elite buyers around the world.

While this story has roots in earlier salvage anthropology and exhibitionary rubrics from the nineteenth century through to the late twentieth, *Golden Eye* differs markedly from the presentation of craftspeople as living relics of past traditions or as practicing an unchanging, timeless craft. The crux of the *Golden Eye* project lay in its synthesis—a production of something new, in the interaction between the creativity of the designer and the skill of the craftsperson. "Collaboration" became the watchword of the exhibition in contemporaneous interviews with the curators and designers, in press coverage, and in the framing of the exhibition itself.[18] The word ostensibly evoked an equality among those involved but in fact made more obvious the significant hierarchies at the heart of the exhibition concept. Certainly, some of the designers modified their designs based on input from the craftspeople in India. But the bulk of the impetus for any of the design prototypes—and indeed the creative credit—went to the internationally renowned designers. Thus, gestures to the collaborative qualities of *Golden Eye* operated as a thin veneer over the underlying asymmetries of the show as a whole. The construction and maintenance of any relationship between designer and maker required a great deal of uneven, difficult, and largely unrecognized mediation. The asymmetry of this synthetic process, and its unfinished project, constitute a central element of the narrative of *Golden Eye*, situating it firmly in larger asymmetries produced by globalizing economics, a growing wealth gap, and the legacies of colonial relations of power.

Design, as a component of art history, had, in the 1980s, not yet entered the mainstream, although the intersection of a rise in postmodern architecture and design alongside shifts in the academy toward cultural studies meant that this decade represented a turning point of sorts for academic and museum approaches to presenting design and the history of design.[19] Design shared this marginality with craft, with the former tainted by its connection with professional arts and practical concerns and the latter tainted by its relation to women's work, the everyday, and lower class producers. For India, the importance of craft both economically and culturally builds slowly from the 1960s through the 1980s. With the National Handicrafts and Handlooms Museum finding a permanent home only in the early 1980s, this period must be acknowledged as one of struggle: craft operated outside of the mainstream, fighting for recognition within India as worthy of preservation and support. From the perspective of the early twenty-first century, it is important to note the secondary status of craft for India's national aesthetic identity in the 1980s and its association with poverty, lower classes and castes, and backward technologies.[20] India also had a vibrant if under-acknowledged design community operating across educational institutions such as the National Institute of Design in Ahmedabad (NID), at government-sponsored Weavers' Service Centres, and through publications such as *MARG: A Magazine of Architecture and Art* and *Design: Review of Architecture, Applied and Free Arts*.[21] Design, unlike craft, had a history of named creative artists who participated in design collectives, wrote manifestos, and sold themselves in ways similar to those in "high-art" circles. The vision of *Golden Eye* involved using these "names" to make more visible the often unnamed and unknown craft producer and to show that collaboration

across these lines might support into the future what were usually seen and exhibited as static familial craft traditions.

In the U.S., craft, too, had emerged as a strand of gallery-driven high art in the 1970s in reaction to Minimalism and Conceptual art's hegemony in the metropolitan art world. Craft, particularly textile, experienced a revival in the lead-up to the U.S. bicentennial celebrations in 1976, and several major exhibitions sought to legitimize aspects of fiber art, celebrating materiality and form over utility and everyday use. Building on both feminism and an interest in seeking out authenticity in the primitive, and drawing on an inheritance of Bauhaus practice, the turn to craft often fell back into gendered, ethnically defined categories (see Adamson 2007; Auther 2010; Buszek 2011). The 1969 show *Wall Hangings at the Museum of Modern Art* grounds many of these discussions and debates; its curators, Mildred Constantine and Jack Lenor Larsen, highlighted the innovative techniques, formal elements, and textural qualities of the works included.[22]

With direct links to high design and high-art craft contexts, *Golden Eye* can be situated then in relation both to craft-driven exhibitions at the Festival and those shows that highlighted historical art. The Metropolitan's *India! Art and Culture*, for example, drew together a wide range of objects dating from the thirteenth through the nineteenth centuries, and in addition to emphasizing their categorization as art, pointed to the exquisite crafting of metalwork, the design sensibilities of Mughal artists, and the engagement with global flows of aesthetics these works demonstrated (Welch 1985). Likewise, the Met's massive historical Indian costume exhibition brought together fashion and design histories in the context of courtly art, showcasing the talents of historical craftspeople in the weaving of fine cloth and the construction of elaborate garments (Costume Institute 1986; Patnaik 1985). One might also see a connection to the three contemporary exhibitions at the Festival; however, none of these three shows moved beyond gallery-driven modernist painting, with only a few printed works and one set of paper "reliefs."[23]

Perhaps the closest cognate for the *Golden Eye* exhibition is a much smaller show entitled *Master Weavers*, curated by Martand Singh and Rakesh Thakore and bringing together regional textile craftspeople with groups of Indian designers who workshopped designs on-site with the weavers and dyers and produced woven and printed works for a globalizing contemporary aesthetic.[24] The connection between historical handicraft, courtly art, and contemporary design came together in both *Master Weavers* and *Golden Eye*. In the former, however, the big-name European and American designers did not drive the project; instead, the post-1947 institutionalization of localized learning and working spaces where Indian metropolitan designers might come to work with local practitioners—these cooperatives drove *Master Weavers*, which put it on a slightly different register than *Golden Eye*. It also meant that, lacking the draw of design superstars, *Master Weavers* received significantly less attention than *Golden Eye*. The combination of celebrity designers, the ethos of salvaging disappearing skills, and the asymmetrical synthesis of a potential for new production and sales streams made *Golden Eye* unique: it supported the "craft" ethos of many Festival exhibitions while clearly operating within a

high-art mode of the celebrity artist. Thus, *Golden Eye* brought together the timelessness of both craft and high-art creativity with the futurity and potentiality of turning this synthesis to entrepreneurial gain.

DESIGN-IN-PROCESS

The celebrity designers depended on a number of mediators to make the prototypes that comprised the exhibition. In conjunction with Lisa Taylor, then director of the Cooper Hewitt, Sethi individually approached a series of contemporary, well-known designers, some of whom had worked in India before, but most of whom had not. The list aimed high, and the organizers exchanged correspondence with and invited designers and architects such as Yves Saint Laurent, Paloma Picasso, Philip Johnson, and Isamu Noguchi. While these declined to participate, those who agreed ranged in age and renown, and provided a variety of material and aesthetic approaches. The final group comprised: the German architect Frei Otto, known for constructing tent-like architectural forms in innovative materials; Mario Bellini, an Italian product, furniture, and industrial designer known for his typewriter designs for Olivetti; Bernard Rudofsky, whose comfortable, ergonomic, and stylish Bernardo sandals had revolutionized footwear over the previous three decades; Jack Lenor Larsen, an American designer who had incorporated Asian design elements into his textiles for many years; the American graphic designer and illustrator Ivan Chermayeff; designer Milton Glaser, most famous for the I "heart" NY graphic; Sir Hugh Casson, a British architect who rose to prominence as the director of the 1951 Festival of Britain; the architect Charles Moore, whose Piazza d'Italia (1978) remains a landmark of postmodernism; New York-based fashion and jewelry designer Mary McFadden; and two members of the then newly emergent Memphis design group—the Austrian architect Hans Hollein and the Italian designer Ettore Sottsass.[25]

This group of architects and designers included those focused on clothing and fashion and those whose major projects included an Olympic stadium, as well as those whose graphic design work continues to shape our everyday lives in subtle ways. The group ranged in age from forty-seven (McFadden) to eighty (Rudofsky); all were well established in their careers with many successes behind them. Including Sottsass, Hollein, Moore, and Bellini demonstrated the strength of postmodern aesthetics within the design community in the mid-1980s. The choice of designers suggests that *Golden Eye* sought to bring India's craftspeople into an international design circuit to show not only how marketable Indian craft might be but also how well these ostensibly timeless skills might serve the most cutting-edge, contemporary aesthetic movement. The project set its sights high.

Rather than present a focused U.S.–India exchange, the organizers recruited elite designers from both the U.S. and Europe. The emphasis in *Golden Eye* was to choose a range of high-end designers from the "West" in order to facilitate the expansion of exchange and collaboration between the art world and markets of Europe, North America, and the subcontinent. It might have been the Festival of India in the U.S., but at

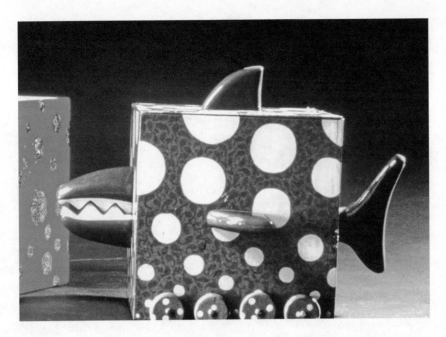

FIGURE 4.2. Ivan Chermayeff papier-mâché animal box, made for the *Golden Eye* exhibition. Cooper Hewitt, Smithsonian Design Museum.

Golden Eye, a slippage occurred between U.S. and "the West" in order to emphasize the larger goal to save and maintain India's human resource: skilled craftspeople.

Once the designers agreed to participate, a round of correspondence went out between the Cooper Hewitt and the designers' offices articulating the details of the project, including planning at least one in-person visit to India to explore links to particular types of craft production across the subcontinent. Here, Sethi led the way. For example, Sethi suggested that Frei Otto work with tent makers and painters from Rajasthan, noting the affinity between Otto's technological breakthroughs in using tented architecture at his 1972 Olympic stadium in Munich and seeking out craft producers working in similar directions.[26] When the designer had worked in India before, as Larsen had, existing connections were enhanced by working with textile artisans who used leather inlay in their work. Sethi operated both as charismatic salesman, wooing the designers with the grand vision of *Golden Eye*, and as a matchmaker, using his contacts within India to link designers with handicraft facilities across the subcontinent.

Sethi did not do these things alone; to make this happen and to move from the planning stages of the exhibition to the opening day in approximately one year meant that he required help from a group of young Indian designers. S. M. Kulkarni, for example, was in his twenties at the time. After graduating from the National Institute of Design in Ahmedabad, he had worked with crafts extensively and had studied textile design. His diploma project was funded by the HHEC; in it he addressed the question of melding traditional textile production with modern design. At Kulkarni's diploma exhibition, Sethi

FIGURE 4.3. Ettore Sottsass at a marble-inlay workshop in Agra, India. Photograph by Jyoti Rath. Cooper Hewitt, Smithsonian Design Museum.

recruited him to work on *Golden Eye*. Kulkarni, with his textile background, worked with Larsen and McFadden quite closely, and also worked with Sottsass and Otto on their projects, sourcing particular materials and techniques for them and traveling with them to meet the craftspeople who produced their designs.[27]

Sethi also tasked the Indian designers with collecting samples of craft techniques from around the country and in a range of materials. These were brought to Delhi and set onto presentation boards that could be folded into suitcase-sized packages. Sethi and some of the Indian designers then traveled with piles of suitcases to Germany, Britain, and the U.S. in order to explore the possibilities with the international designers in *Golden Eye*. Sethi recalls the ridiculous spectacle they made of themselves wheeling stacks of suitcases through customs at various international airports, transporting samples of skills, techniques, materials, stitching—importing not goods but artistic potential.[28]

On both kinds of trips—Europeans/Americans-to-India and Indians-to-Europe/America—the Indian designers served as crucial contact points in the exchange. Traveling to New York to consult with various designers involved significant translation. Jatin Bhatt, for example, was one of the more senior members of the designer group, and worked on making lasts and shoes according to Rudofsky's idiosyncratic approach to footwear. Rudofsky had written extensively about his commitment to anatomically supportive shoes, and the designs he worked on for *Golden Eye* continued this project (Rudofsky 1947; Scott 1999). Making shoes involved several steps, and creating the form for the shoe

FIGURE 4.4. Frei Otto in India, draping fabric over an early prototype of his tent design, March 1985. Photograph by Kirit Patel. Cooper Hewitt, Smithsonian Design Museum.

demanded expertise in wood carving and other skills that would normally be spread among several different craftspeople. Bhatt recalls meeting Rudofsky in New York and in India, showing him various shoes created in response to Rudofsky's designs, and working with the craftspeople to achieve the ends Rudofsky wanted. All of the designers I spoke with described mediation of this sort. For example, Jyoti Rath traveled with Chermayeff to Kashmiri papier-mâché workshops where they were creating toys for the exhibition; the animal designs Chermayeff had proposed were transformed in the hands of craftspeople more used to snakes than alligators (figure 4.2).[29] Compromises, back-and-forth dialogue, and close, hands-on interaction characterized many of these encounters. At times, the linguistic and practical translation fell short, and Bhatt, for example, recalls occasionally taking things into his own hands and modifying the shoe molds using his own skills at wood carving.[30]

This process, despite the ideal of collaboration, did move hierarchically, with European and American designers examining the "raw" materials and skills, selecting (with guidance) certain crafts to work with and then leading the dialogue that ensued as the prototype designs were produced. The craftspeople did not simply carry out orders; as with any commission from outside, they manipulated the design to work with the range of techniques they used, stretching and molding those approaches to fit the new challenge, but

FIGURE 4.5. Charles Moore (R) at the Golden Eye Studio in Delhi, examining his prototype toy cityscape and figures. Cooper Hewitt, Smithsonian Design Museum.

modifying the design as well. The three-way translation from Euro-American designer to Indian designer to craftsperson sometimes occurred through language. But more often it meant a translation of practice, of making—a jostling conversation that worked through the material. All of the Indian designers I spoke with remarked on the inadequacy of drawings when working with craft workshops across India. Transferring knowledge through two-dimensional representation did not work; one had to show, describe, work through the problem to be solved with the artisan in person. Photographs from the time (often taken by Jyoti Rath) show a range of moments in these conversations: Ettore Sottsass crouching over marble inlay in an Agra workshop; Frei Otto testing his tent design; Charles Moore seated on the floor in the Golden Eye Studio in Delhi, going through some of the work done for him (figures 4.3–5). Occasional glimpses into the working process of the craftspeople can be found in the photographs, as in an image of appliqué artisans sewing on the floor while Milton Glaser's design hangs on the wall above them (figure 4.6). These kinds of dialogues-in-process conform neither to the regime of sight nor to the regime of language. Those involved in *Golden Eye*—from the craftspeople to the layers of designers to Sethi and the organizers at the Cooper Hewitt—all understood the need for in-person exchange as a crucial part of communicating and creating. Talking it through, even without a language

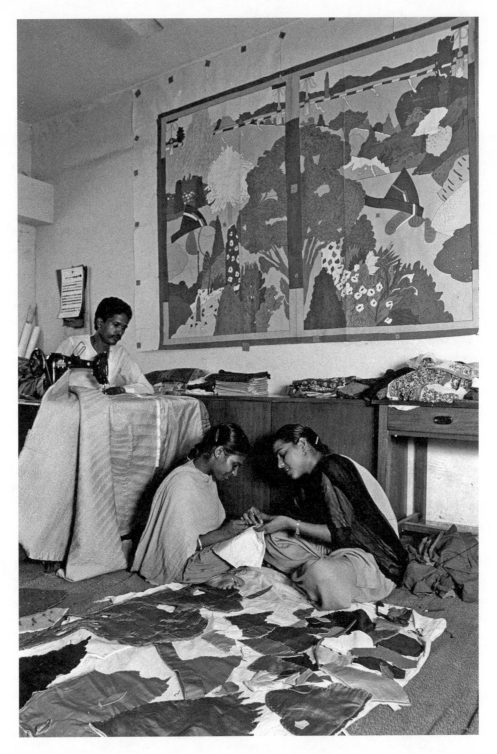

FIGURE 4.6. Appliqué artists working from Milton Glaser design hanging on wall, in their workshop in India. Cooper Hewitt, Smithsonian Design Museum.

barrier, would never suffice; producing the prototypes for the designers necessitated hands-on exchange involving all of the senses and the back and forth of showing, modifying, disagreeing, negotiating. Bringing actual examples of the crafts to New York changed the flow of the process; bringing the designers themselves to India changed it once again.

In any exhibition, the curatorial and organizational staff play a major role in selecting and arranging the works; one of the crucial differences between *Golden Eye* and other design or craft exhibitions was that when they started planning, none of the objects in the show existed. What's more, the timeline for a show of this magnitude was incredibly short: the European and American designers were secured only in November 1984; the show opened one year later. The layering of different roles and the number of people who made, organized, and directed pieces of the exhibition grew in relation to the simple, central fact of the production of the objects. Sethi's desire, quoted at the opening of the chapter, that the exhibition present design-in-progress highlights the instability of this project and the need for its continual and active maintenance by all concerned.

MAKING POTENTIAL: THE ENTREPRENEURS

In support of this vision, an additional human layer quietly added themselves to the mix, were acknowledged in the small folding program for the exhibition, but appear very little in either the paper archive or the memories of others involved in the show: the entrepreneurs. In the brochure, the ten "*Golden Eye* Entrepreneurs" are listed prominently alongside the others who organized the exhibition. Most of the entries pair a name with a company affiliation or type of craft and a location: "Tariq Kathwari, Decorative Furnishings, Srinagar." After some digging and questioning, I found that these individuals were the owners of the craft workshops, overseeing the work and making connections between raw material suppliers and their handicraft manufacturing facilities. Some of them staked funds to support the production of prototypes in the hope of bringing these goods to market after the exhibition had concluded.[31]

The brochure is the most prominent place they appear in the exhibition—with a few small exceptions their names do not feature in the show itself, nor do they come up in the context of the archive. Occasional photographs capture them in the workshops, speaking on the phone while craftspeople work around them (figure 4.7). Most of the people I spoke to did not remember what the particular role of "entrepreneur" meant; when I showed them the brochure listing they would often confirm that these were the factory owners or overseers, but it was clear that the experience of mediating between the Euro-American designers and the crafts workshops did not directly involve these individuals. Moreover, the term "entrepreneur" did not spread much beyond a few captions and the list in the brochure. Its presence in the exhibition seems an artificial construct: how are these actors "entrepreneurial," and how does this relate to an emerging discourse of entrepreneurship in the 1980s?

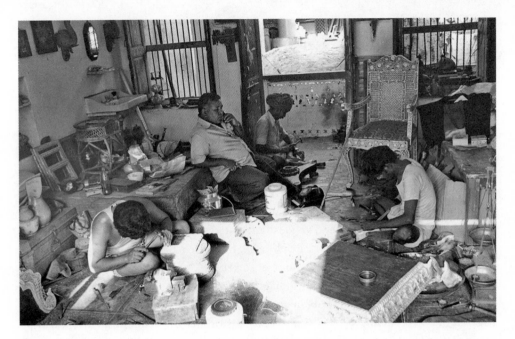

FIGURE 4.7. Interior of unidentified workshop in India, with owner and craftsmen. Cooper Hewitt, Smithsonian Design Museum.

The use of "entrepreneur" in the brochure enables the inclusion and acknowledgment of the important work that the factory owners and middle-men did in relation to the exhibition while simultaneously obscuring the very fact of factories, middlemen, and the longstanding *business* of craft in India. The myth of a "native craftsman" formerly free of commerce and now adrift in the new global economy had to retain its legitimacy as *Golden Eye* produced a secondary utopic vision of salvation—the collaboration between high-end designers and distant craftspeople through the exhibition would then result in bringing crafts, and by extension this isolated craftsperson, into the economic flows of global capital. To acknowledge that these craftspeople already participated in such flows, and had—since at least the beginning of mercantile economic relations in the seventeenth-century—engaged in global aesthetic and economic movements around the world, would be to undercut both the overarching message of salvation and the presumed distance between art and museums on the one hand and money and business on the other. Calling the factory owners "entrepreneurs" erased both the idea of the existing interconnected-ness of the craftspeople, the designers, and the visitors to the exhibition *and* obscured the factory-style organization of these workshops. Workshop, studio, craftsman, entrepreneur—these terms carried positive connotations of creative people coming together to produce a handmade product. Factory, middleman, and overseer had entirely different overtones. The euphemism masked or perhaps even resignified as positive the exploitative relation at the core of capitalism and neoliberal economics.

"Entrepreneur" carried additional weight in the context of the mid-1980s. Both Indian and the American Reagan-era business culture valorized the position of the individuals building and creating opportunities and profits on the basis of their own ingenuity, commanding resources in the service of the growth of their ideas. In the 1980s, economists such as Roger Kaplan noted the new link between entrepreneurism (a neologism from this period) and moral rectitude, marking this connection as an attempt to distance business practices from the stagflation of the 1970s. Built on the neoliberal political and economic theories of George Gilder, Irving Kristol, Milton Friedman and others, the embrace of entrepreneurism as a moral good countered the perceived chaos and turpitude of the pre-Reagan era (Kaplan 1987, 85). The entrepreneurial figure of this period overthrows the staid organizational norms of the day: this individual hero, unencumbered by establishment training, asserts his or her own ideas and as a result injects new dynamism into the economic system (see Kaplan 1987; Reich 1987). Entrepreneurs are thus the hero-saviors of both the economy and the moral fabric of society.

This discourse circulated within Indian business and economic publications as part of a coalescing global dialogue about the new heroic individual business figure. In the pages of India's *Economic and Political Weekly*, historians and economists discussed the place of the term in both business and popular culture, indicating its ubiquity well beyond the confines of economic theory (Tripathi 1985).[32] The idea of the entrepreneur as individual moral hero, contributing not only to his or her bottom line but also to the good of society, comes through in the Indian context as well.

These *Golden Eye* entrepreneurs, then, constitute more than just a smokescreen hiding less savory aspects of craft production in India; the idea of the involvement of entrepreneurs in the exhibition connects it to a wider 1980s discourse of named, dynamic, creative individuals who drive the economy and have the potential to create new business opportunities. The positive moral overtone of the entrepreneurial spirit imbues these individuals with a combination of an intelligent investment savvy and a utopic commitment to the betterment of society; these qualities transferred to the exhibition as a whole and to the objects on display. The message of *Golden Eye*—that international designers could collaboratively produce work in India for a high-end global market, thereby rescuing these ostensibly ancient handicrafts from their immanent demise—here finds an accelerant in neoliberal economic theory and moralizing salvation narratives: it is an entrepreneurial exhibition, full of potential and looking to the future.

PRESENTING POTENTIAL

While Indian and European designers traveled back and forth across the globe, curators and organizers Dorothy Globus and Zette Emmons, along with the staff at the Cooper Hewitt, planned the layout of the galleries, in dialogue with Sethi and the team in Delhi. Some of the architectural prototypes required significant accommodation within the gallery plan; some objects had to be cut from the show, causing the plan to shift slightly;

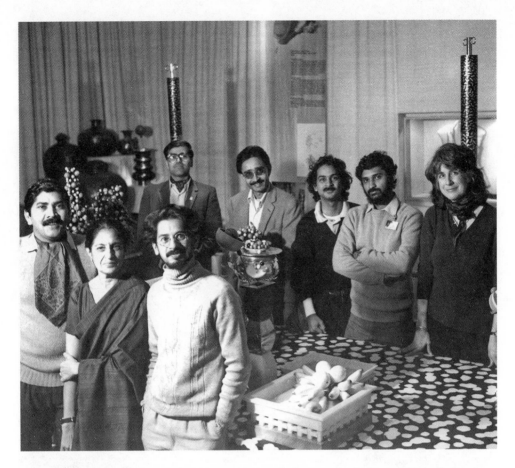

FIGURE 4.8. Indian designers and Cooper Hewitt staff who served as liaisons and installed the exhibition, standing around Ettore Sottsass table in *Golden Eye*. Back row, from left: Chandra Vijay Singh, Kirit Patel, Shakeel Hossain, Jyoti Rath, Zette Emmons; front row, from left: Jatin Bhatt, Maya Johar, S. M. Kulkarni. Cooper Hewitt, Smithsonian Design Museum.

and the usual exigencies of physically putting the pieces together in the end kept everyone on their toes. That the objects were still in production up until the very end added a further layer of pressure to the normal organized chaos of any gallery installation.

The group of Indian designers brought the prototypes to New York and helped to install the show, carrying with them the previous months' experience of working with both craftspeople and Euro-American designers. Their intimate knowledge of the objects, the individual vision of each designer, and the awareness of the craftsperson's contribution came together in the installation (figure 4.8). Many of the prototypes involved several craft workshops from across India, so that the job of coordinating the production at multiple sites and then bringing the pieces together to form a whole fell to the Indian designers. Jyoti Rath remembers the difficulty in fabricating Sottsass's dining table: stone inlay artisans from Agra in northern India made the top, while twelve hundred miles away,

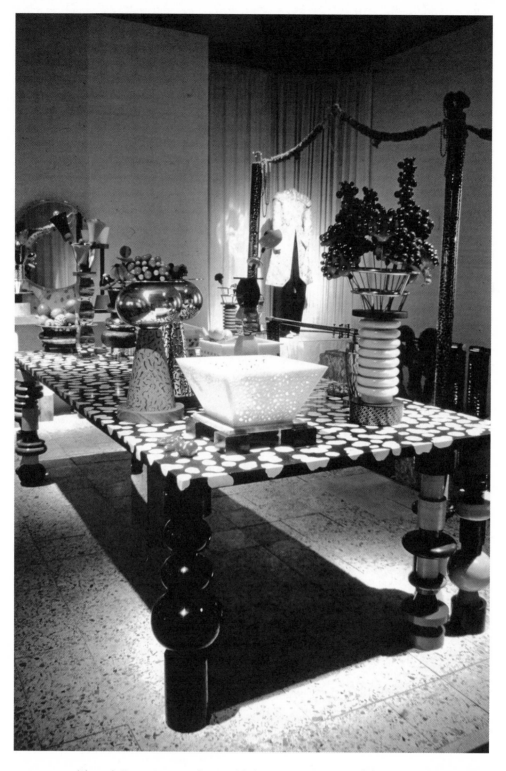

FIGURE 4.9 (Plate 11). Ettore Sottsass, dining table (with mirrored support evident), 1985, *Golden Eye* installation. Cooper Hewitt, Smithsonian Design Museum.

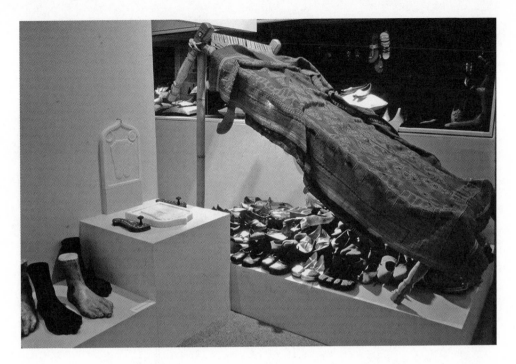

FIGURE 4.10. Bernard Rudofsky, lasts and prototype shoes, *Golden Eye* installation, with charpoy. Cooper Hewitt, Smithsonian Design Museum.

wood carvers in Channapatna in Karnataka made the legs.[33] When the pieces came together at the Cooper Hewitt, the team realized that the legs could not support the weight and breadth of the stone top. Sethi envisioned the solution: a supportive middle post, faced with mirrors on all sides so that it disappeared.[34] Sottsass's table became the central image for publicity surrounding the exhibition; in the photographs, one can, with some effort, make out Sethi's ingenious mirrored support, a trace of the negotiation and design-in-progress that the exhibit embodied (figure 4.9, plate 11).

In the planning stages, the galleries were organized such that each room and section highlighted a particular designer; while that provided some focus for each gallery, the final installation combined works from a range of designers in each room, and the rooms were given thematic, evocative names: Mughal Room, Bedchamber, The Veranda, Blossom Room, Fantasia Room, Sand Room, The Dining Shrine, Tent Room.[35] Some designers, in conjunction with the curators, had a particular vision for their space: Rudofsky's shoe area, for example, included a charpoy, or simple cot, inspired by curator Dorothy Globus's experience seeing Indian merchants and shoemakers use these mobile pieces of furniture in innovative ways, from deploying them as sunshades to using them as armatures for the display of their goods (figure 4.10).[36] Otto wanted his painted tent to create a sense of the canopy of stars at night, and so carefully adjusted the lighting in his section of the galleries (figure 4.11, plate 12).[37]

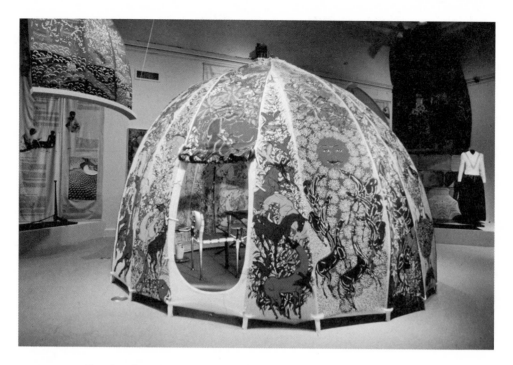

FIGURE 4.11 (See also plate 12). Frei Otto, painted tent, 1985, *Golden Eye* installation. Cooper Hewitt, Smithsonian Design Museum.

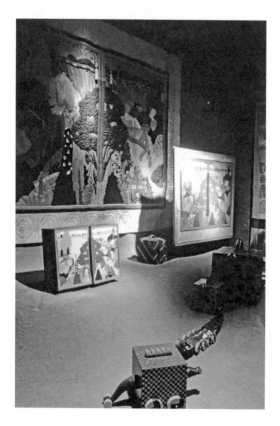

FIGURE 4.12 (Plate 13). Milton Glaser's design in three media (appliqué, embroidery, and papier-mâché), with papier-mâché toys in foreground, *Golden Eye* installation, 1985. Cooper Hewitt, Smithsonian Design Museum.

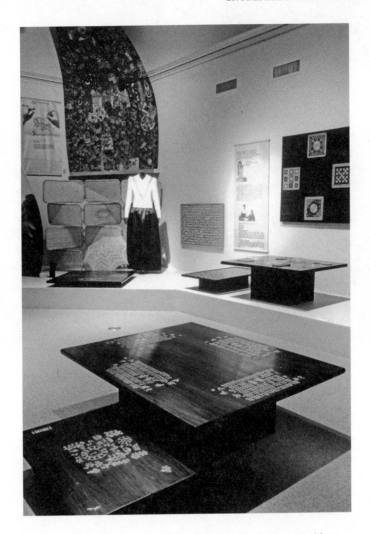

FIGURE 4.13. *Golden Eye* installation view, with a Mary McFadden dress, Hugh Casson inlaid table, and Frei Otto tent panel. Cooper Hewitt, Smithsonian Design Museum.

Some of the craft workshops produced items for multiple designers or the same design was produced by multiple workshops; often those prototypes would appear together in the gallery to highlight the adaptability of the craft techniques and the range of the workshops (figure 4.12, plate 13). The curators and Indian designers used some of the prototypes to vary the media in each gallery, using Larsen's textiles and McFadden's clothing to add texture and a human presence to Bellini's stone benches and Casson's inlaid wood architectural ornamentation (figures 4.13–14).

With the juxtaposition of different designers' visions with the Orientalist, dream-like imaginary of the room names, the installation presented visitors with a series of spaces that evoked possibilities—of an Orientalist fantasy, of an imagined handcrafted past, or of a

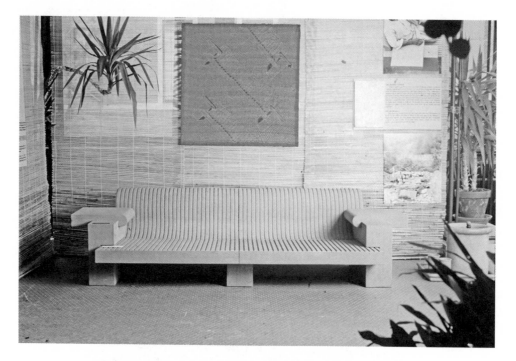

FIGURE 4.14. Mario Bellini, prototype for stone bench, installed in *Golden Eye* exhibition with Jack Lenor Larsen textile above, 1985. Cooper Hewitt, Smithsonian Design Museum.

potential stylish, design-infused future in which dinner guests would exclaim at the extravagant table in the "Dining Shrine." The eclecticism, described often as a "bazaar" atmosphere in the media reports, lent an air of instability to the confection of the show: in every direction new opportunities might await, overwhelming in their promise and potential.

VOICES ON STONE AND CLOTH

Two types of text punctuated the exhibition: the opening title area and cloth text panels hanging from the ceiling in the galleries. The foyer was dominated by a stone and metal wall sculpture surrounded by stone marquetry and featuring a shiny brass abstract eye-form in high relief above text announcing the title of the exhibition—*Golden Eye*. Below the title, a simple note stating that 265 unnamed craftspeople had participated was followed by an alphabetically ordered list of the names of each of the European and American designers. The dramatic stone-and-metal opening to the exhibition lent the space a great deal of gravitas: the permanence and ancientness of stone combined with the wealth signaled by shiny metal. Underneath this formal stone announcement, a rounded stucco surface with an earthy red tone evoked informal architectural and sculptural forms in stucco and clay; on this rougher, organic surface, inspired by Sethi and a similar opening space in his *Aditi* exhibition, the Indian designers and Cooper Hewitt curators left hand-

FIGURE 4.15 (Plate 14). Opening Gallery, *Golden Eye* exhibition, showing marble title panel and handprints below. Cooper Hewitt, Smithsonian Design Museum.

prints in white paint (figure 4.15, plate 14).[38] The contrast at the entrance thereby echoed the balance sought in the exhibition between the connection to handicraft and the commitment to polished, elite design, and between the ephemerality of the craft skills on display and the potential for wealth in its solidity and strength, to protect and nurture those skills through trade and the market.[39]

On entering the gallery, each vista into a new room included tall, narrow cloth panels hanging from the ceiling bearing screen-printed photographs and text (figure 4.16). Here the formerly aggregated 265 craftspeople (men and women) appeared in the gallery. The photographs were sepia-toned, staged images of groups of people in their workshops, alternating with pictures of single craftspeople at work, the latter a long-standing iconography that dates to well before the nineteenth century (Dewan 2004). Printed on undyed cloth, the scenes take on an antiqued tone, evoking the early era of the photograph in the nineteenth century, and positioning the crafts and the people pictured in a time past. None of the pictures include the modern accoutrements that often existed in the workshops such as phones or radios, highlighting the timeless quality of the aesthetic.

Each panel serves as a label for the set of objects nearby, starting with a brief phrase of description referring to the object or the particular medium (table and chairs; leather upholstery), followed in turn by the European or American designer involved and then by the trade and name of the craftsperson. Occasionally the "entrepreneur" or workshop owner will also be listed:

FIGURE 4.16. Overview of gallery including screen-printed text panel on left, lounge chairs by Hugh Casson, and dress by Mary McFadden. Cooper Hewitt, Smithsonian Design Museum.

Khurja Pottery
FREI OTTO
Potters
RASHID AHMED Age 55 years
NAZEER AHMED 60 years
PROPRIETOR R. P. SINGH 40 years
NEW DELHI

This information is accompanied by several paragraphs of text, translated from interviews done with the craftspeople in India.[40] In an echo of the group photographs, the text often includes the translated voices of multiple generations. In the above example, both potters named in the caption have a section of text, along with a younger nephew, Zaheer. Thus panels often start with the grandfather, move to the father and uncle, and close with the adolescent. The textual presentation of the craftspeople underscores the presumption of familial trades passed from one generation to the next; simultaneously, the questions asked and answered support the overarching narrative of the demise of craft traditions and the potential end of this idealized familial system.

Within that framework, however, the craftspeople's responses regularly interrupt presumptions about their distance from global trade or modern technology. Not all of the

craftspeople came from a hereditary tradition; some, such as the Delhi-based quilt maker Mrs. Garg, began as hobbyists and then transformed their hobbies into small-scale hand industry. Some offer philosophical reflections; Rashid Ahmed's statement begins with an elaborate analogy between a pot and human life:

> Now I wonder: how similar is the life of a man and the life of a pot? Both get made and unmade so easily. If a pot falls from the roof, it may survive or it may break, just like a man. As from the mother's womb, we await the arrival of baked vessels from the kiln, never quite sure how they will appear. Everything is in Allah's hands. Even the mind and tongue speak only when he wills.[41]

These poetic musings likely are not new patterns of speech for the fifty-five-year-old potter; the connection to human fragility and human procreation smoothly flows into the anchoring in Ahmed's own faith. Continuing with the pattern of metaphor, analogy, and simile, Ahmed's content changes gears to contrast his process with that of larger scale production: "Industrial pottery is like a test tube baby." His simile resonates with contemporary debates over the legitimacy of in-vitro fertilization, a new technology in 1985; that Ahmed chooses this as his comparison situates him firmly within 1980s cultural debates relating to the expansion of technology into human reproduction.[42] The voices of the craftspeople in the gallery thus confound expectations, escaping and challenging the very frame within which they operate. Reading attentively, the visitor might hear the staged, repetitious nature of the comments, well worn in the telling to many clients, visitors from abroad, and interested tourists and scholars. And, for all of the content that confirms a sense that craft traditions are dying, other voices interject to unseat that assumption, refusing to mourn the loss, or celebrating a different trajectory for handicraft.

Even though the text panels edited out the interview questions, reading the panel texts makes it clear that those interviewing occasionally asked the craftspeople to reflect on their interaction with the European or American designer. Frei Otto, for example, is commended for showing respect for the craftspeople, and for knowing what he wants, not just visually but in terms of the weight of the object, how it fits in the hand, how it might hold water:

> Such a world famous designer coming to work with us in our courtyard is a sign of respect. We feel encouraged. We take beauty in ornamentation over form for granted. When Otto Saheb questions he reminds me of a woman who comes looking for a cooking pot. What can be held well? What washes well? Stores well? What will contain the right quantity? Sit well on which oven? Use most heat? Sound right?"[43]

Otto gains the craftsman's respect by asking questions like a woman, an upturning of our expected gender hierarchies. But the compliment lies in the relation to those who use the pot everyday—that is, in Otto's understanding of the thoroughness with which design

permeates every element of an object, not just its shape and surface decoration. The exchange, pictured in photographs as a very physical and intimate engagement between designer, craftsperson, and the materials involved, here takes on the additional recognition of the haptic quality of design—its tactility but also the importance that the object do what it means to do with grace and efficiency.

The words of the entrepreneurs, or proprietors, occasionally appear on the cloth panels alongside those of the craftspeople. They too participate in the larger salvage discourse and assert the hereditary ancientness of their own roles. They also acknowledge different kinds of economic and social change—Swaleh Ansari, for example, the proprietor of a Benarsi silk-weaving workshop, notes that he was a weaver and now has become a businessman: "Previously only the lower castes would weave. Now even the Khans and Sayyeds are taking to the profession. Economic growth has created social mobility." Swaleh's younger colleague, Shoaib Ansari, asserts the necessity of the entrepreneur's role: "Honestly speaking the industry cannot run without us. . . . Hand weaving allows for constant improvisation and therefore constant supervision and dialogue."[44] Khanna, a jewelry entrepreneur from Delhi, protests: "I am not a middleman! I am a glue, a counsellor, friend, patron, manager, leader, follower." These statements stress the proprietor's involvement in every step of the production process, along with the lives, shortcomings, challenges, and worries of the craftspeople and their families. Tariq Kathwari notes the importance of securing American and European commissions and working with designers overseas, but sees a different path forward: "Cheap labor is making us a nation of suppliers. Larsen's designs can only be his own. Why can't we be designing our own products also? I am happy to be making things for others but I have also decided to launch out collections on my own."[45]

The entrepreneurs, like the craftspeople, do not always come from within the business world of craft production; Sita and Jayant Juneja built their multifaceted craft and design workshop from a love of craft and a life moving around the country, as Jayant was employed in the Indian military. Their statement emphasizes the creativity they can bring to bear by asking a range of different craftspeople to adapt their techniques in working toward a shared goal.[46] The Junejas operate as more than managers of a workshop; they participate directly in the design and creation of each object produced. As "entrepreneurs" within the *Golden Eye* rubric, they constitute one node of a multitude of roles these figures played in the exhibition.

To access this diversity, however, required reading the cloth panels carefully, as the statements by craftspeople were not easily distinguished from those of the proprietors or entrepreneurs who ran the workshops. Some panels included both, some just one or the other. The photographs focused primarily on the craftspeople. To read these carefully required a significant commitment of effort on the part of the gallery visitor; as a result, the differentiation between craftsperson and workshop "entrepreneur" faded, and the cloth panels operated instead as markers for the presence of the craftspeople. The European and American designers' names were etched in stone; the craftspeople's words and images printed on cloth. The "entrepreneurs" largely blended into the background.

FIGURE 4.17. Craftsmen from India demonstrating their work in the galleries, *Golden Eye* exhibition. Cooper Hewitt, Smithsonian Design Museum.

DEMONSTRATED SKILL: RAW MATERIALS WITH POTENTIAL

In addition to these texts and faces peering out from the cloth, a few craftsmen were brought to New York to demonstrate their techniques and skills in the gallery. Unlike the Washington, D.C., exhibition *Aditi*, where a large number of craftspeople were integrated into the plan of the exhibition, here they were not; the location of the craft demonstration area is not marked on any of the plans for the show. Photographs indicate that somewhere in the galleries, two craftspeople sat side by side, with a small woven partition in between (figure 4.17). The craftsmen were not a permanent part of the display but a temporary engagement—similar to a special dance performance or poetry reading in the galleries.

The craftspeople who came to New York and staged demonstrations in the gallery did not put the intersection and collaboration on display, but instead showed "traditional" modes of working. As a result, their presence remained firmly within the "skill" aspect of the marriage between technique and idea: here are the things we can do; what would you like us to do with these skills? The living craftsperson in *Golden Eye*—in contrast to the voices of those pictured on the cloth banners throughout the exhibition, and in contrast to the ostensible goal of presenting the relationship as one of collaboration—served simply as the skillful executor of the will of the Euro-American designer, bringing generational wisdom and high-quality technique to produce exquisite goods made for an elite clientele. The small space of their demonstration areas, the emphasis on tools, and process, and the

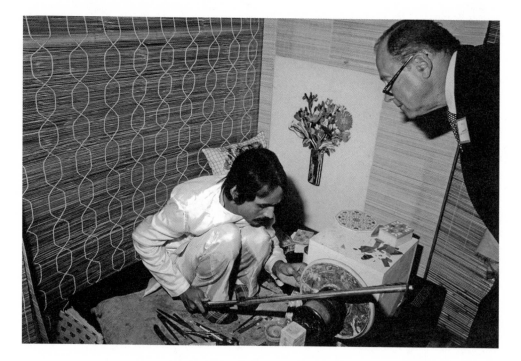

FIGURE 4.18. Visitor to the *Golden Eye* exhibition peering at marble-inlay artist. Cooper Hewitt, Smithsonian Design Museum.

set-aside quality of their location in the gallery meant that the craftspeople worked in tension with the layered sets of meanings embodied by the prototypes, the futurity and imagination of the staged rooms gesturing to moods or environments, and the translated statements of their handicraft colleagues. The living demonstrations tied the maker back to a timeless (yet fading) past rather than highlighting the innovative engagements and transformations *Golden Eye* ostensibly evinced. The most intensive display of process—of object-in-progress—here instead operated as a tether to static skill, a skill on display and for evaluation by designers who might happen to pass through the gallery, assessing the potential of the the the skill-in-action.[47]

Photographs of the craftspeople in their niches struggle to break free of extant iconographies of the artist at work. Images of the two working on either side of the partition emphasize the stasis and timelessness of the demonstrated skill. Shots that look down from above capture the objects in process and the spread of the tools but necessarily present a controlling, almost imperial viewing position. And in an attempt to capture the craftsperson demonstrating to an audience, an eerie photograph includes the torso of an older white man in a suit, leaning over to peer at the seated stone carver as he executes his task (figure 4.18). That none of these photographs were used for the publicity surrounding *Golden Eye* underscores the tension produced by the static, timeless skill amidst a swirl of prototypes and future-directed potentials.[48]

MEDIA MEDIATIONS AND MEDITATIONS

The show opened to a grand celebration, with high-profile designers rubbing shoulders with celebrity politicians from both India and the U.S. Press coverage of the opening and reviews of the show itself reasserted the exhibition's lofty goal to reinvigorate the craft practices of India by staging this design collaboration with internationally renowned designers. Alongside a series of glowing, positive discussions celebrating the project, several critics acknowledged that not all of the design efforts produced positive results. Chermayeff's Matisse-inspired stone inlay design was said to do injustice to both Matisse and the stone carvers of Agra, for example (Russell 1985). Many reviews note the bazaar-like quality of the show, some simply celebratory but others noting both the cluttered, difficult-to-navigate galleries and the positive and negative implications of commercialization (e.g., Courtney 1986; Wissinger 1986). Most press coverage listed the European and American designers, noted Sethi's major role in creating the show, and incorporated a quote from one of the craftspeople, taken from the banners in the exhibition. The more critically engaged, particularly those that had readership in India, commented on the problematic imperial relation of European designer and Indian craftsperson, noting the lack of prominent Indian designers or architects as major contributors to the show (Wallach 1985). Others commented on the social status of the craftspeople, either to support the narrative of uplift and salvage or to make clear the overwhelming challenge facing the philanthropists and NGOs that might want to continue the *Golden Eye* project. Some reviews succumbed to exoticization, describing, for example, one of Sottsass's pitchers as "Ali-Babaesque" (Plumb 1986). Several of the notices quoted an almost poetic early review by John Russell of the *New York Times*, who situated the show at the interstices of art and craft, before proceeding to other pairings: "But it is not, in any traditional sense, an 'art exhibition,' for it treads that ambiguous terrain between art and craft. It also treads the terrain—no less ambiguous in India—between craft and industry, craft and starvation, craft and kitsch" (Russell 1985). Russell here identifies some of the key tensions I've already discussed—between art and craft, and between craft and industry. The tension between kitsch and art ran through much of the coverage, stemming most likely from a statement Sethi made that sought to frame the exhibition as a way to help craftspeople make objects for sale in Europe and America that went beyond "sequined elephants and brass ashtrays made for tourists."[49] Amei Wallach, in her extended essay in *Newsday*, brought these ideas together: "If India wants to expand its markets, kitsch is not the answer" (1985).

Russell's other pairing—craft and starvation—shifts into a different register entirely, bringing his assessment of the exhibition into dialogue with both prevailing stereotypes of India as a nation in poverty and with the more specific imaginary of dying craft and starving craftsperson. By inserting this pair amidst the others, Russell signals the economic asymmetries at work at the heart of the exhibition's remit, and he also points to the aspirational potential *Golden Eye* promises. Not an art exhibition, the show instead balances these multiple dualisms, teetering toward starvation and kitsch while seeking

an escape through craft. Russell's review hits upon the show's key tension—between future potential and past disappointment. Can remaking the craftsperson as a participant in entrepreneurial global design bring craft back from the brink? Russell's review deftly avoids answering this question, noting instead that buyers in America would "kill" for Casson's bed and praising Sottsass's "positively demonic cheese knife" while remarking on a few collaborations that fall short of their promise. The subtle provocation "starvation" evokes at the beginning of his review reverberates through the article without resolution, just as these economic relations echo through the exhibition as potential, never quite coming to fruition.

Those writers working in fashion or style arenas, on the other hand, tended to uncritically embrace the excitement, spectacle, and exoticization surrounding the parties and openings that took place in conjunction with the exhibition and its designers. The rise of the Nehru collar and mirrored embroidery, along with the Kashmiri shawl and decorated sandals, drew from the commercialization of the exhibition both in the show's own discourse and in cognate displays in New York's top department stores—Bergdorf Goodman and Bloomingdale's. The presidents of both stores—Dawn Mello and Marvin Traub, respectively—attended the star-studded opening of *Golden Eye*, along with political and cultural celebrities such as Daniel Patrick Moynihan (his daughter Maura had worked as a liaison in Delhi during the preparations for the show), Robert F. Kennedy Jr., and the conductor Zubin Mehta (Lawson 1985). Coverage noted Mary McFadden's fashion and bubbled over into discussion of what to expect in the near future at both Bergdorf Goodman and Bloomingdale's.

In 1978, Bloomingdale's had staged a major display of Indian interior design and fashion on their top floor; they revived this popular installation for the Festival of India, updating it and expanding it to permeate every floor of their flagship on Lexington Avenue.[50] The store hosted a gala event for the opening of the display in the spring of 1986, inviting hundreds of New York luminaries who rubbed shoulders with Indian diplomats and curators such as Pupul Jayakar and Rajeev Sethi. Ralph Lauren had designed a line inspired by India, and his pieces were highlighted throughout the store. Both this and the Bergdorf display were linked to *Golden Eye* in the press reports—the exhibition at the Cooper Hewitt provided the academic and legitimizing backdrop for the exploration of the possibility of Indian aesthetics and India's craftspeople contributing to high-end commercial products. Julian Tomchin, the vice president of Bloomingdale's, described the rugs and textiles for sale as perfect for the decoration of beach houses—something the intended audience would be contemplating in this late-spring season.[51] These retailers recognized both the high-end market and the potentialities for mining the sense of authenticity and the reality of the inexpensive hand labor from India. In the context of the business-driven, booming 1980s, prior to the rise of fair trade movements, the prospect of working with Indian contacts to bring high-quality, well-designed furnishings and clothing to the American market drew the interest of a wide range of retailers and style reporters.

The critical assessment of the exhibition as cluttered, crowded, untidy, or "like a

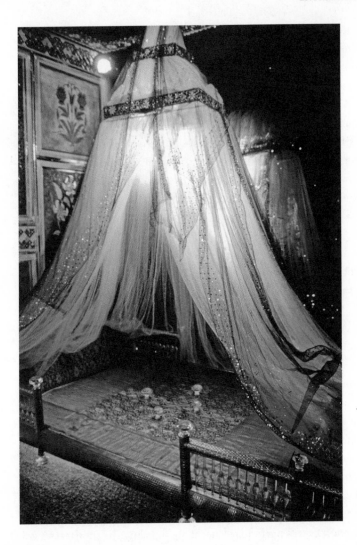

FIGURE 4.19. Hugh Casson, prototype of canopy bed, 1985. Cooper Hewitt, Smithsonian Design Museum.

bazaar" was occasionally articulated in a more positive sense as pastiche or amalgam—a combinatory impulse at the core of the show's many collaborations. Sottsass's dining "shrine" encapsulated for many the multifarious combinations of craft technology (stone inlay, wood carving, ceramic, metalwork, textile) and the vision of an international design superstar (figure 4.9, plate 11). The busy checkered pattern of the stone top echoed the playful pastiche of the wooden legs: each corner was supported by a different number of turned wooden carvings, brightly colored like the faux fruit on the table. Sottsass's designs, with those of the Memphis group, had, by 1985, become iconic representatives of postmodern pastiche and bold, sharp-edged, risk-taking dynamism. The untidy messiness of the exhibition coalesces here in Sottsass's table, a pastiche of different craft techniques, shapes, and forms, his "shrine" to contemporary design and its embeddedness in and indebtedness to long-standing craft techniques. The material reality that the table could

not stand up without additional support echoes the entirety of the exhibition: Sethi's ingenious solution of the mirrored pillar serves as an allegory of the erasure of a wide range of actors who made *Golden Eye* possible, primarily the young Indian mediators and the "entrepreneurs," both of whom disappear in the event of the exhibition. Sottsass's futuristic dining fantasy; Moore's desk that opens to reveal an Indian holy city in miniature; McFadden's shimmering embroidered silk tunics; Casson's bed canopy with its thousands of glass water droplets—the array of fantastic, multisensory experiences in *Golden Eye* made for a spectacular synthesis (figure 4.19). But it also emphasized the multiplicity of the designs themselves, taking their cues both from postmodern bricolage and from the material dispersion of their creators, mediators, makers, and consumers.

EXHIBITION OF AND AS PROTOTYPE

Despite the success surrounding the event of the exhibition itself, its promise—to expand the opportunities for exchange and collaboration between the U.S. and India so that craftspeople could find ongoing and steady support for their work—did not come to fruition, at least as envisioned by the organizers. Sethi's New Delhi–based Golden Eye Studio closed due to lack of funds even as the exhibition in New York opened. A brief effort to raise money for the continuation of the *Golden Eye* project fizzled soon after the close of the exhibition.[52] Other hurdles arose in relation to the objects themselves: brought into the country for exhibition, they could not then remain in the country to be sold and had to return to India due to customs restrictions. Exceptions did exist; Bellini's stone bench, for example, was acquired by the Museum of Modern Art.[53] Plans, floated by Bergdorf Goodman, for a dedicated *Golden Eye* storefront fell by the wayside.[54] The furnishings, textiles, and other objects, once returned to India, remained there, and the European and American designers could not retrieve the prototypes they had developed over the course of the year. No one knows what happened to the thousands of objects produced for and exhibited in *Golden Eye*.[55] Rudofsky was particularly upset about losing the shoe lasts made for the exhibition, and correspondence in the archives indicates that those in New York were unable to help secure these objects on behalf of the designers. The loss of a year's work left a bitter taste for many involved in both India and the U.S. With the exhibition's funding falling short, the promised catalog had to be abandoned, and as a result the only lasting, synthetic, public record of the exhibition was its small folding brochure and the critical press response.

Most often, bureaucratic intransigency at the sponsoring institutions in Delhi—specifically the Handicrafts and Handlooms Export Corporation (HHEC)—is blamed for the lack of follow-through with *Golden Eye*. But this explanation is both too simple and not entirely accurate. One might instead think of the HHEC as working via a temporal model of production flow and sales, while the exhibition operated in a temporality governed by futurity—by the prototype and the process of creation. The HHEC's mission lay in creating a conduit for the "traditional" craft products of India to the outside world, one that

connected craft suppliers with the international market, but not through innovation—through precisely the kind of adaptation and so-called kitsch the creators and critics of *Golden Eye* wished to overcome.[56] Its mission did not include catering to a high-art and design market; indeed its remit fell within the trade and technology sector, not the art sector. As such, the HHEC's pipeline of traditional craft, supporting foreign exchange revenues for the country, needed to keep on churning at its established pace. The entrepreneurial, future-oriented temporality of *Golden Eye* precisely countered this kind of bureaucratic structure—indeed this lies at the core of the definition of the entrepreneur in the 1980s. The contrast in cultures and temporalities operated in tandem during the Festival, supported by governmental funding and the energies of all involved, but the relationship fell apart when faced with setting up structures to capture the entrepreneurial vision of *Golden Eye*.

The shift in frame required to market the designs—from prototype to production—also posed major hurdles for the continuation of the show's future-oriented vision. As many of the Indian designers noted both at the time and in conversation today, very few of the designs were created with a streamlined production process in mind. Sottsass's table was an extreme example, as its structural problems notwithstanding, it required the coordination of two distinct craft workshops from two different regions of India. The craftspeople, too, recognized the limitations of these design projects, as some of their comments for the text panels show. Kesaria Ram, a stoneworker who helped make Bellini's bench, had an optimistic outlook: "Although this sofa took us three months to make, it will take less time now if we make several together."[57] Others, such as Udaygiri Surya Prakash Rao, a wood carver and toy maker working on Moore's miniature cities, acknowledges the difficulty in selling these objects:

> I can't export my skill through traditional toys because there are too many safety rules in the West preventing their sale. This "building design" that is both playful and utilitarian can broaden the scope of display for housing my skill. It's funny, but will someone want to buy such a thing?[58]

The narrative of *Golden Eye*, as remembered by those involved and as found in the correspondence in the archives, prominently includes this denouement: the exhibition fell short of its vision in the lack of ability for those involved to continue the project beyond the Festival of India time frame. But this narrative too-neatly echoes the despair of the salvage ethnography narrative from the nineteenth century: crafts, and the craftspeople who know these skills, are disappearing; something should be done to save them; whatever is done will always fall short. Indeed, the very discourse presumes and requires failure.[59]

Several voices associated with *Golden Eye* challenge or rework this narrative. Jatin Bhatt acknowledged the loss of some craft techniques, but also recognized the constant adaptation that producing useful objects required. For Bhatt, if a particular form or craft technique no longer has a use in everyday life, then it disappears, and another technique,

medium, or form emerges to take its place. Rather than recapitulating the desperate drive to save craft from its imminent demise, Bhatt articulates a broader vision of the ebb and flow of designs to fill emerging needs.[60] This challenge to the salvage narrative is matched by the voice of one of the "entrepreneurs"—Tariq Kathwari, who worked with Larsen on the rug and textile designs executed in his Srinagar-based workshop. Kathwari had studied design and textiles in New York and then set up his workshop in Kashmir in 1980. I quoted him at the beginning of the chapter; the full text of his statement adds a critical edge to the relation between European and American design and India's skilled craftspeople:

> This kind of work only started in the 1930s. An American company in Chicago gave an order to an English man who saw in the traditional blankets and floor coverings made by the people for themselves a new export potential. . . . It was like finding a new use for an heirloom that was gathering dust around the house. . . . Why can't we be designing our own products also?[61]

Here, Kathwari refuses the idea of the timeless craft, marking its emergence precisely in relation to international commissions and a global marketplace. By historicizing the production of Kashmiri embroidery, his statement undermines the idea of salvaging an authentic, pure art: these crafts themselves were revived, created, and rethought in the context of dialogue between maker and interested buyer. He then goes on to mount a critique of the persistence of this asymmetrical relation in the construction of *Golden Eye*: why not include an Indian designer or architect?

Kathwari, along with many of the other entrepreneurs and several of the Indian designers involved in the exhibition, went on to build businesses that leveraged the connections made during *Golden Eye* to design and produce goods that served a growing marketplace inside and outside of India. Kathwari's statement at age thirty-three presaged his own trajectory as an entrepreneur, linking high-end Indian design to global markets. He now runs a company that touts itself as providing "museum quality" textiles to interior design clients around the world, including international retail outlets such as Bloomingdale's. His story is not an isolated one, and it demonstrates both a counternarrative during the 1980s exhibition and the existence of a conversation that continues today. Kathwari's case also demonstrates that the nimble mobility and futurity of the entrepreneurial time that *Golden Eye* produced came to fruition in the form of the entrepreneurs themselves. The design superstars were unable to take advantage of the prototypes they had created, and the department stores couldn't use their brick-and-mortar storefronts to pursue commercial gain through these designs. And the vision of a future-directed, collective resource in India—the Golden Eye Studio—could not sustain itself without major institutional funding. Instead, precisely those individuals labeled as entrepreneurs in the exhibition— small-scale workshop owners, alongside the young Indian designers who went on to start their own firms in India—were able to key themselves to the rhythm of international entrepreneurial flows. Countering the overarching sense of the bureaucratic failure of

Golden Eye, in fact these nodes of entrepreneurial futurity demonstrate exactly what the mid-1980s, neoliberal discourse of the individual, anti-bureaucratic, globalizing actor defined as success.

ENTREPRENEURIAL FUTURES

Russell called Sethi's installation "elegant and hallucinatory," evoking the idea of simultaneously transporting the visitor to a space of fantasy, outside of the everyday, while offering up objects that, if visitors had the money, they could envision in their own living rooms. Where Sethi's *Aditi* exhibition had sought to immerse the visitor in all of the sensorial experiences of a generalized Indian village, *Golden Eye* brought visitors into a diverse and sometimes messy fantasy world, what Wallach, in the quote I opened with, called an "untidy amalgam of futuristic wish-list and respect for past traditions" (1985). The future-oriented quality of *Golden Eye* differentiates it from other craft and high-art exhibitions: the former offer transportation "back" to a simpler time and the latter present static objects, distant in their ancientness and revered for their formal qualities. In *Golden Eye*, the temporal directionality was outward, toward a multitude of almost-possible and fantastic futures, and this futurity positioned it perfectly within the swirling postmodernist pastiche of the mid-1980s (see Adamson et al. 2011). In looking forward to the fantastic, the exhibition demonstrated its own historically situated frame—its participation in the postmodern.

And, rather than mining the past for citations to incorporate into contemporary design, as Moore himself had done for his Piazza d'Italia, the works and environments produced for *Golden Eye* mined the coeval and ostensibly disappearing "past" of India, as found in the hands and skills of its craftspeople. One of the early departure points for the postmodern, as found in Robert Venturi and Denise Scott Brown's *Learning from Las Vegas*, lay in the vernacular—in their case a fascination with and valorization of the kitschy billboard-infested, neon-covered cityscape of Vegas (Venturi et al. 1972; Adamson et al. 2011). It is telling in this regard that Golden Eye looked not to popular culture—film posters, calendar art, matchbook decoration, comic books—but instead to craft. The move underscores the need for differentiation underlying both the Venturi–Scott Brown postmodern appropriations and the *Golden Eye* craft-based ones. Turning to craft draws on a different kind of vernacular, while the distant source location in India parallels the exotic, otherworldly elements the architects celebrated in Las Vegas. In addition to drawing from the "exotic" vernaculars of India's craft traditions, postmodernism as found in *Golden Eye* accommodates, replays, and in its most pointed formulations, critically engages the asymmetrical economic relationships—the legacy of colonialism—that drove the global economy in the 1980s, producing the booming economies of Japan and (somewhat later) the U.S. on the backs of a range of formerly colonized regions of the so-called Global South. In true postmodern form, it also projected a potential, fantastical future, one of canopies of glass beads over a metal bed and miniature wooden theater sets for tiny Indian toy figures (figure 4.20, plate 15).[62]

FIGURE 4.20 (Plate 15). Charles Moore, prototype of miniature Indian city with figures, as installed at *Golden Eye*, 1985. Cooper Hewitt, Smithsonian Design Museum.

Golden Eye set up complicated relations among its many interlocutors and participants, with layers of mediation, communication through the physical and tactile act of working with materials, governmental funding, and structural and financial investment from workshop owners. The exhibition also maneuvered within a global neoliberal economy and cultural ethos that had been growing since the early 1970s. Neoliberalism rests on the idea that one's well-being is best advanced through "liberating individual entrepreneurial freedoms and skills within an institutional framework characterized by strong private property rights, free markets and free trade" (Harvey 2005, 10). The narrative arc of *Golden Eye* that, over the intervening decades, has become the set storyline for those involved, makes for a satisfying-yet-tragic story of individual entrepreneurial vision bringing together independent geniuses with a group of individual craftspeople, only to fall short of setting up longer term business. The morality of this project is embedded in both the presumptive good of an entrepreneurial spirit and the guiding idea that trade and the marketplace will produce positive outcomes in the form of profit for those involved. Government's role lies in producing a positive environment for business, and then business will help individuals

out of poverty.[63] But what this narrative misses is the underlying tenet of neoliberalism: it rests on the individual, not the group, and it relies on the failure of many who seek such entrepreneurial futures. When one focuses on the futurity of the exhibition and looks for those who are the most in step with the rhythms of 1980s individual entrepreneurship, the Tariq Kathwaris and the Jatin Bhatts emerge as those best able to move into that imagined future. Each of the steps in the story, each character or role included therein, operates within the ideological and historically contingent frame of neoliberal economics.

Structural relations of power, historical legacies of colonial economics, class relations, Cold War bipolar politics—all these are ignored as factors in the individual-focused model of neoliberalism. Within this framework, the solution to the loss of craft tradition lay in the market. Rather than pursue the route of rigorous documentation and demonstration, as the nineteenth-century ethnologist might, *Golden Eye* saw the rising elite global marketplace as the answer, bringing Indian craft technologies to the task of creating consumer objects for the extraordinarily wealthy who seek museum-quality decor for their second and third homes. And this distinction separates the 1980s moment from its nineteenth-century colonial-era predecessor.

The exhibition presented an unachievable future, one that, as critics reminded us, captured the imagination and embodied the hopefulness that trade and markets might indeed save the crafts practices of India. Looking back, *Golden Eye* instead operates as an interruption within the flow of neoliberal discourse, embodying many of its most precious tenets—individual entrepreneurial spirit, future-oriented reuse of the past, and the ostensible moral good of free markets and free trade. But it also demonstrated the dystopic underbelly of neoliberalism—that many must lose in order to support the individual entrepreneur, that the legacy of colonialism and asymmetrical relations of power continue to underwrite what is in no way a "free" or morally good global market, and that fantastic futures often turn out to be available only to the extraordinarily rich in a world of ever-increasing income and wealth inequality. Russell's art, craft, industry, kitsch—and starvation—points to the rupture that *Golden Eye* embodies in this burgeoning, future-oriented, hopeful, and moralizing discourse. While wowing its audiences with beautiful potentialities, it failed to criticize the underlying inequities at the root of the neoliberal, entrepreneurial ethos. As such, *Golden Eye*'s contribution to our understanding of the temporalities of exhibitions in the mid-1980s lies in its presentation of an ineffable and unattainable potential—an unsustainable future, alive only in vision and imagination and then quickly snuffed out by the dystopic asymmetries of the "free" market.

CHAPTER 5

The Contemporary, at a Distance

Having examined the way particular materials such as clay transform in short and long durations of time, moved through the interruptive experiences of galleries punctuated with people, and engaged with the entrepreneurial, future-oriented temporality of exhibitions associated with international trade, I turn in this chapter to a different temporal mode: the contemporary. At the multi-sited Festival of India, only a handful of the seventy-seven major art exhibitions featured mid- to late twentieth-century, gallery-driven, urban-centered Indian art.[1] The India of the "now," the "present," and the "contemporary" took a back seat to the celebrations of historical, vernacular, and even colonial-era art.[2]

Indian organizers of the Festival expressed a desire to counter prevailing stereotypes of the subcontinent as a site of poverty, backwardness, and exotic eating habits, impressions fueled by recent films such as *Indiana Jones and the Temple of Doom*.[3] American organizers of the Festival of India, in concert with their Indian counterparts, felt pressure to portray India as traditional: a living example of a craft-centered, simple culture, distanced in both time and space from the modern world and sprinkled with narratives of villagers' experiences riding a roller coaster or seeing the Washington Monument (Jain 1997; Davis 2008; see figure 3.15). That demand for asserting India's distance from the U.S. circumscribed the potential for exhibitions of what organizers at the time called "contemporary" Indian art, a category that threatened to claim the same temporal and artistic space as its North American and European counterparts. To include contemporary Indian art, curators needed to perform a difficult balancing act: staging the art's *distance* from the contemporary even as they presented the works as integral to that very same temporal and value-laden category.

Three exhibitions that attempted this difficult feat were *Indian Art Today* at the Phillips Collection in Washington, D.C., *Contemporary Indian Art* at New York University's Abby Weed Grey Art Gallery, and *Neo-Tantra* at UCLA's Frederick S. Wight Art Gallery.[4]

The Phillips and Grey galleries selected what has become a canonical group of paint-ers, all from one collection—that of Chester and Davida Herwitz. In the decades that followed, this same collection went on to serve as the foundation for the study of India's late twentieth-century art, particularly in the North American academy; challenges to the canonical narrative and a deepening commitment to original research in twentieth-century material began to emerge in the first years of the twenty-first century.[5] The *Neo-Tantra* exhibit at the Wight gallery built on the entwined tropes of India-as-spiritual and modernism-as-abstract to create a show centered on an accessible strand of twentieth-century Indian art.[6]

The very existence of these three exhibitions as part of the diplomatic and nation-driven Festival of India constituted an interruption of the overarching celebration of earlier historical material.[7] These shows acknowledged that Indian contemporary art existed, that it might involve particular movements distinct from European and Ameri-can ones, and that it dealt with problems and issues of concern not only to India but also to a world struggling to come to terms with postmodernity and postcoloniality. Held the year after the first Havana Biennial, almost five years before the *Magiciens de la Terre* exhibition in Paris, and almost a decade before the landmark 1993 Whitney Biennial, this concentrated group of Festival of India shows operated in dialogue with early articula-tions of global modernism, uncomfortable reconfigurations of the boundaries of the contemporary, and the nascent glimmer of a new critical discourse pushing for the rec-ognition of contemporary art made outside the northern Atlantic.[8]

Even as the "contemporary" terminology of these three exhibitions asserted the legit-imacy of India's recent art, thereby claiming a contemporaneity or coevalness with the art of Europe and North America, the shows simultaneously reified a geographic, tempo-ral, and conceptual distance by pursuing a consistently introductory approach to the material and by anchoring the work in the multifaceted imaginary of India. The shows sprang from an internal contradiction, one that balances demands to make the material accessible and recognizable to audiences unfamiliar with it while simultaneously claiming legitimacy for it. The introductory move involves tapping into preconceptions of India as spiritual, static, naive, behind, exotic, and utterly different; the legitimizing move requires bringing India into the fold with the limited gesture of marking the art as con-temporary.[9] Indeed, in contrast to art historical scholarship of the past two decades, these exhibitions staged in 1985 do very little conceptual work to unpack what "contem-porary" might entail, such that the word serves as a rather weak gesture of inclusion and legitimacy. Thus, the shows thinly recognize India's art as contemporary but significantly limit its entry into the northern Atlantic mainstream by continually reinscribing its con-ceptual distance—its location in both a faraway place and a conceptually distinct time. This tension embodied in the "distant contemporary" lies not in the paintings exhibited in these three shows but instead in the international exchange of the Festival, its diffuse cultural diplomatic mission, and the struggle to challenge the canonical range of art by bringing India's recent art to American audiences.

To introduce new material to these audiences, the three curators organized their respective exhibitions by artist in both the gallery and the catalog material, choosing works that might speak across cultures yet still retain some identifiable Indic qualities in subject matter, color, or style.[10] The gallery installations provided minimal labeling, depending on the visitor's eye, the catalog text, and, in some cases, cognate historical material to guide the audience. The artist's style and the visual, formal qualities of the work became the conduits through which visitors might grasp India's contemporary art, with only minimal recourse to the specific historical, political, or economic contexts of the objects or the artists.[11] On the one hand, these shows contribute to a larger conversation about opening up the geographic boundaries of the contemporary, and in doing so they begin to challenge the hegemonic assumption that assessments of quality transcend both temporal and geographic context.[12] On the other hand, in anchoring exhibitionary strategies in the Indic sensibility of these works, the three exhibitions subtly reify distance as an underlying principle, thereby enabling a "recognition" of Indian art that simultaneously prevents such work from participating in broader movements of global contemporary art. Indian art is recognized here, but, through the contradictory tensions of what I call the "distant contemporary," it is recognized *as other*.

In pursuing this argument, I use "contemporary" as a descriptor in keeping with the terminology employed both in the three exhibitions themselves and also in archival and media discussions of the Festival. Scholars and curators today describe India's art from the late twentieth century as "modernist," with the "contemporary" moniker reserved for works from the mid-1990s to the present, in what appears to be a simplistic sliding periodization. Yet in the mid-1980s, writers and curators during the Festival used "contemporary" purposively, positioning the term between a simple periodization and a theoretically rich engagement with questions of global temporalities. The wider context of global art exhibitions at this time encompassed the impassioned critiques of the 1984 exhibition *"Primitivism" in 20th Century Art* at the Museum of Modern Art in New York and the significant political urgency articulated in the first Havana Biennial in that same year (Flam and Deutch 2003, 311–414; Mosquera 1986; Weiss 2007). Given this context, the intentional use of "contemporary" as a descriptor of the art in the Festival positioned the works within those shows in dialogue with major shifts in the approach to art from outside the northern Atlantic.

Recent genealogies of the term "contemporary" mark the decade of the long 1980s—from the establishment of and challenges to Minimalism to the aftermath of the fall of the Soviet Union—as a crucial period for the struggle to rethink periodizations and challenge the seemingly "natural" progression of a series of art movements (Smith 2009, 2010). The "postmodern" came to prominence in the late 1970s as a problematic catchall during this moment of the dissolution of certainty and categorization, but postmodernism gained purchase primarily in popular culture, design, and architecture, never quite finding legitimacy for other modes of art making.[13] At this moment of impasse—what Terry Smith describes as "periodlessness"—these three Indian art exhibitions claimed a coevalness with North America and, to a limited extent, other areas of the globe through the term

"contemporary."[14] Whereas some of the works in these shows critically engage with the past and tradition in what Smith identifies as the contemporary's "postcolonial" turn, other works draw out a continuity or a reengagement with modernism, thereby more closely fitting into Smith's "remodernist" category (Smith 2009, 7). However, even these Indian artists' engagements with the modern remain rooted in the asymmetries of recognition, legacies of colonialism, and presumptions of distance. While the archival traces of these shows lack a thorough theorization of the use of "contemporary," the three shows nonetheless recognized that the Festival of India occurred in concert with a multicultural, canon-challenging mid-1980s moment that had the potential to foster the presentation of India's "contemporary" art to a North American public.[15]

CURATORIAL CHOICES: MISSION, AUDIENCE, ACCESSIBILITY

Each of the three exhibitions took shape through key choices the curators, museum directors, collectors, and collaborators made in the relatively short time frame from the Festival's announcement in June 1982 to its launch three years later. Museums and galleries could draw on the support of the Indo-U.S. Subcommission on Education and Culture, the body tasked with managing and organizing the various events associated with the Festival.[16] In each case, the exhibition organizers balanced concerns relating to the individual museum's mission, its context within a particular urban art environment, and the accessibility of not just artworks but also preexisting curatorial frameworks.

Director Laughlin Phillips explained the motivation for the Phillips's decision to present the work of only four Indian artists—S. H. Raza (figure 5.1, plate 16), M. F. Husain (figure 5.2, plate 17), Laxma Goud (figure 5.3, plate 18), and K. G. Ramanujam (figure 5.4, plate 19):[17]

> My selections of the work of four artists was based on the type of considerations we normally apply to loan exhibitions: that the artists have some affinity with those represented in the permanent collection of this museum; that the artists have a unique, personal esthetic vision; and in this case that that vision strongly reflect [sic] their Indian cultural heritage and not simply the prevailing international art movements. (Phillips 1985, 5)

The oldest modern art museum in the U.S., the Phillips opened to the public in 1921, built around the Phillips family's strong collection of modern European and American painting and sculpture. The museum's location in Washington, D.C., underscores its centrality to the Festival, as the nearby Smithsonian Institution served as a major hub of activity and exhibition throughout the eighteen-month span. The National Gallery of Art—the leading repository for nineteenth- and twentieth-century European and North American art in the city—chose to mount an exhibition of historical Indian sculpture rather than modern Indian art, and so the Phillips served as the primary venue in Washington to display this material.[18] The audience for modern art in the capital largely comprises an elite urban

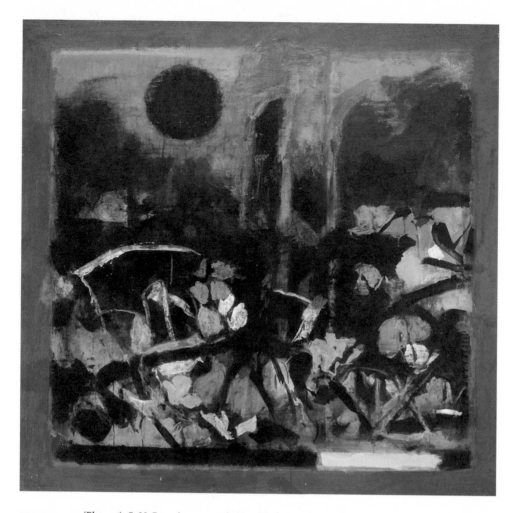

FIGURE 5.1 (Plate 16). S. H. Raza (1922–2016), *L'été '67*, 1967, oil on canvas, 59¼ × 59¼ in. (150 × 150 cm). Peabody Essex Museum, Salem, MA, E301247. Artwork © 2013 Artists Rights Society [ARS], New York/ADAGP, Paris; photograph provided by the Peabody Essex Museum.

group of culturally astute viewers alongside national and international tourists. In this context, the Phillips moved to select images that, as Laughlin Phillips articulates, had some "affinity" with those in the permanent collection but that remained strongly Indian.[19]

Laughlin Phillips initially contacted Pupul Jayakar, chairman of the Indian Advisory Committee for the Festival, to arrange a visit to India for the purpose of selecting works to include in the show.[20] In the end, however, as he notes in both press releases and the foreword to the catalog, he had "no reason to visit India" because the Herwitz family had a wonderful collection of Indian painting much closer to home, in a warehouse "just off the freeway in the heart of Worcester, Massachusetts" (Phillips 1985, 5).

Given the geographic accessibility of the collection and the generosity of the Herwitzes themselves, the choice to select works from the Herwitz collection made things easier

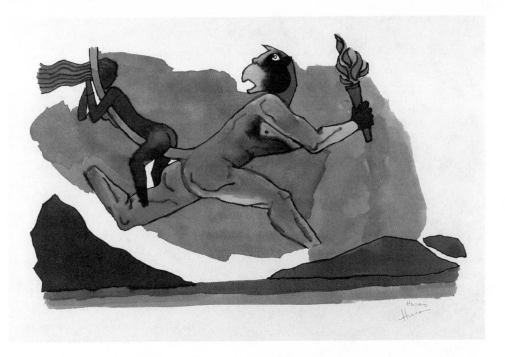

FIGURE 5.2 (Plate 17). M. F. Husain (1915–2011), *Hanuman*, 1968, photolithograph on paper, 18 × 24 in. (45.7 × 61 cm). Los Angeles County Museum of Art, Gift of Mr. and Mrs. Chester Herwitz, M.91.315.1–11. Artwork © Estate of M. F. Husain; digital image © 2013 Museum Associates/LACMA; licensed by Art Resource, New York.

FIGURE 5.3 (Plate 18). Laxma Goud (b. 1940), *Untitled*, 1983, pencil and colored pencil on paper, 16½ × 23¼ in. (41.9 × 59 cm). Peabody Essex Museum, Salem, MA, E301265. Artwork © Laxma Goud; photograph provided by the Peabody Essex Museum.

FIGURE 5.4 (Plate 19). K. G. Ramanujam (1941–73), *Untitled*, 1969, oil on canvas, 29 × 18¾ in. (73.7 × 47.6 cm). Peabody Essex Museum, Salem, MA, E301121. Permission to reproduce courtesy P. Gopinath, Cholamandal Artists' Village; photograph provided by the Peabody Essex Museum.

for both the Phillips in Washington and the Grey Art Gallery in New York. Thomas Sokolowski, the curator of the Grey's exhibition, also drew solely from the Herwitz collection. Unlike Phillips, however, he took advantage of funding from the Indo-U.S. Subcommission on Education and Culture to travel to India and meet with artists, collectors, and critics. The Grey Art Gallery's namesake, Abby Weed Grey, who had passed away only in 1978, had a deep interest in the modern and contemporary art of Iran, Turkey, and India, a legacy that contributed to the gallery's decision to host a show as part of the Festival (Sokolowski 1985, 6). Grey's collecting was spurred largely by a belief that art might help build bridges across international divides. She organized exhibitions of American contemporary art that toured in Iran and Turkey and brought the art and artists of those regions to her home state of Minnesota as well as to other locations across North America.

Abby Weed Grey's ethos fit well with the Festival's goals, and her impetus for the selection of artists and objects for her collection echoes Laughlin Phillips's in one respect: as she wrote in her posthumously published memoir, "I didn't know where to look or exactly what to look *for*, but whatever it was going to be, it had to express the response of a contemporary sensibility to contemporary circumstances" (Grey 1983, 15). Her memoir nar-

rates numerous moments of acquisition, describes works seen in artists' studios around the world, and details the planning for exhibitions. Grey differed from Phillips in her disdain for the exoticization and distancing of global contemporary art. In making her choices, she primarily considered the artistic merit of the work, whether it spoke to her, and whether it might speak to a wider audience of viewers, not whether it represented a particular Indic, Iranian, or Turkic aesthetic. Indeed, one of the reasons for her decision to house her collection in New York City instead of her home city of St. Paul lay in her discomfort with the University of Minnesota's approach to her collection as exotic and strange, in contrast to NYU's proposal to make her collection the center of its cosmopolitan, international academic environment (Grey 1983, 274–75). Grey consistently restated her mission to join the world together through art—to promote global understanding.[21]

Under the guidance of Abby Weed Grey's overarching legacy, and with Festival of India funding, Sokolowski educated himself by engaging with artists, curators, and critics during and after his India trip—in the course of which he traveled to the major art centers in India as well as places off the beaten path, such as to J. Swaminathan's Roopankar Museum of Fine Arts in Bhopal, only months after the devastating Union Carbide gas and chemical leak there. With the exception of M. F. Husain, Sokolowski met every artist later shown in the exhibition.[22] Sokolowski also called on the expertise of Indian printmaker Krishna Reddy of the NYU faculty.

The Grey Art Gallery's location in the crowded and innovative art gallery scene of New York and its stated mission to pursue experimental ideas in a "museum-laboratory" environment shaped the direction Sokolowski and his collaborators chose.[23] In contrast with the small selection of four artists at the Phillips in Washington, the show incorporated a range of styles from thirteen artists born between 1915 and 1953, with works dating between 1967 and 1984.[24] Whereas the Phillips represented an established name in modern Euro-American art in the nation's capital, the Grey Art Gallery tapped into the experimental artistic energies of its location in Greenwich Village and its role as an integral part of a larger educational institution.

Across the country at UCLA's Frederick S. Wight Art Gallery, another university museum planned and mounted an exhibition of very different paintings, drawing only a few works from the Herwitz collection, with the remainder from a group curated by the National Gallery of Modern Art in New Delhi. In collaboration with Laxmi P. Sihare, who had moved from the National Gallery of Modern Art to become director of India's National Museum in 1984 (Phillips 2006, 342), curator Edith Tonelli decided to pursue a narrowly focused show rather than a comprehensive one. In the planning stages, abstract painter and UCLA professor Lee Mullican met with Sihare in Delhi and was shown the catalog for an exhibition Sihare had organized in 1982 for the Government of West Germany— *Tantra: Philosophie und Bildidee* (Sihare 1982). Mullican, whose own abstract painting explored elements of Indic philosophy, "knew immediately that here was an art idea that might appeal to a Los Angeles audience ready for a spiritual spin into contemporary painting."[25]

Each of the three venues operated slightly outside the mainstream, such that the individual mission, urban location, and particular audience of each shaped these museums' ability to mount shows other venues shied away from. In all three cases, the Festival of India provided impetus and funding to pursue these shows: none of the three museums had planned contemporary Indian art exhibitions prior to the announcement of the Festival.

THE MOVEMENT, ECLECTICISM, AND THE ARTIST

How did the content of the three galleries' respective exhibitions emerge from these negotiations? On the East Coast, the Grey and the Phillips chose a wide range of paintings, inviting critical characterizations of the shows as "eclectic," while on the West Coast, the Wight highlighted a singular movement, a choice not without its own problems.

For UCLA, the decision to feature a particular art movement—Neo-Tantra—arose not only from a presupposition about what a Los Angeles audience might want to see but also from a desire to mount a clearly delineated body of objects that centered on a particular conceptual theme. Tonelli begins her introduction to the exhibition with the following explanation:

> Neo-tantric painting is not the only art work that is being produced in India today. Lee Mullican and I chose an exhibition of this small and specialized group of artists as our contribution to the Festival of India because we felt it represented the strongest and most mature contemporary "movement" that was both rooted in Indian sources and also conscious of the art of the rest of the world. We also felt that the individual paintings could be appreciated on their own, with no special knowledge of their roots or sources. (Tonelli 1985, 11)

Working from the thematic core, its Indic sources, and its awareness of global contemporary art, Tonelli and Mullican designed a multilayered experience for the viewer, incorporating everything from aesthetic appreciation to an understanding of the philosophical and artistic roots of the artwork on display.

At both the Grey and the Phillips, the diversity of the selections produced somewhat haphazard exhibitions; a discomfort with such an admixture rises to the surface in the catalog texts and archival materials. Reviews of both shows often note this unevenness as well (sometimes drawing this idea from the galleries' press releases).[26] While both Herwitz shows mark themselves as selected, not comprehensive, events, their eclecticism makes it difficult to see the historical and art historical context of the objects. Putting aside the question of the relative strength of Neo-Tantric art,[27] Tonelli's choice to showcase a *movement* demonstrates a respect for and presumption of an extant historical and art historical structure for the twentieth-century art of India.[28]

Visitors to *Neo-Tantra* had a number of ways to access this movement and the works in the exhibition. They could examine the paintings as formal objects, experiencing their abstract aesthetic, engaging their use of color, and appreciating the compositional and

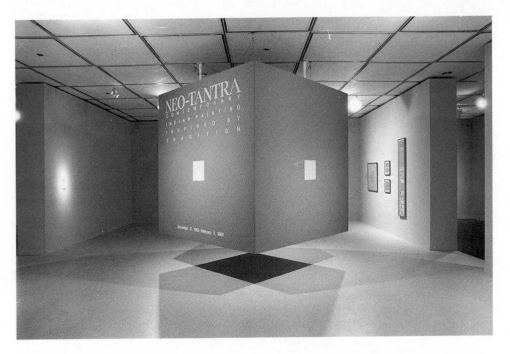

FIGURE 5.5. *Neo-Tantra* installation, Frederick S. Wight Art Gallery, University of California, Los Angeles, showing the central room with historical material. Wight Art Gallery Exhibit Files, Department of Special Collections, Charles E. Young Research Library, UCLA.

painterly aspects of the work. Neo-Tantric art appealed to a European and North American audience because of an easy visual accessibility and a formal relation with established movements such as Abstract Expressionism, Art Informel, and Color Field painting (R. Brown 2005). A short catalog essay by Chandra L. Reedy, then a PhD candidate in archaeology at UCLA, provided a broad introduction to the historical and religious aspects of Tantra. In the gallery, one wall in the central room featured objects representing historical or vernacular approaches to Tantra, including, for example, two eighteenth-century paintings, one a *Maṇḍala of Jambudvīpa* and the other a *Nāga Pāśaka Yantra* from Rajasthan (figure 5.5; Tonelli 1985). Situating contemporary experiments with Tantric forms and philosophies in the context of earlier examples encouraged visitors to draw out historical continuities, a value highlighted in many Festival of India exhibitions, where contemporary crafts and performances were framed as both ancient and modern. The Brooklyn Museum's *From Indian Earth*, for example, brought together historical terracottas with contemporary examples; many shows of "living arts," such as *Aditi* at the Smithsonian, claimed the ancientness of the crafts displayed while simultaneously demonstrating their contemporaneity and vibrancy.[29] In addition to continuity, however, this move established a further distance between India's contemporary and Euro-American contemporary art, asserting a central religious element in the former in contrast to the ostensibly secular core of contemporary art from the northern Atlantic.[30] In addition to this historico-religious

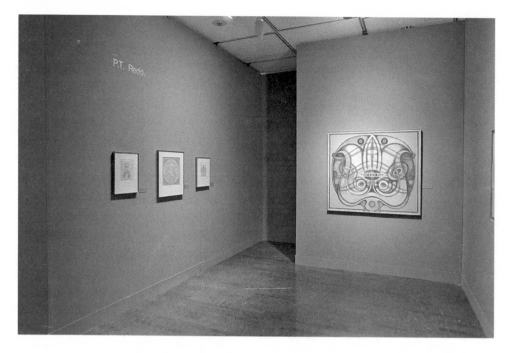

FIGURE 5.6. *Neo-Tantra* installation, showing the P. T. Reddy (1915–96) room. Work © Estate of P. T. Reddy. Wight Art Gallery Exhibit Files, Department of Special Collections, Charles E. Young Research Library, UCLA.

background, the gallery also continuously played a slide show of other types of contemporary Indian painting to acknowledge the breadth of twentieth-century Indian art and to offer visitors a taste of art produced by those outside the Neo-Tantra rubric.[31] This layered approach encouraged self-education, expanding outward from the emphasis on a single movement without losing the spiritual thematic tether.

Even the *Neo-Tantra* show, with its overarching thematic unity and multiple access points, arranged the works by artist, giving each artist his own room (figure 5.6).[32] The other two more eclectic exhibitions also organized their displays by artist. This is not surprising: in 1978, Geeta Kapur had published *Contemporary Indian Artists*, a book comprising six chapters (and an introduction) with each devoted to a single male artist, tracing his biography and artistic approach (Kapur 1978). This groundbreaking publication took contemporary Indian art seriously at a time when it was usually summarily dismissed as derivative (Mitter 2008). The book also established the voice of Indian art in Kapur, who participated in India's art scene alongside these artists. Critical discourse in the 1980s involved a constant struggle for recognition of artists' works and their names on national, regional, and international stages. By the 1960s, India's major cities had established a wide range of commercial galleries; artists' groups agitated for recognition and exhibit space; and biennials and triennials gave international exposure to many Indian

artists.[33] Two decades later, these three American shows depended on this foundation and drew from it: the Phillips Collection extended an invitation to Kapur to contribute an essay to the catalog on the basis of her reputation (this plan did not come to fruition), and Sokolowski noted that he built his understanding of Indian art largely from her expertise and example (Sokolowski 1985, 7). But without a framing scholarly structure to enable viewers to situate the formal experimentations of these artists within a regional and global historical and political context, organizing exhibitions by artist encouraged readings of the art as merely derivative of earlier northern Atlantic art movements.[34] The artist-centered and formally driven presentation of these works—a strategy motivated by an impulse to introduce this art to a new audience—underscores the distancing embodied in the demand for identifiable Indianness, reifying the peripheral role of India's art of the late twentieth century.

MODELS AND PRECEDENTS: EARLIER EXHIBITIONS OF CONTEMPORARY INDIAN ART

Each of the curators and directors involved saved themselves valuable time and energy—while also accepting external constraints—by relying on earlier models for their exhibitions. The Phillips Collection's archival material on the show contains photocopies and notes on several earlier shows, notably those produced for the 1982 Festival of India in the U.K., as well as discussions of what the Grey Art Gallery was planning.[35] Both the Phillips and the Grey not only relied on the expertise of Chester and Davida Herwitz but also included an essay by their son, Daniel, in their respective catalogs. The *Neo-Tantra* show reprised, with fewer artists, the Stuttgart Tantra show of 1982; the main essay in UCLA's catalog repeats, with some edits (and in English), Sihare's essay in the earlier volume (Sihare 1982, 1985). These earlier models enabled these galleries to put the shows together relatively quickly.

Given this reliance on, and awareness of, earlier exhibitions, the curators of the three American shows would have seen a number of thematic and multilayered approaches to India's recent art. *Contemporary Indian Art*, an exhibition at the Royal Academy of Arts in London, took place across two sequential installations with paired themes: "The Gesture, and Motif" and "Stories, Situations" (Padamsee et al. 1982). It surveyed the work of forty-four artists (seven of them women) in painting, printmaking, drawing, and sculpture. The Museum of Modern Art in Oxford mounted *India: Myth & Reality*, which examined India's twentieth-century art thematically and encompassed sculpture, two women artists (Nalini Malani and Mrinalini Mukherjee), and artists today often considered British (e.g., Anish Kapoor). The curators chose six overarching themes, such that the artists operated as a secondary organizing principle.[36] In addition to a variety of short essays by critics and artists, the Oxford catalog published poems by Gieve Patel and M. F. Husain and reprinted F. N. Souza's essay "Nirvana of a Maggot" (Souza 1955). By

acknowledging the multifaceted, multimedia, transnational, and politically engaged land-scape of Indian visual and textual art, this show makes the American exhibitions of 1985 look unidimensional, (male) artist-driven, formally focused, and painting centered.

Given Britain's long colonial connection to the subcontinent, along with its multiple waves of immigration from South Asia in the previous decades, one might expect that the U.K. would evince more interest than the U.S. in India's contemporary culture. While colonialism and migration may have been influential, however, they did not necessarily entail a greater interest in the contemporary art of the subcontinent. In the midst of the 1980s Raj revival, the colonial era anchored many historical exhibitions, and the diversity of South Asian populations in Britain in fact made organizing solely on India's behalf difficult. In part stemming from these complications, the historical record points to several specific events and actions that spurred an engaged dialogue in the U.K. In 1980–81, as the Festival there was in its planning stages, several artists and activists began to call for exhibitions of contemporary Indian art as part of the Festival program. Rasheed Araeen led the campaign, decrying the existing plans' stress on ancient and "folk" art in letters to *Art Monthly* entitled "Does India Have No Present?" Among his cosignatories were several prominent South Asian artists resident in Britain (sculptor Avtarjeet Dhanjal and painters Avinash Chandra and Balraj Khanna) as well as a wide range of critics, writers, and artists.[37] Agitation and organizing within South Asian British communities led to "fringe" events around the official Festival, alongside the staging of contemporary Indian art shows by several major galleries (Durrans 1992, 38). The Royal Academy, Tate Britain, and the Museum of Modern Art Oxford all mounted exhibitions of India's recent art in varied relation to the official Festival. Pushing these efforts was a group of vocal artists and critics already engaged in attempts to overcome what Araeen decried as the institutional racism of the U.K.'s museum and gallery scene; his *Black Phoenix* journal (1978–79) served as one venue for these critical encounters. While *Black Phoenix* was short-lived, Araeen launched its successor, *Third Text*, in 1987. The presence of this critical discourse, accompanied by close ties to colleagues and artists in India, lent Britain's contemporary exhibitions cutting-edge criticism and scholarship that challenged the essentializing priority given to historical and living traditions found in Festival exhibitions. In America, discussions and pleas for contemporary Indian art exhibitions occurred primarily in the confines of private correspondence among the organizers rather than in public venues.[38] The U.S. lacked the focused, organized, and localized discussion that took place within Britain's art community.

While these earlier U.K. exhibitions appear in the archives as key exemplars for the American shows, many of their elements—sculpture, women artists, critical voices from the subcontinent, artists' voices, poetry—were lost in the translation across the Atlantic.[39] The Grey and Phillips shows were therefore significantly shaped by the other factors detailed above: the stated missions of the respective galleries and the particular urban audience each gallery sought to reach. In addition, their reliance on the Herwitz collection and funding from the Herwitzes influenced the selections for these two exhibitions. For

the *Neo-Tantra* show, these contextual factors came into play, but the Stuttgart Tantra exhibition operated as a blueprint: the Wight gallery cut only a few elements from the West German show before remounting the exhibition in the U.S.[40] As a result, the critical engagements found in the British exhibitions did not translate into the American context. Instead, a pervasive sense of introducing this distant material and an emphasis on formal accessibility underwrote the logic of the three American shows.

THE ENDURING LEGACY: READING THE CATALOGS

Close reading of the three catalog texts adds a finer texture and substance to the ephemeral traces of the exhibitions themselves. And while today these texts appear as short essays in a growing group of much more in-depth and thorough treatments of India's twentieth-century visual culture, in the mid-1980s such scholarship was rare. For those visiting these three Festival of India shows, then, the catalogs served as central guides to India's contemporary art.

The *Neo-Tantra* catalog is subtitled "Contemporary Indian Painting Inspired by Tradition." It opens with Tonelli's subtle and careful introduction of the problems involved in the naming and framing of the *Neo-Tantra* show as embodying "the strongest and most mature contemporary 'movement' that was both rooted in Indian sources and also conscious of the art of the rest of the world" (Tonelli 1985, 11). Tonelli lays out the decades-long growth of Neo-Tantric art and then addresses the positioning of the work in relation to India's modernity. She takes a nuanced approach to this question, avoiding the common trap of presuming a stark dualism between modernity and India as she explains the choice of "Neo-Tantra" for the show:

> This work is *not* tantric art, new or otherwise—it is "sort-of" tantric art or "inspired-by" tantric art and reflects the way many Indians are working to fully participate in a "modern" society without rejecting their heritage. The cultural debate in India often has been waged over the disparity and incompatibility between opposing systems, such as "tradition and modernity" or "Eastern and Western." In some circles, however, Indian identity is seen now as firmly rooted in the integration of opposites—in a dualism, or "bi-culturalism," rather than being defined totally by one cultural focus or the other. . . . [These artists] are "modern" artists who have been influenced by, and inspired by, the world they have inherited. (Tonelli 1985, 11)[41]

The world inherited by Tonelli's "modern" artists was not limited to the boundaries of a constructed nation. In her perceptive account, Tonelli pinpoints one of the central problems for post-1947 Indian art: if modern art finds its roots in Euro-America while simultaneously articulating universal concerns, how can artists outside that imagined locus participate in modern art? And how can India's modern art be modern while still asserting and defining a regionalized or national Indianness?[42] In Tonelli's hands, these tensions refuse to collapse into a simple Indian–modern binary. Instead, she complicates

the idea of a fundamental temporal and conceptual distance among India, modernity, and the contemporary and acknowledges the multiplicity of elements embedded within the seemingly uniform idea of "India." Her attentive analysis reveals the critical energy and care put into these shows.

Sihare's essay shifts the reader's attention to the spiritual and formal aspects of the works, offering an overview of Tantric practices and texts and linking that spiritual framework to the works' timeless and universal formal qualities. Neither the artists' short statements in the catalog nor Sihare's essay raises issues of identity politics: G. R. Santosh's (figure 5.7) upbringing in a syncretic Kashmiri Muslim household, for example, goes unremarked. Only occasionally do other arts impinge on the discussion: Sihare and Om Prakash both mention the painter's connections to the sitar and, thus, to music, but neither Santosh's poetry nor P. T. Reddy's sculpture appears here. And the historical context for these individuals' lives—their participation in the Quit India movement before 1947, their migrations around the time of Partition, their experience of violence or tension among religious communities, their understanding of India's poverty, their wonder at global space travel, their concerns about the Cold War and nuclear destruction—these do not appear at all.[43]

Furthermore, the catalog's texts leave out or ignore connections to other artists, including those from Europe and North America: they make no mention of Op art, Color Field painting, De Stijl, Automatism, or Bauhaus. This enables the authors to avoid the problem of entering into a debate about whether the show's works might be considered derivative; it also ignores the long-standing interconnections across the globe among artists and art movements. Neo-Tantra is set forth as a contained Indian movement—a mark of respect for India's contemporary art scene, certainly, but also an erasure of the interpenetration of global visual culture and the mutual visual appropriations from Europe, the Americas, South Asia, and other regions. Although Tonelli recognizes Neo-Tantra as a movement, the critical impetus she voices in her essay is thwarted by the move both to introduce and distance contemporary Indian art for a Los Angeles audience enamored of Sihare's ahistorical approach.

Sokolowski brings an understanding of European and American contemporary art to bear in his catalog essay for the Grey Art Gallery exhibition *Contemporary Indian Art*, combining it with his own examination of the debates then current among critics of India's contemporary art. His text provides some background to the show's works, outlining key moments in India's nineteenth- and early twentieth-century art history and presenting the diversity of India's modern and contemporary art. Sokolowski uses quotes from the artist K. G. Subramanyan to establish that India's contemporary art should not be directly compared to that of the West, that it has its own logic, and that it often emphasizes an "apotheosis of the ordinary" over an obsession with abstraction. Drawing on Geeta Kapur, Sokolowski notes that Indian art may not have had an avant-garde and that "vanguardism is perhaps anti-Indian" (Sokolowski 1985, 19). He concludes by reading three paintings in the show, linking each of them to European or North American movements on the one hand and to India's miniature or folk painting traditions on the other. He

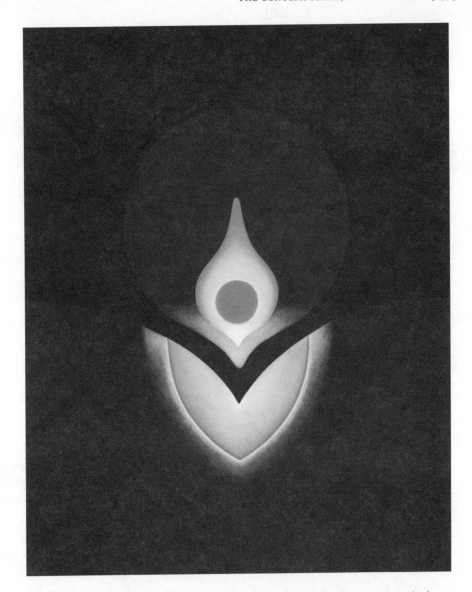

FIGURE 5.7. G. R. Santosh (1929–97), *Untitled*, 1973, 50 × 40 in. (127 × 102 cm). Peabody Essex Museum, Salem, MA, E301212. Artwork © Estate of G. R. Santosh; photograph provided by the Peabody Essex Museum.

bookends his essay with two lyrical moves, beginning with a quote from the framing narrative of the *Mahābhārata*, thereby recursively framing his own essay with one of the great Indian epics, and finishing with a note about the linearity of the West and the cyclical temporality of India. For Sokolowski, the primary challenge for the exhibition lay in convincing visitors that these paintings were worth engaging with, and to meet this challenge he situated these works in a critical discourse while also linking them to European and American examples.

FIGURE 5.8. Somnath Hore (1921–2006), *Wounds Series—8*, 1979, cast handmade paper, 19½ × 24 in. (49.5 × 60.9 cm). Artwork © Estate of Somnath Hore; photograph provided by Aicon Gallery.

Daniel Herwitz's essay in the Grey catalog attempts to draw out the postmodernism of India's relation to its own past, linking contemporary Indian art to an accepted and contemporaneous Euro-American aesthetic maneuver. In discussing Somnath Hore's (1921–2006) *Wounds* series of cast handmade paper works (figure 5.8), Herwitz suggests that "Hore's recreations of ancient plaster are also recollections of the wounded in the throes of India's colonialist 'modernization.' Like any form of the past, a tradition can only speak when the present finds itself willing and more importantly able to acknowledge it" (Herwitz 1985b, 28).[44] He goes on to make a key parallel between postmodernist artists appropriating European Renaissance and classical styles alongside what he calls non-Western imagery, and India's artists performing the same moves with both India's heritage and Euro-American art. Herwitz's insight in this essay centers on his articulation of both the voice of the Indian artist and the necessity for the contemporary world to be able to listen to and pay heed to that voice. Looking at the essay from the vantage point of the early twenty-first century, Herwitz perhaps anticipates Gayatri Spivak's 1988 essay "Can the Subaltern Speak?" by weaving the politics of recognition into a call to acknowledge these painters and their works as legitimately Indian and legitimately contemporary, participating as much in the postmodern as in the postcolonial. That said, Herwitz accepts

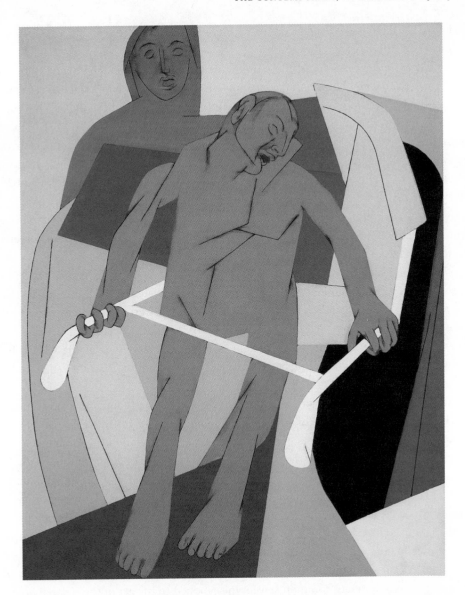

FIGURE 5.9. Tyeb Mehta (1925–2009), *The Rickshaw Puller*, 1982, oil on canvas, 59⅛ × 47¼ in. (150 × 120 cm). Peabody Essex Museum, Salem, MA, E301091. Courtesy and © Tyeb Mehta Foundation; photograph provided by the Peabody Essex Museum.

the distancing terms of "contemporary but Indian," characterizing the works as "vibrant" and valorizing a stereotypical Indic aesthetic.

The poet and painter Gieve Patel, whose essay opens the Grey Art Gallery catalog, uses his textual dexterity to offer both a depth of language and an essay structure that can cope with the difficulties Herwitz and Sokolowski struggle with. His title, "To Pick Up a Brush," is taken from the artist Tyeb Mehta (figure 5.9), quoted on the first page of the essay: "To

pick up a brush, to make a stroke on the canvas—I consider these acts of courage, in this country" (in Patel 1985, 8).

Unlike any other essay across these three catalogs, Patel begins with an understanding of the artist's context that encompasses India's fraught political landscape; an economic situation of desperate poverty that makes painting a luxury; and the global context of constant nuclear threat, the rise of postcolonial nations, and the Cold War. In elaborating on Mehta's quote, Patel explores these themes by introducing further statements from artists and marking the problems he and his colleagues work through in their painting. In addition to Mehta's call to consider art a courageous—even political—act, Patel discusses the problems of negotiating the influence of the West, what subject matter to foreground as an Indian artist, the benefits (and drawbacks) of remaining relatively free from market pressures and outside the international art scene, and the issue of personal, regional, and even national style.[45]

As a painter himself, Patel is able to explore the compositional use of empty, expressive spaces or overwhelming coverage, all without falling into stereotyped phrases describing a chaotic or vibrant Indian aesthetic. This short, utterly groundbreaking essay seeks to establish a new discursive framework for Indian art rather than stand on a foundation of essentialized presumptions. That Sokolowski chose to start the catalog with Patel's essay demonstrates his commitment to charting a new path for the discourse surrounding Indian contemporary art.

In Washington, the Phillips Collection's strategic decision to highlight only four artists limited the scope of the exhibition and the catalog text. Partha Mitter's essay primarily treats each of the four artists in turn, framing the discussion in the same terms that Laughlin Phillips presented for the show: that each artist's works should embody a quality of identifiable Indianness, albeit in different ways.[46] Daniel Herwitz's essay takes on the specter of eclecticism and asks how these works are Indian and also contemporary. He pushes this question further to examine what they might share and, in an echo of some of the language he uses in the Grey catalog, proposes three commonalities: dynamism, brilliant color, and a modeling of the human form "in distinctly Indian ways" (Herwitz 1985a, 19). All three criteria engage with formal aspects of the four artists in the show, and all three criteria reiterate common stereotypes applied to the art of the "Global South." Herwitz notes the vibrancy of the works of Raza and Husain and comments that filling the space of the canvas is "natural" given the "boisterousness of India," and that Cubist spatial and compositional tropes come "naturally" to those in the subcontinent (Herwitz 1985a, 21). At times this makes for somewhat incongruous juxtapositions, as the sparse and gestural monochrome silkscreens in Husain's *Varanasi* series (figure 5.10) fail to exemplify either this filling of space or the supposedly vibrant, colorful qualities of Indian contemporary art.

Patel's essay, Sokolowski's framing, and Tonelli's intervention each in their own fashion point the way toward the possibility of critical engagement beyond formal, artist-centered accounts of late twentieth-century Indian painting. For the most part, however,

FIGURE 5.10. M. F. Husain (1915–2011), *Varanasi III*, 1973, silkscreen on paper, 22 × 30 in. (55.9 × 76.2 cm). Artwork © Estate of M. F. Husain; photograph © 2012 Sotheby's, Inc.

the catalogs struggle to defend the paintings displayed against charges that they are not Indian enough, not contemporary enough, not coherent enough, or not good enough. Along the way they often reiterate Orientalist tropes about the spirituality, cyclical temporality, or definitive otherness of India, despite very sincere attempts to overcome these same discursive patterns. Patel manages to escape these traps by embracing the problems Indian artists encounter and by reading their words and works to navigate that difficult terrain. Perhaps only a poet-painter could provide the textual language necessary to articulate the problems of contemporary visual art in the subcontinent. Patel's essay injects a moment of the best critical writing on India's contemporary art into these exhibitions, bringing the Grey Art Gallery catalog closer in flavor to its predecessors from the U.K.'s Festival of India in 1982.[47]

MISSING PIECES: CRITICAL ENGAGEMENT, THE MID-1980S, AND THE CONTINUING LEGACY

The choice by both the Grey Art Gallery and the Phillips Collection to work exclusively with the Herwitz collection certainly shaped the scope of their exhibitions, an idiosyncrasy both organizers noted, but one that went unexamined in the catalogs themselves.[48]

In many ways this limited them in terms of temporal scope—the works in these exhibitions date between the late 1960s and 1985, with one exception (Husain's *Man*, included in the Grey show) from 1950. This focus, caused in part by the collecting practices of the Herwitz family, becomes codified in the discipline as valorizing a particular generation of artists. In addition, the lack of existing critical discourse among scholars and critics in North America left curators without models to rely on. In a refreshingly frank discussion of this problem, one Festival organizer at the Smithsonian characterized it as a "glaring lack of people who have been able to pull together and analyze in any objective or illuminating way the issues and problems relating to contemporary Indian visual arts."[49] Where Britain drew from a wide range of interlocutors and reacted to vocal challenges from activists in support of presenting contemporary India, the galleries in the U.S. that chose to stage shows of contemporary Indian art offered a narrower range of explanatory texts for the works, couched in language and presuppositions already circulating about India, its spirituality, and its visual culture. Their repeated and overlapping reassertions of difference in the exhibitions and catalogs instantiate and maintain a distance between India's contemporary art and Euro-American contemporary art.

What kinds of aporias do these shows introduce? Where are their silences? Important painters like F. N. Souza (1924–2002), a founding member of the Bombay Progressive Artists' Group, did not appear in any of these shows.[50] Sculpture, as Sokolowski notes, is entirely missing, eliminating artists seen in some of the earlier British shows like Anish Kapoor (b. 1954), Mrinalini Mukherjee (1949–2015), and Dhruva Mistry (b. 1957).[51] Even the *Neo-Tantra* show omitted sculpture, despite the inclusion of Balan Nambiar's (b. 1937) metalwork and K. M. Gopal's (1928–2000) relief panels in the Stuttgart exhibition.

Aesthetic choices produced further gaps, most notably in the absence of the geometric ink and pencil drawings by Nasreen Mohamedi (figure 5.11), the somber, melancholy palette of Ganesh Pyne (figure 5.12), and the nudes of Rameshwar Broota (b. 1941). Abstraction appears only in relation to a Tantric idiom, even in the Grey and Phillips shows, where Raza's work sits uneasily next to a group of figural paintings (figure 5.1, plate 16). And the masculinist character of these exhibitions becomes clear, sometimes due to the very same aesthetic choices above, eliminating key women because they were sculptors (Mukherjee) or pursuing a path of abstraction that did not fit the sought-after aesthetic of the exhibitions (Mohamedi). The Grey put on view two works by Rekha Rodwittiya (figure 5.13, plate 20), the only woman artist in all three shows, even though the Herwitzes owned works by some prominent rising stars of India's art scene who happened to be women.[52]

Even before these decisions were made, the choice to feature the most contemporary art (as Sokolowski put it) eliminated at least fifty years of Indian art from the Festival, including the work of well-studied Indian artists such as Amrita Sher-Gil (1913–41), Rabindranath Tagore (1861–1941), Abanindranath Tagore (1871–1951), Gaganendranath Tagore (1867–1938), Nandalal Bose (1882–1966), and Jamini Roy (1887–1972).[53] The Phillips considered staging a show focused on this period but decided against it, even though the Herwitz collection contained works by many of those earlier figures. Several Festival

FIGURE 5.11. Nasreen Mohamedi (1937–90), *Untitled*, 1980s, ink and pencil on paper, 20 × 19⅞ in. (50.8 × 50.5 cm). Peabody Essex Museum, Salem, MA, E301261. Artwork © Estate of Nasreen Mohamedi; photograph provided by the Peabody Essex Museum.

exhibitions displayed objects from the colonial era, examining maritime trade between India and the U.S. and displaying European views of the subcontinent (Bean 1985; Pal and Dehejia 1986). But the early twentieth-century period did not appear in the Festival exhibition schedule at any point.[54]

The broader museum and gallery context of the mid-1980s may offer a partial explanation for these absences. For example, while the urban North American gallery scene had begun to incorporate the work of women artists, they were underrepresented in major collections, a subject of vocal activism and protest (Heartney 1987; Singerman 2009; Pollock 2010). The strength of 1970s feminist art activism had not made a significant impact on the mainstream, as evidenced by the formation of the Guerrilla Girls—in the very same

FIGURE 5.12. Ganesh Pyne (1937–2013), *The Rag Picker*, 1979, watercolor and pencil on paper, 10¾ × 13¾ in. (27.3 × 34.9 cm). Peabody Essex Museum, Salem, MA, E301108. Artwork © Estate of Ganesh Pyne; photograph provided by the Peabody Essex Museum.

year as the Festival of India (1985)—to protest, among other things, the lack of women artists at the Metropolitan Museum of Art, New York, and the wage differential between male and female artists (Heartney 1987; Withers 1988; Saks et al. 2012). The decade marked a period of rapid transition: by 1987, New York dealer Patricia Hamilton commented that "it's getting to the point where you can't *not* show women. You look like a jerk" (in Heartney 1987, 142). However, while by the late 1980s institutions were challenged to collect and display the work of women artists, the Festival of India planning occurred in the first few years of the decade, and organizers perhaps did not feel pressure to consider gender as centrally. Although archival records for the Wight exhibition indicate a concern for gender balance in the selection of artists for the supplemental slide show that illustrated the broader range of contemporary Indian art, the organizers did not select the work of any female artists for the show itself, largely because there were few, if any, women working in the Neo-Tantric mode.[55]

The works themselves also occupied a narrow range, as they were almost entirely painting with the lone exception of Somnath Hore's paper relief sculptures. At a time when the materiality and dematerialization of contemporary art was in the foreground

FIGURE 5.13 (Plate 20). Rekha Rodwittiya (b. 1958), *How Naked Shall I Stand for You*, 1986, watercolor, gouache, pencil, and pastel on paper, 72½ × 41¼ in. (184 × 105 cm). Peabody Essex Museum, Salem MA, E301281. Artwork © Rekha Rodwittiya; photograph provided by the Peabody Essex Museum.

for art communities in the northern Atlantic, and had been for some time, these shows offered little in the way of material experimentation. One can read this as having the potential to reclaim painting for a 1980s context, reasserting the importance of this mode of art making for a global audience. But it also signals that the organizers overlooked the films of Tyeb Mehta and M. F. Husain, the photography of Homai Vyarawalla, Sunil Janah, and Jyoti Bhatt, and the work of many artists working in a range of three-dimensional media, from metalwork to ceramic to concrete.[56]

The 1980s also experienced a shift in funding for museums generally and university museums in particular. University art museums began rewriting their mission statements

in the mid-1980s to address a change in emphasis from objects and collections to audiences and education.[57] As university museums, the Grey and the Wight could and did stage these Indian contemporary art exhibitions as novel, esoteric, or unexpected bodies of work, but they did so as similar venues began to feel funding and audience pressure that hampered their ability to pursue just such kinds of innovative projects.

The legacy of these choices and the narrow range of these exhibitions remain central to our understanding of Indian art. Today, a generation later, the core of the Herwitz collection represents the only public collection of twentieth-century Indian art in North America, housed at the Peabody Essex Museum, in Salem, Massachusetts (Bean et al. 2013). Just as the Herwitz family financially and intellectually supported the exhibition of twentieth-century Indian art in the 1980s Festivals of India around the world, so their collection continues to define Indian art of this period, shaping everything from which artists are considered the most important to how guide prices are determined at auction houses in Europe, North America, and Asia. In turn, those factors influence the collecting practices of many North America–based collectors of this material, reinforcing a certain narrow range for legitimate Indian twentieth-century art (Desai 1995; Gaur and Sinha 2002).

Slowly, academics and curators are beginning to pursue other questions, working to find another path through the productive problems, negotiations, and struggles that permeate the art of twentieth-century India. Some have situated these works in historical, political, economic, and art historical contexts, doing so at the micro-level of, for example, the week-long exhibition of Group 1890 in 1963, or at the macro-level of Nehruvian non-aligned global politics and the Cold War. The approaches of the shows staged in Britain's 1982 Festival of India offer precedent for thematic, art historically critical frameworks. Some of the essays in the three American catalogs make small gestures toward these issues. Overall, however, they remain mired in discussions of form that highlight the "Indic" qualities of the work while suggesting connections to European and American art, a strategy that encourages comparisons in which the Indian artist always falls short.

DISTANCE AND THE PERPETUAL INTRODUCTION

In 2008, the *Art Bulletin* published a set of essays responding to a provocation by Partha Mitter regarding the position of modernist art "from the periphery." Moving from an analysis of the pseudo-elevation of African art through its formal "affinities" with European modernist art in the 1984 show *"Primitivism" in 20th Century Art* at the Museum of Modern Art to a characterization of non-European modernisms as always hampered by a "Picasso manqué" syndrome, Mitter's essay reads India's turn to primitivism as an anti-colonial, political move, situating it in the global politics of the early decades of the twentieth century. The responses to his essay concur that art history remains at an impasse when it comes to reconfiguring our understanding of twentieth-century art, not merely to acknowledge a multiplicity of modernisms (all lesser than the unmarked [European]

modernism) but also to take up the "challenge of transnational art, calling into question the 'purity' of the modernist canon and the consequent imputation of the derivative character of the periphery" (Mitter 2008, 544). In continuing to deploy these terms, however—"pure" and "derivative," "center" and "periphery," "ahead" and "behind"—academics and curators maintain that distance so crucial to the construction of the three exhibitions of contemporary Indian art discussed here. To bring India's "contemporary" art closer to the audience, organizers had to establish and maintain a distance from the norm, staging India's outsider status even as they deployed the term "contemporary" to bridge that constructed gap.

The paired demand to bring audiences into the galleries, often through playing on existing preconceptions of distant places or exotic belief systems, and to bring India's contemporaneous art into the fold of contemporary art, often through the rather weak gesture of simply using the term "contemporary" in exhibition materials, created a double bind that shaped the Festival of India shows. The "distant contemporary" remains an omnipresent organizing principle today in the few exhibitions of twentieth-century Indian art in Europe and North America, as well as of art of (ostensibly) comparable areas of the world. The past twenty-five years has brought a shift in terminology, such that these once "contemporary" works are now considered "modernist." But in a productive sense, the shift has spurred critical engagement with the very terms used to discuss India's twentieth-century art. Scholarship has taken up the task of retheorizing the tenets of modernism in the context of both early and late twentieth-century art of the subcontinent and the global contexts of anticolonial struggles, the Cold War and nonalignment, and the rise of religio-political tensions. Geeta Kapur's clarion call to take up the question of the temporality of modernism for "Third World" art extends also to current scholarly reconsiderations of the contemporary, as scholars have noted the interpenetration of modernist approaches with countermodern, postcolonial, and deconstructive ones, claiming Rabindranath Tagore's drawings and Tyeb Mehta's films as markers of a contemporary sensibility coeval with modernist engagements across the twentieth century.[58]

For the Festival exhibitions of the mid-1980s, these scholarly endeavors had yet to come to fruition, such that situating these works in a nuanced landscape of transnational and local (art) histories remained outside the scope of these shows. That S. H. Raza lived and painted in France for his adult career; that Neo-Tantric artists responded to movements constructed in relation to European and American demands that India present itself as spiritual; that India's artists, like visitors to these exhibitions from the U.S., lived under the constant threat of nuclear war; that economic legacies of colonialism continued to produce asymmetries of access to particular media and particular buyers—these complicated interwoven strands of biography, history, and politics are smoothed over in the three exhibitions from 1985 to 1986, a time of little scholarship and research on India's twentieth-century art. In Mitter's formulation, we are left with either formal affinities (following the *Primitivism* show) or artists falling short of their European counterparts

(Picasso manqué). That these absences continue today, in the face of a growth of scholarship and discourse regarding global and transnational art histories, should be cause for concern. The legacy of these three contemporary Indian art exhibitions now needs to be unpacked and rethought.

Innovative thematic exhibition strategies can be found in recent curatorial projects related to twenty-first-century global and transnational art, and newly emerging artists from the so-called Global South have ridden the wave of biennials and multinational auction houses and galleries to worldwide fame and acceptance. Nonetheless the exhibitionary narrative for global art of the 1960s through the 1980s has yet to move beyond the distantiated temporality found in the three Festival exhibitions. One can find exceptions to this, however, and those exceptions reveal an emergent emphasis on particular, digestible elements of these decades. For example, a growing body of scholarship on multi-sited nodes of interaction and conversation—from the dispersed, postal, and yet participatory work of the Gutai group of the 1950s to the 1970s to the contentious and lively messiness of the 1980s Havana Biennials—slowly builds a foundation for reconceptualizing this exhibitionary period (Tiampo 2011; Mosquera 1986; Weiss 2007; Rojas-Sotelo 2009). But Gutai and the Havana Biennials already have a place within the canonical narrative centered on New York and Paris. Gutai, for example, is often subsumed (reductively) into a global shift toward happenings or a simple connection with George Macunias and Fluxus; recent exhibitions and publications have productively complicated this narrative but the museums that staged them did so knowing that Gutai was already something familiar to a New York audience (Tiampo 2011; Tiampo and Munroe, 2013). Similarly, one sees the valorization of *particular* aesthetics from this period, often reliant upon the formal language of abstraction or nonrepresentational art. Minimalism and Constructivism find cognates in Brazilian midcentury art, and geometric abstraction too has its familial relations in Islamicate and other contexts. Despite an overwhelming focus on global contemporary art of the last ten years (or the last two years), some exhibitions of India's midcentury modernists have broken through into the mainstream art museums of New York: the Guggenheim staged a retrospective of V. S. Gaitonde (1924–2001) in 2015, and the Metropolitan Museum of Art's Breuer Building opened in 2016 with a retrospective of Nasreen Mohamedi's work (Poddar 2014; Pineda and Rodríguez, 2015). Both signal a healthy interest in the modernism of 1960–85 in the subcontinent, but both also establish the parameters by which that modernism might be accepted within the mainstream. Work must be formally nonrepresentational, must be visually assimilable to familiar movements and artists from the northern Atlantic, and must not challenge viewers to understand complicated iconographies, histories, or regional political references.[59] Indeed, reviews of Mohamedi's show note that her inclusion does not challenge the Met's existing framework: "Mohamedi fits almost too neatly into established art historical narratives, allowing the Met to avoid questioning the functionality of the narratives themselves. . . . Mohamedi could've been included in the Met's galleries at any time—we didn't need a reboot for that to happen" (Vartanian 2016).

In some ways this perhaps signals a turn from difference to assimilation: only those artists whose work can be situated in an existing canon of Euro-American art can be included. And the turn to the similar might reflect our contemporary condition, in the sense that we live in a time that celebrates a leveling globalization that seeks to validate the world as everywhere the same. Drilling down into these exhibitions, however, reveals a significant undertow of difference. In the Gaitonde show, for example, his work was rightly situated in his physical location in the subcontinent, and curatorial text also included reference to various textual and spiritual interlocutors from South Asia. But a show like Gaitonde's finds its foundation in a sameness that does its own damage to a narrative of global modernism. Thus three decades after the Festival of India, we see a slight shift in the consideration of twentieth-century Indian art, but it remains restricted by the limitations felt by curators and museum administrators to build a bridge to an audience unfamiliar with the wider art world during these decades. Ironically, then, the exclusion of Mohamedi's work from the two Herwitz exhibitions positions them as potentially more groundbreaking, or certainly more challenging, than the shows staged in the last few years focused on modernist Indian art.

Just as these three Festival shows moved India's art away from the ethnographic section of nineteenth-century exhibitions while they also presented a particular "now" of India's visual culture unseen in other Festival shows, could curators and academics today shift India's modernist and contemporary art into new spaces and new temporalities? Could they find a new way of exhibiting that eschews the call for temporal, spatial, and conceptual distance in favor of a more finely textured understanding of the global interrelations, asymmetries, and exchanges that produced a range of art around the world? Instead of perpetually introducing, could we present material in medias res, offering a small, focused, thematically or historically driven piece of a larger complex narrative? Perhaps this challenge affords an opportunity—not just for scholars working on South Asian art but also for those examining art and artists whose work is marked by locations in Europe and North America, Africa, South America, the Middle East, Central and East Asia, and the Pacific. In small university galleries and smaller museums these experiments are beginning to occur, and a nascent critical discourse has begun to take shape in catalogs, dissertations, newspaper reviews, and writings by artists themselves.[60] One hopes that in another twenty-five years, the narrative of twentieth-century modernism will look different, acknowledging the contributions of female artists worldwide as well as the crucial and formative engagements of artists working at the reconfigured heart of the modern, in places like Vadodara, São Paulo, and Talinn. With the exponential growth of interest in twenty-first-century transnational, global contemporary art, the art of the late twentieth century must be included in this larger reevaluation so that we might seek out new exhibition strategies and scholarly frameworks, not only for recent art of the globe but also for the twentieth-century material.

The mid-1980s offered a particular conjunction of factors that facilitated the production of these three exhibitions of contemporary Indian art, with their shortcomings and

their innovations. The need for a perpetual, ongoing introduction to the ever-moving target of "contemporary" art from India underscores the dynamic, eclectic, and difficult-to-pin-down moment of postperiodization Smith points to in his analyses of this important decade. I find Sokolowski's metaphor of "playing a volatile stock market" quite fitting. He employed it to describe the process of choosing works for exhibitions of non-Euro-American contemporary art at this time—from India, from Cuba, from Eastern Europe, and from other regions around the world. It works historically as well—as I discussed in the chapter "Entrepreneurial Exhibits," the 1980s saw the entrenchment of economic models based on speculation and presumptions of eternal growth of capital; the risks and rewards of Wall Street here extend to a similar feeling of giddy speculation in the construction of exhibitions of contemporary Indian art. Many of my interlocutors noted in conversation that the Festival of India could only have happened at the end of the Cold War, when two superpowers vied for influence in the subcontinent and when funds for things like cultural programs still flowed from government coffers. I would add that the 1980s moment—when these artists still labored in relative obscurity, when the twenty-first-century international art market with its art fairs and on-line auctions had yet to direct curators and scholars to "important" works and artists around the world—this mid-1980s moment of hesitancy, potential, and risk enabled these three contemporary shows in all their messiness and eclecticism, even as they attempted to limit the threat of their contemporaneity with the promise of distance.

CHAPTER 6

Setting Up the Tent Anew

THE temporal resonance of these exhibitions continues after the 1980s in readers' engagements with the catalogs for these shows, in scholars' poring through archival material, in audiences' peering closely at the installation images, and in our collective listening to the memories of those who created and visited the Festival of India.[1] These recursive moments extend to the writing of this book and the readings that it might generate. As such, the metaphorical tent continues to be staked and set up, folded and struck down, patched and restored, added to and re-formed.

I opened this book with two tents, both at the Metropolitan Museum of Art, one historical and one fanciful. The tents, while they shelter certain objects, are also only fragments of the larger exhibitions they inhabit. If the Festival (in the metaphor I stake out in chapter 1) is a large set of overlapping tents, then these exhibitions are themselves tents, occasionally housing actual tents, next to and jostling with the larger encampment. Let me turn to Frei Otto's tent in the *Golden Eye* exhibition to rearticulate the range of temporalities addressed in this book, the questions that the book raises for future considerations for the exhibitionary complex in the 1980s, and the transformations the Festival presages in the subsequent decades.

Otto had long been interested in roofs and in experimentation with tensile structures. For *Golden Eye* he wanted a tent that operated like an umbrella; Rajeev Sethi suggests that Otto was inspired by the heavily decorated umbrellas carried by young prospective grooms at the annual Tarnetar Mela in Gujarat.[2] Otto might also have been drawing on earlier work he had done in Gujarat that produced his so-called Sarabhai tent, a portable, tensile structure that could withstand wind and heavy snow and provide adaptable shelter in a wide range of climates.[3] He worked with a variety of Indian craftspeople including the embroiderer and quilting artist Tejiben Makwana (b. 1945) from Gujarat, who appliquéd mirrors onto the interior to replicate the twinkling of stars when a lamp or candle was lit inside.[4] But Tejiben (as she is known) was not the only artist working with Otto.

The paintings on the exterior of some of the tent panels were done by Piraji Sagara (1931–2014), an Ahmedabad-based artist who had been trained at the Sir J. J. School of Art in Mumbai, taught at the School of Architecture at the Centre for Environmental Planning and Technology in Ahmedabad, and drew on a wide range of sources for inspiration, from Buddhist philosophy to contemporary scientific discoveries and European modernism. Lalith Sharma and his father, Ghanshyam Sharma, decorated the tent in the style of *pichhāvai* paintings from Nathadwara; T. Mohan painted panels as well, in a *kalamkārī* mode. Otto also designed furnishings, tableware, and cutlery to go into the tent, working with an additional range of ceramicists, leather workers, carpenters, and specialists in damascening. As one of the Ahmedabad-based architects who worked with Otto remarked, "The Otto tent is a token of team spirit in today's India."[5] These figures were a mix of those pursuing and expanding upon so-called traditional craft, those trained in major art and engineering institutions, and a range of interlocutors and mediators who facilitated communication and the exchange of ideas and samples within India and across the globe. The canvas of Otto's tent, the bamboo poles, the mirrorwork, the delicately incised cutlery, the folding chairs and table—these involved an extensive and dispersed team working on different aspects to transform materials into the many elements that make up "the Otto tent."

In the installation photographs of *Golden Eye*, the tent serves as a dramatic centerpiece, its colorful exterior drawing the eye and its interior inviting visitors to imagine themselves enjoying a meal while seated in the sparkling, colorful, intimate space (see figure 4.11, plate 12). Indeed, the tent might evoke in some viewers scenes from colonial nostalgia films popular at the time, which often featured the luxurious tents of imaginary sultans and princes as set pieces. The encouragement to fantasy extended to the flow of the galleries themselves. In the press guide to the exhibition, one moves from the Fantasia Room, through the Sand Gallery, into the Forest, and then into the Tent Room, the culmination of one's path through the exhibition spaces, the last to be listed in the guide.[6] The Otto Tent thus inhabits and defines the Tent Room, a room that also includes the installation of Bernard Rudofsky's shoes and shoe lasts under a charpoy, Mary McFadden's dress designs, and Hans Hollein's wood screens inlaid with mother-of-pearl.

The physical fabric of Otto's tent is itself also dispersed, as he commissioned additional panels that hang from the ceiling in the gallery, demonstrating the range of designs one might commission were the tent to move from its current status as prototype to something that might be in wider production, perhaps sold in Bergdorf Goodman's India display. As such, the tent here serves as visual and spatial anchor, but also looks to the future, anticipating its own potential reworking into a commercial object, circulating in slightly different display contexts, summer homes, and back gardens. Its components are movable and malleable, and its decoration can derive from traditional modes of painting, such as that used in Indian temple hangings in Rajasthan, from modernist engagements with abstraction, or from patterns derived from decorative dying techniques

practiced across western India. Otto's tent is not whole or complete—it continues to be imagined, reopened, redecorated, and redirected to different aspirations and futures.

Its decorations reinforce this underlying thematic of movement, repetition, potentiality, and aspiration. On the main tent, horses twist and cavort up the side of each panel, their legs entwined in vegetal designs and their dynamic dance joined by lizards and birds. Inside the tent, the ghostly echoes of these same figures envelop anyone who might pull a leather folding chair up to the table. The combination of these designs, Tejiben's mirrors, and flickering candle or lamp light would put it all into motion, both for those on the interior and for those viewing the tent from the outside.

These dynamic, flowing surfaces extend to other pieces of the tent as well. One of the two additional sections of decorated canvas tent in the corner depicts a lush green forest against a cream background that curves toward the apex of the tent; the dynamics of this color range, when combined with the tent in active use, would mean a glowing sky for those seated inside and the silhouettes of the tent's inhabitants projected on its walls (figure 6.1). The other tent panel carries an illustration of a village at night, a scene which features in the brief guide to the exhibition: "In the *kalamkari* [dye-painted] panel, a traditional temple painter has depicted his aspirations for his newborn son's future, envisioning him as a scientist and astronaut who will travel to the moon."[7] An aspirational, future-oriented wish, one that offers further layers of temporality to those already at play in the making, setting up, inhabiting, viewing, and imagining of the tent.

For the 1980s, one might see Ettore Sottsass's table (figure 4.9, plate 11) as the quintessential exemplar of pastiche, destabilizing expectations of materiality and playing with the relation between decoration and shape. But Otto's tent, even though it bypasses the geometric and bold colors of the Memphis group, offers up similar kinds of temporal and combinatory aesthetics, thereby participating in the flow of partial, fragmented, citational elements characteristic of this period. Thus, while Otto experiments with natural tensile strength, pressing the umbrella into service as a larger roof form, he also moves beyond a clean blank surface to one of painted decoration. The tent builds on a wide range of previous precedent in terms of form, decoration, and the mode with which it was conceived; it thereby takes part in the aesthetic and engineering design conversations current in the mid-1980s. And it does not shy away from incorporating so-called traditional modes of decoration, nor from encouraging experimentation from the artists who participated, including the damascene craftsman who made Otto's cutlery: "There was a great dialogue between Frei Otto and Gopi Lal (a *lohār* [blacksmith] from Udaipur). Otto was amazed by Gopi Lal's work; Gopi Lal had developed the designs far beyond what he had thought possible."[8] Just as Rajeev Sethi had encouraged the artists at *Aditi* to stay true to their "tradition" while encouraging experimentation, so these dynamics permeated *Golden Eye*.

In Otto's tent, we see a turn to the material, a recognition of craft, an intimate relation to the past and to vernacular culture, reworking old sources into something new, and into something that might extend to future encampments. Otto's tent, like almost all of the

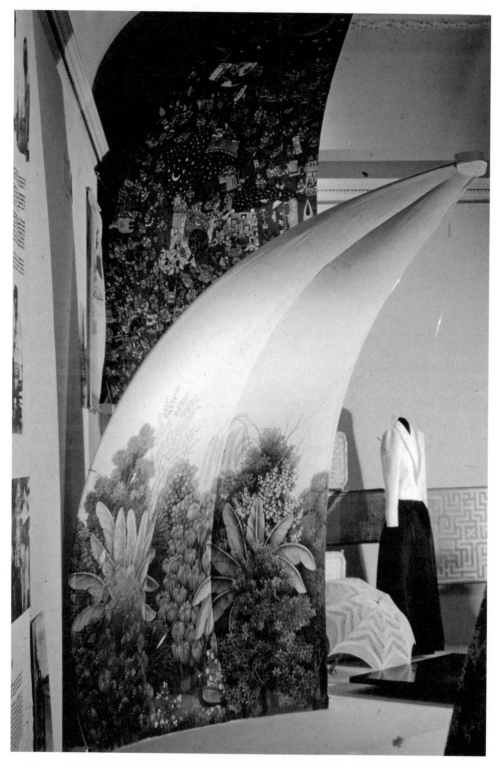

FIGURE 6.1. Corner of the Tent Room, *Golden Eye* exhibition, with panels of Frei Otto's tent and a Mary McFadden dress. Cooper Hewitt, Smithsonian Design Museum.

prototypes made at *Golden Eye*, did not go into production. And so it also gives us a moment of interrupted potential, almost as if the momentum for this government-led program to join craft and design hesitated, only to be taken up in the following decade by private "entrepreneurs" in their workshops and by craftspeople like Gopilal Lohar and Tejiben Makwana in their ongoing work for both Indian and global audiences.

In the 1990s, one sees a shift—in India and the U.S. but also elsewhere around the world—from grand, government-funded initiatives and collaborations like the Festivals of India to private-public partnerships and corporate-funded exhibitions, biennials, and art fairs, often populated and driven by private galleries and individual investors. The moment of hesitancy in the 1980s that I described in the previous chapter remade itself in the subsequent decades as multinational corporations, nongovernmental organizations, and commercially grounded fair trade initiatives took over the conversation. Everyone I spoke with who had worked on a part of either the U.K. or the U.S. Festival remarked on how exceptional they were, and how Festival-scale, multi-sited events and government-driven joint efforts could not happen now and would not happen again. The grand, nation-centered festival with its similarly grand promises of cultural diplomacy and intergovernmental understanding no longer drive politics or the governments that participated in these efforts in 1985.

This narrative of the uniqueness of this moment and the Festival exhibitions often came with a second underlying story particularly related to the circulation of art objects around the world. Never again would loans like this be granted by Indian institutions, as the experience of these international festivals in the 1980s had put a bad taste in the mouth of the Indian art world. Some objects, it was argued, were damaged during their journey to the U.S. The Didarganj Chauri-Bearer (second century CE) was one of the most famous examples in this regard, generating great controversy when the sculpture came back to India from the National Gallery in Washington, D.C., with a chip missing from its face (see Davis 1997; Guha-Thakurta 2004, 205–33; 2007, 649–51).[9] To see it now, one must travel to the Patna Museum in Bihar. But these hesitations and patterns of distrust had long existed prior to the Festival, and they directly affected Festival exhibitions. The National Gallery exhibition, for example, opened without several of the southern Indian, Chola-era bronzes included in the catalog and even on its cover. Their delay was the result of maneuvering in the state legislature of Tamil Nadu and a legal block put in place by the Madras High Court "on the grounds that these were 'religious objects housed in temples,' and that their travel abroad would 'offend the sentiments of worshippers'" (as quoted in Guha-Thakurta 2007, 642). The Rampurva Bull capital, dating to the third century BCE and housed at the Rashtrapati Bhavan in Delhi, did not travel to the National Gallery despite its position in a governmental collection.

An additional slight came in the form of the lack of reciprocity Indian institutions experienced in the aftermath of the U.S. Festival. A "Festival of the United States in India" was proposed for 1984, but only a handful of performances occurred during the year.[10] Letters and memos in the files of many of the Festival exhibitions discuss the makeup of

reciprocal shows of American art coming to India. Follow-through on such discussions was rare; in a key exception, the curators of the UCLA *Neo-Tantra* exhibition organized and, in 1988, staged an exhibition of American painting at the National Gallery of Modern Art in New Delhi entitled *Visions of Inner Space: Gestural Painting in Modern American Art* (Dubin 1987). But the overwhelming pattern was to forgo sending any works to India, even in the face of the fact that India had sent its treasured objects to the U.S. In the end, few of America's art treasures traveled to the subcontinent.[11]

But the fault lies not entirely on the shoulders of those who failed to send exhibitions to India in the aftermath of the Festival. The mid-1980s was a moment for both India and the U.S. when the economic, political, museum, and art history worlds aligned to produce this group of exhibitions. In part this was due to the friendliness between Indira Gandhi and Ronald Reagan, a rapport that had not existed with prior presidents. The loosening of the economy in India and Gandhi's own reconsolidation of power after the 1975–77 Emergency created a moment ripe for big diplomatic gestures. And the friendship between Pupul Jayakar, India's Festivals chairman, and Indira Gandhi facilitated the link between the cultural and governmental sectors. The museum world embraced the spectacular, single-focused exhibition in the wake of the wildly successful Tutankhamen show of the late 1970s, and this too paved the way for the Festival of India's major exhibitions.

The North American curatorial profession was also shifting during this decade. Many of the curators who worked on the Festival exhibitions did not hold a PhD in the discipline; most had master's degrees, a norm at the time even at major museums. In the decades since, the professionalization of the museum has meant that a PhD has become a requisite curatorial qualification. The organizers of exhibitions in India had a wide variety of training and experience, some with degrees in anthropology or archaeology and others with history training. The study of art history as its own discipline had not yet emerged in Indian higher education; the fine arts school at Maharaja Sayajirao University in Baroda (now Vadodara) offered art history lectures for its studio students, and history departments often included visual and material culture as part of the curriculum. Curators and keepers of collections in India today often still bring a mixture of disciplinary outlooks and experience to these positions. The institutional shift in India happened instead in terms of the type of entity that enabled partnerships with North American museums: a shift away from state-funded museums to privately funded galleries and individual collectors. The Kiran Nadar Museum of Art (KNMA) in Delhi, for example, showcases contemporary and modern art from the Nadar collection in a large space housed inside one of Delhi's mega-shopping malls, and organizes exhibitions that bring together material from a wide range of collections. The KNMA, with perhaps greater nimbleness than its state-funded counterparts, pursues collaborations with museums around the world, including the Metropolitan Museum of Art in New York.[12] This reorientation toward the private sector, combined with the normal difficulties of negotiating loans with archaeological museums and state-run institutions, has discouraged the curators of North American museums from planning exhibitions dependent on loans from India.

A shift in the geographic range of art history was also under way in the 1980s, one that saw a generation of scholars moving into newly created Asian art history positions. While larger art history departments in research universities housed a few positions in South Asian art history, in the 1980s, smaller and medium-sized departments across the U.S. that had previously focused solely on European and North American art now expanded to include scholars whose research focused on a wide range of regions, following the pattern of the Cold War Area Studies programs across the U.S. This expansion fed debates over multiculturalism inside and outside of the academy alongside critiques of the Area Studies model, a model tainted by its underlying encouragement of research that might assist in winning the geopolitical cold and hot wars between the superpowers, wars that were often fought in arenas studied by Area Studies scholars. Combine all of this with the concurrent celebration of India's colonial past in various popular media, the rising critical engagement with Orientalism in the wake of Edward Said's 1978 book, the broader uptake of deconstruction within academic discourse, and the rise of black and "Third World" feminist theory, and the landscape looks ripe for a reassessment of India's art history through these Festival exhibitions and other events across the country.

A final thread winds its way through the mid-1980s moment: the growth and consolidation of a South Asian American community in the U.S. In the aftermath of the 1965 Immigration and Nationality Act, a much greater number of professional and skilled immigrants came to the U.S., including a large cohort from India. In 1985, their American-born children were coming to maturity, and many narratives during the Festival recount the ways in which these exhibitions and performances opened up a new way for teenagers to see their own Indian heritage. Some of these teenagers went on to study South Asian culture and to pursue graduate work in the field. The volunteer translators for *Aditi* came from D.C.'s surrounding South Asian immigrant population, and the Festival served as a spark for the development of community-based organizations as well as partnerships with museums and arts organizations. Indeed, a particular conjunction of developments in international state relationships, the professionalization of curators in North American institutions, the importance of state museums in India, the personal connections between leaders in government and cultural sectors, and the generational shift in the South Asian American community all came together to support and produce the Festival in its many and varied forms.

These are the grand narratives of the 1980s, a time of dispersal, fragmentation, nostalgia, neocolonial politics, and neoliberal economics. And in the 1990s the fabric of that decade shifts slightly and is remade into a new tent, of slightly different decoration and made by slightly different actors. This book has sought to read the textured minute moments of these grand narratives in order to unpack the tent, smell the dust and mold, and touch the embroidered, mirrored surface. The small moments of performance or demonstration, fragments of process, of waiting for the kiln to finish or the perfect piece of broken ceramic to appear, of being on the road—these layered durations are crucial for understanding the ways in which the exhibitionary fabric of the decade engaged visitors,

objects, and participants. And they help us to see the changes to come in subsequent decades because they are thoroughly implicated in bigger historical flows. The story of cultural diplomacy or of governmental exchange happens in the minutiae of shoe lasts, *kalamkārī* paintings of space travel, and the creativity of a damascene artist.

The Otto tent sits in the gallery, its dispersed panels and multifarious objects housed within and around it, its horses climbing up the canvas, a sun shining from its walls. It is installed by a team of Indian designers alongside curators from the Cooper Hewitt and with the guidance of the visionary Rajeev Sethi. It reaches back in time to earlier Otto designs, outward to new source material in Rajasthan's regional matrimonial festivals, and upward to space. It has the potential of a prototype embedded within, and it repeats itself across the gallery even as the horses on its surface gallop over one another. It could not have been made without the sourcing of the bamboo framing poles, the travel to Ahmedabad and Gujarat, the conversations with Gopilal, the tanning of buffalo leather, the quilting of Tejiben. Its display depends on the work of lighting designers who spent hours making the mirrorwork on the interior sparkle. It comes to us via installation photographs, textual descriptions, memories of those involved, and my own writing in this book. As such it is a tent within a tent, pitched next to and in conjunction with other tents. This folding over, citation, ghostly return, and deconstruction of the fabric of these exhibitions remains forever open, resisting holistic theorization and grand narratives so as to focus on the process, the transformations, and the do-ing at play in these exhibitions in and of the mid-1980s. People say they could never happen now. But they continue to happen, continue to play out their moments of interruption, waiting for a new reader and a new writer to open the tent flap, see the mirrors sparkle, and stake out the exhibition again.

PLATE 1 (Figure 1.1). *India! Art and Culture, 1300–1900* installation view with Mughal tent, mid-seventeenth century, silk velvet, embroidered, with metal-wrapped yarns and cotton, 152 × 297 × 294 in. (380 × 742.5 × 735 cm). Object in the collection of Mehrangarh Museum Trust, Fort, Jodhpur, on loan from Maharaja Sri Gaj Singhji II of Jodhpur (L21/1981). Photo by Al Mozell. The Metropolitan Museum of Art, September 14 1985–January 5, 1986, Special Exhibition Galleries. Image © The Metropolitan Museum of Art. Image source: Art Resource, New York.

PLATE 2 (Figure 1.2). *Costumes of Royal India* installation view with tent. The Metropolitan Museum of Art, December 20, 1985–August 31, 1986, The Costume Institute Galleries. Image © The Metropolitan Museum of Art. Image source: Art Resource, New York.

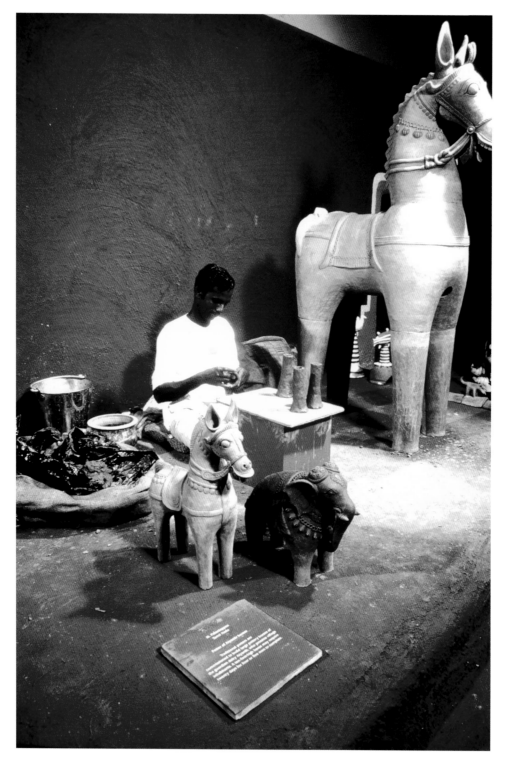

PLATE 3 (Figure 2.3). M. Palaniappan in *Aditi: A Celebration of Life*. National Museum of Natural History, Smithsonian Institution. June 4–July 28, 1985. Smithsonian Institution Archives. Accession 97-012, box 5, folder: Aditi–A Celebration of Life Clippings and Slides, folder 2.

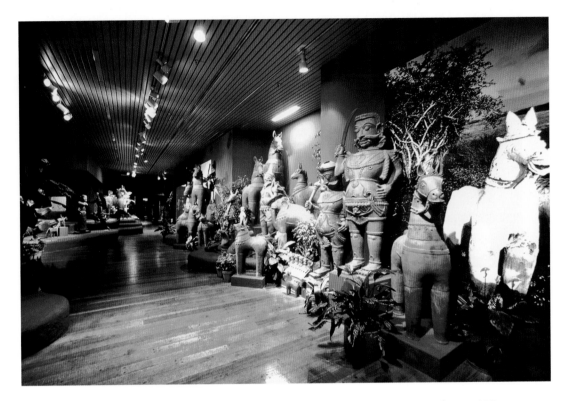

PLATE 4 (Figure 2.6). Installation view of *Aditi: A Celebration of Life*. National Museum of Natural History, Smithsonian Institution. June 4–July 28, 1985. Smithsonian Institution Archives. Accession 97-012, box 5, folder: Aditi–A Celebration of Life Clippings and Slides, folder 2.

PLATE 5 (Figure 2.11). Nek Chand (1924–2015), *Three Ladies Fetching Water*, Chandigarh, India, c. 1984. Glass bracelet fragments, porcelain tableware fragments, and cement, on mortar and iron armature. From left: 27 × 10 × 4 in. (68.6 × 25.4 × 10.2 cm); 32 × 11 × 4 in. (81.3 × 27.9 × 10.2 cm); 31 × 11 × 4 in. (78.7 × 27.9 × 10.2 cm). Collection American Folk Art Museum, New York, Gift of the National Children's Museum, Washington, D.C., from the Capital Children's Museum Nek Chand Fantasy Garden, in honor of Gerard C. Wertkin, American Folk Art Museum director (1991–2004), 2004.25.2, 11, 10. Photograph by Gavin Ashworth.

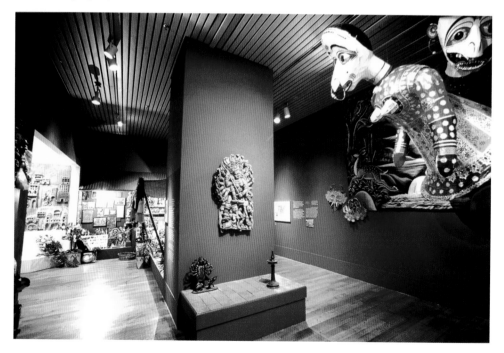

PLATE 6 (Figure 3.1). Overview of first gallery, *Aditi: A Celebration of Life*. Smithsonian Institution Archives. Accession 97-012, National Museum of Natural History, Office of Exhibits, Special Exhibition Records, box 5.

PLATE 7 (Figure 3.6). Amina Bai Ismail Khatri seated in her "veil maker" niche, *Aditi* exhibition. Smithsonian Institution Archives. Accession 97-012, National Museum of Natural History, Office of Exhibits, Special Exhibition Records, box 5.

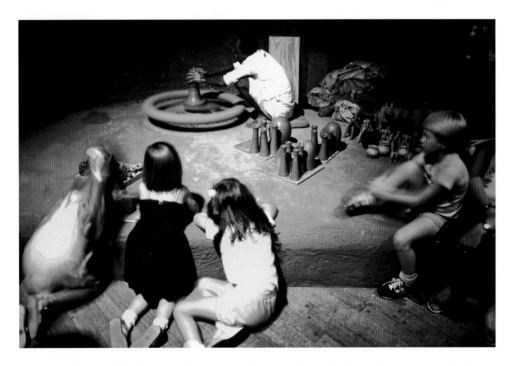

PLATE 8 (Figure 3.7). Jhithru Ram Kumhar, seated in the "tribal potter" area, demonstrating his Bastar pottery, with children looking on, *Aditi* exhibition. Smithsonian Institution Archives. Accession 97-012, National Museum of Natural History, Office of Exhibits, Special Exhibition Records, box 5.

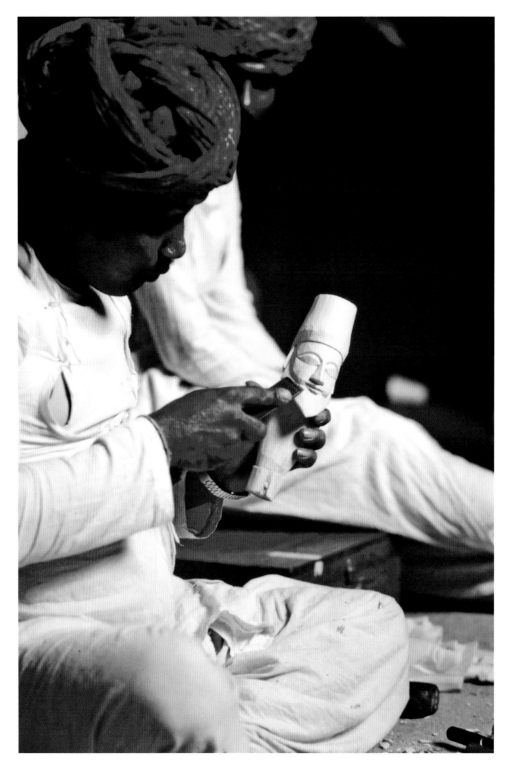

PLATE 9 (Figure 3.11). Puran Bhaat, puppeteer, carving a new puppet, *Aditi* exhibition. Smithsonian Institution Archives. Accession 97-012, National Museum of Natural History, Office of Exhibits, Special Exhibition Records, box 5.

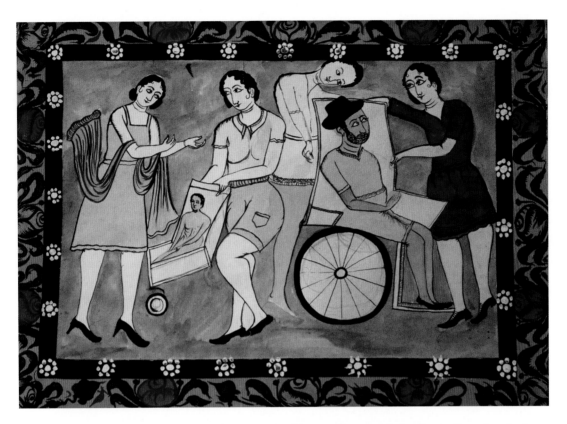

PLATE 10 (Figure 3.16). Banku Patua, detail of his Washington *pat*, showing panel with a stroller and a wheelchair, *Aditi* exhibition. Photograph courtesy of the Ralph Rinzler Folklife Archives and Collections, Smithsonian Institution.

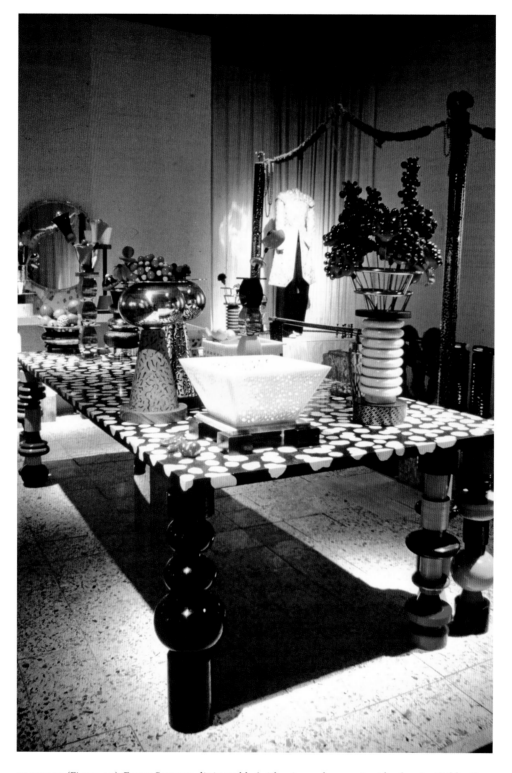

PLATE 11 (Figure 4.9). Ettore Sottsass, dining table (with mirrored support evident), 1985, *Golden Eye* installation. Cooper Hewitt, Smithsonian Design Museum.

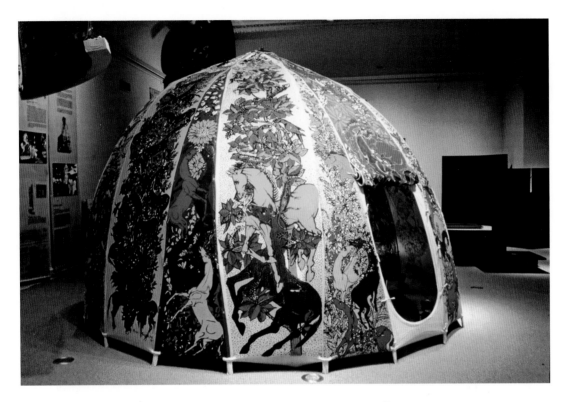

PLATE 12 (See also figure 4.11). Frei Otto, painted tent, 1985, *Golden Eye* installation. Cooper Hewitt, Smithsonian Design Museum.

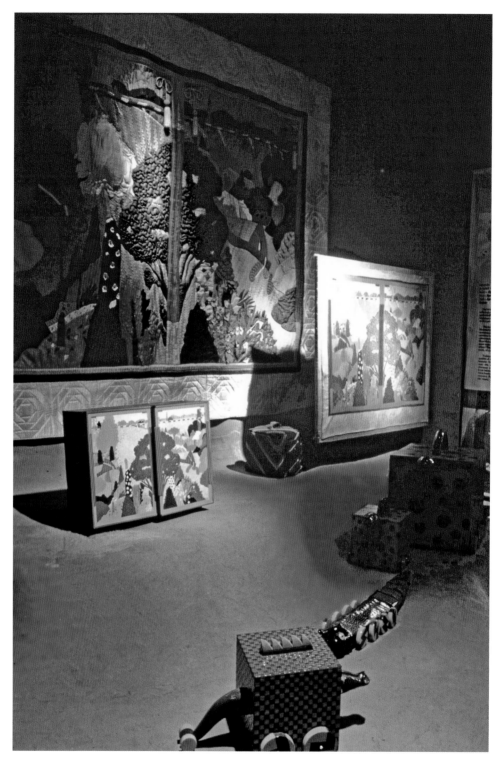

PLATE 13 (Figure 4.12). Milton Glaser's design in three media (appliqué, embroidery, and papier-mâché), with papier-mâché toys in foreground, *Golden Eye* installation, 1985. Cooper Hewitt, Smithsonian Design Museum.

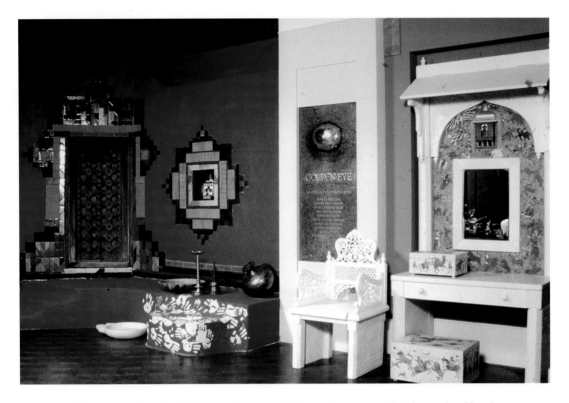

PLATE 14 (Figure 4.15). Opening Gallery, *Golden Eye* exhibition, showing marble title panel and handprints below. Cooper Hewitt, Smithsonian Design Museum.

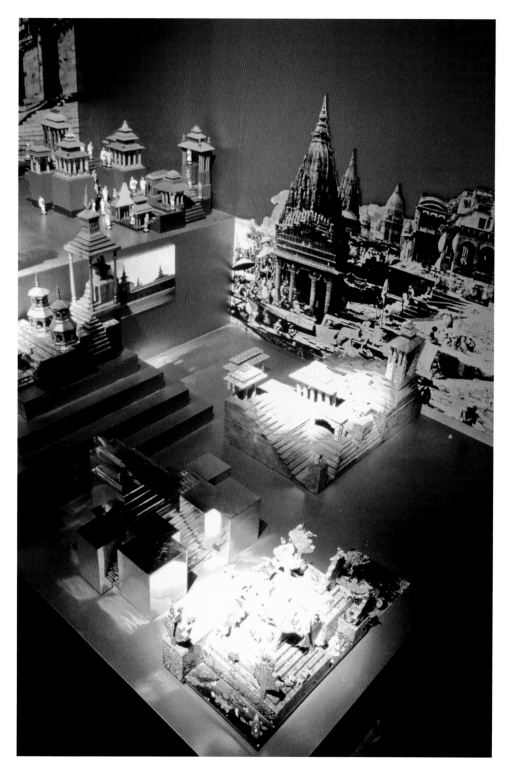

PLATE 15 (Figure 4.20). Charles Moore, prototype of miniature Indian city with figures, as installed at *Golden Eye*, 1985. Cooper Hewitt, Smithsonian Design Museum.

PLATE 16 (Figure 5.1). S. H. Raza (1922–2016), *L'été '67*, 1967, oil on canvas, 59¼ × 59¼ in. (150 × 150 cm). Peabody Essex Museum, Salem, MA, E301247. Artwork © 2013 Artists Rights Society [ARS], New York/ADAGP, Paris; photograph provided by the Peabody Essex Museum.

PLATE 17 (Figure 5.2). M. F. Husain (1915–2011), *Hanuman*, 1968, photolithograph on paper, 18 × 24 in. (45.7 × 61 cm). Los Angeles County Museum of Art, Gift of Mr. and Mrs. Chester Herwitz, M.91.315.1–11. Artwork © Estate of M. F. Husain; digital image © 2013 Museum Associates/LACMA; licensed by Art Resource, New York.

PLATE 18 (Figure 5.3). Laxma Goud (b. 1940), *Untitled*, 1983, pencil and colored pencil on paper, 16½ × 23¼ in. (41.9 × 59 cm). Peabody Essex Museum, Salem, MA, E301265. Artwork © Laxma Goud; photograph provided by the Peabody Essex Museum.

PLATE 19 (Figure 5.4). K. G. Ramanujam (1941–73), *Untitled*, 1969, oil on canvas, 29 × 18¾ in. (73.7 × 47.6 cm). Peabody Essex Museum, Salem, MA, E301121. Permission to reproduce courtesy P. Gopinath, Cholamandal Artists' Village; photograph provided by the Peabody Essex Museum.

PLATE 20 (Figure 5.13). Rekha Rodwittiya (b. 1958), *How Naked Shall I Stand for You*, 1986, watercolor, gouache, pencil, and pastel on paper, 72½ × 41¼ in. (184 × 105 cm). Peabody Essex Museum, Salem MA, E301281. Artwork © Rekha Rodwittiya; photograph provided by the Peabody Essex Museum.

NOTES

CHAPTER 1

Letter from Diana Vreeland to Martand Singh, April 22, 1985, Costume Institute Records, Metropolitan Museum of Art Archives, accession 2010.A.021, box 18, file folder "Singh, Martand Correspondence."

1 I expand on the underlying fabric of my approach to temporality in the interruption that follows this introductory chapter.

2 Feminist approaches to domestic labor, alongside studies of migrant and undocumented labor, have been helpful for me in thinking through these smaller durations. Most often, however, these texts are concerned with articulating the shape of subjectivity that emerges in relation to labor, or they focus on the valuing of the aggregated time of this labor in the context of larger political or economic concerns (see Bergeron 2016 for an overview of feminist theory in relation to labor). Here, I would like to unpack the multiple layers of minute durations and actions that make up the museum exhibition to explore the ways in which politics emerges here as a partition of the sensible following Jacques Rancière (see below).

3 The official "Calendar of Events" lists 215 separate exhibitions, performances, lectures, symposia, and films, and it includes only those planned in advance of their March 15, 1985, publication deadline. Memo from Ted Tanen to Festival Program Organizers, March 1, 1985, *Indian Art Today: Four Artists from the Chester and Davida Herwitz Family Collection*, Phillips Collection Archives, Exhibition Records, series 1, folder 1.

4 India was not alone in staging a country-based festival during the long 1980s; many other countries took this course, on varying scales. See Wallis 1991 for an overview of this 1980s wave of national festivals.

5 For more on the postmodern in architecture and culture, see Harvey 1990; Adamson et al. 2011. For neoliberalism, see Harvey 2005. For the spectacle of Reagan's inaugurals see Silverman 1986; Rogin 1988. For the approach to entrepreneurship in the 1980s, see Sanghvi 1984; Tripathi 1985; Kaplan 1987; Reich 1987.

6 My thanks to Natasha Eaton for this insightful vision of the historicity of both my theoretical interlocutors and the Festival material. Please see "An Interruption," following the introduction, for more on the Derridean fabric that permeates this book.

7 In this approach I am indebted to the work of Samuel Chambers and Paul Apostolidis and their readings of temporality as it shapes the social formation. Drawing on Althusser's readings of Marx, Chambers's work refuses an ontological understanding of time or subjectivity, instead acknowledging the imbrication of temporality itself in histories and politics (2011, 2014). Apostolidis offers

a particular example of time as used and manipulated by manual laborers to challenge and reshape working conditions through distributed actions often not seen as political by those performing them (2016). My chapter "Time, Interrupted" addresses these issues in more depth.

8 These questions were productively explored in a conference that took part in the American Institute of Indian Studies seventy-fifth anniversary celebrations in December 2012, "The Long 1980s: Recovering a 'Lost Decade.'" The discussions that I enjoyed with Karin Zitzewitz and Sumathi Ramaswamy as we organized the event, and the productive dialogue across disciplines at the event itself, informed my thinking very centrally as I developed this book.

9 While this book focuses on the U.S. Festival, I bring the 1982 U.K. Festival into dialogue with its later counterpart at several points in the book as a productive contrast, particularly in the chapter "Time, Interrupted," where the *Aditi* exhibition in the U.K. serves as a precedent for the same exhibition in the U.S., and in "The Contemporary, at a Distance," where I compare the contemporary exhibitions and activist dialogue in the U.K. with the rather more subdued conversations happening around the contemporary in the U.S.

10 Major cities of course hosted many events, but even small towns across the U.S. were involved, hosting traveling exhibitions or dance performances, such that in addition to Los Angeles, San Francisco, New York, and Boston, the Festival of India extended to university towns like Madison, Wisconsin, and small community museums in places like Anaconda, Montana. Many of these exhibitions are in the March 1985 list, but many others are not, either taking place as "unofficial" Festival events or coming to fruition after the list's publication deadline. A report was commissioned after the Festival to assess these numbers and generate a more accurate count and archive, but it never came to fruition. Early figures from this report put the total number of events at approximately 650 (personal communication, Maureen Liebl, December 13, 2012).

11 For an overview of some of the major exhibitions in the U.S. Festival, see Jayakar 1985.

12 I do not bring the growing body of literature on new materialism to bear on this question, as in many respects it addresses larger scale environmental and geographical problems that my particular query lingers at the edge of. I share with new materialism the concern to take seriously minute and localized "stuff" that has a significant role in the formation of relations of power and the production of certain possible paths over others. I turn toward temporality and the way that movement, duration, and doing or making operate in relation to a range of materialities. Jane Bennett's work centrally shapes my understanding of the new materialism literature (2010).

13 For discussion of the nineteenth-century examples, see Swallow 1998; Dewan 2004; Mathur 2007; McGowan 2009.

14 See Mathur 2000; a revised version of her article appears as chapter 2 of Mathur 2007; see also Corbey 1993; Breckenridge 1989; Cohn 1996. Studies of the humans on display at the 1904 St. Louis World's Fair include Afable 2004; Parezo and Troutman 2004; Delsahut 2008.

15 For an examination of the history of bodies in exhibitions and the performing of the festival-within-a-festival, see Kirshenblatt-Gimblett 1998, 17–78.

16 Arindam Dutta (1997; see also 2007, 235–78) has written about *Aditi* and *Golden Eye* in dialogue with the 1886 Colonial and Indian Exhibition in London, seeing the Festival and the 1886 exhibition as presentations of vignettes and fragments in the service of larger hegemonic discursive regimes. In his larger project, Dutta situates the political and economic impetus of these exhibitions, as well as their overarching thesis, within a continuum that has its roots in British colonial bureaucracies, specifically the British Department of Science and Art (DSA, founded 1851). For Dutta, the exhibitions of the Festival erase the artisan's subjectivity in order to assert the "magical . . . counterfigure" of the artisan as a conduit for global capital (2007, 276). *Aditi* and *Golden Eye* (among other exhibitions) thus perpetuate ideas about a timeless, exotic India inherited from nineteenth-century modes of understanding the subcontinent and its material production. While

certainly these genealogies are at play in the Festival, my focus on the minute temporalities of exhibitionary practices situates these elements within the postmodern, fragmentary, and uneasy relation to time and history evident in the mid-1980s.

17 *Neo-Tantra: Contemporary Indian Painting Inspired by Tradition*, Wight Art Gallery exhibit files RS#665, box 91, folder 8.

AN INTERRUPTION

1 The small clay models of craftspeople were included in the *Aditi* exhibition during the Festival of India; for more on these and on large-scale models, see Bean 2011b and Wintle 2009.

2 Rebecca Schneider's work in performance studies (2011) beautifully engages this element of Derridean thinking and has been incredibly helpful for me as I have thought through photography, the archival photograph, performance, and repetition.

3 Edmund Husserl, *Ideas I*, originally published 1913, as quoted in Derrida 1973 [1967], 1, and again, in slightly edited form, on 104.

4 One of Derrida's critical engagements with Husserl and others points to the ways in which many philosophers, following Hegel, seek out comprehensive understandings of language and thought, a project Derrida rejects. Hence my use of the verb "comprehend" to describe Husserl's thinking. See Gasché 1986, 60 ff.

5 Untimeliness and time "out-of-joint" anchor several political theorists' approaches to temporality, drawing on Derrida, Gilles Deleuze, and others to think against the grain of historical, clock time (Connolly 2002; Chambers 2003; W. Brown 2005; Chambers 2011; see also essays in Cheah and Guerlac 2009). Several of these thinkers have been helpful for me but their projects often tend toward questions related to ontology or to a conceptualization of historical sense on a grand scale. Likewise, the importance of the historical and the contingent led me away from Henri Bergson's work. I'm more convinced by the interruptive partitioning I see in Rancière than in the continuous flow articulated by Bergson. My thanks to Bill Connolly for conversations around this question and helping me think through these issues.

6 I end this interruption with another: a footnote regarding the incredibly long list of large-scale temporal investigations made by historians, art historians, and political theorists. Many scholars have written about temporality, but have done so in ways very different from those I pursue here. They have asked questions related to big, periodizing, world-ordering modes of understanding grand historical eras (modernity, for example), and abstract, untethered theorizations of time as a free-floating, universal concept. Some explore the relation between history and heritage as differing modes of politicized time (Daniel 1996) or relate different historical modes of time to labor, capitalism, and colonialism (Chakrabarty 2000, 47–71; Banerjee 2006). Others propose a heterochronic time to assist us in thinking through the asymmetries of global modernism (Moxey 2013). Some theorize the heterogeneity of time via nonsimultaneity (Bloch 1977 [1935]; Durst 2002) or through the suspended temporality of supermodernity (Augé 1995, 1999). Each of these studies has shaped my thinking on these large-scale questions, but for this project they only hover in the background, occasionally informing my understanding of modernity, colonialism, Orientalism, postmodernity, and the postcolonial condition.

CHAPTER 2

1 Here I echo formulations employed by Roland Barthes in his work on photography's temporal phenomenology (1981); I tie my reading of these exhibitions to Barthes more directly later in the chapter.

2 I build on Timothy Mitchell's world-as-exhibition in this phrase, as the exhibitionary space cannot be limited to the museum or gallery (1992).

3 For more on how my project differs from these larger scale temporalities, see chapter 1. My use of the temporal eschews these sorts of larger scale interpretive frames, instead seeking to describe the intimate overlays of duration in these shows.

4 For more on the social formation in relation to this project, see chapter 1 and also Chambers 2014.

5 See Chandra 1985. For more on the National Gallery show, see Guha-Thakurta 2007. The misplaced Anno Domini appears in the catalog and all publicity for the exhibition.

6 See the "Time, Interrupted" chapter for more on *Aditi*.

7 Christopher Pinney's work on India's popular print culture also engages with this recursivity. See Pinney 2004, 2005.

8 Furthermore, unlike most objects brought to the U.S. for the Festival of India, Palaniappan's horses remained in the U.S.—the Smithsonian, for example, acquired several of his works, as did both the Mingei and the Museum of International Folk Art in Santa Fe. Most of the Festival exhibitions brought objects into the U.S. under loan and customs agreements that meant the works could not be sold or gifted to American institutions or individuals. This caused some problems for several exhibitions, and correspondence in the archives indicates wide-ranging attempts to keep some works in U.S. collections. Objects made in the U.S. had fewer restrictions; most of the works that remained in American collections were those made on-site. See my "Entrepreneurial Exhibits" chapter for more on this issue.

9 The two photographs at the entrance to the exhibition were taken by Stephen Huyler and are published in his 1996 volume *Gifts of Earth*. The photograph on the left side of the doorway depicts two large (three-meter-tall) Aiyaṉār sculptures that are over thirty years old (Huyler 1996, figure 5.6). The photograph on the right side of the doorway depicts a mid-nineteenth-century group of sculptures that stand over five meters high (Huyler 1996, figure 5.24). Huyler was also involved in research for the exhibition (personal communication, October 17, 2015), and the catalog includes his essay (1986).

10 In India, the deities' horses are made by the potters of the village (Vēlārs), who also serve as the priests presiding over the annual festivals. These include the creation and installation of the horses and other vehicles for Aiyaṉār's soldiers, who protect the village and its outlying crops. The most colossal horse sculptures must be made and fired in situ, but even large examples are fired at the potter's kiln site and transported to the shrine. Several scholars have written on the worship practices surrounding Aiyaṉār and the construction of the terracotta vehicle sculptures. See Dumont 1970, 20–32; Inglis 1980a, 1980b, 1984; Du Bois 1982; Kjaeholm 1982; Dirks 1987, 297–305.

11 Positioning Aiyaṉār's mounts at the opening of the exhibition echoes their placement in village contexts in southern India, where the shrines or temples to Aiyaṉār and Karuppaṉ sit at the edge of villages near a tank or reservoir. Each year, and sometimes also in times of particular strife, villages commission new mounts for Aiyaṉār and his soldiers; these new sculptures join their earlier counterparts and create an imposing processional pathway to the shrine or temple. As a result, these large groups of vehicles for the deity—horses primarily, but also elephants and bulls—often are the first thing a visitor to a village might see. The ongoing process of decay and the ephemerality of these objects are central to their efficacy and their prominent role in ritual practice. Indeed, clay's fragility and fungibility mean it is central to numerous religious contexts. See Bean 2011b.

12 Mingei International Museum Archives, Iron Mountain Box 50, envelope 46: Forms of Mother Earth: Contemporary Terracottas of India.

13 The curator of the exhibition, Haku Shah, was likely informed here by George Kubler's 1962 book *The Shape of Time*, which sought to validate craft processes by proposing an approach to art that

refused to privilege the original or independent work, instead turning to works that were repeated, where the process of making and the repetition became the central valued element. Kubler discusses closed series, open sequences, simple and complex processes; his theories remain provocative but are also embedded in a teleological, hierarchical, progress-driven understanding of time in which simple gives way to complex and cultural diffusion works ever outward.

14 For a discussion of the intersection of demonstration, documentation (often via photography), and craft, see Adamson 2007, 112–15. See also Ardery 1998, 227–81.

15 Personal communication, October 17, 2015.

16 One finds this cinematic trope (the close-up on the hands) in a wide range of craft documentaries and photography of the craftsperson, a maneuver that underpins the genre with a slightly too-obvious emphasis on one aspect of the maker's body. See Adamson 2007, 112–15, and Ardery 1998, 227–81.

17 At *Aditi*, forty artists and performers populated the exhibition for its entire run. In addition to *Aditi* and *Forms of Mother Earth*, exhibitions such as *Golden Eye* and *Women Painters of Mithila*, both Smithsonian exhibitions, included artists demonstrating their work for limited portions of the run of the show.

18 The initial group arrived late and thus were only on-site for approximately five weeks. A list in the archives gives the names of the additional potters: Mohanlal Kumhar (Rajasthan), Smt. Neelamani Devi (Manipur), Shyamjai Singh (Manipur). The archives are unclear on when each group arrived and who came for each segment of the exhibition. Mingei International Museum Archives, Iron Mountain Box 50, envelope 46: Forms of Mother Earth: Contemporary Terracottas of India, Correspondence and Documentation.

19 At the Cooper Hewitt's *Golden Eye*, craftspeople demonstrated their work in two designated areas, partitioned by bamboo screens. In *Aditi* at the Natural History Museum in D.C., artists took up a number of different types of spaces in the gallery but in each case the space included a label identifying the artist by name, and often the artist sat on a platform alongside his or her objects.

20 Guha-Thakurta 2007, 636; Chandra 1985, 18; for her discussion of the 1947–48 exhibition, see Guha-Thakurta 1997.

21 The National Gallery was not alone in staging historical sculpture exhibitions during the Festival. Most notably, the Cleveland Museum of Art organized *Kushan Sculpture: Images from Early India* (Czuma and Morris 1985).

22 Ralph Rinzler had established the Folklife Festival at the Smithsonian in the late 1960s and by the mid-1980s was the Assistant Secretary for Public Service at the Smithsonian. His position and enthusiasm for folk music and art meant he was one of the key actors involved in organizing the Festival of India at the Smithsonian and also across the country. See Walker 2013, 93 ff.

23 Various correspondence between August 29, 1983, and May 9, 1984, among the parties involved, Smithsonian Institution Archives, Record Unit 367, Assistant Secretary for Public Service, subject files, box 38, "Nek Chand" file.

24 The exhibition continued for nineteen years, until the museum closed its Northeast Washington location in 2004. In 2013, the Capital Children's Museum reopened just across the state line in Maryland as the National Children's Museum. It closed in 2015 and remains closed as of this writing (2016).

25 The moment of the Festival presages a groundswell of interest in the questions of "outsider art," a term not widely used in 1985. Roger Cardinal coined the phrase in his 1972 overview of a range of artists who evinced an "expressive impulse" and who had "externalize[d] that impulse in an unmonitored way which defies conventional art-historical contextualization" (quoted in Jones et al. 2010, 68). Starting in the late 1980s—after the Festival—a number of exhibitions and books were published on the topic, attempting to define and hone its parameters (e.g., South Bank Centre

1987). Current scholarship builds connections across the twentieth century to Art Brut and Surrealism (Maizels 2009; Maclagan 2009).

26 Memo from Wilcomb E. Washburn to Ralph Rinzler, February 8, 1984, Smithsonian Institution Archives, Record Unit 367, Assistant Secretary for Public Service, subject files, box 38, "Nek Chand" folder.

27 For more on Le Corbusier, Chandigarh, and the construction of the city, see Prakash 2002; see also Brown 2009, 103–30.

28 The three-fold brochure for the exhibit lists the many contractors who helped to build the installation, led by the Sigal Construction Company (National Children's Museum Archives). The volunteers and other collaborators are mentioned in press coverage and local newsletters: Thadani 1985; Howe 1985, B11; Lewin 1985, 21; Groer 1985, E7. A panel near the installation also listed donors and volunteers.

29 See Howe 1985, B11; Lewin details the search for the proper rock in her own narration of the process (Lewin 1985, 21); at long last they found a four-ton rock that Chand was satisfied with (Groer 1985, E7).

30 Iain Jackson notes the small daily tragedies embedded in the sculptures (Jackson 2003, 137); glass bangles carry an additional poignancy as they may have been broken on the occasion of a woman's widowhood. Indeed, theorists working on the materiality of trash have noted its resonance with trauma (Yeager 2002).

31 See Beardsley 1996 for a discussion of Chand's visit to D.C. in that year and the decay of the installation; see Anderson 2006 for an overview of the American Folk Art Museum's conservation and exhibition of Chand's sculptures. Reviews of the show were positive but noted the decontextualization (e.g., Shuster 2006). I had the privilege of visiting the National Children's Museum's storage facility in April of 2014 to see the de-installed Chand sculptures. Stabilized by conservators at the museum, some of the sculptures will remain in the collection while plans are under way to transfer groups of the works to other North American museums. My thanks to Veronica Szalus, then Director of Exhibits at the National Children's Museum.

32 This characterization of Chand as a creative innovator working on his own has resonances with that of the entrepreneur, another figure in circulation during the mid-1980s and at the Festival. However, Chand is not characterized as an entrepreneur, as the discourse at the time separates the artist or artisan from the machinations of business. See the "Entrepreneurial Exhibits" chapter.

33 Chand's pedagogical approach has its counterpart in that expounded by Rancière (1991).

34 "Nek Chand Fantasy Garden: A Permanent Exhibit at the Capital Children's Museum," National Children's Museum Archives.

35 I take both "triangulated" and "highly active" from Michael Baxandall's formulation of the intellectual space created between label, object, and viewer; here I emphasize the time involved in this activity rather than the (analytical) space. See Baxandall 1991, 37–38.

36 Jackson 2003 provides an in-depth analysis of Chand's relation to modernity, arguing that his garden can be read as a subversive critique of Corbusier's Chandigarh. Paul Virilio's theorization of speed speaks to the asymmetries of modernity's velocities (1986 [1977]). Elsewhere I've questioned the presumptive acceleration often associated with the nineteenth and twentieth centuries (Brown 2013).

37 Ann Reynolds's (1988) discussion of Robert Smithson's *Nonsite (Ruhr-District)* points to Smithson's almost obsessive concern with particular forms of slag and with the industrial landscape, an attentiveness akin to Chand's seeking out particular rocks and forms both in Chandigarh and in Washington, D.C. Reynolds highlights the temporary, unstable quality of Smithson's work; the same ephemerality and fleeting character attends Chand's work. Glenn Adamson uses Reynolds's analysis to further point out the way materials like slag undermine the normalized understanding of the garden as a pure, "natural" space—a reconsideration that then also reshapes our presump-

tions about the authentic craftsperson in that pastoral landscape (2007, 134). Chand's use of detritus also resonates with Claes Oldenburg's critical engagement with urban transformations happening in lower Manhattan in the 1960s (Bois 1997; Shannon 2004). Both Oldenburg and Chand work alongside and against modernist reworkings of city space, and both turn to detritus. Oldenburg's work, for Joshua Shannon, challenges the flow of representation and meaning, attempting to block it and thereby unpack the logic of an all-encompassing modernism. This element Chand does not share with Oldenburg, an indication perhaps of the limits of Chand's criticality. However, both share a commitment to materiality against the erasures and simplifications of modernist architecture and art. See Shannon 2004. Susan Sontag also notes the connection between trash and modernism, seeing photography and American art of the 1970s as marks of affluent, wasteful societies (1977, 68–69).

38 In 2006, conservators working to restore Chand's sculptures for display at the American Folk Art Museum ran into trouble sourcing clinkers, as new environmental standards in the U.S. required cleaner fuels which no longer created this byproduct (Reilly 2006).

39 As Ted Tanen, the head of the Indo-U.S. Subcommission, the body tasked with organizing the Festival, wrote to Ann Lewin, the exhibition "meets one of the criteria which we have been worrying about; developing projects which would live beyond the Festival." [semi-colon in the original] Letter from Ted Tanen to Ann Lewis, April 22, 1984, Smithsonian Institution Archives, Record Unit 367, Assistant Secretary for Public Service, subject files, box 38, "Nek Chand" folder. Lewin reiterated this to the press and in her own statements. See, e.g., Lewin 1985, 22; Groer 1985, E7; Murphy 1986.

40 Several scholars have written on the relation between temporality and landscape (Ingold 1993; Bender 2002); gardens in particular have received less attention in terms of temporality, as they are analyzed most often as spatial (Moore et al. 1988). For examples of scholarship examining temporality and the poetics of gardens see Miller 1999; Conan 2006; Bhatti et al. 2009; Ferrari 2010.

41 For an expansion of the Derridean fabric of the book, please see "An Interruption."

42 See Krauss 1999; Doane 2007; Auther 2010.

43 See Venturi et al. 1972; Soja 1989; Harvey 1990; Adamson et al. 2011; Sontag 1969.

CHAPTER 3

1 The literature on international exhibitions in the nineteenth and early twentieth centuries is vast, as is the scholarship on human "zoos" and "freaks" of the same era. I discuss this in further depth below.

2 Indeed, I build throughout the book on Mitchell's engagement with Derridean thought, an indication of how thoroughly Mitchell's work has informed my thinking. See "An Interruption" for more on the book's Derridean fabric.

3 The case of Tulsi Ram is not an isolated one. Several individuals on display in the nineteenth and early twentieth centuries have been the focus of study due to their presence in the archives. The most famous of these are Saartjie (Sara) Baartman (Gilman 1985; Bogdan 1988; Abrahams 1998; Qureshi 2004), Ota Benga (Blume 1999; Rydell 1999), Ishi (Heizer and Kroeber 1979; Starn 2004), and Goyathla, a.k.a. Geronimo (Parezo and Fowler 2007, 100–134; Clements 2013).

4 For a fascinating discussion of tourist contexts and the production of a "commodified persona" for visitors, see Bunten 2008. See also Stanley 1998 for discussion of a wide range of contemporary ethnic and cultural performance. Rebecca Schneider's work on performance and reenactment engages with this reaction as well—capturing a particular historical moment or cultural practice through bodily movement and performance (2011).

5 These observations are indebted to Darielle Mason's research on this topic (2014). For the catalog

of the exhibition, see Kramrisch 1968. For more on the exhibitions of Indian modern and contemporary art that took place in the U.S. from 1953 to 1970, see Bean 2014.

6 The 1904 World's Fair and the 1886 Colonial and Indian Exhibition are but two of hundreds of international exhibitions and world's fairs that took place between 1850 and World War II. The scholarship on world's fairs and expositions is vast; the study of humans on display in these contexts is a relatively large subset within this scholarly domain. See Rydell 1984; Breckenridge 1989; Corbey 1993; Rydell et al. 2000; Hoffenberg 2001; Poignant 2004; Parezo and Fowler 2007; Blanchard 2008; Qureshi 2011.

7 See Karp 1980; Wallace 1981; Anderson 1984; Magelssen 2004a, 2004b, 2007; Magelssen and Justice-Malloy 2011.

8 While internal industry dialogue often celebrates the shift to first-person narration as an improvement in the "realism" of these historical museum experiences, Magelssen debunks the idea that the museums "develop" from third person to first person, arguing that by remaining in third person (as Skansen does), opportunities for critical engagement with history emerge, and the beautification of the past can thus be complicated even within the context of edutainment. First-person narration operates in tandem with an obsession with detail, a maneuver that works to obscure significant gaps in the historical record, gaps particularly acute in the case of women's lives on seventeenth-century New England farms, for example. See Magelssen 2004a.

9 Renata Dohmen's work (2004) on women's painting of Kolam designs on their thresholds in Tamil Nadu also speaks to the importance of repetition—reperformance is crucial for the protection of this liminal space, a temporality that engages with continual maintenance to shore up the efficacy of the action.

10 For more on performance art, see Goldberg 1998 and Amelia Jones 1998, 2008, 2011; for participatory art, see Bishop 2012. For a specific discussion of Martha Rosler's 1988 participatory art projects, see Rounthwaite 2014.

11 Jennifer Fisher (1997) draws connections between nineteenth-century *tableaux vivants* and twentieth-century performance practices, but quickly moves to differentiate the two rather than tracing genealogies. Rebecca Schneider links early modern tableaux vivants to contemporary performance and its relation to photography (2011, 145–48). Qureshi closes her book with a brief discussion of a contemporary performance celebrating Zulu culture (2011, 271 ff) and mentions contemporary artists working through the imagery of Saartjie (Sara) Baartman (Qureshi 2004).

12 Qureshi (2011, 57) notes: "The associations between displayed peoples, imperialism, and ethnic difference are neither inherent nor self-evident; rather they must be both created and maintained. Where such associations exist, they are not to be relied on or assumed as explanatory factors but are to be regarded as historically specific developments that require further explanation." See also Mathur 2007.

13 In addition to *Aditi*, the other six exhibitions were *Golden Eye* (Cooper Hewitt, Smithsonian Design Museum, New York; see the "Entrepreneurial Exhibits" chapter), *Master Weavers* (Smithsonian Institution Traveling Exhibition Series, or SITES), *Women Painters of Mithila* (SITES), *Mela!* (part of the Festival of American Folklife), *Nineteenth-Century Photographs of Lala Deen Dayal* (National Museum of Natural History, Washington, D.C.), *Rosalind Solomon: India* (photography exhibition, National Museum of Natural History, Washington, D.C.).

14 Both the entry *pūjā* and the smaller *tulsī pūjā* were recorded on video; see 1985 Festival of American Folklife, Smithsonian Folklife Festival Documentation Collection, Ralph Rinzler Folklife Archive and Collections, Smithsonian Institution, FP-1985-VTR-110.

15 I found no commentary from visitors on smell or touch during my archival research, as the dominant response focused on the visual or sometimes aural spectacle of the exhibition. However, film and photographic records of the exhibition include coverage of both the major opening *pūjā* and

the smaller *pūjā* the dancers perform at the *tulsī* plant. In both cases, incense was lit. Henna has a distinct and powerful smell that would have filled the gallery where the henna artist worked and followed those who had their hands hennaed. With artists carving wood, weaving straw, and making clay objects throughout the gallery, the smells of these media would have intertwined with the others to produce a rich olfactory experience. The film also shows visitors touching the textiles the "veil maker" demonstrated, offering their hand to the henna artist, and participating in a number of ways in the performances, including holding objects for the magician. While incense and other smells must have permeated the gallery, food was not allowed; however, those visitors who came to *Aditi* during the Festival of American Folklife would have had an opportunity to taste Indian food outside on the Mall.

16 Smithsonian Institution Archives, Record Unit 367, Smithsonian Institution, Assistant Secretary for Public Service, subject files, box 39; P. D. Trenner, "Old World—And New," Letter to the Editor, *Washington Post*, July 6, 1985; response from Walter Hauser, "Soles of Tradition," Letter to the Editor, *Washington Post*, July 16, 1985.

17 See Reynolds, 1985. For more on the Bloomingdale's connection to *Golden Eye*, see Schiro 1986. The synergy between exhibitions and department stores dates to the emergence of both institutions in the mid-nineteenth century. See Mitchell 1992; Crossick and Jaumain 1999; Henning 2006, 37–69; Macdonald 2011.

18 See Harden 1985; the article focuses on fashion trends, anchored by a discussion of the forthcoming Festival of India.

19 Qureshi analyzes advertisements for nineteenth-century human displays, arguing that everything from font type and size to the choice of image and language helps to mold an idea of the other, both for those who could afford to see the shows and those who could not (2011, 47–100).

20 See Timothy Luke's work on the "edutainment" potential of politically charged exhibitions: Luke 2002, 37–54.

21 For more on labels and the way they triangulate the visitor's experience, see Baxandall 1991.

22 I use "South Asian" here to indicate that the diaspora community in the D.C. area came from a variety of locations in South Asia, not just India, and while the Festival focused on a particular nation-state, the community crossed over these lines.

23 See Kurin 1991b, 18, for a brief mention of this collaboration. See also Beaudry et al. 1987. Kenoyer notes Altman's participation in his report to the Smithsonian, Smithsonian Institution Archives, Record Unit 367, Smithsonian Institution, Assistant Secretary for Public Service, subject files, box 36, "Evaluations" folder.

24 Cantwell (1993, 131) describes a planning meeting for *Mela!* that addresses this issue head-on: "Diana Parker, the Festival director, defines the Mela as an event balanced uneasily between a presentation, in which there is too much mediation, and a 'cultural zoo,' in which there isn't enough, especially because the Indians don't speak English." Cantwell also relates another moment in Festival history when the participants refused to ride in a bus loaned by the National Zoo for the occasion, as it had the words "Zoo Bus" written on the side (145).

25 One of the fascinating stories of the Festival of India that I am only able to gesture toward in this project is the consolidation of the American South Asian community around the Festival at the same moment that identity politics and the demands for recognition of Asian American cultures were coming to the fore.

26 Personal communication, Puran Bhaat, December 16, 2012. For more on the puppeteers of Rajasthan, many of whom now live in Delhi, see Jairazbhoy 2007.

27 Namely, the contentious negotiations to end the civil war that had been under way since 1986. See Thoden van Velzen 1990; Price 2011.

28 Kenoyer notes several instances of misrepresentation on the part of the volunteers in his report.

Smithsonian Institution Archives, Record Unit 367, Smithsonian Institution, Assistant Secretary for Public Service, subject files, box 36, "Evaluations" folder.

29 For more on labor and delay see Apostolidis 2016.

30 At the London iteration of *Aditi* in 1982, a visitor recalled seeing a performer seated on a chair on his labeled platform, calmly reading a newspaper as people walked past; no reports of similar events appeared in the archive or in interviews related to the 1985 exhibition in Washington, D.C. (story told during my personal communication with one of the U.K. Festival organizers). This rather extreme example presents a particular case of temporal and behavioral resistance to the fact of being on display, interrupting the illusory façade of festival and village for those visiting the event. Archival research and interviews about *Aditi* at its various venues suggest that the setting at the Barbican, with its severe concrete-and-glass architecture, was much more difficult to transform into an immersive experience than the outdoor D.C. Mall or the underground galleries of the Smithsonian's Natural History Museum. This spatial and aesthetic difficulty may have contributed to the interruption of the man-reading-newspaper in London.

31 Personal communication, Mark Kenoyer, September 18, 2012.

32 Smithsonian Institution Archives, Record Unit 367, Smithsonian Institution, Assistant Secretary for Public Service, subject files, box 36, "Evaluations" folder.

33 See Kurin 1991b, 19, for a discussion of the closing party with the participants; these interactions were also noted by Puran Bhaat in conversation with me, December 16, 2012.

34 Mark Kenoyer mentions these visits by Sethi in his evaluative report submitted at the close of the Festival. Smithsonian Institution Archives, Record Unit 367, Assistant Secretary for Public Service, subject files, box 36, "Evaluations" folder.

35 1985 Festival of American Folklife, Smithsonian Folklife Festival Documentation Collection, Ralph Rinzler Folklife Archive and Collections, Smithsonian Institution, 2011-VTR-269 and 270.

36 Smithsonian Institution Archives, Record Unit 367, Assistant Secretary for Public Service, subject files, box 36, "Evaluations" folder.

37 His performance is recorded on video. See 1985 Festival of American Folklife, Smithsonian Folklife Festival Documentation Collection, Ralph Rinzler Folklife Archive and Collections, Smithsonian Institution, FP-1985-VTR-110. For more on the history of the *pat* scroll and the relation among song, storytelling, and painting, see Ghosh 2003.

38 Another model might be found in theorizations of the diaspora, particularly James Clifford's meditations on questions of movement and travel in several of his essays. I want to resist a turn to displacement that often centers discussions of diaspora, as my interlocutors in this project did not seem displaced (at least not in relation to their careers performing around the world). As Clifford might say, there is a sense of "dwelling-in-travel" that these performers embody when they are on tour. They are also quite grounded when it comes to their physical homes in India. While some elements of Clifford's thought have been helpful here, I resist the underlying idea in Clifford's writing of needing to bridge the traditional and the modern, or the local and the globalizing. In many respects these performers show us that those distinctions have never had salience. See Clifford 1997, especially the essays on diaspora and traveling cultures.

39 See Peter Seitel's discussion of the temporality of the Folklife Festival in Kurin 1998, 84. The temporality of festivals has been the subject of longstanding discussion in philosophy, from Friedrich Nietzsche to Hans-Georg Gadamer. See Shapiro 1989, 97–123. Gadamer's use of the festival in his aesthetic theory enables him to move from individual aesthetic experience to the communal and to articulate a distinction between work time and play time. For a concise summary see Davey 2011.

40 For more on Rancière's approach to the police, the political, and the *partage du sensible*, see Panagia 2009; Chambers 2013.

41 Personal communication, Puran Bhaat, December 16, 2012.

CHAPTER 4

1 The exhibition's name predates the James Bond film *GoldenEye* (1995); the two are, as far as I can determine, unrelated.

2 The Festival of India comprised over two hundred events, exhibitions, performances, and symposia across the entire United States. It was held from June 1985 to December 1986. For more details, see chapter 1.

3 As I discuss at greater length in both chapter 1 and in the "Time, Interrupted" chapter, these Festival exhibitions echo the nineteenth- and early twentieth-century international and colonial exhibitions in many respects, not least in the connections among trade, handicraft, and material culture evinced in *Golden Eye*. One could read the 1980s context and its various national Festivals as a neo-colonial reworking of these earlier palaces of craft, art, and industry. While comparisons can certainly be made, I find it more illuminating to explore the detailed maneuvers of these multifaceted exhibitions in their own particular historical, political, and economic contexts. For, as scholars of the nineteenth-century exhibitions have shown, even those exhibitionary projects included more resistance and complexity than the narrative of colonial power might suggest. Here too, the Festival shows participate in the 1980s political and social world in ways too complex to place under a banner of neocolonialism or a mere reprising of their nineteenth-century precedents.

4 Smithsonian Institution Archives, Record Unit 531, Cooper Hewitt Museum, Department of Exhibitions, Exhibition Records, box 22, "Golden Eye: List of Panels" folder, panel 17.

5 The Festival events, with *Aditi* at the center, were sold as an opportunity for Americans to travel to India without leaving home, or to get a taste of the subcontinent in hopes that they might visit in the future. And many did: S. K. Misra, who helped to coordinate the Festival from New York and later worked at the India Tourism Development Commission, told me that after the Festivals of India tourism to India went up by 80 percent from the U.S. and 70 percent from Europe (personal communication, December 12, 2012). The statistics for this period do indicate an uptick in both foreign arrivals and foreign exchange receipts from tourism during the 1986–87 fiscal year; the foreign exchange earnings table from Tamil Nadu, for example, show 6 to 8 percent increases in the years prior to the Festival in the U.S., followed by several years of 10 to 17 percent growth (data from the Department of Tourism, Government of Tamil Nadu, via http://www.indiastat.com /table/tourism/29/tourismreceipts/106/53687/data.aspx, accessed June 4, 2014). The push to increase tourism can also be seen in the sponsorship by India's national airline; Air India circulated packets of information to Festival-goers and flew people and objects over to the Festivals, facilitating the remote tourism the Festival provided to American visitors.

6 The Indian director of the later Festival in the U.S.S.R., Daljit Singh Aurora, encapsulated this complaint for the *New York Times*, noting that the U.S. Festival focused on "exotica . . . village India and royal costumes" and claiming that the 1987 Festival in the Soviet Union sought instead "to show contemporary India to the Russians" (quoted in Hazarika 1987). As with any major undertaking, debate over the scope of the Festivals characterized many discussions; several of those I interviewed about the U.K. and U.S. Festivals noted the (often productive) tensions created by these disagreements.

7 HHEC served as an institutional support network (sometimes in a restrictive manner) for many of the Festival exhibitions focused on handicraft. Founded in 1962 as part of the Government of India's Ministry of Textiles, the corporation continues to develop new production of handicraft and to support regional and international trade in India's handicrafts. For more on the history of handicrafts in India, including the relation to the HHEC, see Liebl and Roy 2003; for an overview see Mohsini 2011; for historical discussion of the relation to the earlier All India Handicrafts Board, see McGowan 2009.

8 The craftsperson-centered Smithsonian traveling show focused on Mithila painters and included demonstrations from several of the women who had benefited from the legacy of Pupul Jayakar's interventions in northern Bihar in the 1960s (see Brown 1985; Davis 2008).

9 *Forms* was curated by Haku Shah of the Tribal Museum in Ahmedabad, who had staged a version of the show at the Crafts Museum in Delhi in 1983; he credits Jayakar with the idea for the exhibition (Shah 1984, 19). He produced a documentary catalog for the earlier show that was used as the catalog for the Festival of India version (Shah 1985). The Mingei International Museum produced a short film focusing on several of the artists who came to the U.S. to demonstrate their craft (Mingei International 1986). See the "Material Transformations" chapter for more discussion of this exhibition.

10 Jyotindra Jain, former director of the National Handicrafts and Handlooms Museum, notes that the craft and handloom industries were housed within the Ministry of Commerce, indicating their importance to foreign exchange receipts as well as marking them as industries, not arts (personal communication, December 11, 2012). On the National Handicrafts and Handlooms Museum and the tensions this positioning as industry evokes for that institution, see Greenough 1995. I examine *Aditi* and *Mela!* in the "Time, Interrupted" chapter; for more on *Forms of Mother Earth*, see the "Material Transformations" chapter.

11 These kinds of initiatives are, in the second decade of the twenty-first century, much more commonplace, with western designers collaborating with local workshops and even creating local workshops to produce artistic and commercial products. But in the 1980s, while some designers and artists had worked in India and elsewhere in Asia (most notably, from this group, Jack Larsen, Ivan Chermayeff, Frei Otto, and Bernard Rudofsky), *Golden Eye* represented a fairly new idea in the way it brought together multiple designers to connect them to workshops across the country. India's regional Weavers' Service Centres pursued similar goals, focused entirely on textiles. See see Kumar 1988; Freitag 1989, 125–29.

12 The year 1991 and the economic legislation passed that year often serve as a watershed moment in the writing of India's economic history; many scholars have challenged the reliance on this singular moment, arguing that reforms and economic shifts had been in progress for many years prior, and that the 1989–91 global crisis provided the political opportunity for pro-liberalization politicians to act. For an overview, see Ganguly and Mukherji 2011, 60–108; for a critical assessment of the politics, see Corbridge and Harriss 2013, 143–72; for a set of essays questioning the break at 1991 through a range of disciplinary lenses, see D'Costa 2010.

13 I discuss this in more depth in the conclusion to this chapter; for more on neoliberalism and its links to postmodernity, see Harvey 1990, 2005.

14 After finishing an art degree in India, Sethi studied and worked in Paris, eventually with Pierre Cardin. On his return to India in 1972 he worked to build several organizations in support of rural artisans and performers. See Sethi 2010.

15 Her official title was "chairman"; the Festival largely predated the introduction of terms such as "chairwoman" into common discourse.

16 Sethi's interviews with the press often highlight the skills of the Indian craftsperson: "These skills represent not merely the glories of the past . . . There are 20,000 wood workers in India who are unemployed or underemployed in India and their skills are often quite high." Quoted in Mayer 1985. Almost all of the press coverage uses the term "skill" to describe what the Indian craftspeople bring to the asymmetrical collaboration.

17 This logic is so taken for granted as to go unremarked in much of the literature on capitalism. For more on the development of the concept of human capital, see Becker 1975; Chambers 2016.

18 See, e.g., Holt 1985; MassBay Antiques 1985.

19 Design had been slowly entering the mainstream of art historical and museum circles in previous decades, with the Museum of Modern Art in New York staging shows focused on individual designers and emerging national "schools" of design, international publications highlighting design histories and innovations, and through the auspices of the annual Design Conference in Aspen, inaugurated in 1951. See Woodham 1997.

20 My thanks to Sonal Khullar for this insight; see Khullar 2015.

21 For more on the history of design in India, particularly in relation to domestic space and interior decoration, see Gupta 2011, 182 ff. See also Karim 2011. Several of the European and American designers had been affiliated with NID prior to *Golden Eye* (Dutta 2007, 265); many of the Indian designers had also come from training at NID.

22 See the press release for the exhibition, dated February 25, 1969, available on-line, http://www .moma.org/momaorg/shared/pdfs/docs/press_archives/4198/releases/MOMA_1969_Jan-June_0031 _25.pdf?2010, accessed June 4, 2014. The curators later published a major volume on the textile art of the 1960s (Constantine and Larsen 1973). Larsen had a long-standing interest in Japanese and Indian textiles and, sixteen years after this MoMA exhibition, participated in *Golden Eye* at the Cooper Hewitt.

23 I discuss these exhibitions in the following chapter, "The Contemporary, at a Distance." The three exhibitions were *Indian Art Today* at the Phillips Collection in Washington, D.C., *Contemporary Indian Painting* at New York University's Abby Weed Grey Art Gallery, and *Neo-Tantra* at UCLA's Frederick S. Wight Art Gallery. The Grey exhibition included a selection of Somnath Hore's *Wounds* series, works in cast handmade paper.

24 *Master Weavers* circulated in the U.S. to various venues as part of the Smithsonian Institution Traveling Exhibition Service (SITES); SITES published a small catalog (Smithsonian Institution 1986). In the 1970s and 1980s, Singh had been involved in the development of India's regional Weavers' Service Centres, set up and run by the office of the Development Commissioner for Handlooms. The *Master Weavers* exhibition sprang from the idea to revive historical techniques in the service of designs that might appeal to an Indian and worldwide market. For more on the Weavers' Service Centres, see Kumar 1988; Freitag 1989, 125–29.

25 The designers' dates: Mario Bellini, b. 1935; Sir Hugh Casson, 1910–99; Ivan Chermayeff, b. 1932; Milton Glaser, b. 1929; Hans Hollein, 1934–2014; Jack Lenor Larsen, b. 1927; Mary McFadden, b. 1938; Charles Moore, 1925–93; Frei Otto, 1925–2015; Bernard Rudofsky, 1905–88; Ettore Sottsass, 1917–2007. The Memphis design group came together in 1981. See Radice 1981, 1984; Horn 1985; Adamson et al. 2011.

26 Personal communication, S. M. Kulkarni, December 12, 2012.

27 Personal communication, December 12, 2012.

28 Personal communication, December 17, 2012.

29 Personal communication, December 11, 2012.

30 Personal communication, Jatin Bhatt, December 16, 2012.

31 The near erasure of the "entrepreneurs" from the history of this exhibition parallels other erasures in the historical record related to patronage. Deborah Hutton's work, for example, on architectural patronage in early seventeenth-century Bijapur reveals a collaborative, multifaceted set of patrons for imperial monuments—these actors are often named in inscriptions but overlooked in scholarship that seeks to identify a singular (often male and imperial) patron. I see a similar maneuver taking place here, with the inscribed names in the brochure erased from the narrative of the exhibition. See Hutton 2005.

32 The entrepreneur literature of the 1980s in India does not take up "*jugaad*," a key term in the business and economic literature of the 2010s that overlaps significantly with some of the elements of

entrepreneurship. In the 1980s, "*jugaad*" doesn't appear often in the economic or sociological literature, and then usually in relation to its ostensible source: as a descriptor for a hand-built vehicle sourced from different cast-off parts. For the multivalent meanings of "*jugaad*," see Jauregui 2014.

33 Personal communication, December 11, 2012.

34 Personal communication, Zette Emmons and Dorothy Globus, May 12, 2012.

35 Smithsonian Institution Archives, Record Unit 531, Cooper Hewitt Museum, Department of Exhibitions, Exhibition Records, box 21, "A Brief Guide to the Exhibition," dated November 18, 1985.

36 Personal communication, Dorothy Globus, May 12, 2012.

37 Personal communication, S. M. Kulkarni, December 12, 2012. (Kulkarni worked with Otto.)

38 In India, handprints have been used in a number of regional contexts to decorate homes, with varying explanations for the practice, from the simple expediency and potential for visual patterning that a handprint provides to an apotropaic power important for protecting the entryway and outside of homes. Handprints can also be found on garments in some regions of India, where they operate, in some cases, as blessing for the wearer at a time of transition, often marriage. See King 1984, 21; Cooper and Dawson 1998, 23. Handprints have also been used in India to mark the location of a widow immolation (*satī*) or a group suicide of courtly women in certain wartime contexts (*jauhar*). For more on *satī* and *jauhar*, see John Stratton Hawley's edited volume (1994b) and especially Veena Oldenburg's (1994) response to Ashis Nandy. See also Hawley's essay on fundamentalism and *satī* (1994a).

39 The entrance also echoed a spectrum of erasures and presences at the exhibition, from the prominent names of the European and North American designers to the anonymized handprints of the Indian designers and the simply enumerated artists. The entrepreneurs, listed in the folding brochure, are absent here.

40 Text from Smithsonian Institution Archives, Record Unit 531, Cooper Hewitt Museum, Department of Exhibitions, Exhibition Records, box 22, "Golden Eye: List of Panels" folder, panel 33. The interviews were compiled and finalized with the assistance of Maura Moynihan and Rochelle Kessler in Delhi; the panels were silk-screened in India and the process was complicated by a number of factors, from the quality of the translations to a worry that there would be too much text in the gallery. See letter from Maura Moynihan to Zette Emmons, September 26, 1983, Smithsonian Institution Archives, accession 99-015, Cooper Hewitt Museum, Department of Design, Exhibition Records, box 6, "Festival of India: Notes and Letters" folder.

41 Smithsonian Institution Archives, Record Unit 531, Cooper Hewitt Museum, Department of Exhibitions, Exhibition Records, box 22, "Golden Eye: List of Panels" folder, panel 33.

42 The first "test-tube baby" was born in 1978 in London. The first American test-tube baby was born in December 1981. See Rowland 1992.

43 Quote from Khurja pottery workshop panel, Zakeer (nephew), Smithsonian Institution Archives, Record Unit 531, Cooper Hewitt Museum, Department of Exhibitions, Exhibition Records, box 22, "Golden Eye: List of Panels" folder, panel 33.

44 Smithsonian Institution Archives, Record Unit 531, Cooper Hewitt Museum, Department of Exhibitions, Exhibition Records, box 22, "Golden Eye: List of Panels" folder, panel 12.

45 Smithsonian Institution Archives, Record Unit 531, Cooper Hewitt Museum, Department of Exhibitions, Exhibition Records, box 22, "Golden Eye: List of Panels" folder, panel 17.

46 Smithsonian Institution Archives, Record Unit 531, Cooper Hewitt Museum, Department of Exhibitions, Exhibition Records, box 22, "Golden Eye: List of Panels" folder, panel 28. The Junejas are mentioned in press coverage as well, where Sita Juneja's company is given as the contact for those interested in purchasing similar items (Stein 1986).

47 Anecdotal evidence suggests that this exhibition drew a significant number of New York's design community, many of whom remember it fondly as one of the best shows the Cooper Hewitt staged

during this period. I've spoken with several designers whose later work was in some measure shaped by visiting the exhibition, pursuing similar directions in their own work even to the extent of seeking out workshops in India. Given my own field as a South Asianist, I tend to encounter those who have interest in India, so my sample is certainly skewed toward those who were affected, but I am surprised by a high number of chance encounters with American designers in which *Golden Eye* is both recognized and remembered with clarity.

48 This discomfort is something common (and often sought out) in performance art and participatory art. In those cases and here, it has the potential to elicit a disorienting shift in one's understanding of the exhibition and the visitor's role in the exhibition. See Rounthwaite 2014 for an example of Martha Rosler's participatory art in this vein.

49 Quoted in Winship 1986.

50 Schiro 1986. For brief mention of the 1978 Bloomingdale's installation, see Stevens 1979, 80; McFadden 2012.

51 Quoted in Schiro 1986.

52 Menezes 1985; Currimbhoy 1986, 174. The Smithsonian Archives include documentation related to the Golden Eye Foundation; the Golden Eye Studio in Delhi closed while the exhibition was under way in New York. See Smithsonian Institution Archives, Record Unit 492, Cooper Hewitt Museum, Office of the Director, subject files, box 20, "Golden Eye Foundation" folder.

53 Bellini had a retrospective at MoMA in 1987 (see Museum of Modern Art 1987), including the stone bench, accession number 101.1989.

54 Plans for these department store marketing opportunities are noted several times in the archives, particularly in plans for a Golden Eye Foundation after the Festival had concluded. See letter from S. Dillon Ripley to Pupul Jayakar, March 6, 1987, Smithsonian Institution Archives, Record Unit 492, Cooper Hewitt Museum, Office of the Director, subject files, box 20, "Golden Eye Foundation" folder.

55 Several involved indicated that the objects were housed in an HHEC godown (warehouse) somewhere in Delhi. When the warehouse was opened years later, most of the objects had deteriorated completely; some reported seeing some of the stone furniture in the offices and hallways of government officials thereafter, but these remain unsubstantiated rumors. And, several of my informants noted that some of the smaller prototypes, including one of Rudofsky's lasts, were quietly secreted away for the designer before the objects were shipped back to India.

56 As stated on their current website, the HHEC mission is to "strive to make available Indian handicrafts and handlooms products *traditionally produced* in the remote parts of the country to all parts of Globe. Strive to achieve qualitative improvement in goods produced by the artisans, weavers and crafts persons in order to augment the credibility of India handlooms and handicrafts products in the *export markets*. Strive to improve the productivity of the artisans, weavers and crafts persons through developmental activities in order to improve and sustain their quality of life." HHEC "Corporate Saga" webpage, www.hhecworld.com/corporatesaga1.html, accessed June 22, 2014 (my emphasis).

57 Smithsonian Institution Archives, Record Unit 531, Cooper Hewitt Museum, Department of Exhibitions, Exhibition Records, box 22, "Golden Eye: List of Panels" folder, panel 25.

58 Smithsonian Institution Archives, Record Unit 531, Cooper Hewitt Museum, Department of Exhibitions, Exhibition Records, box 22, "Golden Eye: List of Panels" folder, panel 20. The panel spells the wood carver's name "Udaygirj"—Udaygiri is more likely, as it indicates where Surya Prakash Rao is from. Udayagiri in Andhra Pradesh is known for its woodcarving.

59 For nineteenth-century salvage ethnography, see Stocking 1987.

60 Personal communication, December 16, 2012.

61 Smithsonian Institution Archives, Record Unit 531, Cooper Hewitt Museum, Department of Exhi-

bitions, Exhibition Records, box 22, "Golden Eye: List of Panels" folder, panel 17. For a history of Kashmiri textiles in a global perspective, see Maskiell 2002; Rizvi 2009.

62 It is telling that the postmodern move to valorize American kitsch and popular culture finds a parallel here in the juxtaposition of India's vernacular craft with high design rather than a turn to India's popular culture. Indeed, the Festival completely overlooked this aspect of India's visual culture, from Bollywood to shop signage and calendar art. At the time, Bollywood was seen as an embarrassment by most in elite art circles (despite the truth that some of India's top artists worked doing set design and painting hoardings, or billboards, for the films). Likewise, calendar art was not yet seen as a valuable element of India's culture. See Ganti 2012 for the trajectory of acceptance of Bollywood in elite circles; see Jain 2007 for calendar art.

63 Indeed, trade barriers posed a major problem for the movement and sale of *Golden Eye* objects and prototypes, and the inconsistency in copyright law and its enforcement also meant that the international designers were at a disadvantage in pursuing their designs.

CHAPTER 5

1 The Festival itself included over two hundred events spread across the entirety of the U.S.; for more details, see chapter 1.

2 The Festival included historical shows such as *India! Art and Culture* at the Metropolitan Museum of Art (Welch 1985), *The Sculpture of India, 3000 B.C.–1300 A.D.* at the National Gallery in Washington, D.C. (Chandra 1985); vernacular exhibitions such as *Aditi: A Celebration of Life* at the Smithsonian (Thomas M. Evans Gallery 1985); and colonial-era installations such as *From Merchants to Emperors: British Artists and India, 1757–1930* at the Pierpont Morgan Library in New York (Pal and Dehejia 1986).

3 Niranjan Desai, a member of the Indian committee organizing the Festival, cited the film's monkey brain scene when discussing the hope that the events would counter existing stereotypes about India and instead would inform the American public about India's arts and crafts. See Reynolds 1985. *Raiders of the Lost Ark* was released in 1981; the monkey brain scene was in the sequel, *Indiana Jones and the Temple of Doom* (1984).

4 An additional three small exhibitions from the Herwitz family collection took place at Dartmouth College (*Indian Painting of the 80s from the Herwitz Family Collection*) and at the Worcester Art Museum (*Flowers of the Vine–Contemporary Indian Painting from the Chester and Davida Herwitz Collection* and *Flame of Many Colors–Contemporary Indian Painting from the Chester and Davida Herwitz Collection*) during the 1985–86 Festival; see Bean 2013. An exhibition of contemporary Indian prints was shown at the San Diego State University Art Gallery, and a touring exhibition of Raghubir Singh's photographs (1942–99) was held at several venues. Other exhibitions incorporated or emphasized recent visual culture and art from India, including textiles, terracottas, and so-called folk art: *From Indian Earth: 4,000 Years of Terracotta Art* (Brooklyn Museum), *Women Painters of Mithila* (traveling exhibition), *Master Weavers* (Smithsonian Institution Traveling Exhibition Service), *Golden Eye* (Cooper Hewitt), *Aditi* (Smithsonian), and *Mela!* (Folklife Festival, Smithsonian), several of which I've discussed in earlier chapters. While these last exhibitions have the potential to disturb an understanding of what "contemporary" means, the three shows discussed here self-identified as bringing India's high-art, gallery-driven, contemporary painting to American audiences; see Jayakar 1985.

5 Chester and Davida Herwitz started traveling to India in 1962 and began collecting Indian contemporary art in 1972. At its peak twenty-five years later, their collection numbered more than four thousand objects. Chester Herwitz was a designer and manufacturer of fashion accessories. In 1995 and 1996, some of their collection was auctioned at Sotheby's to support the Chester and Davida

Herwitz Charitable Trust, intended to establish a museum in the U.S. dedicated to contemporary Indian art (Sotheby's 1995, 1996). After Chester's untimely death in a car accident in 1999 (Davida died in 2002), their collection was given (in 2001) to the Peabody Essex Museum in Salem, Massachusetts, where a dedicated gallery in their name was opened in 2003. See de Guardiola 1986; Gaur and Sinha 2002; Bean 2013, 2014.

6 Neo-Tantra offers a particularly ingenious solution to the problem of how to be modern and Indian at the same time. Like European artists who looked to the other (in West African sculpture, Eastern European rural traditions, or Mayan art), Indian Neo-Tantric artists looked to an "internal" other in the form of the esoteric tradition of Tantra; see R. Brown 2005. In its self-referentiality the move to the Tantric reifies the otherness of India, thereby playing into (rather than undermining) Orientalist presuppositions. See also Sen-Gupta 2001.

7 Because the three shows under discussion here took part in the Festival of India, they represent a particularly strong node of exhibitionary practices across a half century that saw only a handful of isolated, small shows, beginning with the 1959 *Trends in Contemporary Painting from India* at the Graham Gallery in New York. See Gaur and Sinha 2002; Bean 2011a, 2013, 2014. The 1982 Festival of India in the U.K. staged a set of contemporary Indian art exhibitions that served as a recent precedent for the three shows in the U.S. See Elliott and Alkazi 1982; Padamsee et al. 1982; Hodgkin 1982.

8 For the Havana Biennial, see Weiss 2007 and Rojas-Sotelo 2009. For *Magiciens de la Terre*, see Araeen 1989 and Martin 1989. For the 1993 Whitney Biennial, see Kelly 2000; Supangkat 1996.

9 The "distant contemporary" I lay out here echoes the concern with anthropological practice as articulated by Johannes Fabian. Fabian draws a genealogical connection between the turn to visualism for teaching philosophical concepts to teenagers through charts and orderly tables (an introduction) and the presupposition of a hierarchical relationship between teacher and student, extended to that between anthropologist and other. Fabian's central claim in the book—that "anthropology has managed to maintain distance, mostly by manipulating temporal coexistence through the denial of coevalness"—here is joined by an acknowledgment of what I see as the demand for a "perpetual introduction" to the other (Fabian 1983, 121).

10 Terry Smith has articulated this problem as the demand for works that are accessible outside particular local contexts and readable for a wider, global culture (2010). Holland Cotter's review of the first Guggenheim UBS MAP Global Art Initiative exhibition, *No Country: Contemporary Art for South and Southeast Asia*, shares a concern that audiences continue to reject art that requires exegesis outside the work itself (Cotter 2013). The 2013 Peabody Essex Museum exhibition of the Herwitz collection, *Midnight to the Boom: Painting in India after Independence*, juggled these concerns by presenting individual artists within one of three generational frames (Bean et al. 2013).

11 In the mid-1980s, contemporary Indian art was barely nascent within art history. None of the three curators—Edith Tonelli (Wight), Laughlin Phillips (Phillips), and Thomas Sokolowski (Grey)—for the Festival's contemporary exhibitions was a scholar of South Asian art. Laxmi Sihare, then director of the National Gallery of Modern Art in New Delhi, organized an earlier version of the *Neo-Tantra* show; his PhD dissertation examined twentieth-century European painters (Sihare 1967). Graduate training in twentieth-century Indian art remained a peripheral concern: in 1985, graduate institutions had produced one PhD dissertation on Abdur Rahman Chughtai (1899–1975), by Marcella Sirhandi (then Nesom, 1984), and an MA thesis by Geeta Kapur (1970). In the 2000s, PhD students began working in earnest on this broad period (Dadi 2003; Richardson 2005; Zitzewitz 2006; Wyma 2000; Ali 2008; Citron 2009; Khullar 2009; Gupta 2011).

12 Lucy R. Lippard (1990) articulates this problem in the context of the rise of multiculturalism within North America and elsewhere. See also Supangkat 1996; Appadurai 1986; Frow 1995; Maravillas 2006.

13 In his analysis of the 1996 exhibition *Contemporary Art in Asia: Traditions/Tensions* (held concurrently at the Asia Society Galleries, the Grey, and the Queens Museum of Art in New York; Poshyananda 1996), Ajay Sinha (1999) outlines a mid-1990s understanding of the contemporary in the context of a carnivalesque, spectacle-driven pastiche of references to the sights circulating and melding together in India's popular culture, urban space, and constructed historical traditions. In mounting a critique of the exhibition's emphasis on an ironic, deconstructive approach to globalization and neoliberal capitalism within the rising "Asian tiger" economies of South and Southeast Asia, Sinha draws out his own critically engaged approach to the contemporary, one that enables a rich interweaving of historical material working in dialogue with concerns of art making that move across national boundaries. Sinha's essay is one of several in a landmark issue of *Art Journal* dedicated to India's contemporary and modern art, the first time the journal devoted an entire issue to this topic. The publication signals that "the contemporary" as a term had begun to gain traction within art writing; fifteen years earlier, during the Festival, this kind of analysis had not yet come to the fore.

14 As discussed below, the mission of the Grey Art Gallery's founder, Abby Weed Grey, involved bringing the art of many underrepresented areas to the awareness of the North American public (Grey 1983).

15 Any attempt to summarize a decade will fall short; other elements of the mid-1980s moment include the AIDS crisis and a growing emphasis on trauma as a cultural trope, a return to painting and continued linkages to modernism in the art world, the rise and legitimation of street art, and the criticized increasing demand for an entrepreneurial, privately funded display context for art. See Singerman 2009. For the Festival's relation to the entrepreneurial, see the chapter "Entrepreneurial Exhibits."

16 In addition to the two governments, funding came from a few corporate sponsors and programs such as the Smithsonian Institution's Special Foreign Currency Program. The Indo-U.S. Subcommission on Education and Culture oversaw the organization of the Festival and provided some funding as well.

17 I have chosen to reproduce, where possible, works that were included in the Festival of India exhibitions. Here, M. F. Husain's work from the Hanuman series was not in the exhibition, but its composition and style are similar to those of several of his works that were included.

18 See Chandra 1985. A small exhibition of Kaiko Moti's (1921–89) watercolor and ink painting was held at the gallery of Meridian House International in Washington, D.C., and Nek Chand (1924–2015) installed versions of his self-taught sculptural work at the Capital Children's Museum (for the latter, and for the National Gallery exhibition, see the chapter "Material Transformations").

19 Phillips's choice of words here echoes the subtitle of the 1984 *"Primitivism" in 20th Century Art* show at the Museum of Modern Art: "Affinity of the Tribal and the Modern" (Rubin 1984). As discussed below, the very idea of formal affinity came under significant criticism in relation to this exhibition; that Phillips used the same word indicates it circulated in the discourse to express a superficial visual link, elevating the visual culture of the other only through formal coincidence.

20 Jayakar's official title was "chairman," not "chairwoman."

21 Grey herself (1983, 69) calls this approach rather naive; scholars at the time of the Festival questioned the validity of the cliché that art communicates across cultural borders (Chandra 2001, 128). Chandra's essay was part of a 1986 Festival of India symposium.

22 Thomas Sokolowski, personal communication, April 11, 2012.

23 The characterization as a "museum-laboratory" also anchors the mission statement of Harvard University's Fogg Art Museum—an "art laboratory"—as that institution built its modern art collection (Jones 1985). Sokolowski saw the university museum as a venue for inventive and experimental exhibitions (personal communication, April 11, 2012; see also King 2001).

24 The thirteen artists were Manjit Bawa (1941–2008), Bikash Bhattacharjee (1940–2006), Bal Chhabda (1923–2013), Jogen Chowdhury (b. 1939), Vinod Dave (b. 1948), Somnath Hore (1921–2006), M. F. Husain (1915–2011), Ranbir Singh Kaleka (b. 1953), Tyeb Mehta (1925–2009), Gieve Patel (b. 1940), Sudhir Patwardhan (b. 1949), S. H. Raza (1922–2016), and Rekha Rodwittiya (b. 1950).

25 Mullican 1985; Mullican's own abstract painting evinced a commitment to a universalism and a timeless aesthetic engaged with midcentury transcendental philosophies and the exploration of the unconscious. He had traveled to India and titled some of his paintings in the 1960s with references to Indian *rāga*s (Eliel et al. 2005). Tonelli recalled these intersections as a decisive factor in pursuing an abstract painting exhibition and confirmed that the sense at the time was that the art community in Los Angeles was particularly open to Indic spirituality and abstract art (personal communication, March 8, 2013).

26 "Eclecticism" has a particular value as a term within discussions of South Asian modern and contemporary art. Geeta Kapur notes that eclecticism within individual artists' works is often an effect of postcolonial cultures dealing with the hegemony of modern art understood as emerging solely from Europe and North America. She urges not "hybrid solutions" but "dialectical synthesis" from Indian artists (Kapur 1996, 63). If we apply her argument to the curating of these Festival exhibitions, we see that they tend to present eclecticism as a hodgepodge rather than as either a fully articulated hybrid or synthesis. This produces a double level of the eclectic—the work and the exhibition—making these shows even more difficult to grasp for visitors struggling to get a clear picture of India's contemporary art.

27 Neo-Tantra was one of the few identifiable "movements" within Indian art during this period. Artists often resisted this label or, alternatively, took on the mantle of Neo-Tantra at moments when to do otherwise would cause major problems financially or politically within India's art community or among collectors. Many artists saw this framing as the only way to get their work exhibited outside India, even if they did not feel a connection with the philosophy.

28 Highlighting a movement presumes that India's modern and contemporary art might fit into canonical art historical frameworks. Geeta Kapur has contested the idea of mapping canonical temporal progressions onto India and has analyzed whether India might have an avant-garde at all and in what ways Indian art resists temporally inflected designations (Kapur 1993, 2005). One of the structuring problems of these three shows is the lack of a clear art historical canon for this material. As discussed above, this feeling of leaving behind solid periodizations permeated the art criticism and art history of the 1980s; one was left without an anchor after Minimalism and Conceptual art, and the emergence of postmodernism did not fill the void in a satisfactory manner (see Smith 2009).

29 See Poster 1986; Thomas M. Evans Gallery 1985. See also the chapters "Material Transformations" and "Time, Interrupted," respectively.

30 My thanks to Atreyee Gupta for drawing out this insight.

31 Many of the artists included in the slide show also figured in the Grey Art Gallery show: Bawa, Bhattacharjee, Chowdhury, Dave, Husain, Kaleka, Mehta, Patel, Patwardhan, and Rodwittiya. The others are Suneela Bindra (now Chopra, b. 1953), Pottekkad Gopinath (b. 1948), Laxma Goud (b. 1940), Shamshad Hussain (1946–2015), Bhupen Khakhar (1934–2003), Devayani Krishna (1910–2000), Nasreen Mohamedi (1937–90), Ganesh Pyne (1937–2013), Krishna Reddy (b. 1925), Arpita Singh (b. 1937), K. G. Subramanyan (1924–2016), Anupam Sud (b. 1944), Viren Tanwar (b. 1952), and Vasundhara Tewari (now Broota, b. 1955). *Neo-Tantra: Contemporary Indian Painting Inspired by Tradition*, Wight Art Gallery exhibit files RS#665, box 91, folder 8. See chapter 1, where I explore the traces of Vasundhara Tewari Broota's attempts to be included in these exhibitions.

32 The artists in the exhibition were Biren De (1926–2011), K. V. Haridasan (1937–2014), Mahirwan Mamtani (b. 1935), Prafulla Mohanty (b. 1936), Om Prakash (1932–98), K. C. S. Paniker (1911–77), P. T. Reddy (1915–96), and G. R. Santosh (1929–97).

33 For example, Abby Weed Grey's foundation had sponsored a number of traveling exhibitions of Indian artists, as well as providing major impetus and financial support for America's contribution to India's first two triennials in New Delhi (in 1968 and 1971; Grey 1983). Smith (2009, 151–71) notes that for postcolonial artists in the last decades of the twentieth century, the biennial circuit was a crucial locus for exhibiting and selling work and exchanging ideas across the globe.

34 Sokolowski sometimes found himself defending the works against dismissal as merely derivative of various European art movements, spending time with high-profile art world visitors to enable them to see the particularity of the problems dealt with by the artists in the show (personal communication, April 11, 2012). For discussion of the ongoing problems of acknowledging India's recent art, see Mitter 2008; Desai 1995.

35 Exhibition records, *Indian Art Today*, Phillips Collection Archives, series 1, folder 9.

36 The show was organized around the following themes: "The Hinterland of Myth: Indian and Christian" (Husain, F. N. Souza, Satish Gujral), "Nature as Pictorial Metaphor: Forest, Mountain, River" (Raza, Akbar Padamsee, Ram Kumar), "The Dislocated Persona" (Mohan Samant, Mehta, Subramanyan), "Social Satire and Political Protest" (Krishen Khanna, A. Ramachandran, Bhattacharjee, Chowdhury, Rameshwar Broota, Kaleka), "The Urban Scene: Strangers in the City" (Patel, Patwardhan), "Middle Class Alienation" (Malani), and "New Myths, New Realities" (Mukherjee, Kapoor). See Elliott and Alkazi 1982.

37 Four issues of *Art Monthly* include correspondence on this subject: 40 (October 1980): 22; 41 (November 1980): 23–25; 42 (December/January 1981): 30–31; 43 (February 1981): 30.

38 Voices in India, including M. F. Husain, also criticized the Festival for focusing on historical material instead of India's contemporary art and culture. Husain remarked that Pupul Jayakar "only thinks anything which is 5,000 years old is art" (as quoted in Desai 1985, 29). The Indian organizer of the 1987 Festival of India in the Soviet Union contrasted his efforts with those of earlier Festivals of India precisely by indicating the presentist focus of the Soviet Festival (Hazarika 1987). And organizers raised concerns regarding the lack of contemporary Indian art and culture in the Festival (Smithsonian Institution Archives, accession 90-087, Smithsonian/Man and the Biosphere Program Records, box 3). India's contemporary art was one of several themes addressed in the Smithsonian's major Festival of India symposium, "A Canvas of Culture," held June 21–24, 1985 (published as Borden 1989). Gulammohammed Sheikh (b. 1937), Gieve Patel (b. 1940), Girish Karnad (b. 1938), Raj Rewal (b. 1934), Charles Correa (1930–2015), and Balkrishna Doshi (b. 1927) spoke at roundtables devoted to artists and architects. Smithsonian Institution Archives, accession 91-017, Smithsonian Institution, Directorate of International Activities Records, box 3.

39 Only the Grey Art Gallery exhibition catalog includes an essay by an artist in the show (Gieve Patel).

40 Primarily, the Wight show left out sculpture. The Stuttgart show did not generate the kind of discussion that the exhibitions in the U.K. did. Unlike the shows in the U.K., it was an isolated event and not part of a Festival of India program.

41 Sokolowski (1985, 19) also notes this in his essay for the Grey Art Gallery show, turning to K. G. Subramanyan's observation that Indian art is not compatible with the West. Gieve Patel's essay in the same catalog cites Gulammohammed Sheikh's dismissal of dualisms such as East–West (Patel 1985, 10).

42 For more on the modern–Indian paradox, see Brown 2009.

43 While it is difficult to find evidence as to why the artists frame their statements in similar ways, I suggest that the pressure to conform to the overarching spiritual core of the constructed Neo-Tantrism movement led many of them to focus on those elements of their work and biography. Certainly, market pressures and the expectation that the works be sufficiently "Indic" and authentic contributed to this framing, as did editing and selection by Sihare.

44 Six of Hore's *Wounds* series were shown at the Grey Art Gallery; only one was reproduced in the catalog. The example reproduced here is representative of the larger series.

45 Patel presages the Guerrilla Girls' 1988 poster enumerating "The Advantages of Being a Woman Artist," which begins: "Working without the pressure of success." Unlike the Guerrilla Girls' commentary, Patel's remark is not presented with overt humor or cynicism. See Withers 1988; Saks et al. 2012.

46 Mitter was a well-established scholar, having published *Much Maligned Monsters* in 1977 and having also worked with questions of art and nationalism in a 1981 essay.

47 See Brown (forthcoming) for a more in-depth analysis of Patel's essay and its import for this particular mid-1980s moment in articulating the position of contemporary Indian art in a global context.

48 Sokolowski (Grey Art Gallery) met several artists in India he would have liked to include in the exhibition but whose work was not in the Herwitz collection. With crucial financial support for the exhibition and the catalog coming from the Herwitz family, the show had to come solely from that collection (personal communication, April 11, 2012).

49 Maureen Liebl to Wilton Dillon, May 16, 1984, Smithsonian Institution Archives, accession 90-087, Smithsonian/Man and the Biosphere Program Records, box 3.

50 In part this may be due to lack of knowledge or particular frames of knowledge. Mullican's initial handwritten list of possible artists for the Wight gallery slide show marks "important" artists with an asterisk. Souza's name is not marked (*Neo-Tantra: Contemporary Indian Painting Inspired by Tradition*, Wight Art Gallery exhibit files RS#665, box 91, folder 8). With a lack of critical and even commercial frameworks to provide context for emerging artists, identifying "important" artists was, as Sokolowski characterized it to me, a bit like playing a volatile stock market (personal communication, April 11, 2012).

51 Sokolowski recalls wanting to include Mukherjee in the Grey show, and even wanting to purchase some of her works for the gallery's collection; he was unable to do so because of funding limitations (personal communication, April 11, 2012).

52 Among the female artists in the Herwitz collection at the time were Rekha Rodwittiya, Arpita Singh, Nalini Malani, Vasundhara Tewari (now Broota), Nasreen Mohamedi, and Anupam Sud (*Neo-Tantra: Contemporary Indian Painting Inspired by Tradition*, Wight Art Gallery exhibit files RS#665,, box 91, folder 8). Sokolowski was enthusiastic about the work of women artists he met in India but felt that with the exception of Rodwittiya, the Herwitz collection did not have a strong enough sample of women artists' work to include in the show (personal communication, April 11, 2012). Neither the Stuttgart nor the UCLA *Neo-Tantra* shows presented women artists. The painting reproduced here was not in the exhibition but is a representative example from this period of Rodwittiya's oeuvre.

53 A proposal for an exhibition of Rabindranath Tagore paintings reached the Smithsonian and UCLA curators but was not included in the Festival. See Smithsonian Institution Archives, Record Unit 367, Smithsonian Institution, Assistant Secretary for Public Service, subject files, box 37; *Neo-Tantra: Contemporary Indian Painting Inspired by Tradition*, Wight Art Gallery exhibit files RS#665, box 91, folder 8.

54 Some proposals for historical exhibitions centering on Mohandas Gandhi and Jawaharlal Nehru were circulating during planning for the Festival. See Smithsonian Institution Archives, Record Unit 367, Smithsonian Institution, Assistant Secretary for Public Service, subject files, box 38.

55 Tonelli remembers this as a major concern that was discussed during the organization of the show; in part, the supplemental slide show was meant to speak to the lack of women in the exhibition proper (personal communication, March 8, 2013). Drafts of the slide lists are marked to indicate which artists are women, but the printed slide lists available in the gallery were not marked

(*Neo-Tantra: Contemporary Indian Painting Inspired by Tradition*, Wight Art Gallery exhibit files, RS#665, box 91, folder 8). As a result, while the slide show included women artists, visitors unable to identify the gender of the artist from the names would not be able to distinguish women from men on the list.

56 The photographer Raghubir Singh did enjoy his own solo exhibition, which circulated to several venues during the Festival, but this exhibition presented his work as in line with documentary photography. No photography was included as part of the contemporary art exhibitions at the Festival.

57 The mission of the university museum subtly shifted from what Steven Conn has called an "object-based epistemology" to one centered on the audience (Conn 1998). This shift occurred as funding and support for university museums shrank; the need to increase visitor numbers and secure outside funding moved the focus from collections to education (Weil 1999; King 2001).

58 Brown 2009; Dadi 2010; Zitzewitz 2014; Khullar 2015. For Rabindranath Tagore, see Mitter 2007, 65–99; Vajpeyi 2012, 157–63. For Mehta, see Citron 2009, 66–109; 2011.

59 I am struck by the similarities here with the criticisms leveled at the Whitney's 1971 exhibition of the work of African American artists. The prevalence of abstraction in that show and in between 1968 and 1975 tended to exclude figural and more overtly political work circulating at the time. See Jones 2006; Cooks 2011; Wallace 2015; Cahan 2016.

60 In addition to the dissertations listed above, several smaller exhibitions at university galleries and small museums have pursued different paths in presenting post-1947 Indian art. Examples include Chaudhri et al. 2009; Brown 2011; and a series of three exhibitions curated by Beth Citron in 2011 (for online exhibition materials, see http://www.rmanyc.org; accessed April 9, 2012). Some exhibitions of twenty-first-century Indian art include earlier objects, such as San Jose Museum of Art 2011. Portions of larger scale, monographic exhibitions have also been successful in situating artists historically, politically, and within India's art historical discourse, including the 2008 Nandalal Bose exhibition (Quintanilla et al. 2008).

CHAPTER 6

1 I thank the students in Vishakha Desai's cultural diplomacy seminar at Columbia University, whose critical and engaged discussion has informed my thoughts here.

2 From an undated note recording Sethi's summary of Otto's approach to the tent, Smithsonian Institution Archives, Record Unit 531, box 22, "Golden Eye: Lenders" folder.

3 For more on Otto's body of work, see Nerdinger 2005.

4 Tejiben Makwana traveled to London during the U.K. Festival of India in 1982, and is mentioned in Ford 1984 and Prakash 1984.

5 Shri Vasovada, an architect in Ahmedabad, quoted on the draft labels for *Golden Eye*, Smithsonian Institution Archives, accession 04-122, Cooper Hewitt Museum, Exhibition Records, 1976-2000, subseries 2, Design and Publicity Records, box 7, folder "Exhibition #122: The Golden Eye, 1985–1986."

6 "A Brief Guide to the Exhibition," November 18, 1985, Smithsonian Institution Archives, accession 04-122, Cooper Hewitt Museum, Exhibition Records, 1976-2000, subseries 2, Design and Publicity Records, box 7, folder "Exhibition #122: The Golden Eye, 1985–1986."

7 "A Brief Guide to the Exhibition," November 18, 1985, Smithsonian Institution Archives, accession 04-122, Cooper Hewitt Museum, Exhibition Records, 1976-2000, subseries 2, Design and Publicity Records, box 7, folder "Exhibition #122: The Golden Eye, 1985–1986."

8 As related by Kirit Patel, "Remarks from the Golden Eye Staff," Smithsonian Institution Archives,

accession 04-122, Cooper Hewitt Museum, Exhibition Records, 1976-2000, subseries 2, Design and Publicity Records, box 7, folder "Exhibition #122: The Golden Eye, 1985–1986."

9 This sculpture, sometimes called the Didarganj Yakshi, has traditionally been dated to the third century BCE, during the reign of the Mauryan ruler Ashoka. But recent scholarship has questioned that date as well as the designation of *yakṣin*, or female nature divinity, and has placed the work in a regional style contemporary with the Kushan period in the second century CE. See Asher 2011.

10 In 1984 Zubin Mehta and the New York Philharmonic performed in India, as did the Merce Cunningham Dance Company. One Indian government official asked whether Indians really wanted to see American culture: "If there is in fact a great demand in the villages of Karnataka to see 'Hello Dolly'—all right, we'll do it" (quoted in Bumiller 1985, B2).

11 The director of the National Gallery (who had been the director of the National Museum of Modern Art when the Festival planning was first under way), Laxmi Sihare, was one of the most vocal critics of this aspect of the Festival, pointing out the hypocrisy in the American resistance to sending U.S. treasures to India. Part of the problem lay in Sihare's own list of requested works, which included many European paintings and came from a wide range of U.S. collections. Without a curator or administrator to spearhead the loans in America, discussion of a large-scale exhibition, even one focused solely on American works, ground to a halt. See Bumiller 1985.

12 The KNMA organized the retrospective of Nasreen Mohamedi's work, which served as one of the opening exhibitions at the Met's Breuer gallery in 2016. See Pineda and Rodríguez 2015.

BIBLIOGRAPHY

ARCHIVES

1985 Festival of American Folklife: Aditi/Mela Program, Smithsonian Folklife Festival Documentation Collection, Ralph Rinzler Folklife Archives and Collections, Smithsonian Institution, Washington, DC.

Costume Institute Records, accession 2010.A.021, boxes 16–19, Metropolitan Museum of Art Archives, New York.

Festival of India files, Islamic Art Department, Metropolitan Museum of Art, New York.

Forms of Mother Earth: Contemporary Terracotta of India folder, Mingei International Museum Archives and Library, San Diego, CA.

From Indian Earth: 4,000 Years of Terracotta Art files, Brooklyn Museum Archives, Brooklyn, NY.

Golden Eye: An International Tribute to the Artisans of India records, Library and Archives, Cooper Hewitt, Smithsonian Design Museum, New York.

India! Art and Culture, 1300–1800 files, Metropolitan Museum of Art Archives, New York.

Indian Art Today: Four Artists from the Chester and Davida Herwitz Family Collection exhibition records, Phillips Collection Archives, Washington, DC.

Nek Chand: Fantasy Garden files, National Children's Museum Archives, Washington, DC.

Neo-Tantra: Contemporary Indian Painting Inspired by Tradition, Wight Art Gallery exhibit files RS#665, Library Special Collections, University of California, Los Angeles.

Official Records of the Smithsonian Institution, Smithsonian Institution Archives, Washington, DC.

The Sculpture of India, 3000 B.C.–1300 A.D. records, Gallery Archives, National Gallery of Art, Washington, DC.

BOOKS AND ARTICLES

Abrahams, Yvette. 1998. "Images of Sara Bartman: Sexuality, Race, and Gender in Nineteenth-Century Britain." In *Nation, Empire, Colony: Historicizing Gender and Race,* edited by Ruth Roach Pierson et al., 220–36. Bloomington: Indiana University Press.

Adamson, Glenn. 2007. *Thinking through Craft*. Oxford: Berg.

Adamson, Glenn, Jane Pavitt, and Paola Antonelli. 2011. *Postmodernism: Style and Subversion, 1970–1990*. London: Victoria and Albert Museum.

Afable, Patricia O. 2004. "Journeys from Bontoc to the Western Fairs, 1904–1915: The 'Nikimalika' and Their Interpreters." *Philippine Studies* 52.4: 445–73.

Ali, Atteqa Iftikhar. 2008. "Impassioned Play: Social Commentary and Formal Experimentation in Contemporary Pakistani Art." PhD diss., University of Texas at Austin.

Althusser, Louis, and Étienne Balibar. 2009 [1968]. *Reading Capital*. New York: Verso.

Anderson, Brooke Davis. 2006. "Concrete Kingdom: Sculptures by Nek Chand." *Folk Art* 31.1–2 (Spring/Summer): 42–50.

Anderson, Jay. 1984. *Time Machines: The World of Living History*. Nashville: American Association for State and Local History.

Apostolidis, Paul. 2016. "Migrant Day Laborers, the Violence of Work, and the Politics of Time." In *Time, Temporality and Violence in International Relations (De)Fatalizing the Present, Forging Radical Alternatives,* edited by Anna M. Agathangelou and Kyle Killian, 159–71. New York: Routledge.

Appadurai, Arjun. 1986. "Commodities and the Politics of Value." In *The Social Life of Things: Commodities in Cultural Perspective,* edited by Arjun Appadurai, 3–63. Cambridge: Cambridge University Press.

Araeen, Rasheed, ed. 1989. "Special Issue on *Magiciens de la Terre*." *Third Text* 6. Translated from *Les Cahiers du Musée National d'Art Moderne* 28 (1989).

Ardery, Julia S. 1998. *The Temptation: Edgar Tolson and the Genesis of Twentieth-Century Folk Art*. Chapel Hill: University of North Carolina Press.

Asher, Frederick M. 2011. "On Maurya Art." In *The Companion to Asian Art and Architecture,* edited by Rebecca M. Brown and Deborah S. Hutton, 421–45. Malden, MA: Wiley.

Augé, Marc. 1995. *Non-Places: Introduction to an Anthropology of Supermodernity*. London: Verso.

———. 1999. *An Anthropology for Contemporaneous Worlds*. Stanford: Stanford University Press.

Auther, Elissa. 2010. *String, Felt, Thread: The Hierarchy of Art and Craft in American Art*. Minneapolis: University of Minnesota Press.

Banerjee, Prathama. 2006. *Politics of Time: "Primitives" and History-Writing in a Colonial Society*. New Delhi: Oxford University Press.

Barthes, Roland. 1981. *Camera Lucida: Reflections on Photography*. New York: Hill and Wang.

Baxandall, Michael. 1991. "Exhibiting Intention: Some Preconditions of the Visual Display of Culturally Purposeful Objects." In *Exhibiting Cultures: The Poetics and Politics of Museum Display,* edited by Ivan Karp and Steven D. Lavine, 33–41. Washington, DC: Smithsonian Institution Press.

Bean, Susan. 1985. "Yankee Traders and Indian Merchants, 1785–1865." In *The Festival of India in the United States, 1985–1986,* edited by Pupul Jayakar, 131–37. New York: Harry N. Abrams.

———. 2011a. "On American Collectors of Indian Art." In *Goddess, Lion, Peasant, Priest: Modern and Contemporary Indian Art from the Shelley and Donald Rubin Collection,* edited by Rebecca M. Brown, 9–11. Atlanta, GA: Oglethorpe University Museum of Art.

———. 2011b. "The Unfired Clay Sculpture of Bengal in the Artscape of Modern South Asia." In *The Companion to Asian Art and Architecture,* edited by Rebecca M. Brown and Deborah S. Hutton, 604–28. Malden, MA: Wiley.

———. 2013. "Chester and Davida Herwitz: American Collectors of Indian Art." In *Midnight to the Boom: Painting in India after Independence,* 65–73. New York: Thames and Hudson.

———. 2014. "Post-Independence Art from India in the American Art World, 1950–1970." In *Indian Painting: Themes, History and Contexts,* edited by Mahesh Sharma and Padma Kaimal, 378–89. Ahmedabad: Mapin.

Bean, Susan, et al. 2013. *Midnight to the Boom: Painting in India after Independence.* New York: Thames and Hudson.

Beardsley, John. 1996. "Critic at Large: Garden of Sorrows." *Landscape Architecture* 86.9 (September): 139–40.

Beaudry, Marilyn P., J. Mark Kenoyer, and Rita P. Wright. 1987. "Traditional Potters of India: Ethnoarchaeological Observations in America." *Expedition* 29.3 (Spring): 55–63.

Becker, Gary S. 1975. *Human Capital: A Theoretical and Empirical Analysis, with Special Reference to Education.* New York: National Bureau of Economic Research.

Bender, Barbara. 2002. "Time and Landscape." *Current Anthropology* 43 (August–October): S103–12.

Bennett, Jane. 2010. *Vibrant Matter: A Political Ecology of Things.* Durham: Duke University Press.

Bergeron, Suzanne. 2016. "Formal, Informal, and Care Economies." In *The Oxford Handbook of Feminist Theory,* edited by Lisa Jane Disch and M. E. Hawkesworth, 169–206. New York: Oxford University Press.

Bhatti, Mark, et al. 2009. "'I love being in the garden': Enchanting Encounters in Everyday Life." *Social and Cultural Geography* 10.1 (February): 61–76.

Bishop, Claire. 2012. *Artificial Hells: Participatory Art and the Politics of Spectatorship.* London: Verso.

Blanchard, Pascal, ed. 2008. *Human Zoos: Science and Spectacle in the Age of Colonial Empires.* Liverpool: Liverpool University Press.

Bloch, Ernst. 1997 [1935]. "Nonsynchronism and the Obligation to Its Dialectics." Translated by Mark Ritter. *New German Critique* 11 (Spring): 22–38.

Blume, Harvey. 1999. "Ota Benga and the Barnum Complex." In *Africans on Stage: Studies in Ethnological Show Business,* edited by Bernth Lindfors, 188–203. Bloomington: Indiana University Press.

Bogdan, Robert. 1988. *Freak Show: Presenting Human Oddities for Amusement and Profit.* Chicago: University of Chicago Press.

Bois, Yve-Alain. 1997. "Ray Guns." In *Formless: A User's Guide,* by Yve-Alain Bois and Rosalind E. Krauss, 172–78. New York: Zone Books.

Borden, Carla M., ed. 1989. *Contemporary Indian Tradition: Voices on Culture, Nature, and the Challenge of Change.* Washington, DC: Smithsonian Institution Press.

Breckenridge, Carol. 1989. "The Aesthetics and Politics of Colonial Collecting: India at World Fairs." *Comparative Studies in Society and History* 31.2 (April): 195–216.

Brown, Carolyn Henning. 1985. "The Women Painters of Mithila." In *Festival of India in the United States, 1985–1986*, edited by Pupul Jayakar, 155–61. New York: Harry N. Abrams.

Brown, Rebecca M. 2005. "P. T. Reddy, Neo-Tantrism, and Modern Indian Art." *Art Journal* 64.4 (Winter): 26–49.

———. 2009. *Art for a Modern India, 1947–1980.* Durham: Duke University Press.

———. 2010. *Gandhi's Spinning Wheel and the Making of India.* London: Routledge.

———. 2011. *Goddess, Lion, Peasant, Priest: Modern and Contemporary Indian Art from the Shelley and Donald Rubin Collection.* Atlanta, GA: Oglethorpe University Museum of Art.

———. 2013. "Colonial Polyrhythm: Imaging Action in the Early Nineteenth Century." *Visual Anthropology* 26.4: 269–97.

———. Forthcoming. "To Pick Up a Brush: A Double-take, Gieve Patel, and Indian Art of the 1980s." *Third Text,* special issue on Partitions edited by Natasha Eaton and Alice Correia.

Brown, Wendy. 2005. *Edgework: Critical Essays on Knowledge and Politics.* Princeton: Princeton University Press.

Bryant, Barry. 1992. *The Wheel of Time Sand Mandala: Visual Scripture of Tibetan Buddhism.* San Francisco: Harper.

Bumiller, Elizabeth. 1985. "The India Festival's Long Road." *Washington Post*, June 12, B1–B3.

Bunten, Alexis Celeste. 2008. "Sharing Culture or Selling Out? Developing the Commodified Persona in the Heritage Industry." *American Ethnologist* 35.3 (August): 380–95.

Buszek, Maria Elena, ed. 2011. *Extra/Ordinary: Craft and Contemporary Art.* Durham: Duke University Press.

Cahan, Susan. 2016. *Mounting Frustration: The Art Museum in the Age of Black Power.* Durham: Duke University Press.

Cantwell, Robert. 1993. *Ethnomimesis: Folklife and the Representation of Culture.* Chapel Hill: University of North Carolina Press.

Cardinal, Roger. 1972. *Outsider Art.* New York: Praeger.

Chakrabarty, Dipesh. 2000. *Provincializing Europe: Postcolonial Thought and Historical Difference.* Princeton: Princeton University Press.

Chambers, Samuel A. 2003. *Untimely Politics.* Edinburgh: Edinburgh University Press.

———. 2011. "Untimely Politics *avant la lettre*: The Temporality of Social Formations." *Time and Society* 20.2 (July): 197–223.

———. 2013. *The Lessons of Rancière.* New York: Oxford University Press.

———. 2014. *Bearing Society in Mind: Theories and Politics of the Social Formation.* London: Rowman and Littlefield.

———. 2016. "Learning How to Be a Capitalist: From Neoliberal Pedagogy to the Mystery of Learning." In *The Pedagogics of Unlearning*, edited by Eamonn Dunne and Michael O'Rourke, 71–106. Brooklyn: Punctum Books.

Chandra, Pramod. 1985. *The Sculpture of India, 3000 B.C.–1300 A.D.* Washington, DC: National Gallery of Art.

———. 2001. "American Understanding of Indian Art." In *American Understanding of India: A Symposium*, edited by Louis A. Jacob, 123–40. New Delhi: Manohar.

Chaudhri, Rajiv Jahangir, Edward Saywell, and Malcolm Rogers. 2009. *Bharat Ratna: Jewels of Modern Indian Art*. Boston: Museum of Fine Arts.

Cheah, Pheng, and Suzanne Guerlac, eds. 2009. *Derrida and the Time of the Political*. Durham: Duke University Press.

Citron, Beth. 2009. "Contemporary Art in Bombay, 1965–1995." PhD diss., University of Pennsylvania.

———. 2011. "Approaching Abstraction in Indian Modernist Art: Tyeb Mehta's Film 'Koodal' (1969) and 'Diagonal' Painting Series (1969–75)." Unpublished paper given at the American Council for Southern Asian Art Symposium, University of Minnesota, Minneapolis, September 22–25.

Clements, William M. 2013. *Imagining Geronimo: An Apache Icon in Popular Culture*. Albuquerque: University of New Mexico Press.

Clifford, James. 1997. *Routes: Travel and Translation in the Late Twentieth Century*. Cambridge, MA: Harvard University Press.

Cohn, Bernard. 1996. "The Transformation of Objects into Artifacts, Antiquities, and Art in Nineteenth-Century India." In *Colonialism and Its Forms of Knowledge*, 57–75. Princeton: Princeton University Press.

Conan, Michel. 2006. "Fragments of a Poetic of Gardens." *Landscape Journal* 25.1 (January): 1–21.

Conn, Steven. 1998. *Museums and American Intellectual Life, 1876–1926*. Chicago: University of Chicago Press.

Connolly, William. 2002. *Neuropolitics: Thinking, Culture, Speed*. Minneapolis: University of Minnesota Press.

Constantine, Mildred, and Jack Lenor Larsen. 1973. *Beyond Craft: The Art Fabric*. New York: Van Nostrand Reinhold.

Cooks, Bridget R. 2011. *Exhibiting Blackness: African Americans and the American Art Museum*. Amherst: University of Massachusetts Press.

Cooper, Ilay, and Barry Dawson. 1998. *Traditional Buildings of India*. London: Thames and Hudson.

Corbey, Raymond. 1993. "Ethnographic Showcases, 1870–1930." *Cultural Anthropology* 8.3 (August): 338–69.

Corbridge, Stuart, and John Harriss. 2013. *Reinventing India: Liberalization, Hindu Nationalism and Popular Democracy*. Hoboken: Wiley.

Costume Institute. 1986. *The Costumes of Royal India: A Checklist to the Exhibition at the Costume Institute, December 20, 1985, through August 31, 1986*. New York: Metropolitan Museum of Art.

Cotter, Holland. 2013. "Acquired Tastes of Asian Art." *New York Times*, February 21, C23.

Courtney, Cathy. 1986. "The Golden Eye: An International Tribute to the Artisans of India, Cooper-Hewitt Museum, 5 November–23 February." *Crafts* 80 (May/June): 58.

Crossick, Geoffrey, and Serge Jaumain. 1999. *Cathedrals of Consumption: The European Department Store, 1850–1939*. Aldershot: Ashgate.

Currimbhoy, Nayana. 1986. "Crafts for Today." *Interiors* 146.5 (December): 174–79.

Czuma, Stanislaw J., and Rekha Morris. 1985. *Kushan Sculpture: Images from Early India.* Cleveland: Cleveland Museum of Art in cooperation with Indiana University Press.

Dadi, Iftikhar. 2003. "Visual Modernities in a Comparative Perspective: The West, and South Asian and Asian-American Art." PhD diss., Cornell University.

———. 2010. *Modernism and the Art of Muslim South Asia.* Chapel Hill: University of North Carolina Press.

Daniel, E. Valentine. 1996. *Charred Lullabies: Chapters in an Anthropography of Violence.* Princeton: Princeton University Press.

Danto, Arthur C. 2002. "Reflections on Fabric and Meaning: The Tapestry and the Loincloth." In *New Material as New Media: The Fabric Workshop and Museum,* edited by Marion Boulton Stroud and Kelly Mitchell, 82–89. Cambridge, MA: MIT Press.

Davey, Nicholas. 2011. "Gadamer's Aesthetics." In *The Stanford Encyclopedia of Philosophy* (Winter 2011 edition), edited by Edward N. Zalta. http://plato.stanford.edu/archives /win2011/entries/gadamer-aesthetics/. Accessed 29 June 2014.

Davis, Richard. 1997. *Lives of Indian Images.* Princeton: Princeton University Press.

———. 2008. "From the Wedding Chamber to the Museum: Relocating the Ritual Arts of Madhubani." In *What's the Use of Art? Asian Visual and Material Culture in Context,* edited by Jan Mrázek and Morgan Pitelka, 77–99. Honolulu: University of Hawai'i Press.

D'Costa, Anthony P., ed. 2010. *A New India? Critical Reflections in the Long Twentieth Century.* London: Anthem Press.

de Guardiola, Jeanne. 1986. "An Auction of Contemporary Indian Paintings to Benefit the Chester and Davida Herwitz Charitable Trust, Part II." In *Contemporary Indian Paintings from the Chester and Davida Herwitz Charitable Trust, Part II.* New York: Sotheby's.

Delsahut, Fabrice. 2008. "The 1904 St. Louis Anthropological Games." In *Human Zoos: Science and Spectacle in the Age of Colonial Empires,* edited by Pascal Blanchard et al., 294–306. Liverpool: Liverpool University Press.

De Michelis, Elizabeth. 2005. *A History of Modern Yoga: Patañjali and Western Esotericism.* London: Continuum.

Derrida, Jacques. 1973 [1967]. *Speech and Phenomena, and Other Essays on Husserl's Theory of Signs.* Translated by David B. Allison. Evanston: Northwestern University Press.

———. 1988 [1972]. "Signature Event Context." In *Limited Inc,* edited by Gerald Graff, translated by Samuel Weber and Jeffrey Mehlman, 1–24. Evanston: Northwestern University Press.

Desai, Anita. 1985. "The Rage for the Raj." *New Republic* 193.22 (November 11): 26–30.

Desai, Vishakha N. 1995. "Re-visioning Asian Arts in the 1990s: Reflections of a Museum Professional." *Art Bulletin* 77.2 (June): 169–74.

Dewan, Deepali. 2004. "The Body at Work: Colonial Art Education and the Figure of the 'Native Craftsman.'" In *Confronting the Body: The Politics of Physicality in Colonial and Post-Colonial India,* edited by James H. Mills and Satadru Sen, 118–34. London: Anthem Press.

Dewan, Deepali, and Deborah Hutton. 2013. *Raja Deen Dayal: Artist-Photographer in 19th-Century India.* New Delhi: Alkazi Collection of Photography in association with Mapin.

Dirks, Nicholas. 1987. *The Hollow Crown: Ethnohistory of an Indian Kingdom.* New York: Cambridge University Press.

Doane, Mary Ann. 2007. "The Indexical and the Concept of Medium Specificity." *differences* 18.1: 128–52.

Dohmen, Renata. 2004. "The Home in the World: Women, Threshold Designs and Performative Relations in Contemporary Tamil Nadu, South India." *Cultural Geographies* 11: 7–25.

Dubin, Zan. 1987. "Exhibit of 'Just-Let-It-Happen' Works." *Los Angeles Times*, December 20, 105.

Du Bois, Ron. 1982. *The Working Processes of the Potters of India: Massive Terracotta Horse Construction of South India.* Film. Stillwater: Audiovisual Center, Oklahoma State University.

Dumont, Louis. 1970. *Religion, Politics and History in India.* Paris: Mouton.

Durrans, Brian. 1992. "Competitive Pragmatism: Organising the 1982 Festival of India in Britain." *History and Anthropology* 6.1: 23–45.

Durst, David C. 2002. "Ernst Bloch's Theory of Nonsimultaneity." *Germanic Review* 77.3 (Summer): 171–94.

Dutta, Arindam. 1997. "The Politics of Display: India 1886 and 1986." *Journal of Arts and Ideas* 30–31 (December): 115–45.

———. 2007. *The Bureaucracy of Beauty: Design in the Age of Its Global Reproducibility.* London: Routledge.

Eliel, Carol S., et al. 2005. *Lee Mullican: An Abundant Harvest of Sun.* Los Angeles: Los Angeles County Museum of Art.

Elliott, David, and Ebrahim Alkazi, eds. 1982. *India: Myth and Reality: Aspects of Modern Indian Art.* Oxford: Museum of Modern Art.

Fabian, Johannes. 1983. *Time and the Other: How Anthropology Makes Its Object.* New York: Columbia University Press.

Ferrari, G. R. F. 2010. "The Meaninglessness of Gardens." *Journal of Aesthetics and Art Criticism* 68.1 (Winter): 33–45.

Fisher, Jennifer. 1997. "Interperformance: The Live Tableaux of Suzanne Lacy, Janine Antoni, and Marina Abramovic. *Art Journal* 56 (Winter): 28–33.

Flam, Jack D., and Miriam Deutch, eds. 2003. *Primitivism and Twentieth-Century Art: A Documentary History.* Berkeley: University of California Press.

Ford, Colin. 1984. "The Living Crafts." *Marg* 35.4 (June): 85–86.

Freitag, Sandria B., ed. 1989. *Culture and Power in Banaras: Community, Performance, and Environment, 1800–1980.* Berkeley: University of California Press.

Fried, Michael. 1967. "Art and Objecthood." *ArtForum* 5 (June): 12–23.

Frow, John. 1995. *Cultural Studies and Cultural Value.* Oxford: Clarendon Press.

Ganguly, Sumit, and Rahul Mukherji. 2011. *India since 1980.* New York: Cambridge University Press.

Ganti, Tejaswini. 2012. *Producing Bollywood: Inside the Contemporary Hindi Film Industry.* Durham: Duke University Press.

Gasché, Rodolphe. 1986. *The Tain of the Mirror: Derrida and the Philosophy of Reflection.* Cambridge, MA: Harvard University Press.

Gaur, Umesh, and Gayatri Sinha. 2002. "American Collectors of Contemporary Indian Art in the Northeast." *Orientations* 34.6 (June): 31–36.

Gere, Charlie. 2006. *Art, Time, and Technology.* Oxford: Berg.

Ghosh, Pika. 2003. "Unrolling a Narrative Scroll: Artistic Practice and Identity in Late-Nineteenth-Century Bengal." *Journal of Asian Studies* 62.3 (August): 835–71.

Gilman, Sander L. 1985. "Black Bodies, White Bodies: Toward an Iconography of Female Sexuality in Late Nineteenth-Century Art, Medicine, and Literature." *Critical Inquiry* 12.1 (Autumn): 204–42.

Goldberg, Roselee. 1998. *Performance: Live Art since 1960.* New York: Harry N. Abrams.

Greenhough, Paul. 1995. "Nation, Economy, and Tradition Displayed: The Indian Crafts Museum, New Delhi." In *Consuming Modernity,* edited by Carol Breckenridge, 216–48. Minneapolis: University of Minnesota Press.

Grey, Abby Weed. 1983. *The Picture Is the Window, The Window Is the Picture: An Autobiographical Journey.* New York: New York University Press.

Groer, Anne. 1985. "A Celebration of India: Artist Creates Treasures from Trash." *Orlando Sentinel,* June 13, E1, E7.

Guha-Thakurta, Tapati. 1997. "Marking Independence: The Ritual of a National Art Exhibition." *Journal of Arts and Ideas* 30–31 (December): 89–114.

———. 2004. *Monuments, Objects, Histories: Institutions of Art in Colonial and Postcolonial India.* New York: Columbia University Press.

———. 2007. "'Our Gods, Their Museums': The Contrary Careers of India's Art Objects." *Art History* 30.4 (September): 628–57.

Gupta, Atreyee. 2011. "The Promise of the Modern: State, Culture, and Avant-Gardism in India (c. 1930–1960)." PhD diss., University of Minnesota.

Harden, Tracey. 1985. "All the Raj: India Is In and Everyone Is Going Subcontinental." *Daily News* (New York) February 3.

Harris, Clare. 2012. *The Museum on the Roof of the World: Art, Politics, and the Representation of Tibet.* Chicago: University of Chicago Press.

Harvey, David. 1990. *The Condition of Postmodernity: An Enquiry into the Origins of Cultural Change.* Oxford: Blackwell.

———. 2005. *A Brief History of Neoliberalism.* Oxford: Oxford University Press.

Hawkins, Gay, and Stephen Muecke. 2002. "Introduction: Cultural Economies of Waste." In *Culture and Waste: The Creation and Destruction of Value,* edited by Gay Hawkins and Stephen Muecke, ix–xvii. New York: Rowman and Littlefield.

Hawley, John Stratton. 1994a. "Hinduism: *Satī* and Its Defenders." In *Fundamentalism and Gender,* edited by John S. Hawley, 79–110. New York: Oxford University Press.

———, ed. 1994b. *Satī, the Blessing and the Curse: The Burning of Wives in India.* New York: Oxford University Press.

Hazarika, Sanjoy. 1987. "Coming Attraction in Soviet: Festival of India." *New York Times,* June 28, 5.

Heartney, Eleanor. 1987. "How Wide Is the Gender Gap?" *ARTnews* 86.6 (Summer): 139–45.

Heizer, Robert F., and Theodora Kroeber, eds. 1979. *Ishi, the Last Yahi: A Documentary History.* Berkeley: University of California Press.

Henning, Michelle. 2006. *Museums, Media and Cultural Theory.* New York: Open University Press.

Herwitz, Daniel. 1985a. "Indian Art from a Contemporary Perspective." In *Indian Art Today: Four Artists from the Chester and Davida Herwitz Family Collection*, 17–27. Washington, DC: Phillips Collection.

———. 1985b. "Indian Identity and Contemporary Indian Art." In *Contemporary Indian Art from the Chester and Davida Herwitz Family Collection*, edited by Thomas Sokolowski, 22–28. New York: Grey Art Gallery and Study Center.

Hess, Julia Meredith. 2009. *Immigrant Ambassadors: Citizenship and Belonging in the Tibetan Diaspora.* Stanford: Stanford University Press.

Hickey, Gloria. 2015. "Why Is Sloppy and Postdisciplinary Craft Significant and What Are Its Historical Precedents?" In *Sloppy Craft: Postdisciplinarity and the Crafts*, edited by Elaine Cheasley Paterson and Susan Surette, 109–24. London: Bloomsbury.

Hodgkin, Howard. 1982. *Six Indian Painters: Rabindranath Tagore, Jamini Roy, Amrita Sher-Gil, M. F. Husain, K. G. Subramanyan, Bhupen Khakhar.* London: Tate Gallery.

Hoffenberg, Peter H. 2001. *An Empire on Display: English, Indian, and Australian Exhibitions from the Crystal Palace to the Great War.* Berkeley: University of California Press.

Holt, Steven. 1985. "Collaborations: Western Designers and Indian Craftsworkers Create Objects for the Global Community." *ID: Magazine of International Design* 32.6 (November/December): 28–33, 72.

Horn, Richard. 1985. *Memphis: Objects, Furniture, and Patterns.* Philadelphia: Running Press.

Howe, Desson. 1985. "Artist of Garden Variety: Nek Chand and the Recycled Creations." *Washington Post*, August 28, B1, B11.

Hutton, Deborah. 2005. "Carved in Stone: The Codification of a Visual Identity for the Indo-Islamic Sultanate of Bidjāpūr." *Archives of Asian Art* 55: 65–78.

Huyler, Stephen P. 1986. "Terracotta Traditions in Nineteenth- and Twentieth-Century India." In *From Indian Earth: 4,000 Years of Terracotta Art*, edited by Amy G. Poster, 57–66. Brooklyn, NY: Brooklyn Museum.

———. 1996. *Gifts of Earth: Terracottas and Clay Sculptures of India.* New Delhi: Indira Gandhi National Centre for the Arts.

Inglis, Stephen R. 1980a. "Night Riders: Massive Temple Figures of Rural Tamil Nadu." In *A Festschrift for Prof. M. Shanmugam Pillai*, edited by M. Israel, R. Shanmugam, and G. Vijayavenugopal, 297–307. Madurai: Madurai Kamaraj University.

———. 1980b. *A Village Art of South India.* Madurai: Madurai Kamaraj University, Department of Tamil Studies.

———. 1984. "Creators and Consecrators: A Potter Community of South India." PhD diss., University of British Columbia.

Ingold, Tim. 1993. "The Temporality of the Landscape." *World Archaeology* 25.2 (October): 152–74.

Irish, Sharon. 2004. "Intimacy and Monumentality in Chandigarh, North India: Le Corbusier's Capitol Complex and Nek Chand Saini's Rock Garden." *Journal of Aesthetic Education* 38.2 (Summer): 105–15.

Jackson, Iain. 2003. "Politicised Territory: Nek Chand's Rock Garden in Chandigarh." In *Picturing South Asian Culture in English: Textual and Visual Representations*, edited by Tasleem Shakur and Karen D'Souza, 126–45. Liverpool: Open House Press.

Jackson, Shannon. 2011. *Social Works: Performing Art, Supporting Publics*. New York: Routledge.

Jain, Jyotindra. 1997. *Ganga Devi: Tradition and Expression in Mithila Painting*. Middletown, NJ: Mapin.

Jain, Jyotindra, Aarti Aggarwala, and Pankaj Shah. 1989. *National Handicrafts and Handlooms Museum, New Delhi*. Ahmedabad: Mapin.

Jain, Kajri. 2007. *Gods in the Bazaar: The Economies of Indian Calendar Art*. Durham: Duke University Press.

Jairazbhoy, Nazir Ali. 2007. *Kaṭhputlī: The World of Rajasthani Puppeteers*. Ahmedabad: Rainbow.

Jauregui, Beatrice. 2014. "Provisional Agency in India: *Jugaad* and Legitimation of Corruption." *American Ethnologist* 41.1 (February): 76–91.

Jayakar, Pupul. 1980. *The Earthen Drum: An Introduction to the Ritual Arts of Rural India*. New Delhi: National Museum.

———. 1985. *Festival of India in the United States, 1985–1986*. New York: Harry N. Abrams.

Jones, Amelia. 1998. *Body Art/Performing the Subject*. Minneapolis: University of Minnesota Press.

———. 2008. "Live Art in Art History: A Paradox?" In *The Cambridge Companion to Performance Studies*, edited by Tracy C. Davis, 151–65. Cambridge: Cambridge University Press.

———. 2011. "'The Artist is Present': Artistic Re-enactments and the Impossibility of Presence." *TDR: The Drama Review* 55.1 (Spring): 16–45.

Jones, Caroline A., ed. 1985. *Modern Art at Harvard*. New York: Abbeville Press.

Jones, Karen, et al. 2010. *Framing Marginalised Art*. Parkville, VIC: Cunningham Dax Collection.

Jones, Kellie. 2006. "It's Not Enough to Say 'Black Is Beautiful': Abstraction at the Whitney, 1969–1974." In *Discrepant Abstraction*, edited by Kobena Mercer, 154–81. Cambridge, MA: MIT Press.

Kaplan, Roger. 1987. "Entrepreneurship Reconsidered: The Anti-Management Bias." *Harvard Business Review* 65.3 (May/June): 84–89.

Kapur, Geeta. 1970. "In Quest of Identity: Art and Indigenism in Post-Colonial Cultures, with Special Reference to Contemporary Indian Painting." MA thesis, 2 vols., Royal College of Art, London.

———. 1978. *Contemporary Indian Artists*. New Delhi: Vikas.

———. 1993. "When Was Modernism in Indian/Third World Art?" *South Atlantic Quarterly* 92.3 (Summer): 473–514. Reprinted 2000. *When Was Modernism*, 297–323. New Delhi: Tulika.

———. 1996. "Dismantling the Norm." In *Contemporary Art in Asia: Traditions/Tensions*, edited by Apinan Poshyananda, 60–69. New York: Abrams.

———. 2005. "Dismantled Norms: Apropos Other Avantgardes." In *Art and Social Change: Contemporary Art in Asia and the Pacific*, edited by Caroline Turner, 46–101. Canberra: Pandanus Books.

Karim, Farhan S. 2011. "Modernity Transfers: The MoMA and Postcolonial India." In *Third World Modernism: Architecture, Development and Identity*, edited by Duanfang Lu, 189–210. New York: Routledge.

Karp, Walter. 1980. "Greenfield Village." *American Heritage* 32.1 (December): 98–107.

Kelly, Michael. 2000. "The Political Autonomy of Contemporary Art: The Case of the Whitney Biennial." In *Politics and Aesthetics in the Arts*, edited by Salim Kemal and Ivan Gaskell, 221–63. Cambridge: Cambridge University Press.

Kester, Grant H. 2011. *The One and the Many: Contemporary Collaborative Art in a Global Context*. Durham: Duke University Press.

Khullar, Sonal. 2009. "Artistic Labor, Sexual Form, and Modernism in India, c. 1930–1980." PhD diss., University of California, Berkeley.

———. 2015. *Worldly Affiliations: Artistic Practice, National Identity, and Modernism in India, 1930–1990*. Berkeley: University of California Press.

King, Anthony D. 1984. *The Bungalow: The Production of a Global Culture*. London: Routledge and Kegan Paul.

King, Lyndel. 2001. "University Museums in the 21st Century: Opening Address." In *Managing University Museums: Education and Skills*, edited by OECD, 19–28. Paris: OECD.

Kirshenblatt-Gimblett, Barbara. 1998. *Destination Culture: Tourism, Museums, and Heritage*. Berkeley: University of California Press.

Kjaeholm, Lars. 1982. "Myth, Pilgrimage and Fascination in the Aiyappa Cult: A View from Field Work in Tamil Nadu." *South Asia Research* 2: 25–52.

Krauss, Rosalind. 1999. *"A Voyage on the North Sea": Art in the Age of the Post-Medium Condition*. New York: Thames and Hudson.

Kramrisch, Stella. 1968. *Unknown India: Ritual Art in Tribe and Village*. Philadelphia: Philadelphia Museum of Art.

Kriegel, Laura. 2001. "Narrating the Subcontinent in 1851: India at the Crystal Palace." In *The Great Exhibition of 1851: New Interdisciplinary Essays*, edited by Louise Purbrick, 146–78. Manchester: University of Manchester Press.

Kubler, George. 1962. *The Shape of Time: Remarks on the History of Things*. New Haven: Yale University Press.

Kumar, Nita. 1988. *The Artisans of Banaras: Popular Culture and Identity, 1880–1986*. Princeton: Princeton University Press.

Kurin, Richard. 1991a. "Cultural Conservation through Representation: Festival of India Folklife Exhibitions at the Smithsonian Institution." In *Exhibiting Cultures: The Politics and Poetics of Museum Display*, edited by Ivan Karp and Steven D. Levine, 315–43. Washington, DC: Smithsonian Institution Press.

———. 1991b. *Cultural Conservation through Representation: Festival of India Folklife Exhibitions at the Smithsonian Institution*. Washington, DC: Smithsonian Institution Press.

———. 1997. *Reflections of a Culture Broker: A View from the Smithsonian.* Washington, DC: Smithsonian Institution Press.

———. 1998. *Smithsonian Folklife Festival: Culture of, by, and for the People.* Washington, DC: Center for Folklife Programs and Cultural Studies, Smithsonian Institution.

Kwon, Miwon. 1997. "In Appreciation of Invisible Work: Mierle Laderman Ukeles and the Maintenance of the White Cube." *Documents* 10: 15–18.

Lawson, Carol. 1985. "The Evening Hours." *New York Times*, November 22, Style Section.

Leahy, Helen Rees. 2012. *Museum Bodies: The Politics and Practices of Visiting and Viewing.* London: Ashgate.

Levell, Nicky. 2000. *Oriental Visions: Exhibitions, Travel, and Collecting in the Victorian Age.* London: Horniman Museum and Gardens.

Lewin, Ann M. 1985. "The Nek Chand Garden at Capitol [*sic*] Children's Museum." *Hilltonian* (October/November): 20–21.

Liebl, Maureen, and Tirthankar Roy. 2003. "Preliminary Analysis of Crafts Producers and Crafts Production." *Economic and Political Weekly* 38.51–52 (December 27): 5366–76.

Lippard, Lucy. 1990. *Mixed Blessings: New Art in a Multicultural America.* New York: Pantheon.

Luke, Timothy W. 2002. *Museum Politics: Power Plays at the Exhibition.* Minneapolis: University of Minnesota Press.

MacCannell, Dean. 1999 [1976]. *The Tourist: A New Theory of the Leisure Class.* New York: Schocken.

Macdonald, Sharon. 2011. "Collecting Practices." In *A Companion to Museum Studies*, edited by Sharon Macdonald, 81–97. Chichester: Wiley-Blackwell.

Maclagan, David. 2009. *Outsider Art from the Margins to the Marketplace.* London: Reaktion.

Magelssen, Scott. 2004a. "Living History Museums and the Construction of the Real through Performance." *Theatre Survey* 45.1 (May): 61–74.

———. 2004b. "Performance Practices of [Living] Open-Air Museums (and a New Look at 'Skansen' in American Living Museum Discourse)." *Theatre History Studies* 24 (June): 125–49.

———. 2007. *Living History Museums: Undoing History through Performance.* Lanham, MD: Scarecrow Press.

Magelssen, Scott, and Rhona Justice-Malloy. 2011. *Enacting History.* Tuscaloosa: University of Alabama Press.

Magubane, Zine. 2009. "Ethnographic Showcases as Sites of Knowledge Production and Indigenous Resistance." In *Contesting Knowledge: Museums and Indigenous Perspectives*, edited by Susan Sleeper-Smith, 45–64. Lincoln: University of Nebraska Press.

Maini, Darshan Singh. 1986. "Nek Chand's Fantasy Gardens." *Span* (June): 1–6.

Maizels, John. 2009. *Outsider Art Sourcebook: Art Brut, Folk Art, Outsider Art.* Radlett: Raw Vision.

Maravillas, Francis. 2006. "Cartographies of the Future: The Asia-Pacific Triennials and the Curatorial Imaginary." In *Eye of the Beholder: Reception, Audience and Practice of Modern Asian Art*, edited by John Clark et al., 244–70. Sydney: Wild Peony.

Martin, Jean Hubert. 1989. *Magiciens de la terre*. Paris: Éd. du Centre Georges Pompidou.

Maskiell, Michelle. 2002. "Consuming Kashmir: Shawls and Empires, 1500–2000." *Journal of World History* 13.1 (Spring): 27–65.

Mason, Darielle. 2014. "Stella Kramrisch: Creating a Canon of India's Folk Arts." Unpublished paper given at the Ray Smith Symposium: "Transformations in South Asian Folk Arts, Aesthetics, and Commodities," Syracuse University, Syracuse, NY, February 27–March 1.

MassBay Antiques. 1985. "Collaboration of Indian Crafts Held at Cooper Hewitt." *MassBay Antiques* 6.9 (December): 15.

Mathur, Saloni. 2000. "Living Ethnological Exhibits: The Case of 1886." *Cultural Anthropology* 15.4 (November): 492–524.

———. 2007. *India by Design: Colonial History and Cultural Display*. Berkeley: University of California Press.

Mayer, Barbara. 1985. "East Meets West during Handicrafts Display." *Tribune* (Bismarck, ND), December 29.

McFadden, Robert D. 2012. "Marvin S. Traub, Impresario of Bloomingdale's, Dies at 87." *New York Times*, July 12, A21.

McGowan, Abigail. 2009. *Crafting the Nation in Colonial India*. New York: Palgrave Macmillan.

McLagan, Meg. 1997. "Mystical Visions in Manhattan: Deploying Culture in the Year of Tibet." In *Tibetan Culture in the Diaspora*, edited by Frank Korom, 69–90. Vienna: Verlag der Österreichischen Akademie der Wissenschaften.

Menezes, Naomi. 1985. "A Golden Eye on 2001." *Times of India*, December 22.

Miller, Mara. 1999. "Time and Temporality in Japanese Gardens." In *Relating Architecture to Landscape*, edited by Jan Birksted, 43–58. London: Taylor and Francis.

Mingei International Museum. 1986. *Forms of Mother Earth: Contemporary Indian Terracottas*. Videocassette (VHS), 16 min.

Mitchell, Timothy. 1992. "Orientalism and the Exhibitionary Order." In *Colonialism and Culture*, edited by Nicholas Dirks, 289–317. Ann Arbor: University of Michigan Press.

Mitter, Partha. 1977. *Much Maligned Monsters: History of European Reactions to Indian Art*. Oxford: Clarendon Press.

———. 1981. *Art and Nationalism: The Case of India 1850–1947*. London: School of Oriental and African Studies.

———. 1985. "Indian Art Today." In *Indian Art Today: Four Artists from the Chester and Davida Herwitz Family Collection*, 5–16. Washington, DC: Phillips Collection.

———. 2007. *The Triumph of Modernism: India's Artists and the Avant-Garde, 1922–1947*. London: Reaktion.

Mitter, Partha, et al. 2008. "Interventions: Decentering Modernism." *Art Bulletin* 40.1 (December): 531–74.

Mohsini, Mira. 2011. "Crafts, Artisans, and the Nation-State in India." In *A Companion to the Anthropology of India*, edited by Isabelle Clark-Decés and Christophe Guilmoto, 186–201. London: Wiley-Blackwell.

Molesworth, Helen. 2000. "House Work and Art Work." *October* 92 (Spring): 71–97.

Moore, Charles Willard, William J. Mitchell, and William Turnbull. 1988. *The Poetics of Gardens.* Cambridge, MA: MIT Press.

Mosquera, Gerardo. 1986. "El tercer mundo hará la cultura occidental." *Revolución y Cultura* (July/September): 39–47.

Moxey, Keith P. F. 2013. *Visual Time: The Image in History.* Durham: Duke University Press.

Mullican, Lee. 1985. "Foreword." In *Neo-Tantra: Contemporary Indian Painting Inspired by Tradition*, edited by Edith Tonelli, 9. Los Angeles: Frederick S. Wight Art Gallery.

Murphy, Pat. 1986. "Nek Chand." *Spaces* (Summer): 2.

Museum of Modern Art. 1987. "Mario Bellini: Designer." *MoMA* 44 (Summer): 2–3.

Nerdinger, Winifred, ed. 2005. *Frei Otto: Complete Works. Lightweight Construction, Natural Design.* Basel: Birkhäuser.

Oldenburg, Veena. 1994. "The Continuing Invention of the Satī Tradition." In *Satī, the Blessing and the Curse: The Burning of Wives in India*, edited by John Stratton Hawley, 159–74. New York: Oxford University Press.

Padamsee, Akbar, Richard Bartholomew, and Geeta Kapur. 1982. *Contemporary Indian Art: An Exhibition of the Festival of India, 1982.* London: Royal Academy of Arts.

Pal, Pratapaditya, and Vidya Dehejia. 1986. *From Merchants to Emperors: British Artists and India, 1757–1930.* Ithaca: Cornell University Press.

Panagia, Davide. 2009. *The Political Life of Sensation.* Durham: Duke University Press.

Parezo, Nancy J., and Don D. Fowler. 2007. *Anthropology Goes to the Fair: The 1904 Louisiana Purchase Exposition.* Lincoln: University of Nebraska Press.

Parezo, Nancy J., and John W. Troutman. 2001. "The 'Shy' Cocopa Go to the Fair." In *Selling the Indian: Commercializing and Appropriating American Indian Cultures*, edited by Carter Jones Meyer and Diana Royer, 3–43. Tucson: University of Arizona Press.

Patel, Gieve. 1985. "To Pick Up a Brush." In *Contemporary Indian Art from the Chester and Davida Herwitz Family Collection*, edited by Thomas Sokolowski, 8–16. New York: Grey Art Gallery and Study Center.

Patnaik, Naveen. 1985. *A Second Paradise: Indian Courtly Life, 1590–1947.* Garden City, NY: Doubleday.

Phillips Collection. 1985. *Indian Art Today: Four Artists from the Chester and Davida Herwitz Family Collection.* Washington, DC: Phillips Collection.

Phillips, Kristina. 2006. "A Museum for the Nation: Publics and Politics at the National Museum of India." PhD diss., University of Minnesota.

Phillips, Laughlin. 1985. "Foreword." In *Indian Art Today: Four Artists from the Chester and Davida Herwitz Family Collection*, 4–5. Washington, DC: Phillips Collection.

Pineda, Mercedes, and Mafalda Rodríguez, eds. 2015. *Nasreen Mohamedi: Waiting Is a Part of Intense Living.* Madrid: Museo Nacional Centro de Arte Reina Sofía.

Pinney, Christopher. 2004. *"Photos of the Gods": The Printed Image and Political Struggle in India.* London: Reaktion.

———. 2005. "Things Happen: Or from Which Moment Does That Object Come?" In *Materiality*, edited by Daniel Miller, 256–73. Durham: Duke University Press.

Plumb, Barbara. 1986. "Living: When East Meets West, a "Golden" Collaboration: Stars of Modern Design Now Mine New Craft Riches in India." *Vogue* (April): 218.

Poddar, Sandhini. 2014. *V.S. Gaitonde: Painting as Process, Painting as Life.* New York: Guggenheim Museum.

Poignant, Roslyn. 2004. *Professional Savages: Captive Lives and Western Spectacle.* New Haven: Yale University Press.

Pollock, Griselda. 2010. "The Missing Future: MoMA and Modern Women." In *Modern Women: Women Artists at the Museum of Modern Art,* edited by Connie Butler and Alexandra Schwartz, 29–56. New York: Museum of Modern Art.

Poshyananda, Apinan, ed. 1996. *Contemporary Art in Asia: Traditions/Tensions.* New York: Asia Society.

Poster, Amy G. ed. 1986. *From Indian Earth: 4,000 Years of Terracotta Art.* Brooklyn, NY: Brooklyn Museum.

Prakash, Swatantrata. 1984. "The Living Arts of India." *Marg* 35.4 (June): 79–84.

Prakash, Vikramaditya. 2002. *Chandigarh's Le Corbusier: The Struggle for Modernity in Postcolonial India.* Seattle: University of Washington Press.

Price, Richard. 2011. *Rainforest Warriors: Human Rights on Trial.* Philadelphia: University of Pennsylvania Press.

Price, Richard, and Sally Price. 1994. *On the Mall: Presenting Maroon Tradition-Bearers at the 1992 FAF.* Bloomington: Folklore Institute, Indiana University.

Quintanilla, Sonia Rhie, et. al. 2008. *Rhythms of India: The Art of Nandalal Bose.* San Diego: San Diego Museum of Art.

Quizon, Cherubim A., and Patricia O. Afable. 2004. "Rethinking Display of Filipinos at St. Louis: Embracing Heartbreak and Irony." *Philippine Studies* 52.4: 439–44.

Qureshi, Sadiah. 2004. "Displaying Sara Baartman, the 'Hottentot Venus.'" *History of Science* 42: 233–57.

———. 2011. *Peoples on Parade: Exhibitions, Empire, and Anthropology in Nineteenth-Century Britain.* Chicago: University of Chicago Press.

Radice, Barbara. 1981. *Memphis, The New International Style.* Milan: Electa.

———. 1984. *Memphis: Research, Experiences, Results, Failures, and Successes of New Design.* New York: Rizzoli.

Rancière, Jacques. 1991. *The Ignorant Schoolmaster: Five Lessons in Intellectual Emancipation.* Stanford: Stanford University Press.

———. 1999. *Disagreement: Politics and Philosophy.* Minneapolis: University of Minnesota Press.

———. 2012 [1981]. *Proletarian Nights: The Workers' Dream in Nineteenth-Century France.* London: Verso Books.

Reich, Richard B. 1987. "Entrepreneurship Reconsidered: The Team as a Hero." *Harvard Business Review* 65.3 (May/June): 77–83.

Reilly, Ann-Marie. 2006. [Untitled]. Supplement to Brooke Davis Anderson, "Concrete Kingdom: Sculptures by Nek Chand." *Folk Art* 31.1–2 (Spring/Summer): 49.

Reynolds, Ann. 1988. "Reproducing Nature: The Museum of Natural History as Nonsite." *October* 45 (Summer): 109–27.

Reynolds, Mark. 1985. "Special Focus: The Festival of India." *Hollywood Reporter*, November 26, S1–S2.

Richardson, Margaret. 2005. "The Formation of K. G. Subramanyan's 'Polymorphic Vision' of Art in Twentieth-Century India." PhD diss., Virginia Commonwealth University.

Rizvi, Janet, with Monisha Ahmed. 2009. *Pashmina: The Kashmir Shawl and Beyond*. Mumbai: Marg.

Rogin, Michael Paul. 1988. *Ronald Reagan, The Movie, and Other Episodes in Political Demonology*. Berkeley: University of California Press.

Rojas-Sotelo, Miguel. 2009. "Cultural Maps, Networks and Flows: The History and Impact of the Havana Biennale 1984 to the Present." PhD diss., University of Pittsburgh.

Rounthwaite, Adair. 2014. "In, around, and Afterthoughts (on Participation): Photography and Agency in Martha Rosler's Collaboration with Homeward Bound." *Art Journal* 73.4 (Winter): 46–63.

Rowland, Robyn. 1992. *Living Laboratories: Women and Reproductive Technologies*. Bloomington: Indiana University Press.

Rubin Museum of Art. 2011. "Modernist Art from India." Series of three exhibitions. Curated by Beth Citron. On-line exhibition materials, www.rmanyc.org. Accessed 9 April 2012.

Rubin, William. 1984. *"Primitivism" in 20th Century Art: Affinity of the Tribal and the Modern*. New York: Museum of Modern Art.

Rudofsky, Bernard. 1947. *Are Clothes Modern? An Essay on Contemporary Apparel*. Chicago: P. Theobald.

Rushdie, Salman. 1984a. "Outside the Whale." *Granta* 11: 125–38.

———. 1984b. "The Raj Revival." *Observer* (London), April 1, 19.

Russell, John. 1985. "Close-Up on the Craftsmen of India." *New York Times*, November 22, C1, C24.

Rydell, Robert W. 1984. *All the World's a Fair: Visions of Empire at American International Expositions, 1876–1916*. Chicago: University of Chicago Press.

———. 1999. "'Darkest Africa': African Shows at America's World's Fairs, 1893–1940." In *Africans on Stage: Studies in Ethnological Show Business*, edited by Bernth Lindfors, 135–55. Bloomington: Indiana University Press.

Rydell, Robert W., John E. Findling, and Kimberly D. Pelle. 2000. *Fair America: World's Fairs in the United States*. Washington, DC: Smithsonian Institution Press.

Said, Edward W. 1978. *Orientalism*. New York: Vintage Books.

———. 1996. *Representations of the Intellectual*. New York: Vintage Books.

Saks, Jane M., et al. 2012. *Not Ready to Make Nice: Guerrilla Girls in the Art World and Beyond*. Chicago: Columbia College.

Sanghvi, Nita. 1984. "In-house Entrepreneurship." *Economic and Political Weekly* 19.39 (September 29): 1697.

San Jose Museum of Art. 2011. *Roots in the Air, Branches Below: Modern and Contemporary Art*

from India. Exhibition curated by Kristen Evangelista (February 25–September 4). www
.sjmusart.org/roots-in-the-air-branches-below. Accessed 9 April 2012.

Schneider, Rebecca. 2011. *Performing Remains: Art and War in Times of Theatrical Reenactment.*
Abingdon: Routledge.

Scott, Felicity. 1999. "Underneath Aesthetics and Utility: The Untransposable Fetish of Bernard
Rudofsky." *Assemblage* 38 (April): 58–89.

Sen-Gupta, Achinto. 2001. "Neo-Tantric 20th Century Indian Painting." *Arts of Asia* 31.3 (May/
June): 104–15.

Sethi, Rajeev. 2010. *Scrapbook.* New Delhi: Asian Heritage Foundation.

Shah, Haku. 1984. "Form and Many Forms of Mother Clay." *Museum International* 36.1 (January/
December): 19–22.

———. 1985. *Form and Many Forms of Mother Clay: Contemporary Indian Pottery and Terra-
cotta.* New Delhi: National Crafts Museum.

Shannon, Joshua A. 2004. "Claes Oldenburg's 'The Street' and Urban Renewal in Greenwich
Village, 1960." *Art Bulletin* 86.1 (March): 136–61.

Shapiro, Gary. 1989. *Nietzschean Narratives.* Bloomington: Indiana University Press.

Schiro, Anne-Marie. 1986. "India Is Revisited at Bloomingdale's." *New York Times*, April 9, C12.

Shrivastava, Paul. 1992. *Bhopal: Anatomy of Crisis.* London: P. Chapman.

Shuster, Rob. 2006. "Asphalt Jungle." *Village Voice* (July 18). www.villagevoice.com/2006-07-18
/art/asphalt-jungle/. Accessed 6 January 2014.

Sihare, Laxmi. 1967. "Oriental Influences on Wassily Kandinsky and Piet Mondrian, 1909–1917."
PhD diss., New York University.

———. 1982. *Tantra: Philosophie und Bildidee, Aspekte zeitgenössischer indischer Kunst*
[Tantra: Philosophy and image, aspects of contemporary Indian art]. Stuttgart: Institut für
Auslandsbeziehungen.

———. 1985. "Contemporary Neo-Tantra Art: A Perspective." In *Neo-Tantra: Contemporary
Indian Painting Inspired by Tradition*, edited by Edith Tonelli, 15–23. Los Angeles: Frederick
S. Wight Art Gallery.

Silverman, Debora. 1986. *Selling Culture: Bloomingdale's, Diana Vreeland, and the New
Aristocracy of Taste in Reagan's America.* New York: Pantheon Books.

Singerman, Howard. 2009. "Pictures and Positions in the 1980s." In *A Companion to Contem-
porary Art since 1945*, edited by Amelia Jones, 83–106. Malden, MA: Blackwell.

Sinha, Ajay. 1997. "Envisioning the Seventies and Eighties." In *Contemporary Art in Baroda*,
edited by Gulammohammed Sheikh, 145–209. New Delhi: Tulika.

———. 1999. "Contemporary Indian Art: A Question of Method." *Art Journal* 58.3 (Fall): 31–39.

Sirhandi, Marcella [as Marcella Nesom]. 1984. "Abdur Rahman Chughtai: A Modern South Asian
Artist." PhD diss., Ohio State University.

Smith, Terry. 2009. *What Is Contemporary Art?* Chicago: University of Chicago Press.

———. 2010. "The State of Art History: Contemporary Art." *Art Bulletin* 92.4 (December):
366–83.

Smithsonian Institution. 1986. *The Master Weavers.* Washington, DC: Smithsonian Institution.

Soja, Edward W. 1989. *Postmodern Geographies: The Reassertion of Space in Critical Social Theory.* London: Verso.

Sokolowski, Thomas, ed. 1985. *Contemporary Indian Art from the Chester and Davida Herwitz Family Collection.* New York: Grey Art Gallery and Study Center.

Sontag, Susan. 1969. "Godard." In *Styles of Radical Will.* New York: Farrar, Straus and Giroux, 147–92. Adapted and expanded from her 1968 "Going to the Movies: Godard." *Partisan Review* 35: 290–313.

———. 1977. *On Photography.* New York: Farrar, Straus and Giroux.

Sotheby's. 1995. *Contemporary Indian Paintings from the Chester and Davida Herwitz Charitable Trust, Part I.* New York: Sotheby's.

———. 1996. *Contemporary Indian Paintings from the Chester and Davida Herwitz Charitable Trust, Part II.* New York: Sotheby's.

South Bank Centre. 1987. *In Another World: Outsider Art from Europe and America.* London: South Bank Centre.

Souza, F. N. 1955. "Nirvana of a Maggot." *Encounter* 4 (February): 42–48.

Spivak, Gayatri C. 1988. "Can the Subaltern Speak?" In *Marxism and the Interpretation of Culture,* edited by Cary Nelson and Lawrence Grossberg, 271–313. Urbana: University of Illinois Press.

Stanley, Nick. 1998. *Being Ourselves for You: The Global Display of Cultures.* London: Middlesex University Press.

Starn, Orin. 2004. *Ishi's Brain: In Search of America's Last "Wild" Indian.* New York: Norton.

Stein, K. D. 1986. "Passage from India." *Architectural Record* 174.4 (April): 156–57.

Stevens, Mark. 1979. *"Like No Other Store in the World": The Inside Story of Bloomingdale's.* New York: Crowell.

Stocking, George W. 1987. *Victorian Anthropology.* New York: Free Press.

Supangkat, Jim. 1996. "Multiculturalism/Multimodernism." In *Contemporary Art in Asia: Traditions/Tensions,* edited by Apinan Poshyananda, 70–81. New York: Asia Society.

Swallow, Deborah. 1998. "Colonial Architecture, International Exhibitions, and Official Patronage of the Indian Artisan." In *Colonialism and the Object: Empire, Material Culture and the Museum,* edited by Tim Barringer and Tom Flynn, 52–67. London: Routledge.

Tambiah, Stanley Jeyaraja. 1996. *Leveling Crowds: Ethnonationalist Conflicts and Collective Violence in South Asia.* Berkeley: University of California Press.

Thadani, Jaya. 1985. "Children's Museum: India Comes to Stay." *The Tribune* (Chandigarh), October 24.

Thoden van Velzen, H. U. E. 1990. "The Maroon Insurgency: Anthropological Reflections on the Civil War in Surinam." In *Resistance and Rebellion in Suriname: Old and New,* edited by Gary Brana-Shute, 159–88. Williamsburg: Department of Anthropology, College of William and Mary.

Thomas M. Evans Gallery and Festival of India in the United States. 1985. *Aditi: The Living Arts of India.* Washington, DC: Smithsonian Institution Press.

Tiampo, Ming. 2011. *Gutai: Decentering Modernism.* Chicago: University of Chicago Press.

Tiampo, Ming, and Alexandra Munroe, eds. 2013. *Gutai: Splendid Playground*. New York: Guggenheim Museum.

Tonelli, Edith, ed. 1985. *Neo-Tantra: Contemporary Indian Painting Inspired by Tradition*. Los Angeles: Frederick S. Wight Art Gallery.

Tripathi, Dwijendra. 1985. "An Integrated View of Entrepreneurship." *Economic and Political Weekly* 20.48 (November 30): M163–68.

Upshaw, Jim. 1985. "Aditi Festival." Segment of *Channel Four News*, June 4. Washington, DC: WRC Television. Transcript in the Smithsonian Institution Archives, Record Unit 367, Smithsonian Institution, Assistant Secretary for Public Service, subject files, box 36.

Vajpeyi, Ananya. 2012. *Righteous Republic: The Political Foundations of Modern India*. Cambridge, MA: Harvard University Press.

Vartanian, Hrag. 2016. "The Metropolitan Museum Is Still Very Eurocentric and Conservative." *Hyperallergic* (March 1). http://hyperallergic.com/279679/the-metropolitan-museum-is-still -very-eurocentric-and-conservative/. Accessed 3 March 2016.

Venturi, Robert, Denise Scott Brown, and Steven Izenour. 1972. *Learning from Las Vegas*. Cambridge, MA: MIT Press.

Virilio, Paul. 1986 [1977]. *Speed and Politics: An Essay on Dromology*. New York: Columbia University Press.

Walker, William S. 2013. *A Living Exhibition: The Smithsonian and the Transformation of the Universal Museum*. Amherst: University of Massachusetts Press.

Wallace, Caroline V. 2015. "Exhibiting Authenticity: The Black Emergency Cultural Coalition's Protests of the Whitney Museum of American Art, 1968–71." *Art Journal* 74:2 (Summer): 5–23.

Wallace, Michael. 1981. "Visiting the Past: History Museums in the United States." *Radical History Review* 25: 63–96.

Wallach, Amei. 1985. "Stemming the Tide of Plastic in India." *Newsday* (Dec-ember 6).

Wallis, Brian. 1991. "Selling Nations." *Art in America* 79.9 (September): 84–91.

Weil, Stephen E. 1999. "From Being *about* Something to Being *for* Somebody: The Ongoing Transformation of the American Museum." *Daedalus* 128.3 (Summer): 229–58.

Weiss, Rachel. 2007. "Visions, Valves, and Vestiges: The Curdled Victories of the Bienal de La Habana." *Art Journal* 66.1 (Spring): 10–26.

Welch, Stuart Cary. 1985. *India: Art and Culture, 1300–1900*. New York: Metropolitan Museum of Art.

Winship, Frederick M. 1986. "Museum Exhibit Looks to the Future of Indian Crafts." *Journal* (Kankakee, IL), February 5.

Wintle, Claire. 2009. "Model Subjects: Representations of the Andaman Islands at the Colonial and Indian Exhibition, 1886." *History Workshop Journal* 67: 194–207.

Wissinger, Joanna. 1986. "Mughal to Memphis: Modern Indian Crafts." *Progressive Architecture* 67 (January): 35–36.

Withers, Josephine. 1988. "The Guerrilla Girls." *Feminist Studies* 14.2 (Summer): 284–300.

Woodham, Jonathan M. 1997. *Twentieth-Century Design*. Oxford: Oxford University Press.

Wyma, Kathleen Lynne. 2000. "The Discourse and Practice of Radicalism in Contemporary Indian Art, 1960–1990." PhD diss., University of British Columbia.

Yeager, Patricia. 2002. "Trash as Archive, Trash as Enlightenment." In *Culture and Waste: The Creation and Destruction of Value,* edited by Gay Hawkins and Stephen Muecke, 103–15. New York: Rowman and Littlefield.

Zimmerman, Andrew. 2001. *Anthropology and Antihumanism in Imperial Germany.* Chicago: University of Chicago Press.

Zitzewitz, Karin. 2006. "The Aesthetics of Secularism: Modernist Art and Visual Culture in India." PhD diss., Columbia University.

———. 2014. *The Art of Secularism: The Cultural Politics of Modernist Art in Contemporary India.* London: Hurst.

INDEX

GLOBAL
SOUTH
ASIA

Padma Kaimal, K. Sivaramakrishnan, and Anand A. Yang

SERIES EDITORS

GLOBAL SOUTH ASIA takes an interdisciplinary approach to the
humanities and social sciences in its exploration of how South Asia,
through its global influence, is and has been shaping the world.

A Place for Utopia: Urban Designs from South Asia, by Smriti Srinivas

The Afterlife of Sai Baba: Competing Visions of a Global Saint, by Karline McLain

Sensitive Space: Fragmented Territory at the India-Bangladesh Border, by Jason Cons

The Gender of Caste: Representing Dalits in Print, by Charu Gupta

Displaying Time: The Many Temporalities of the Festival of India, by Rebecca M. Brown

Banaras Reconstructed: Architecture and Sacred Space in a Hindu Holy City,
by Madhuri Desai